Art and Photography

PENGUIN B

Dr Aaron S United States. He studied art and anthropology at the University of California and subsequently took his doctorate at the University of London's Courtauld Institute. He was a bomber pilot during the Second World War and spent some years after the war as a painter and potter in Los Angeles. Until 1982 he was Professor of the History of Art in the Open University in England. His other publications include *Creative Photography*.

Penguin Books

Aaron Scharf Art and Photography

Penguin Books Ltd, Harmondsworth, Middlesex, England
Penguin Books, 40 West 23rd Street, New York, New York 10010, U.S.A.
Penguin Books Australia Ltd, Ringwood, Victoria, Australia
Penguin Books Canada Limited, 2801 John Street, Markham, Ontario, Canada L3R 1B4
Penguin Books (N.Z.) Ltd, 182–190 Wairau Road, Auckland 10, New Zealand

First published in Great Britain by
Allen Lane The Penguin Press 1968
Published with revisions in Pelican Books 1974
Reprinted 1979
Reprinted in Penguin Books 1983

Printed and bound in Great Britain by
William Clowes Limited, Beccles and London
Set in Baskerville

Where measurements are given in the text, width precedes height

Preface

The scope of this book is confined primarily to art and photography in England and France. It also includes other countries where events of significance to art and photography took place: Italy, Germany, Russia and America.

I could not have completed it without the help of many others whose interest alerted them – and they me – to the widely scattered references to photography's relation to art in the last 125 years. In addition, I was able to work on the solid foundations established by earlier publications on the history of photography and, in more recent years, by the first attempts to merge that history with that of the other pictorial arts.

The idea for a study of this kind is not new. George Moore proposed it in *Modern Painting* in 1898, showing some surprise, not to say incredulity, that 'no paper on so interesting a question has appeared in any of our art journals'. He said that the absence of such a paper constituted 'a serious deficiency in our critical literature'. In 1900, the German writer on art, Alfred Lichtwark, also commented on this *lacuna* in historical studies suggesting that a future history of nineteenth-century painting which knew the facts would have 'to devote to photography a special detailed chapter'.

Though several books on the history of photography published in the last century brought into that sphere discussions of photography's impact on art, these references in essence were oblique, somewhat evangelical in tone, and betrayed a lack of sensitivity to the real conditions of art. Not until the appearance of other books on that subject in the 1930s did the relevant details of the relationship between the two arts begin to emerge.

One of the first art historians to interest himself seriously in the subject was Heinrich Schwarz whose admirable monograph on David Octavius Hill, published in Leipzig in 1931 and translated into English the following year, set the pattern for subsequent and more extensive research. In 1936, Gisèle Freund's penetrating *La photographie en France au dix-neuvième siècle: Essai de sociologie et d'esthétique* dealt adroitly with some of the profound inroads photography had made on modern life and art. The six or seven important histories of photography published in this century clearly confirm that, through other published studies on art, the hitherto obfuscated details about the artists' use of photographs and their reactions to the camera were finally being brought into the open. In his *History of Photography* (1949) and in his articles, Beaumont Newhall

has scrutinized the complex relations between art and photography, approaching the problems of style with a higher-powered magnifying glass than was used by his predecessors. Any subsequent writer is especially indebted to him.

Most recently, the whole field has been thrown open to such an extent that it is even to be wondered whether the current predilection of many artists for photographic imagery reflects in some part the cumulative results of these investigations. It is not necessary to mention here the many articles which in the last twenty-five years have contributed substantially to this subject. They will be referred to in appropriate parts of the text and in the notes. Three recent and worthwhile books dealing exclusively with art and photography have brought into prominence a great deal of new information and have established the important categories for further research. They are: *Une brève histoire de l'art de Niepce à nos jours* by André Vigneau (1963), *The Painter and the Photograph* by Van Deren Coke (1964) and *Kunst und Photographie* by Otto Stelzer (1966). What then, one may ask, is the usefulness of another book on the subject? There is, I believe, yet more to be said, and in particular, about the problems of style which hinge on the rather complex exchange between these different media.

This book was first written as a doctoral thesis for the Courtauld Institute of Art in the University of London. It has been entirely revised and new material added. In order to keep the greatest degree of continuity in the text, supplementary information has been put in the notes which have been treated as a semi-independent unit. A separate bibliography would be redundant as each passage of notes has been sub-titled to facilitate the location of sources.

I wish to acknowledge the generous assistance for travel abroad and for the collection of photographic material provided by the Central Research Fund of the University of London during the initial period of research. I am especially grateful for the kind and thoughtful assistance which I received from Professor Sir Anthony Blunt, Director of the Courtauld Institute of Art and from Professor Lawrence Gowing, of the University of Leeds, during the writing of the thesis. To Professor Leopold Ettlinger, University College, London, my sincere thanks are due for the many useful suggestions he made after reading the thesis. It is difficult to know how to thank Professor Ernst Gombrich, Director of the Warburg Institute, for apart from the useful observations and the material he has offered me, and from his unflagging interest in this area of study, I have derived much indirect help from his published work.

I would like also to thank Monsieur Jean Adhémar of the Cabinet des Estampes, Bibliothèque Nationale, Paris, Beaumont Newhall, Director of George Eastman House, Rochester, New York, and Dr David Thomas of the Science Museum, London, for making available photographic material in their collections. To André Jammes of Paris, who has given as freely of his large

collection of early photographs as he has of his considerable knowledge of the subject, I am greatly indebted. My thanks are also due to Professor Van Deren Coke, Chairman of the Department of Art in the University of New Mexico, for his kind support of my work and for the benefit I have derived from his publications on the same subject. The Société française de Photographie and the Royal Photographic Society in London have never hesitated to put their facilities at my disposal, for which I am very grateful. I owe many thanks also to Professor Dr Otto Stelzer of the Höchschule für Bildende Künste in Hamburg, Dr R.S.Schultze, Curator of the Kodak Museum in Harrow, and Professor Heinrich Schwarz of Wesleyan University, Connecticut, for their assistance. To Francis Haskell, Professor of Art History at Oxford University, and to Standish Lawder of Yale University I am grateful for the useful references which they have kindly given me.

To some of my colleagues and students, especially at the St Martin's School of Art, London, who for years have had to endure my interminable references to this subject and my compulsion to poke the omniscient lens into every nook and cranny of art, I offer my sincere apologies. Often, their astringent observations forced me to moderate certain assumptions which too easily flourish in the heat generated by a study of this kind.

No work of any substance on the history of the relations between art and photography could possibly be accomplished without the solid bases provided by both photographic and art historians. To them I respectfully give my thanks. For the invaluable assistance given in preparing photographs for the reproductions in this book I want to thank Peter Jones, Gerry Jones and George Forey and also the very helpful photographic department staff at the Courtauld Institute.

I am deeply grateful to the late Tony Richardson for the many valuable suggestions he made in editing this book for the press. To the publishers, and especially to David Thomson and the others who saw this book through its final stages, and to Gerald Cinamon and Veronica Loveless for their superb reconstruction of the book for the present edition, I offer my sincere thanks.

Above all, it is impossible to give enough thanks here to my wife, Marina, who has read the script through all its revisions and helped not only with the literary organization but has tried, not without difficulty, to keep me on the straight and narrow path of historical and analytical logic.

The collaboration of others in this work is not yet ended. For with its publication, a still untapped reservoir of information – documents, letters, literary references, photographs, etc. – will undoubtedly be brought to light and will enhance the growth of some of the many seedlings which I hope I will have implanted here. *Aaron Scharf*

Baudelaire: 'The word "imitate" is not the right one. M. Manet has never seen any Goyas; he has never seen an El Greco; he has never been to the Pourtalès gallery. This sounds incredible, but it is true. I myself have been amazed by such strange coincidences. . . . So much has been said about his *pastiches* of Goya that he is now trying to see some. . . . Do you doubt that such astonishing parallels can occur in nature? Well then, I am accused of imitating Edgar Poe! Do you know why I have studied Poe so patiently? Because he resembles *me*!' (Reply to the critic, Théophile Thoré-Bürger, June 1864)

Oscar Wilde: '. . . things are because we see them, and what we see, and how we see it, depends on the arts that have influenced us.' (*Intentions*, 1891)

Introduction

Inevitably, following the discovery of photography, no artist, with minor exceptions, could approach his work without some awareness of the new medium; no photographer without some consciousness of the other visual arts. Through the symbiosis of art and photography, a complex stylistic organism was created. To describe it merely as art influenced by photography, or photography by art, is an oversimplification. There are many examples of artists deriving formal ideas from photographs which were already influenced by paintings, and of photographers being inspired by paintings which contained elements of photographic form. Indeed, that compounding of influences, that very process of subjecting one medium to the capacities of another, may to a significant extent account for the high incidence of pictorial inventiveness in art after the appearance of photography.

Even in cases where photographic form is intrinsic to that medium itself, resulting from its own peculiar mechanical or chemical properties rather than from the personal predilections of the photographer, it is not guaranteed that the photograph has the priority. For almost every definable characteristic of photographic form had been anticipated by some artist before the invention of the photographic camera. The cutting-off of figures by the frames frequently seen in snapshots, for example, can be found in Donatello's reliefs, in Mantegna, in Mannerist painting and in Japanese prints. The high-speed camera revealed to artists positions of horses in gallop and birds in flight which were entirely contradictory to contemporary conventions. But several examples of such instantaneous attitudes exist earlier. Other prefigurations might also be described in respect of tone, perspective scale and instantaneity of pose and gesture. Even the strange residual images encountered in photographs of moving objects were rendered by Velasquez in the spinning-wheel of *Las Hilanderas*. They will sometimes be discovered in the vehicles represented in early nineteenth-century engravings, and their more primitive antecedents exist in the works of obscure medieval artists.

What is important, however, is that none of these things, nor others of the kind, had any currency in nineteenth-century European art until they appeared in photographs, and if photographs did not in themselves suggest entirely new conventions, by their authority, at least, they must often have confirmed ideas

already germinating in the minds of artists. Though it is always difficult and often impossible to unravel even a few of the knotty strands which make up the fabric of inspiration, there can be little doubt that photography served to heighten the artist's perception of both nature and art.

Never, before the discovery of photography, had pictorial images poured forth in such immense quantities. So inexorably did photography insinuate itself into the art of that era that, even in the works of artists who repudiated it, the unmistakable signs of the photographic image can be detected. Even when artists claimed to surpass the camera in the objectivity of their vision, attempting to overcome deficiencies known to exist in photographs, the very excessiveness of their beliefs and the fastidiousness with which they approached their work were generated, in part, under the ominous shadow of the camera. How different, one wonders, would Ruskin's *Modern Painters* have been, with its apostolic fixation on optical truth, if photography had been invented twenty years later.

Either directly, or through some kind of pictorial osmosis, the tonal uniformity and descriptive logic of the photographic image entered into the bloodstream of nineteenth-century art. As can be expected, most artists were conditioned by photography in a very conspicuous and uninspiring way. Supported both by critics and a large section of the picture-going public that persistently called for verisimilitude, their only act of imagination was in choosing the appropriate photographs from which to copy, reverently, down to the last detail, everything which the indifferent light had registered on the plates. Many examples of this kind of picture exist. But it is far more interesting and much more useful to examine the way in which artists employed photographs, not just to copy from, not as a matter of convenience or to satisfy the current dictum of pictorial truth, but to try to capture in their works the novel delicacies or the astounding aberrations to be found in those images. In their repudiation of convention, artists on the search for fresh visual ideas often found photographs immensely pertinent. In this way the less apparent though intrinsic peculiarities of the photographic image were absorbed into the vocabularies of painting and drawing. Often artists found, in those very irregularities which photographers themselves spurned, the means to create a new language of form. Thus, ironically, through its own vernacular, photography offered ways to overcome a commonplace photographic style.

The faculty of photographs to reproduce the most minute objects in view, rendered solely by light and shade, had seldom been approached in painting or drawing. The exquisite tonal delicacy and miraculous uniformity with which natural objects were simulated elicited the highest praise, but also the most

profound despair, from artists who felt themselves incapable of matching the virtuosity of the picture-making machine. Details which escaped the eye were captured by the lens. 'A withered leaf lying on a projecting cornice, an accumulation of dust in the hollow moulding of a distant building', paving stones, roofing tiles and window panes were all recorded with such devastating finesse that no artist, it seemed, however dedicated to the punctilious imitation of nature, could ever hope to equal it. Of course, by careful shading with pencil or chalk, by following one of Ruskin's famous drawing lessons, it was possible to produce at least as subtle a range of tones as could be found in any photograph. But to unite tone and form with the logic of the daguerreotype was believed to be beyond the capabilities of even the most scrupulous draughtsman.

In the first decade following the appearance of photography, painting and drawing styles became noticeably more tonal. The impetus thus given to an already prevalent conception of form at the expense of line, was a provocation to many artists and critics who saw in this surrender to photographic imagery the destruction of the Ideal and the triumph of materialism.

The discovery of photography was announced in 1839. Quite optimistically, many artists held the view that it would 'keep its place' and function primarily as a *factotum* to art. But this was both presumptuous and futile. The medium was so *en rapport* with the mentality of a large and growing section of the public which prided itself on mechanical achievement, and not less with the growing preoccupation of artists with truthful representation, that it could hardly be relegated to such an inferior position. It is not surprising, during an age in which the efficacy of the machine would appear to be one of the essential virtues, that the authority invested in a machine by which nature could take her own picture would impinge on art in the most fundamental way.

The exaggerated belief in pictorial precision had also been nurtured by a long tradition in the use of optical instruments and mechanical devices for producing works of art. But perhaps more important, the initial enthusiasm for photography was largely an indication of the extent to which it confirmed the previous visual commitments of artists. Had the general character of painting by chance been significantly different, artists could not have given to photography the same enthusiastic reception. The tonal representation of natural objects and natural conditions transmitted by the lens was essentially similar to a style already ascendant in painting.

But in nineteenth-century art the character of naturalism was ambiguous and, despite generic likenesses in style, it could not easily or precisely be defined. It was hoped that in the photographic image one unquestionable authority might be established as the standard against which all naturalistic painting

would be measured. However, it soon became obvious that there was no uniformity in the images produced by the camera, not only because of the inherent technical differences in the several photographic processes, but because these processes themselves were subject to other than mechanical control. The images of the daguerreotype and the calotype were as dissimilar as the paintings of Meissonier and Monet.

Conscious of the mechanical limitations of their medium, photographers increasingly developed new, often elaborate means for augmenting the artistic content of their work. At the same time their assertiveness grew. They saw little reason why photography should not be considered as a Fine Art and thus share the advantages enjoyed by painting and sculpture. As a consequence of this, many artists and critics who formerly looked upon photography with benign condescension now, alarmed at its audacity, began to propose means of combating the threat. Within twenty years of its appearance the influence of photography on art was already thought of as pernicious. By the 1860s photographers had convincingly broken the quarantine imposed on them. Anxiety about the growing photographic style in painting rose to a new pitch. Photography and its flood of images were accused of having caused a decline in artistic taste, and blamed for having forced painters into a deadly homogeneity of style, for subverting their individuality. Art's mortal enemy, it was called, and there is abundant literary evidence to indicate that such feelings were widespread.

Colour photography seemed imminent in the 1860s and 1870s and artists were warned that this mechanical interloper would soon take possession of all pictorial representation. They were made conscious of the necessity for reviving more 'spiritual' values in art. They were called upon to return to art's 'higher realms'. For some who had long valued 'spirit' above 'substance', photography was seen as a welcome purgative: a destroyer of the mechanical, insensitive and mediocre artist.

Because of the stigma attached to artists who were known to rely on photography, its use was generally concealed so that many photographs obviously were afterwards destroyed. Consequently the pattern of such usage becomes much more difficult to trace. Those artists who spurned any direct use of photographs – and it seems they were not many – did so for the most part as a matter of principle. Some, because they were placed in an awkward position by the highly photographic character of their work; others, because they believed there was something noble in industry and sacrifice, that a painter taking short-cuts damaged his integrity.

With the appearance of more or less instantaneous photographs from about 1860, artists were faced with yet another and very fundamental problem. For many of these images defied the customary ways of depicting objects in motion

and, though they were factually true, they were false so far as the human optical system was concerned. Was the artist then to confine his representations only to observable things, or was he justified in showing those which, as the instantaneous camera demonstrated, existed in reality yet could not be seen? Convention notwithstanding, it was now possible to learn to see many of the new and startling forms, or to perceive them on a threshold level, but the subjects of high-speed photographs, taken from the 1870s, some with exposures as fast as 1/1000th and then, in the 1880s, 1/6000th of a second and less, could never be comprehended by the human eye alone. Though previously the photograph had been criticized for certain deficiencies of information, now the camera was accused of telling too much. Photographs of invisible objects taken through the microscope or telescope were known long before the instantaneous image, but because these had not posed a threat to vested artistic interests they were thought to fall safely within the purview of science or in the domain of visual curiosities. It was only, it seems, when some artists and their supporters began seriously to think in terms of another kind of truth, another kind of nature, when the restrictions of convention were seriously and consistently challenged, that the representation of natural conditions which escaped the unaided eye was considered detrimental to art.

As any glance into the catalogues of either the Salon or Royal Academy exhibitions at the end of the century will show, most painters were still working within the rather rigid confines of some photographic style. And, what is more, one discovers, on comparing photographs and paintings of the period, that a topsy-turvy situation had come about. With the assistance of several new and quite unorthodox techniques, many photographers were producing pictures which looked more like products of the hand than of the lens.

But painters for whom the accurate imitation of external realities had lost both its moral and its artistic force sought new images commensurate with their belief that art involved a more creative process. To them, perception was not purely an optical procedure. They considered it the artist's right, if not his mission, to convey the essential reality, the intrinsic character of his subject, to emphasize at will for the sake of poetry and expression. However much other factors may have contributed to the growing antipathy such artists held for material truth, the photographic image undeniably had become a tangible and most convenient symbol of that truth. And while the camera through its peculiarities of form continued to suggest, even to these artists, new means of representation, it served inexorably to hasten the demise of a purely imitative art.

The salient features of the history of photography and its relation to art are best described in terms of subject-matter, with chronology a secondary consideration

– though, conveniently, each major photographic development in turn carried a particular meaning for one or other category of art. Thus, in the 1840s, immediately following the appearance of the daguerreotype and calotype, portrait painting was the first art directly affected. The first important influence on landscape painting was felt in the latter part of that decade, when landscape photography became more practicable and more popular. The dilemma of realism in art confronted by such machine-made images was essentially a problem of the 1850s and 1860s with the further elaboration of the photographic medium. The urban realism of Impressionist painting is paralleled by the snapshot in the 1860s and 1870s. The 1880s were truly the watershed in nineteenth-century art and photography. The occurrence then of the Kodak camera and the great popularization of photography, the extra-perceptive high-speed camera and the first convincing attempts at cinematography, the intense efforts made by photographers in the artistic development of their medium, and the defiant chorus of artists and writers asserting the futility of mimetic art – these, together, were quite enough to create havoc with the conventional functions of both photography and art. From the 1890s, superseding all arguments, photography was accepted as an established form of art. Traditional aesthetic concepts were stood on their heads or, if one prefers, had finally landed back on their feet, and the territorial rights of both artists and photographers were summarily established. And finally, in this century the integration of photography with other visual arts was effected in a way and on a scale never contemplated earlier. That pattern largely determined the structure of this book.

Art and Photography

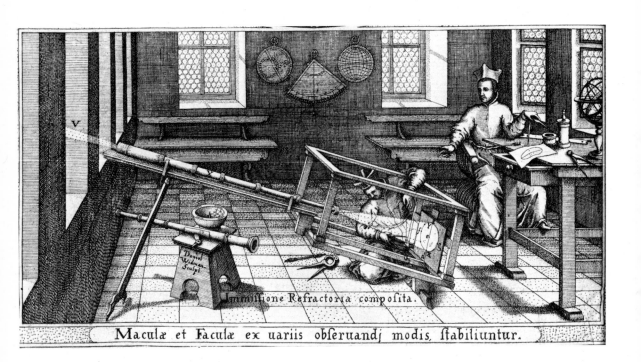

1. Camera obscura used for observing sunspots

1. The invention of photography

THE CAMERA OBSCURA

Long before it was ever believed possible to fix its images, the camera was employed first by astronomers (1) then by artists; by the latter to authenticate their views of nature and as a labour-saving device. With this camera, or camera obscura as it was called, natural images could be registered on a ground corresponding to a retina from which either linear tracings or tonal drawings, or even paintings, could be made. The camera obscura was by no means limited to topographical subjects. In the reproduction of architectural monuments, exterior and interior, especially for those which posed difficult problems of perspective, its use was widely recognized. In 1568 Daniele Barbaro, the Venetian writer on architecture, recommended the camera obscura as an aid to artists:

By holding the paper steady you can trace the whole perspective outline with a pen, shade it, and delicately colour it from nature.

The Venetians, Antonio Canale and Bernardo Bellotto, both used this instrument for their landscape and perspective views. Several books published in the seventeenth and eighteenth centuries contained instructions and illustrations describing the operation of the camera obscura and other 'machines for drawing'. Moreover, this same device was employed by figure and portrait artists and its utility in these fields was suggested as early as 1558 by the famous Neapolitan philosopher, Giovanni Battista della Porta. Several Dutch and Italian painters in the seventeenth and eighteenth centuries, including Vermeer and Giuseppe Maria Crespi, are said to have used the camera obscura in this as in other ways, and it is likely also that Reynolds later used it.

But the camera obscura was most frequently of service in drawing and painting landscapes. A surprisingly extensive list of artists who took advantage of it could be compiled: among them are Guardi, Claude-Joseph Vernet, Thomas and Paul Sandby, Loutherbourg, John Crome, Thomas Girtin, Samuel Prout, Ruskin and, of course, Daguerre and Talbot. Indeed, one can reasonably assume that most artists engaged in the vast production of those *voyages pittoresques*, extremely popular in the eighteenth and nineteenth centuries,

made significant use of the camera obscura. Apart from the convenience of this instrument, the perplexing problems of light and shade and of aerial perspective, which beset artists who wanted to convey the utmost naturalism in their pictures, coupled with a confidence in optical aids, accounted for the fact that in some cases the images of the camera obscura were given a degree of authority equal almost to that bestowed later upon the photograph. Paul Sandby's son said of his father,

he aimed at giving his drawings the appearance of nature as seen in a camera obscura with truth in the reflected lights, clearness in shadows and aerial tint and keeping in the distances and skies (2).

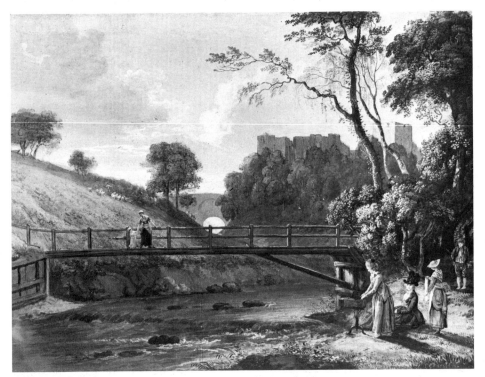

2. Paul Sandby: *Rosslyn Castle*. Late eighteenth century (water-colour)

But just as artists were later to debate the usefulness and even the accuracy of the photographic image, so too did their precursors, in the eighteenth century especially, quarrel over the image of this seeing machine. Hogarth, for example, rejected the camera on the grounds that it subjugated the vision of the artist to the imitation of a lifeless rather than an animated nature. By direct observation alone he proposed to store his memory full of a variety of natural forms and gestures thereby minimizing the dependence on the conventional forms of pictures by earlier masters:

thus what ever [I] saw [he wrote in *The Analysis of Beauty*], was more truly to me a picture than one seen by a chamera obscura. By this Idle way of proceeding I grew so profane as to admire Nature beyond Pictures and I confess sometimes objected to the devinity of even Raphael Urbin Corregio and Michael Angelo for which I have been severely treated.

Though Reynolds himself owned and undoubtedly experimented with a camera obscura, in his thirteenth discourse, fearful that the rigid optical accuracy fostered by that instrument would tend to detract from the supremacy of the imagination, he declared:

If we suppose a view of nature represented with all the truth of the camera obscura, and the same scene represented by a great Artist, how little and mean will the one appear in comparison of the other, where no superiority is supposed from the choice of the subject. The scene shall be the same, the difference only will be in the manner in which it is presented to the eye. With what additional superiority then will the same Artist appear when he has the power of selecting his materials, as well as elevating his style?

What precisely was the appearance of the image as seen in the camera obscura? From the sixteenth to the nineteenth century a great variety of cameras were designed: large and small, with or without lenses, some with reversing mirrors and with different arrangements of plates of ground glass or other materials on which the natural forms could be registered. There must consequently have been considerable variation in these images though not as much as was possible later with the more versatile equipment and techniques of photography. A very useful description of the camera obscura image by M.G.J.Gravesande occurs in Charles-Antoine Jombert's mid-eighteenth-century instructional book on drawing (3). He intended this as a warning to artists not to be misled by its distortions:

It can be noticed regarding the camera obscura, that several Flemish painters (according to what is said about them) have studied and copied, in their paintings, the effects that it produces and the way in which it presents nature; because of this several people have believed that it was capable of giving excellent lessons for the understanding of that light, which is called chiaro-oscuro. It cannot be denied that certain general lessons can in fact be drawn from it of broad masses of shadows and light: and yet too exact an imitation would be a distortion; because the way in which we see natural objects in the camera obscura is different from the way in which we see them naturally. This glass interposed between objects and their representation on the paper intercepts the rays of the reflected light which render shadows visible and pleasantly coloured, thus shadows are rendered darker by it than they would be naturally. Local colours of objects being condensed in a smaller space and losing little of their strength seem stronger and brighter in colour. The effect is indeed heightened but it is false. Such are the pictures of Wouvermans. A painter should

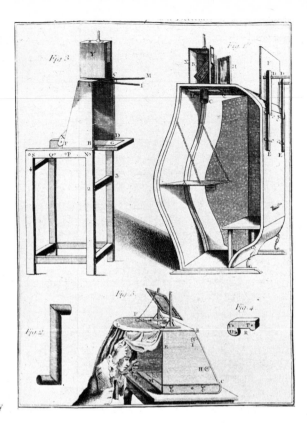

3. Camera obscura. Eighteenth century

bring before the eyes of all men nature as they normally see it and not with a heightened effect (as is seen in the camera obscura) but which in fact only a few know.

Conversely, the eighteenth-century Venetian, Count Francesco Algarotti, collector, patron of Tiepolo and others, and writer on science and art, unreservedly advocated the use of the camera. Algarotti was highly influential among artists, not only in Italy but in other countries as well. His *Essay on Painting* was translated into English in 1764, only a few years after its original publication. Almost prophesying the invention of photography, he wrote,

we may well imagine, that, could a young painter but view a picture by the hand of Nature herself, and study it at his leisure, he would profit more by it than by the most excellent performance by the hand of man.

The artificial eye, he continued, presents to the artist

a picture of inexpressible force and brightness; and, as nothing is more delightful to behold, so nothing can be more useful to study, than such a picture. For, not to speak of the justness of the contours, the exactness of the perspective and of the chiaroscuro, which exceeds conception; the colours are of a vivacity and richness that nothing can excel . . . the shades are strong without harshness, and the contours

precise without being sharp. Wherever any reflected light falls, there appears, in consequence of it, an infinite variety of tints, which, without this contrivance, it would be impossible to discern. . . . At least we can only see them in so dull and confused a manner, as not to be able to determine any thing precisely about them. Whereas, in the Camera Obscura, the visual faculty is brought wholly to bear upon the object before it.

Enthusiastic about the results which could be obtained, Algarotti declared that

the best modern painters among the Italians have availed themselves greatly of this contrivance; nor is it possible they should have otherwise represented things so much to the life. It is probable, too, that several of the tramontane masters, considering their success in expressing the minutest objects, have done the same. Every one knows of what service it has been to Spagnoletto of Bologna, some of whose pictures have a grand and most wonderful effect.

He also noted the approbation of the camera obscura by a few 'very able masters' in his acquaintance, one of whom was of the opinion that to revive the art of painting an academy needed no more than: 'the book of da Vinci, a critical account of the excellencies of the capital painters, the casts of the finest Greek statues, and the pictures of the Camera Obscura'. Algarotti thus concluded:

Let the young painter, therefore, begin as early as possible to study these divine pictures, and study them all the days of his life, for he never will be able sufficiently to contemplate them. . . . Painters should make the same use of the Camera Obscura, which Naturalists and Astronomers make of the microscope and telescope; for all these instruments equally contribute to make known, and represent Nature.

From the fifteenth century, at least, there were of course innumerable other contrivances, both mechanical and lenticular, designed to guarantee the reproduction of nature with maximum precision. A long list could be made beginning with the ambiguous mechanism described by Alberti, including those fascinating framed grids and eye-pieces illustrated by Dürer and ending with the incredible plethora of contraptions which poured from the industrial cornucopia of the nineteenth century. That era gave its artists the camera lucida and the graphic telescope; the diagraph, the agatograph, and the hyalograph; the quarréograph, pronopiograph and eugraph; the graphic mirror and the periscopic camera, the solar megascope, the *prisme ménisque*; the physionotrace, the universal parallel and any number of other pantographic instruments. But all of these were eclipsed by the invention of photography.[1]

DAGUERRE, TALBOT, NIEPCE

The traditional concern with the camera obscura and other implements helped to prepare the way for the acceptance of the photographic image and accommodated the growing conviction that a machine alone could become the final

arbiter in questions concerning visual truth. What could have been more desirable for artists using the camera obscura than to have its image permanently fixed on a sheet of paper to be taken away and, as Algarotti envisaged, studied at leisure? So it was that, in the first place, utilizing the discoveries of scientists, photography was invented by artists for the use of artists. Well before his discovery Louis-Jacques-Mandé Daguerre had acquired a considerable reputation as a painter and inventor of illusionist effects in panoramas and, from 1816, as a designer of stage settings for the Paris opera. Almost at the same time as he invented the diorama, the most popular of all early nineteenth-century *trompe l'œil* entertainments, Daguerre in 1823 began to experiment with the photographic process. With little doubt, for the huge dioramic paintings, Daguerre made use of the camera obscura and later perhaps of unfixed photographic images in order to obtain the most naturalistic rendering of contour and tone possible. If so, he would have to be counted as probably the first artist to utilize photographs for his paintings – before photography was in effect discovered.

William Henry Fox Talbot, the discoverer of another photographic process, was an amateur artist who used the camera lucida and the camera obscura from the early 1820s as aids to his landscape drawings. Among other discoverers or near-discoverers of photography were artists who sought through the camera obscura, one might say, the last word in art.

In 1822, Joseph-Nicéphore Niepce succeeded in fixing what he called a heliograph on glass. Niepce and his son, Isadore, the latter said to be a painter and sculptor, had been practising the new art of lithography since about 1813. Because litho stones of good quality were difficult to obtain, they soon substituted pewter plates. When later working alone (*c.* 1816) the elder Niepce, who had little ability for drawing, conceived the idea of recording, photographically, an image on the plate and etching it for printing. Unlike Daguerre, he was principally interested in this as a reproductive method. After unsuccessful experiments with chloride of silver, he used another light-sensitive substance called bitumen of judea; the unexposed parts could be dissolved, baring the metal to be etched. Niepce actually managed to pull a few proofs by this method, using as negatives engravings made transparent by oiling or waxing. One of his heliograph engravings was a landscape after Claude Lorrain. About this time (1826–7) he took the view of a courtyard with a camera obscura, though it needed an exposure of about eight hours.

When Daguerre learned of this he felt it wise to contact Niepce, especially because he was encountering many difficulties in his own photographic experiments. Following the exchange of several cautious and tentative letters a partnership was agreed upon and the appropriate papers signed in 1829. But Niepce died in 1833, leaving his son to continue the experiments with Daguerre.

The latter, convinced that his own iodine and mercury process was more practicable and that the Niepce procedure should be abandoned, was soon able to fix the camera's image, though impermanently. By 1837, with common salt as a fixative, Daguerre made his first relatively permanent photograph, probably a still-life with plaster casts. He now planned to sell his invention either through subscriptions totalling 400,000 francs, or to a single purchaser for half that amount. When it became apparent that the required number of subscribers was not forthcoming, he attempted to attract investors about the end of 1838 by distributing a printed notice outlining several applications for his method, including its potential for portraiture – though this was rather premature considering the long exposure times necessary at that date. Daguerre believed that his discovery would

give a new impulse to the arts . . . and far from damaging those who practise them, it will prove a great boon to them. The leisured class will find it a most attractive occupation . . . the little work it entails will greatly please the ladies . . . the daguerreotype is not merely an instrument which serves to draw nature . . . [it] gives her the power to reproduce herself.

He indicated that on 15 January (1839) between forty and fifty daguerreotypes would be placed on exhibition.

The exhibition, it seems, was not held. It is likely that Daguerre was dissuaded from trying to sell his invention to private interests (where he was not meeting with much success) by François Arago, the distinguished scientist and Republican member of the Chamber of Deputies. Arago had advocated the great social advantages to be derived from industrial production ('let the machine and human decency turn away from centuries of ignorance, barbarism and misery'). Author of essays on city planning, workers' housing and such specialized problems as the wasteful operation of Cornish mines, he believed that photography could be as beneficial for society as printing. It was in this spirit, undoubtedly, that he was eager for the French government to award pensions to Daguerre and Niepce and then magnanimously to place the invention of photography in the public domain.

Arago lost little time in putting his plan to work. At the 7 January meeting of the Académie des Sciences he made an announcement describing, in general terms, the new process:

the image is reproduced to the most minute details with unbelievable exactitude and *finesse* . . . in M. Daguerre's copies . . . as in a pencil drawing, an engraving, or, to make a more correct comparison, in an aquatint-engraving . . . there are only white, black and grey tones representing light, shade and half-tones. . . . Light itself reproduces the forms and proportions of external objects with almost mathematical precision.

Arago mentioned daguerreotypes he and others had seen: views of Parisian buildings and bridges which, he said, retained their sharpness even under a magnifying glass. He pointed out the advantages of the daguerreotype for 'those travelling private gentlemen' who draw important architectural structures:

the ease and accuracy of the new process, far from damaging the interests of the draughtsman, will procure for him an increase in work. He will certainly work less in the open air, and more in the studio.

He went on to describe the usefulness of the invention to archaeologists, physicists and astronomers (Arago was then Director of the Observatory of Paris) and announced that Daguerre had already taken a picture of the moon. He then suggested that the government compensate Daguerre and the younger Niepce, and 'nobly give to the whole world this discovery which could contribute so much to the progress of art and science'.[2]

FIRST REACTIONS TO PHOTOGRAPHY

The intense interest with which this news was received can well be imagined. Though the magic of the photographic camera elicited a predominantly enthusiastic response, in the popular Press especially, reports from artistic quarters were often tinged with that same irony with which a defeated champion congratulates his successor. Some reactions were unequivocally pessimistic. Most of the comments in the art and literary journals, however, appeared at least hopeful. It was said that this admirable, incredible invention would become indispensable to the artist, that this process promised to make a revolution in the arts of design and would be completely at the service of the artist. 'Will the artist not be driven to starvation when a machine usurps his functions?' it was asked.

No, the daguerreotype does not deprive the landscape painter of his bread and butter; on the contrary he can make it yield profitable returns. He can photograph a locality with the daguerreotype in a few minutes, to serve as a sketch for a painting in any desired proportions at home.

Paying tribute to the notion, *le temps est de l'argent*, the critic Jules Janin praised the daguerreotype for its usefulness to the artist 'who does not have the time to draw'. Janin was one of the first to see, in the new medium, the great possibility of accurately reproducing earlier works of art.

It is destined to popularize among us, and cheaply, the most beautiful works of art of which we have now only costly and inaccurate reproductions; before long . . . one will send his child to the museum and tell him: in three hours you must bring me back a painting by Murillo or Raphael.

This could hardly have been reassuring to engravers, though elsewhere they were confidently told that they would benefit from the discovery of photography as once scribes had from that of printing:

Even in our own time, the substitution of steel-plates for engraving, instead of copper, although fifty times as many copies may be taken from them, has, by the substitution of good engravings for indifferent ones, so extended the demand, that more steel-plates are now required than were formerly used of copper.

The more sceptical artists were assured by the experts that photography was no threat to them; moving objects could not be fixed without blurring, and the tones of certain colours were grossly distorted. Though topographical artists

will see how far their pencils and brushes are from the truth of the daguerreotype . . . let not the draughtsman and the painter, however, despair . . . the results obtained by M. Daguerre are very different from their works, and in many cases cannot be a substitute for them.

There was some encouraging objection to the daguerreotype since it failed to communicate the personal touch and the selective eye of the artist. The mechanical exactness of Daguerre's views, it was believed, might soon become monotonous.

Le Charivari and *La Caricature provisoire* carried news of the discovery, and to mitigate the fears of artists the latter journal tried a bit of satirical exorcism:

There is a muffled rumour going around that thanks to this instrument one will see vanishing at the same stroke landscapists, portraitists, ornamental painters and all the other artists.

Artists were becoming unduly alarmed:

You want a landscape? You go and put yourself with your camera in front of the landscape in question, you pull the string, the machine does its job and, after five minutes, the required landscape has been stuck onto a piece of paper. You want a portrait of your doorman? Very well! Pull the bell-rope for the fellow, get him to remove his fur cap, ask him to stay facing this same camera, and three and a half minutes later you possess a faithful copy of a mighty ugly original, and you have only to ask this doorman for a lock of his hair as a further, precious keepsake! Artists came to find us to tell us with some alarm, that M. Daguerre was going to take out a patent for perfecting the thing. From now on such new improvements will be made to his machine, that during the sittings the same instrument will play various *airs de circonstance* and the portrait will come out after five minutes, not only entirely finished but completely framed as well! And what a frame! Of the most admirable lemon-wood!

During that eventful January the painter Paul Huet received a letter from the Duchess of Orleans describing the invention to him:

There is a bit of news among the artists, there is a lot of talk of Daguerre's invention, a kind of camera obscura in which the light, that acts in an unalterable way on a metal sheet, prepared by a chemical process, leaves on this sheet, after a ten-minute exposure, a wonderfully precise monochrome drawing. One can't use this invention of course except for inanimate objects; it is marvellous, I should go and see it on Sunday, and I'll talk to you about it again when I am better informed.

Huet, in turn, wrote later that year to the painter, A.-M. Decaisne:

I am all in a daze over Daguerre's discovery, what will they say about it then in Paris, the big city! Progress, emancipation, etc., etc., have you seen the marvel? To tell the truth I am a bit prejudiced despite my astonishment and admiration.

It is impossible to know how many other artists shared Huet's doubts about the advantages of the new medium.

What could the artist be expected to say of pictures which were declared to be more beautiful than paintings; which, 'drawn' by the sun, exceeded the most capable of human hands? A view of Paris taken from the Pont des Arts was described as 'drawing carried to a degree which Art can never attain . . . we count the paving stones; we see the humidity caused by the rain'.[3]

OTHER INVENTORS OF PHOTOGRAPHY

Niepce and Daguerre, it has been noted, were not the sole inventors of photography, though the latter's particular technique appears to be almost entirely his own. Several other photographic methods, more or less successful, had been developed before 1839. In England, Talbot had been working on one since 1833. When he learned of Daguerre's achievement he promptly published a report of his own process which he called 'Photogenic Drawing'. During the first months of 1839, after Daguerre's and Talbot's discoveries had been advertised, other inventors or would-be inventors appeared with evidence of their experiments. A few had actually been able to fix natural images or had copied drawings and engravings by direct contact, while others seem only to have verged on success. One claim indicated that certain artists (their names were not given), thirty years previously, had developed a negative process using diluted nitric acid as a fixative. Because they were unable to obtain positive images the project was abandoned. It had not, it seems, occurred to them, as later it did to Talbot, to make the negative translucent and re-photograph it.

Talbot's method was significantly different from that of Daguerre. Whereas the daguerreotype was a direct positive process, each photograph a unique image on a highly polished metal plate, photogenic drawing was soon to develop into a negative–positive one allowing for multiple copies on paper.

Though Talbot had earlier taken a series of diminutive views with specially constructed cameras, photogenic drawing was at first confined to the direct

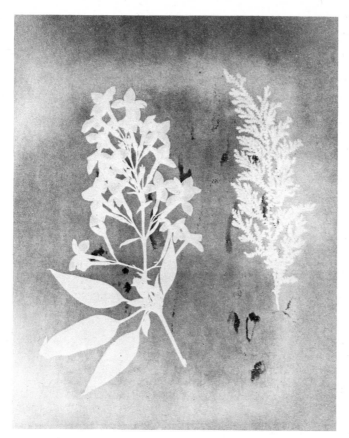

4. Fox Talbot:
Photogenic drawing. 1839

contact reproduction of prints, drawings, lace and leaf forms (4). But even after the process was adapted for use in a camera, about the middle of 1839, it seems that daguerreotypes were still largely considered to be superior, for these could describe with what must have seemed microscopic precision the tiniest parts of the objects in view and convey with great accuracy the intangible characteristics of light and weather effects (5).

5. Daguerreotype. Panorama of Paris. 1844

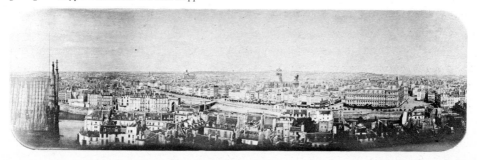

On the other hand, Talbot's camera views, soon called calotypes, were printed from oiled or waxed paper negatives. They thus reproduced the fibrous texture of the paper, giving the print broad tonal masses of dark and light and indistinct contours (6). In comparison with the daguerreotype, the calotype was inferior in transmitting the animalcula of nature and also in its meteorological subtleties, then so highly prized.

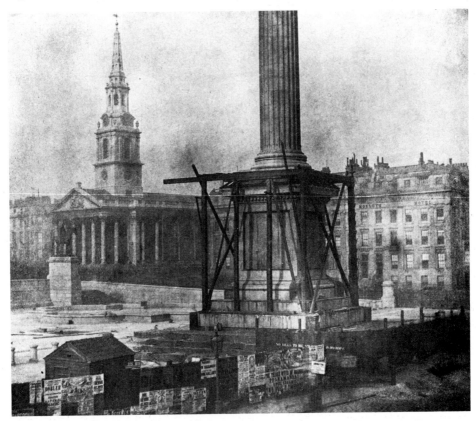

6. Fox Talbot: Calotype of Trafalgar Square. *Nelson's Column under construction.* 1845

Talbot believed that the photograph would become an important aid to artists. But apparently unconcerned with the wonderfully soft, luminous effects possible with the calotype and with the other positive attributes of that medium, he thought the great advantage lay in the multitude of minute details which to some extent certainly was obtainable even in that kind of photograph, but which 'no artist would take the trouble to copy faithfully from nature'. Talbot wrote this in 1844 in his book, *The Pencil of Nature*, the first publication using actual photographic prints in conjunction with a text.

Contenting himself with a general effect [Talbot continued], the artist would probably deem it beneath his genius to copy every accident of light and shade; nor could he do

so indeed, without a disproportionate expenditure of time and trouble, which might be otherwise much better employed. Nevertheless, it is well to have the means at our disposal of introducing these minutiae without any additional trouble, for they will sometimes be found to give an air of variety beyond expectation to the scene represented.

Principally, however, it was because Talbot's process was a reproductive one that its ultimate ascendancy over the daguerreotype (which shortly before 1860 went completely out of fashion) was ensured.

Among the early French inventors of other photographic processes, largely ignored in the great hullabaloo over Daguerre, was Hippolyte Bayard who is known to have produced successfully natural images on paper (*dessins photogènes*) at least as early as 5 February 1839. Furthermore, not only were they exhibited that same month, but some were owned by the artist Henri Grevedon (who was to serve on an official committee to report on Daguerre's discovery) and it is said, though likely exaggerated, that 'all of Paris' knew them. Probably the first to obtain direct positive prints on paper (54), Bayard actually showed his pictures to Arago on 20 May. And while the scientist obtained for him a grant of 600 francs with which to continue his photographic researches, his work was suspiciously obscured during the effort to win government support for Daguerre.[4]

PHOTOGENIC DRAWING AND THE *CLICHÉ-VERRE*

Talbot's photogenic drawings were first presented to the Royal Institution on 25 January 1839 and to the Royal Society shortly afterwards, notices appearing in the Press early in February. At both institutions Talbot exhibited several of these 'drawings' and some of his small views taken with the camera in 1835. While the details of Daguerre's procedure were not divulged until 19 August, Talbot's were made public on 23 February. Talbot soon attempted to secure to his name patents for almost every possible variation and application of his invention. And Daguerre, despite the avowed intention of making the daguerreotype freely accessible to the world, had it patented in England and her colonies. About a year later, when the initial excitement abated, the strangling effects of both Talbot's and Daguerre's patents were noticeably curtailing the practice of photography in England. The engraver, John Pye, was especially interested in photography as early as 1839 and he wrote to Daguerre (4 October) politely indignant about the patenting in England of that invention which was then 'the most interesting and pleasurable subject of conversation amongst men of art and science in London'. Talbot submitted, in 1852, to the pressure exerted by a number of artists and scientists and ceded most of his patent rights.

In a very short time the commercial advantages of the 'new art' were exploited and in March and April of 1839, several months before Daguerre was

to release the secret of making daguerreotypes, advertisements appeared in London offering for sale photogenic drawing paper: 'by means of which the most delicate and beautiful object either of Nature [plant forms] or Art [drawings, engravings] may be accurately copied' and 'photogenic drawing boxes' for 'copying Objects by means of the Sun'. About the beginning of April the Society of Arts Museum in London exhibited 'a variety of pretty photogenic drawings'.

The English engravers, Frederick James Havell and James Tibbitts Willmore, known for their reproductions of some of Turner's paintings, including *The Fighting Téméraire*, had by the end of March developed two procedures for executing pictures on glass plates which were then used as negatives for printing on photo-sensitized paper; designs they explained 'which the sun may be said to print [and which] may be multiplied with perfect identity for ever!' The first, linear, was effected simply by covering the glass plate with a smoked etching ground, the drawing then scratched through and the glass used as a contact negative for photographic printing. The second, tonal, required that the picture be painted on the glass with a semi-opaque varnish. By varying the thickness of the coating, the amount of light coming through in the printing could be controlled and a full range of tones obtained. Havell described his procedure in copying Rembrandt's etching, *Faust Conjuring Mephistopheles*. The announcement of this process appeared in March and with it came an expression of relief that engravers would not after all be driven into penury:

The first report of the discovery in France alarmed the painters from nature; next, the specimens of etched plates and printed impressions alarmed the engravers; this further discovery has replaced it, as an art, in the hands of its professors.

Havell was optimistic about the glass-plate method:

It will give rise to a new employment: to the artist, in making original designs on glass, as well as copies from pictures . . . but it is doubtful if it can ever be made to rival the beauty of [engraving] or the facility of [printing]. It will be an art *per se*.

But Talbot, who had revealed a variety of improvements on his invention, challenged the priority of the Havell–Willmore method. He was rebuffed by the artists. Willmore, whose 'beautiful subjects . . . were the admiration of the persons assembled' at the Graphic Society where the 'new art . . . seemed to be the chief subject of conversation', complained that when he and two other artists tried to patent their method they found it impossible since the process had already been publicly disclosed:

Our object was to have united with us as many artists as a patent would allow, viz. twelve. Self-protection prompted this, – for the new art, as it was spoken of, threatened

us with the loss of our occupation. 'Tis sufficient that it was neither a selfish nor an unworthy procedure by which twelve artists might have been saved from the ruin, if the threatened power of the new art could have been realised.

Though it had actually been attempted earlier, and was subsequently to be practised in later years as the *cliché-verre* by Corot, Millet and the painters of Barbizon, and by Delacroix, not until well into the twentieth century did this technique achieve the prominence it deserved. As a method for reproducing other works of art it had serious drawbacks and could hardly compete with the photographic camera, but as a means of producing original works of art it had great promise (7). Its lack of popularity can perhaps be attributed to the fact that it was so intimately linked with the photographic process and consequently it may have been devalued in the eyes of the picture-purchasing public.

7. Corot: *Figures in a Landscape. Cliché-verre.* n.d.

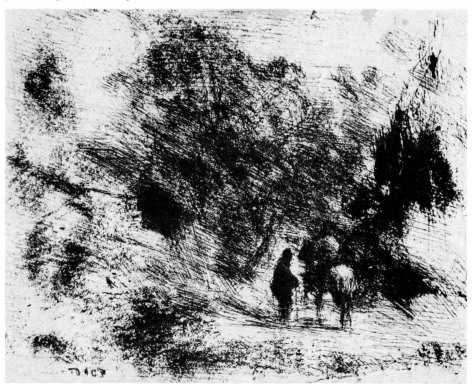

Brusquely assessing the delicate position in which engravers now found themselves, one critic predicted that Daguerre's method not only threatened seriously to supersede mechanical picture-making instruments like Gavard's diagraph, but 'it only remains for someone to invent the means of reproducing the images in quantity as one does with a print'. He went on:

Once you discover that, the profession of engraving by hand is finished; and it is not a great pity when you think of the long and painful effort it entails to achieve such meagre results.

The obsolescence of artists whose chief occupation was that of reproducing other works of art was not in fact as imminent as some gloomy prophets envisaged. It is probably even true that for two or three decades their services were in greater demand because of photography and the general increase in the use of illustrative material. Ultimately, however, as will be described in a later chapter, that profession was completely pre-empted by photo-mechanical methods.[5]

THE DAGUERREOTYPE IS MADE PUBLIC

When Daguerre's discovery was announced in January, Samuel Morse, the American artist and inventor of the electro-magnetic telegraph, was in Paris. Morse, a student of Benjamin West from about 1812 to 1815, had, like his master, been interested in the camera obscura. About 1812 he attempted to fix its image but with little or no success. Eager to be shown the results of the new process, he contacted Daguerre. A meeting was arranged for 7 March. In a letter to his brothers (9 March), Morse described the daguerreotypes as resembling aquatint engravings, 'for they are in simple chiaro oscuro, and not in colours. But the exquisite minuteness of the delineation cannot be conceived. No painting or engraving ever approached it.' In the magnified image of a spider taken through a solar microscope, he recognized the great potential photography had for science, but he could not fairly be expected to grasp the significance the invisible world was later to have for art. This plate, he wrote, showed

a minuteness of organization hitherto not seen to exist. You perceive how this discovery is, therefore, about to open a new field of research in the depth of microscopic nature. We are soon to see if the minute has discoverable limits. The naturalist is to have a new kingdom to explore, as much beyond the microscope as the microscope is beyond the naked eye.

Morse proposed Daguerre as an honorary member of the American Academy which voted unanimously in his favour. Daguerre was subsequently made an Academician in Edinburgh, in Vienna and in Munich. He also received decorations from the heads of various foreign governments. Louis-Philippe (about the middle of 1839) promoted him from Chevalier to Officer of the Legion of Honour. However, no similar recognition was offered from either the English or French Academy, an indication probably of the reluctance of these two internationally powerful groups to accord photography anything pertaining to the status of a Fine Art.

In May, Daguerre showed his works to visiting scientists and artists from Great Britain. The names of the artists are unfortunately unknown. The group included the astronomer and chemist, Sir John Herschel, and the physicist Sir John Robison who, on his return to Edinburgh, reported his findings to the Society of Arts in that city on 1 June. The charm of these pictures by Daguerre, he noted, 'must arise, in some measure, from finding that so much of the effect which we attribute to colour, is preserved in the picture, although it consists only of light and shade'. Robison saw that this discovery could be applied to book illustration; he emphasized the relatively low cost of making prints if the photographic image were transferred on to copper or stone. He anticipated considerable improvements in anatomical and surgical drawings which, with the help of photography, could be executed with a fidelity previously unknown. Robison believed that even the Fine Arts would gain, 'for the eyes accustomed to the accuracy of daguerreotype pictures, will no longer be satisfied with bad drawing however splendidly it may be coloured'. Perhaps most interesting of all in the present context, calling to mind Monet's later series of haystacks and cathedrals, was Robison's reference to

a set of three pictures of the same group of houses, one taken soon after sunrise, one at noon, and one in the evening; in these the change of aspect produced by the variations in the distribution of the light, was exemplified in a way which art could never attain to.

Apparently uneasy about the outcome of the application for a pension to be made to the government, and no doubt irritated by the claims of Talbot and others in England, Daguerre engaged a patent agent in London on 1 June. Four days later Count Duchâtel, Minister of the Interior, finally acted by forming a committee to submit a report on the invention. Paul Delaroche, among the foremost history painters of the time, a member of the Institut and professor at the École des Beaux-Arts, was to head the group. On 15 June, Duchâtel presented the Bill to pension both Daguerre and Niepce's son to Louis-Philippe and to the Chamber of Deputies. He described the new process with great enthusiasm, basing his observations on the report of the Delaroche committee.

Arago soon followed Duchâtel by presenting the Chamber, on 3 July, with a more elaborate account of the findings of the committee. He gave a summary of the use of the camera obscura since della Porta. He spoke of early experiments with light-sensitive substances, and how Niepce's efforts were stimulated by a desire to copy engravings. On the Sunday following Arago's report, several daguerreotypes – street views, the interior of Daguerre's studio and still-lifes of antique casts – were placed on exhibition for the benefit of the deputies and peers. The astonishing exactness with which the slightest accidental effects of

the sun, or the different degrees of transparency in water were described was ecstatically reported in both French and English periodicals. The pictures measured approximately 6 by 9 inches, and the value of each (perhaps minimized to convince the officials of the low cost of the process) was set by Daguerre at $3\frac{1}{2}$ francs (about 15p or 36¢). But this was not a public exhibition, nor had Daguerre yet held one.

On 30 July a report was made to the French peers by the scientist, Joseph-Louis Gay-Lussac. While regretting, as others had, a shortcoming of the daguerreotype – its inability to record faithfully the proper tones of coloured objects – he nevertheless praised it highly. Nothing can escape the eye and pencil of this new painter, he stated: 'the problem of its adaptation to portrait painting is almost resolved'. He suggested that the principal advantage of this process was in its ability to obtain the exact representation of objects and to reproduce them by engraving or lithography. The peers, like the deputies, were impressed. On 1 August, pending the signature of the King, the Daguerreotype Bill became law. At a meeting of the Académie des Sciences on Monday, 12 August, Arago announced that Louis-Philippe had given his sanction. He then read a letter from Duchâtel who proposed that a meeting be held the following Monday to which the members of the Académie des Beaux-Arts should be invited.

The excitement and suspense of the past seven months were now to be brought to a climax. The London *Art-Union* wrote shortly afterwards that 'the most intense curiosity existed in Paris to ascertain the mode by which M. Daguerre obtained his wonderful results', and other contemporary accounts testify to the almost carnival spirit of that day. On the benches reserved for the public, according to the eye-witness account of Ludwig Pfau, were crowded all the scholars and all the artists present in Paris. Having received no formal invitation, Pfau had to stand in the crowded vestibule of the Institut at the Mazarin Palace. Three hours before the meeting began more than 200 persons are reported to have gathered in the court outside.

No document has yet been uncovered indicating which artists were present. Of the fourteen painter-members of the Académie des Beaux-Arts that year at least two of the most important were outside France. Ingres was in Rome and Horace Vernet in the Near East. Vernet was soon to become the first of the major artists actually to take daguerreotypes (at the end of 1839): an extensive series of views of the monuments and architecture of the Near East. Delaroche, who must certainly have attended this meeting, would very likely have communicated his interest to the students of his large *atelier*, several of whom were later to become well-known photographers. In their early twenties at this time were Thomas Couture, who entered Delaroche's studio probably about 1835–6,

Jean-François Millet, a pupil from 1837, and Charles Daubigny, there in 1838. Of the other artists likely to have been interested, Delacroix was probably travelling in Holland during that time. Courbet, only twenty years old in 1839, was not in Paris and there is no indication of the response of the older Barbizon painters to the event. Paul Huet, maintaining a rather recalcitrant attitude, seems to have been in the south of France during the autumn of 1839. Though some British scientists were in attendance, it is not clear which British artists, if any, were present.

The symbolic union of science and art which ushered in the daguerreotype could not have been better expressed than by the presence in the chair of Eugène Chevreul, the new President of the Académie des Sciences, whose famous work on the simultaneous and successive contrasts of colours was published in book form that same year.

At this meeting, implementing the text of his 3 July report to the Chamber, Arago gave a detailed verbal account of the history and technique of the daguerreotype process. He quoted from Delaroche's report in which the artist declared that M. Daguerre's process 'brings to such a pitch of perfection certain essential attributes of art that even for the cleverest of painters it will become the object of scrutiny and study'. What strikes M. Delaroche in these photographic drawings is the 'unimaginable refinement of finish which neither disturbs the harmony of the composition nor weakens the general effect'. The correctness of the drawing, M. Delaroche adds, the precision of the forms in M. Daguerre's pictures,

is as perfect as can be, and at the same time one sees there broad, vigorous forms and an ensemble as rich in tone as can be found. . . . The painter will discover in this process an easy means of collecting studies which he could otherwise only have obtained over a long period of time, laboriously and in a much less perfect way, no matter how talented he might be.

After having defeated by sound arguments the opinions of those who imagined that photography would harm our artists and above all our skilled engravers, M. Delaroche, stated Arago, finishes his note with this thought: 'To sum up, the admirable discovery of M. Daguerre has rendered an immense service to the arts.'[6]

2. Portraiture

FIRST REACTIONS TO PORTRAIT PHOTOGRAPHY

Since no practical demonstration of the daguerreotype process had been given at the 19 August meeting, arrangements were made in both Paris and London to show how the complex procedure worked. On 17 September, Daguerre himself performed the operation in Paris before a selected audience. And in London at the Adelaide Gallery the technique was explained daily by Antoine Claudet, a Frenchman whom Daguerre licensed to make daguerreotypes in England. On 14 September *The Times* reported that daguerreotype experiments were being carried out for the public by 'M. Ste. Croix at No. 7 Piccadilly'. A notice in the *Art-Union* (October) advised that at the Polytechnicon Mr Cooper was lecturing on the new process thrice a week and that this discovery was absorbing the attention of artists and chemists on the Continent.

Through the very close liaison maintained between France and England virtually every new photographic event in either country was made known in the other. The same articles often appeared in French and English journals, the same photographs were distributed in both countries, exhibitions were international in scope and, by the early 1850s, with the appearance of the first photographic societies, dual memberships were not uncommon.

Among artists and writers a certain uneasiness prevailed. In France there was some concern over the alacrity with which the State had granted pensions to Daguerre and his partner. *La Caricature* immediately took issue with the government. In France, it said, the machine rather than genius was encouraged. Worthwhile books, worthwhile pictures, never received the national recom-. pense that had been given for the daguerreotype. As for the direct threat of photography to art, this journal, in a long satirical article, attempted to reassure artists that there was really little to worry about: the current fears were entirely unfounded. Daguerreotypes could only reproduce things in black and white. You ask it to give you the lily and rose complexion of your mistress, and it gives you her features in black and white instead. That indeed was a shortcoming in the daguerreotype, but very little time was lost in developing methods for colouring its images. A greater difficulty in the earliest days of photography was the excessively long exposure. Subjects sitting for their portraits had to

remain still for as long as twenty minutes, even in full sunshine, sometimes with their eyes closed; these were opened again by careful retouching after-wards.

Yet despite these initial difficulties inherent in the photographic process, the alarm of artists, even though mitigated somewhat by the reassuring quips of satirists, was unmistakable. On 8 December *La Caricature* published a lithograph by Théodore Maurisset entitled *La daguerréotypomanie*. A multitude of *Daguer-réotypophiles* are shown in a frantic rush to embrace the new discovery. Desperate engravers who have committed suicide *en masse* hang from a series of scaffolds. On the lower right, under a sign reading '*Appareil pour les portraits daguerréotypes*', is clamped an unfortunate sitter in a frightening exag-geration of the paraphernalia soon to be employed by photographers to keep their subjects steady throughout the lengthy sittings. This is one of the first of such caricatures lampooning the new and very vulnerable subject, and in the following decades photography provided Daumier, Grandville, Nadar, Cruikshank and many others with an abundance of material for their pas-quinades. Daumier made over thirty-five lithographs and drawings on this subject alone (8). In 1840, for example, his lithograph satirizing the long exposure times required by the photographer was entitled *Patience is the Virtue of Asses.*

8. Daumier: *Photographie. Nouveau procédé.* 1856 (lithograph)

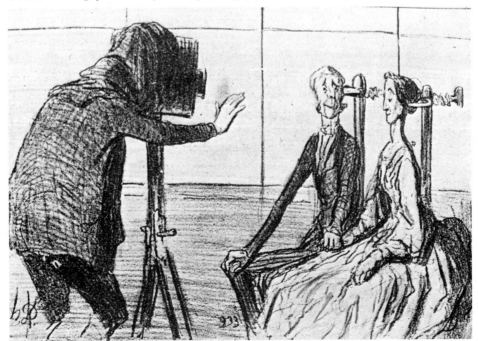

Each improvement in photography produced a reaction in the journals concerned with the visual arts. When the Beard process for reducing the exposure time (by adding bromine to the sensitive plate) to four or five minutes was announced, the *Art-Union* in April 1841 assured artists that they need not fear this innovation would injure them, for, while a photographic portrait was inexorably faithful, none knew better than they themselves how rarely a very close resemblance pleased the sitter. But the *Literary Gazette* in November described portraits taken in daguerreotype by M. Gaudin of Paris, complimenting him on the rapid and beautiful results. Of Claudet's 'much improved' portraits, it noted:

The old and serious looks, the stern frown, the fixed stare, in the first portraits, have given place to smiles and to natural and pleasing expression, and stiff attitudes to ease and grace.

By February 1841 Talbot had already experimented with portraiture using his calotype method. He claimed an exposure time of half a minute in full sunshine.

The *Art-Union* wrote of the superiority of the portrait artist over the camera. The photograph lacked the charm of colour and could not impart any of the 'innumerable graces' a 'judicious' artist gave to his work. By March 1842, however, Richard Beard patented a method for applying colour to daguerreotypes. It originated probably in 1841 with the Swiss miniature painter, J.B. Isenring, who had taken up the daguerreotype immediately in 1839. *A Treatise on Photography*, by N.-P. Lerebours, first published in Paris about 1842, described several methods for colouring daguerreotypes: those of Messieurs Laicky, Léotard, Chevalier and Claudet. On 30 July 1842 the *Spectator* favourably compared daguerreotypes with painted portraits. The daguerreotype was valuable for 'limning the fleeting shades of expression in the human face: for here the art of the painter, however great his skill, is most at fault'. And by 1846, reversing its earlier position, the *Art-Union* praised Claudet's coloured daguerreotypes as truly and undoubtedly works of art.[7]

PHOTOGRAPHY AS AN INDUSTRY

Photographic portraiture was rapidly becoming an industry in both England and France. The cost of a daguerreotype, even in the early 1840s, was far below that of a painting. In 1841 one Parisian photographer charged only 15 francs per portrait. In 1845 Beard's studio in London issued a price list with daguerreotype portraits ranging from one guinea 'for a bust' (the profit being about 18s.) to two guineas 'full-length' (profit about 34s.). As the technique was improved the costs diminished and the demand for daguerreotype portraits increased. It is said that in 1849 100,000 daguerreotype portraits were taken in Paris alone.

This is a very modest figure if we consider a contemporary source which claimed that in 1847 half a million photographic plates were sold in Paris, and it is likely that most of them were for portraits. Though daguerreotypes were single positive pictures, a method had been developed in the 1840s for their multiplication, although it does not appear to have caught on. From the mid 1850s with the introduction of the small and exceedingly popular *carte-de-visite* photograph, the price of portrait photographs had fallen to about 20 francs per dozen. According to an estimate made at the time, over 105 million photographs were produced in Great Britain in 1862. These were mostly portrait *cartes* at an average price of 1s (5p). The photographic studio of Alfred Harman & Co. (Peckham), to take only one example, advertised *cartes* in 1865 at prices of one for 2s. or 5s. per dozen. Copies could be had at 1s. each, six for 2s. 6d. and twelve for 4s. Enlargements 'to any size required' were offered. Well over 100,000 copies of John Edwin Mayall's portraits of Queen Victoria were sold in the 1860s. In 1867 300,000 copies were sold of a *carte* portrait of the popular Princess of Wales carrying Princess Louise on her back. The time had come when almost anyone could possess a portable portrait gallery, not only of their own families and acquaintances but of all the distinguished personalities of the time. The sociological effects of this, not least the obvious relation to traditional beliefs in physiognomics, must have been profound and would bear closer scrutiny. In 1861, in London, there were over 200 photographic portrait studios, thirty-five of them in Regent Street. In 1863 one London establishment employed about 100 people and many other studios engaged over fifty people each. It is against this background that one must evaluate the decline of portrait painting in the nineteenth century.[8]

MINIATURE PAINTING

The first group of artists to suffer from the effects of photography were the portrait miniaturists. In both 1800 and 1810 over 200 miniature paintings were exhibited at the Royal Academy. In 1830, of 1,278 paintings in the R.A. exhibition, about 300 were miniatures. By 1858, however, there was a marked absence of such works in the Miniature Room of the Academy. There, according to a contemporary source, 'a few yards of space in the centre of that once crowded side suffice for all that are worth exhibiting'. By 1860 only sixty-four were on view. In 1863 a Royal Commission report on the Academy noted that on the basis of a return of paintings exhibited from 1823 to 1833 about half were portraits. Sir Charles Eastlake, then President of the Academy, was asked whether this was still the case. He answered:

I should say not. I think it will be found that works of invention are far more numerous now than they were then; and also from an accidental circumstance, namely, that

the miniatures . . . which count as portraits, are far less numerous than they were formerly.

In 1870 only thirty-three miniature paintings were exhibited.

The magic of the miniature portrait was captured by the camera. The proximity of the daguerreotype to the Lilliputian appearance of the miniature painting, its lower cost, greater veracity and the relative ease with which it was executed, made it almost necessary for the average miniaturist, if he were to ensure his survival as an artist, either to utilize the daguerreotype in his work or to go over completely to the new process. It has been estimated that of fifty-nine daguerreotypists in Berlin and Hamburg before 1850, at least twenty-nine were or had been painters, one a lithographer and another an engraver. Carl Stelzner, for example, a German miniaturist who had studied under Isabey in Paris, soon became a photographer, and his wife, also a miniaturist, copied directly from her husband's photographs. The situation was certainly similar in France and England. J. Mansion, a French painter who exhibited in the R.A. from 1829 to 1831, became an assistant in Antoine Claudet's London studio, where he retouched and coloured portrait photographs. Jean-Baptiste Sabatier-Blot was both miniaturist and photographer and stopped sending work to the Salon after 1841, devoting himself wholly to photography.

Miniaturists found 'renewed occupation in colouring photographs' about mid century. Robert Lock, for instance, 'cast his lot with photography' and applied himself to 'colouring the photographs of Mr Henneman', finally establishing a photographic firm of his own. Writing in 1866 of the impact of photography on this kind of painting, Richard and Samuel Redgrave quoted Sir William Ross R.A., the 'last of the important miniaturists', who on his death-bed in 1860 lamented that 'it was all up with future miniature painting'.

Sir William Newton, miniaturist to William IV and then to Queen Victoria, wrote that the miniature-painter Robert Thorburn had to leave his field because of photography. Newton himself, from about 1853, became a photographer and landscape painter.

In the 1840s a price list from Beard's showed a charge of four guineas for 'a miniature painted from a daguerreotype'. In the 1850s an advertisement for 'Beard's Photographic and Daguerreotype Miniatures' informed the public that

Mr Beard's Daguerreotypes are remarkable . . . for breadth of effect and beauty of colour, and the Photographs on Paper (finished as paintings in water colours or crayons) are equal to the best Miniatures, with this advantage, that the likenesses are marvellously accurate.

More quickly than in any other *genre* of painting, portraits in miniature underwent a profound stylistic change after the appearance of photography. A few

recalcitrants held fast to tradition. But the rest succumbed with surprising alacrity to the compelling virtues of the impartial vision. So ingenuous was the attitude of artists, especially when livelihoods were at stake, that often portraits in miniature were painted directly over photographic bases, as in the work of François Rochard and Thomas Carrick. But for the mere suggestion of the personal touch these portraits are almost indistinguishable from photographs, and even the London *Art Journal* in 1858 found the procedure commendable (9). By 1860, with good reason, Claudet could pronounce that miniature portraits were no longer painted without the help of photography. Even eminent artists, he said – discreetly neglecting to name them – turned their talents to painting or copying from photographs.

One of the last-ditchers, determined to hold out against the mechanical menace, was Alfred Chalon R.A., a Swiss miniaturist who worked in England. His contribution to history rests largely on the acidity of a remark made to

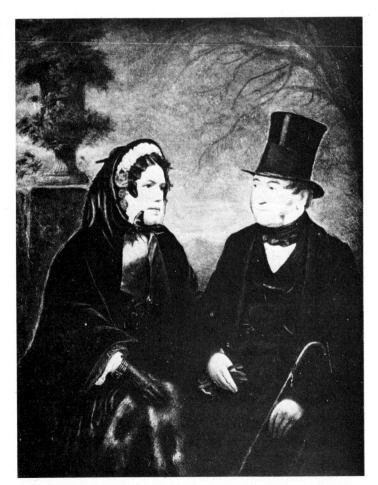

9. Anon. Miniature photo-painting of an Old Darby and Joan. *c.* 1840s

Queen Victoria when she questioned him about the danger of photography to miniature painting. 'Ah, non Madame, photographie can't flattère' was his shrewd retort.

In 1855 Cuthbert Bede, in a page of caricatures on portrait photography and painting in *Photographic Pleasures*, referring probably to that remark, drew 'the Hon. Miss Haggis, from the portrait by Chaloon, R.A.' as a lovely young lady, and contrasted this with the same Miss Haggis 'from a daguerreotype', looking twenty years older and in a most disreputable condition (10). Chalon was possibly too complacent, for with skilful retouching and colouring by artists employed in the photographic studios, even too truthful portraits could be doctored and the missing charms restored.

Sometimes photography was seen as having a beneficial, purgative effect on painting. It was recognized that the relative scarcity of miniature painting was due to photography, which had 'swept away' third- and fourth-class painters

10. Cuthbert Bede:
Photographic People
from *Photographic Pleasures*.
1855

and turned them into photographic colourists. William Newton, conceding the disastrous effect of photography on miniature painting, placed the blame on the artists. Photography, he wrote, is 'calculated' to aid Fine Art, but naturally idle artists will misapply the photograph.

The demise of miniature painting was often discussed in the 1850s and 1860s. In 1856, after praising Claudet's portrait photographs, a writer in the *Athenaeum* gloomily observed: 'What can the miniature painter – the painter of real portraits, not ideal and poetic images – do against the sun?' Another blow to miniature painting was dealt with the appearance of the *carte-de-visite*. The French photographer André Disderi had in 1854 begun to produce these small photographs mounted on card (usually about 2½ by 4 inches) and, by the end of that decade, they were so much in demand that in 1861 he was said to have been earning the astonishing sum of £48,000 a year. The *Art Journal* reported in 1857 that portrait photography had become so popular as to create a public nuisance. The streets were sometimes impassable because of the 'touters' who almost dragged passers-by into their establishments and 'It has really now become a matter for Police interference both on the grounds of propriety and public comfort!' In the same journal (1859) Francis Frith stated that photography was dreaded by 'certain classes' of artists and with good cause, for 'it has already almost entirely superseded the craft of the miniature painter, and is on the point of touching, with an irresistible hand, several other branches of skilled art'.

In 1865 Claudet, now a recognized spokesman for photography, came to its defence when it was maliciously attacked by a writer in the *Gazette des Beaux-Arts*. He extolled the advantages of photography for man and for civilization. He compared its invention to that of printing: the arts of pictorial reproduction, like calligraphy, admirable though they were, had become the inevitable victims of progress, and rightly so, he intimated:

One cannot but acknowledge that there are *arts which are on their way out* and that it is photography which has given them the death-blow! Why are there no longer any miniaturists? For the very simple reason that those who want miniatures find that photography does the job better and instead of portraits more or less accurate where form and expression are concerned, it gives perfectly exact resemblances that at least please the heart and satisfy the memory.

Though miniature painting was almost eclipsed by the early 1860s, late in the century it enjoyed a brief revival. At that time, with the virtual disappearance of the daguerreotype, with photographic portraits printed on large formats, and probably because of a certain contempt for photography's now commonplace image, these paintings once more came into fashion. The R.A. exhibited

106 miniatures in 1891, 165 in 1900 and 202 in 1907. In 1899 miniature painting was said to have once again assumed a position of some importance: 'Even miniature work, which photography was reputed once to have killed, has risen again.'[9]

PORTRAIT SITTINGS

The relations between the portrait artist and photography are well illustrated by the work of satirists and caricaturists in the first five years following the invention of photography. In 1842 the difficulties of the artist turned portrait-daguerreotypist were brilliantly burlesqued in J.J.J.Grandville's book, *Scenes from the Private and Public Life of Animals*. The story of Topaz, the portrait painter, a mocking travesty of the artist *manqué*, traces the peregrinations of a talented monkey from Brazil who studies painting in Paris. His career is cut short when he discovers that imagination, rather than imitation, is required of art. To compensate, this ape of nature purchases a daguerreotype camera and returns to his native land, there establishing the first photographic portrait studio (11).

11. Grandville: Engraving from *Scenes from the Private and Public Life of Animals*. 1842

He is soon the rage and all jungle society come to have their portraits taken. The vicissitudes of the photographer in catering to the vanity of his clients are delightfully described in the text by Louis Viardot and in the drawings by Grandville. For at the height of his reputation Topaz is undone by the elephantine narcissism of a powerful king and in despair the poor monkey hurls himself into the waters of the Amazon.

The threat of portrait photography to painting is described in Theodor Hosemann's tragi-comic drawing of the interior of a daguerreotype studio in

1843. There, *The Unhappy Painter*, the miserable, impecunious victim of progress, is supplanted by the machine (12).

12. Theodor
Hosemann:
*The Unhappy
Painter.* 1843

In the following year Daumier published *Le portrait au daguerréotype* in which the commercial advantages of the new art commodity are being scrutinized by the greedy-looking purchasers at a fine-art auction (13).

13. Daumier:
*Le portrait au
daguerréotype.*
1844

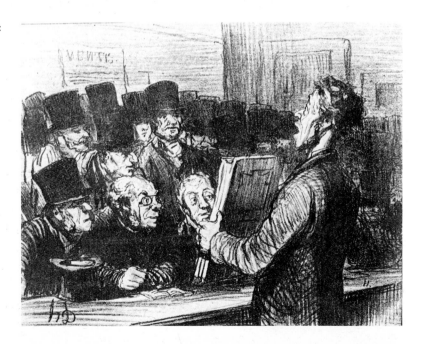

Portrait painters found that by employing photographs the interminable sittings traditionally required could be reduced considerably and in some cases eliminated entirely. Reynolds and Lawrence often needed up to fifty sittings for portraits. The former's painting of Sir George Beaumont had taken twelve sessions for the cravat alone! Though sitting many times for a well-known artist may have had some compensation in the prestige acquired, the price paid included the discomfort and extreme tediousness of posing. The Duchess of Richmond, it was said, found it painful standing for preliminary drawings for a portrait by Lawrence, and 'he got quite irritable if she moved in the slightest degree'.[10]

INGRES

Ingres may have been among the very first artists to employ the daguerreotype in the execution of portrait commissions. In 1855 Eugène de Mirecourt, a contemporary of the painter, associated his work with the photographs of the legendary Nadar:

Young Nadar is the only photographer to whom he sends all those whose perfect likenesses he wishes to have. Nadar's photographs are so marvellously exact, that M. Ingres, with their help, has produced his most admirable portraits without the necessity of having the original before him.

In 1857 Nadar himself, in a caricature of the Salon exhibition, connected Ingres with photography. Though the exact meaning of the drawing is somewhat ambiguous, the academician is shown trying to catch a camera which is running away on the legs of its tripod.

It may have been as early as 1841 that Ingres, returning to Paris after his stay in Rome as Director of the Académie française, first utilized the daguerreotype. He is one of the first painters to have his own work recorded by photography. In a letter from Paris dated 10 December 1842 he wrote,

I have just finished my *Saint Peter* completely, and I can say too, this time, to my satisfaction and to that of my superiors. However, I am waiting to have some daguerreotypes made of it, and to varnish it, before showing it to the public.

Often, it was only with great reluctance and many misgivings that artists, who aspired to more elevated positions, like that of history painter, carried out portrait commissions. Certainly, Ingres was not very happy about his work in the early 1840s on the portraits of the Baroness de Rothschild and the Countess d'Haussonville. '*Vive les portraits!*' he wrote sarcastically, '*Que Dieu confonde les . . .!*'

Similarly motivated, Théodore Chassériau's remark is exactly to the point.

I want to execute plenty of portraits first of all to become better known, then to make money, and finally to get the necessary independence that will allow me to fulfil the duties of a history painter.

Given these circumstances it is easy to see how photographs would have reduced the agony of executing such pictures which by force of convention and economic necessity artists were obliged to accept.

Ingres's early portrait paintings, like those of the Rivière family, are distinctly different in colour from those executed after his return from Rome. In the first group the colours are cool and delicately tint the refined surfaces of the porcelain-like figures. But in portraits after about 1841 they become warm and metallic, and as closely approximate to the hues of coloured daguerreotype plates as they do to the fine precision with which this type of photograph described textured surfaces. A comparison with David's handling in similar portraits will reveal how remote Ingres's descriptive detail was from the predominantly painterly appearance of the works of his master. One might reasonably characterize these later portraits as 'enlarged daguerreotypes'.

Some curious features in them suggest the use of the daguerreotype. A new kind of pose, for example, found frequently in the paintings is typical of early portrait photographs, in many of which the hand of the subject is brought up to the face, as though in pensive mood but actually to steady the head through the long exposures (14, 15). Additionally, the unusual reversals of small preliminary studies for the Rothschild, Haussonville and Moitessier portraits point

14. Daguerreotype.
c. 1845 (2¼ x 2¾ inches)

15. Hill and Adamson:
Calotype. c. 1845

to daguerreotypes (16, 17, 18). For a defect peculiar to this kind of photograph was that of the lateral transposition of the image; painters using them would, for the sake of accuracy, be obliged to put the forms back in their original positions. Yet another anomaly is found later in Ingres's self-portraits of 1857 and 1865. Had the artist used daguerreotypes without correcting them or had

16. Ingres: *La Comtesse d'Haussonville*.
Probably first study for painting. *c.* 1842

17. Ingres: *La Comtesse d'Haussonville*.
(Drawing, *c.* 3 x 4½ inches)

18. Ingres: *La Comtesse d'Haussonville*.
1845 (oil on canvas, *c.* 36½ x 53½ inches)

19. Blanquart-Evrard: Photograph of Herculaneum
wall painting. *Hercules Recognizing Telephus*
(detail). See note 11

he employed the usual mirror image of self-portraits in these paintings, as in his self-portraits of 1804 and 1835, the mole on his right cheek would have been shown in reverse. Similarly, in the early paintings, the buttoning of his frock-coat, contrary to custom, is right over left – as it would appear when reflected from a mirror. But in the late self-portraits these features occur instead as normally perceived, or as they would have been seen in ordinary photographic prints on paper from which they may well have been derived.

Though this kind of evidence gives no conclusive proof that Ingres used photographs, it cannot easily be dismissed when considering the whole context of nineteenth-century portrait painting. Generally attributed to the artist is a statement in which he proposed that portrait painters should emulate the accuracy of the daguerreotype but that they must not say they were doing so. The origins of such remarks are obscure. They concur neither with Ingres's ideas about art nor with his hatred of photography. Yet, in view of the impact of photography on painting, and the inevitable demands made in commissioning portraits, it is entirely conceivable that Ingres should be forced to suffer the same ambivalence in regard to his art that was to confound many other artists.[11]

DAVID OCTAVIUS HILL

Another painter who not only found the camera useful but who subsequently became known as one of the nineteenth century's outstanding portrait photographers was David Octavius Hill. It was also early in the 1840s that Hill, who had helped in the founding of the Scottish Academy of Painting (1826) and the National Gallery of Scotland (1850), first employed photographs in the difficult task of completing a large group portrait containing no less than 474 likenesses. When confronted in 1843 with a commission to commemorate the first general assembly of the new congregation of ministers who had withdrawn from the established Presbyterian Church of Scotland, Hill, who was principally a landscape painter, found the task almost insurmountable. Photography helped to provide the solution. Together with the chemist and photographer Robert Adamson, he began that year systematically to take portraits of each person to appear in the painting. They favoured the calotype probably because it was easier to handle than the daguerreotype and also because the broad and soft tonal effects typical of this medium were more consistent with Hill's admiration for Rembrandt, Turner and English portraits in mezzotint.

Unfortunately, the painting, *The Signing of the Deed of Demission* (1843–66), reflects little of the dramatic chiaroscuro and powerful compositions of most of the photographs. It is instead a farrago of faces compressed into an impossible space, with confused lighting from several sources, hopelessly contradictory in scale and meagre in execution.

Presumably the obstacles inherent in the completion of such a painting prevented Hill from utilizing the great pictorial virtues of his photographs which on almost all counts surpass the finished canvas.

The outstanding quality of Hill's calotypes was confirmed by his contemporaries. In the 1840s when the enthusiasm of artists for the so-called 'sun-paintings' was relatively unsullied by fears of the camera's power, photographs could sometimes be found alongside paintings in official exhibitions. Eight portraits in calotype by Hill were shown in the 1844 exhibition of the Royal Scottish Academy. In 1845 ten of his photographs, portrait and *genre* subjects, were hung there and in 1846 a 'Frame of Calotype Sketches'. Hill's photographs were then favourably compared with the work of earlier masters: Reynolds, Rembrandt and Murillo and, it was said, in his 'group of Newhaven fishermen, we have a Teniers's Dutch boors, or Ostade's Village Alehouse – or against a crumbling brick wall . . . Peter de Hooghe lies mezzotinted before us'. The painter and draughtsman Clarkson Stanfield, whom Ruskin called 'the great English realist', found them superior to the work of Rembrandt. Sir Charles Eastlake thought them admirable and his wife, Elizabeth Rigby, whom Hill had photographed, referred to his calotypes as 'small, broadly treated Rembrandt-like studies . . . which first cast the glamour of photography upon us'. William Etty's appreciation of these photographs may be estimated by his effective use of a Hill calotype for two 'self-portraits' (20, 21). The Scottish

20. Hill and Adamson: Calotype portrait of William Etty. 1844

21. William Etty: *Self-Portrait.* (Oil on canvas, 10¾ x 16½ inches)

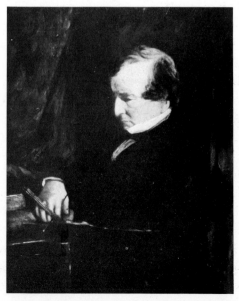

artist Thomas Duncan painted a 'self-portrait' from a Hill and Adamson calotype. Hill himself utilized his photographic study of Dr Chalmers and his grandson (1844) for a painting which was exhibited in 1853, and very likely – though the extent of this practice has not yet been determined – based other paintings on his photographs.

After a lapse of some thirty years, his reputation was re-established, especially among artists who looked upon photography less as a threat than as an expurgator of insipid painting. And it has been maintained to this day, thanks to the publication of Heinrich Schwarz's excellent monograph. Whistler found Hill's work 'curiously attractive' and Sargent, 'simply magnificent'. A letter by Wilson Steer in 1933, obviously referring to Schwarz's book, extols these photographs, explaining that

no doubt Hill scores from the fact of his being an artist . . . and hence the good sense of composition and placing which puts his work far beyond any other photographer that I have seen. I showed it to Professor Tonks who was delighted with it.[12]

FRITH

William Powell Frith who prided himself in abstaining from the use of photographs, or at least in employing them reluctantly, intended to have one made of Charles Dickens in 1859 prior to painting the author's portrait.

As I had heard that portrait painters had often derived advantage from photography [wrote the artist], I asked Dickens to give me a meeting at Mr Watkins's, who was thought one of the best photographers of that day. In due course the photograph was taken; but not very successfully, nor did I derive the slightest assistance from it in the prosecution of the portrait.

It is likely that at least one photograph, a view of the grandstand at Epsom, served Frith for his elaborate documentary painting, *Derby Day* (1858). Possibly knowing this, Ruskin, in a complimentary tone, described the famous picture as 'a kind of cross between John Leech and Wilkie, with a dash of daguerreotype here and there, and some pretty seasoning with Dickens's sentiment'. Though the wary artist denied that his *Paddington Station* (1860–62), that great demonstration of Victorian industry and skill, was in any way dependent on photography ('for the information of young painters . . . every object, living or dead, was painted from nature'), it is claimed that photographers were consulted. Frith's disparaging references to photography did not prevent him from making use of it for some of the portraits in the painting of the marriage of the Prince of Wales (*c.* 1863). The artist described the difficulties of arranging sitting times for those attending that notable event:

I had therefore to trust to that most unsatisfactory process for my likenesses of them, which are consequently the worst in all respects in the whole picture. . . . The present

Queen of Denmark and the Princess Dagmar, now Empress of Russia, were painted from photographs. . . . Some of the figures in the distance were so small that I refrained from troubling the originals finding good photographs sufficient guides. Amongst these was Mr Disraeli, whose face on the canvas was certainly not larger than a shilling.

Tenniel and Du Maurier are said to have supplied Frith with photographic portraits of themselves, possibly for the painting *The Private View of the R.A., 1881*.

It is inconceivable that paintings like Frith's *The Salon d'Or at Bad Homburg* with its many exacting likenesses would, after the invention of photography, have been executed without its assistance. The immense problem of painting such factual records of historic events as David's *Coronation of Napoleon* (1805–9) is apparent, especially before photography could 'lend a hand'. It is therefore not surprising that Frith, like Hill, Meissonier, Yvon and others engaged on such ceremonial group portrait commissions, had recourse to the camera.[13]

THE USE OF PHOTOGRAPHS BY PORTRAIT PAINTERS

Gisèle Freund recounts an amusing episode in the life of the painter Adolphe Yvon (a pupil of Delaroche). For his picture of the battle of Solferino (exhibited in the 1861 Salon) (97) in which he wanted to portray Louis Napoleon astride a horse, Yvon engaged the photographer Bisson, and the appropriate portrait was taken at the Tuileries. The painting – *L'empereur au képi* – finished, Yvon was dismayed to find that Bisson was selling copies of the photograph to the public. The artist had assumed that in hiring the photographer he secured all rights to the photograph, which he would of course have wanted suppressed, since on its distribution it became demonstrably clear that he had simply copied the photograph without making the slightest alteration.

'The most frequent instances in which photographs have been copied by painters,' explained the Pre-Raphaelite John Brett, 'occur in the practice of portraiture, where the sitter's time is precious.' But of course there were other reasons for using photographs. While George Frederick Watts, for example, despaired at the difficulty of painting likenesses: 'it has ever cost me more labour to paint a portrait than to paint a subject-picture', he was full of admiration for the soft, and even out-of-focus calotype portraits of Julia Margaret Cameron. 'I wish I could paint such a picture as this', he is said to have remarked on seeing one of her photographs and with little wonder, for those enchanting evocations of the human face would be the temptation and the frustration of any artist whose own work was conceived with the same predilection for rich, diffused light effects. Watts, it is reported, did use photographs and, in one case at least, executed a painting after a portrait by Julia Cameron. His pencil drawing of Ellen Terry in the costume of Ophelia

(*c.* 1878–9) was made from a photograph and it is likely that a small oil painting of the actress, *The Madness of Ophelia* (*c.* 1880), was based on another.

Some artists were quite ingenuous about the manner in which they employed photographic material, though in most cases, it seems, a discreet silence prevailed. Charles Méryon, primarily known for his etchings of Paris, based some of his portraits on photographs. He frankly described that of Benjamin Fillon, which dates probably from 1862:

From the point of view of execution, it is the best of the series. I have made it after a good photograph which I have most faithfully reproduced, apart from a few slight modifications which I introduced in order to accentuate certain characteristics so as to make the face more interesting.

It became common practice to take advantage of photography for making accurate representations of persons either deceased or for other reasons inaccessible. Even an avowed enemy of the camera like the academician Hippolyte Flandrin did not abstain from using photographs, one of them for a posthumous portrait. Less conventional artists like Courbet, Manet, Degas, Cézanne and Gauguin were equally indebted to photography in similar cases.

Photography was of immense service to caricaturists such as Carjat, Nadar and Bertall, all of whom worked with the camera as well as the crayon. Étienne Carjat's caricature of Courbet in profile (1863), for example, and his photograph of the painter dated 1861 are strikingly similar. Nadar's sensitive drawings for his caricatures and his large lithograph of 1854, containing 270 portraits of distinguished contemporaries called the *Panthéon Nadar*, must surely have benefited from his *Panthéon* of photographs of these same people. Several of the caricatures in the Nadar lithograph, like those of Gustave Doré and Adam Mickiewicz (Polish patriot and author), can be closely related to his photographs. Many of the heads, both in tonal structure and instantaneity of expression, approximate much more closely to photographs than to traditional forms of caricature.

By the 1870s it was generally conceded that 'no painter at this day, whatever may be his talent, will attempt to paint a portrait without having good photographic likenesses of his sitter'. And by the 1890s Walter Sickert, believing that traditional methods in portraiture were obsolete, stated categorically that to demand more than one sitting, when photographs could be put to use, was 'sheer sadism'.[14]

PHOTOGRAPHS ON CANVAS

As the reliance of artists on the photograph became increasingly apparent, enterprising photographic technicians set about devising means by which even more of the painter's time and effort could be saved. By the 1860s methods

were developed for either projecting or fixing the camera image on the very canvas itself, so that it served as a preliminary sketch merely to be painted over.

An early reference to this practice is found in the *Photographic News* of 1863, under the heading 'Photography on Canvas'. A letter was published calling attention to the fact that Disderi was in communication with an American artist who had 'discovered' a technique for producing positive pictures on canvas. The result was said to be remarkable:

The painter having only to terminate the sketch painted for him by photography, and being no longer inconvenienced by the nature of the substance he is painting upon, produces a work which has all the merit of photographic accuracy, and which at the same time has given him free scope for his talent.

The correspondent then claimed that he himself had perfected the same process as early as March 1859. However, in the following issue another writer insisted that the procedure was known already in 1855 or 1856.

The technique soon became widespread. Franz Lenbach in Germany was said to have photographed his sitters and then enlarged the images upon the canvas. It must also have been practised in the United States. The American, M. A. Root, in *The Camera and the Pencil* (1864), wrote of avoiding wearisome sittings by transferring photographs to canvases. From 1865 several notices can be found in the photographic journals of both England and France describing such methods.

Disderi's negotiations with the American artist were probably successful, for *Le Monde illustré* on 9 September 1865 had the following to say about a process which it called *photo-peinture*:

A simple *carte* photograph, enlarged by the apparatus perfected by the Disderi Company, allows the artist to paint – after one or two sittings – a portrait, naturally with the resemblance guaranteed, enhanced by all the brilliance of colouring. . . . Let us add that in an era where more than ever 'time is money' there is a remarkable economy in using *photo-painting*.

Not only was this technique applicable to portraiture, continued the notice, but also to '*genre* paintings, family groups, theatrical settings, even landscapes – everything is within the range of *photo-painting*'.

A method called 'photo-sciagraphy' was devised in 1868 by Claudet whereby a photographic portrait could be projected on to canvas or paper while the artist was at work. In the 1870s advertisements often announced: 'Enlargements made direct upon canvas at moderate prices.'

The well-known photographer, P. H. Emerson, stated in 1889 that it was 'common practice for painters to take photographs of their models and throw

enlargements of those on to a screen when the outlines are boldly sketched in'. Emerson was critical of current exhibitions in which it could be seen that 'drawings' made by the photographic lens were simply 'transferred to the panel or canvas'. George Moore, in *Modern Painting*, suggested that Sir Hubert Herkomer R.A. photographed on canvas and criticized him for his over-reliance on the camera. It is a little surprising then to find the painter W.B. Richmond A.R.A. writing of the procedure as late as 1893 as though it had only just come into being. Photography, he said in a letter to the *Studio*, is being

largely used by portrait painters who, unless I have been wrongly informed, are beginning to photograph their sitters upon their canvases, and paint over. If this is the case the ruin of the art of portrait painting is certain.[15]

PHOTOGRAPHIC TONE

One of the most obvious ways in which the photograph distorts natural objects is its inaccuracy in translating colour into tone. Whether or not the plate or film is sensitive to all colours there are no means, in the black-and-white photograph, of distinguishing between the same tones produced by different colours. The shapes of certain forms which are only distinguishable because of their colours may be entirely lost because the black-and-white photograph cannot sufficiently discriminate between different hues. The earliest photographic emulsions were as sensitive to blue as they were to white. In the print both yellow and red objects were rendered quite dark; the blues and violets appeared light (22, 23). Imagine, then, the difficulties facing portrait and landscape photographers before the 1880s when orthochromatic plates became easily available. If counter-measures were not taken, one can well understand the chagrin of excessively ruddy-faced sitters – especially those with purple noses – when they were handed their likenesses. But even though orthochromatic emulsions, an improvement on the earlier coatings, were *more* sensitive to the visible spectrum, the orange and red rays were still translated inaccurately and the greens and blues were still rendered in a manner totally inconsistent with our optical sensations of colour-tone. Not until the development of panchromatic film, at the beginning of this century, was the tonal accuracy of the photograph corrected and made to conform more closely with optical perception. Even so, reds and greens of the same tone, for example, were bound to appear in the black-and-white film with much the same value. Even in colour film, as is well known from the distortions so often encountered in reproductions of works of art, accuracy depends upon the most stringent laboratory techniques.

This tonal distortion in early photographs was frequently commented upon in the nineteenth century. A pertinent description of that fault occurs in Lady

22. Photograph taken on ordinary plate, insensitive to most colours

23. The same subject taken on panchromatic plate

Elizabeth Eastlake's extremely perspicacious article on the nature of photography which appeared in the *Quarterly Review* in 1857. Enumerating other peculiarities intrinsic to the photograph she describes its shortcoming in the translation from colour to black and white in portraiture:

If the cheek be very brilliant in colour, it is as often as not represented by a dark stain. If the eye be blue, it turns out as colourless as water; if the hair be golden or red, it looks as if it had been dyed. . . . Here and there also a head of fierce and violent contrasts, though taken perhaps from the meekest of mortals, will remind us of the Neapolitan or Spanish school . . . the very substance of the colour has been lost and dissolved in the solar presence; while so laggard have been the reds and yellows and all the tints partaking of them, that they have hardly kindled into activity before the light has been withdrawn. Thus it is that the relation of one colour to another is found changed and often reversed, the deepest blue being altered from a dark mass to a light one, and the most golden-yellow from a light body to a dark. . . . [Photography's] strong shadows swallow up all timid lights within them, as her blazing lights obliterate all intrusive half-tones across them; and thus strong contrasts are produced, which, so far from being true to Nature, it seems one of Nature's most beautiful provisions to prevent.

Another aspect of this photographic characteristic was discussed by the illustrator, Walter Crane, in his book, *Line and Form*, published in 1900.

Commenting on the means of obtaining the appearance of volume by line and shade he said:

The definition of form by means of light is strictly the principle of the photograph, which comprehends and illustrates its complementary of relief by means of shade, and I think it is due to the influence of the photograph that modern black-and-white artists have so often worked on these principles. The drawings of Frederick Walker and Charles Keene may be referred to as examples.

The influence on painters of this tonal aberration was of much concern to R. H. Wilenski who published his views in 1927, in *The Modern Movement in Art*. It was perpetrated, he said, by the camera. He berated the 'drawing by the shadows method' in the canvases of John Singer Sargent and others, calling it a degenerate technique. It originated, he believed, in certain pictures by Corot when that artist attempted to rival the camera's vision. This meretricious kind of painting, lacking all architectural concern with form was only, he said, a short-cut to illusionism: mechanical trickery. Wilenski was appalled not only by the way a photograph or a painting derived from such a photograph would flatten, in uniformly tonal shapes, the three-dimensional forms of the objects represented, but he also resented the manner in which it incorporated more

24. Charles Nègre: *Le joueur d'orgue de barbarie.* Paris *c.* 1850 (calotype)

25. Nadar: *The Catacombs of Paris.* *c.* 1860

than one form in a single tonal patch with no apparent distinction made between them (24). He invoked the traditional concern for imparting to each physical object a structural identity of its own: a tactile character. To demonstrate the differences in these two methods he compared details from Sargent's portrait of Henry James with others from Rubens's painting of Marie de' Medici.[16]

ARTIFICIAL LIGHT

With the invention of several techniques for producing light by artificial means, this aberration of photographic form became more obtrusive. The harsh divisions of tone found earlier in photographs taken in direct brilliant sunlight were now even more grotesquely exaggerated as a result of the use of electric battery or pyrotechnic systems such as magnesium wire. Photographs of portraits and interiors can be found, taken from about the mid 1850s, in which the violent contrasts of dark and light masses literally eradicate any intermediate tones. (These were often considered to be failures because of the absence of one of the most highly prized attributes of the photographic image, one which it did not often have: the subtle, almost imperceptible, transitions of tone ranging from black to white.) To artists who were looking for new and unconventional means of representation, this photographic idiosyncrasy must have had a special pertinence. It is probable that Daumier, Fantin-Latour and Manet derived some benefit from photographs of this kind.

One of the earliest photographers to interest himself in the use of artificial lighting was Nadar. His studio in the boulevard des Capucines contained a large portable Bunsen battery, and with this equipment he astounded Parisians about 1860 by taking the first photographs of Paris catacombs and sewers (25). Daumier, a friend of Nadar, may himself have studied the unusual tonal effects caused by strong artificial light, probably to confirm and to elaborate what had already become characteristic of his work. There, the stark incandescence of Nadar's photographs can be found. In his *grisaille* painting *Don Quixote and Sancho Panza* the division of tones is so extreme that the middle values are eliminated entirely, even more than in Nadar's photographs of subterranean Paris (26). It is interesting, and perhaps more than merely fortuitous, that probably the first owner of this painting was Nadar.

Jean Adhémar suggests that there was some connection between Nadar's photographs and Daumier's paintings from about the middle of the 1850s, because of their mutual investigations into artificial lighting. He compares one of Daumier's portraits of Carrier-Belleuse (Rodin's master) with a photograph by Nadar taken of the sculptor at the same time: 'Carrier-Belleuse has exactly

the same features, the same hair, the same moustache, the same neck-tie. If it is necessary to go further and look for more links, they exist.'

About 1884, in his studio in the rue des Beaux-Arts, Fantin-Latour and a group of friends conducted experiments in photography using artificial light. One of them was most enthusiastic about everything concerning photography, he 'tried to take us in the evening by magnesium flash and only succeeded, most times, in getting pictures where almost everyone had abruptly shut their eyes'.

Those evenings at Fantin's coincided with the execution of his painting *Autour du piano* (Salon of 1885), in which at least two of these friends appear. The kind of lighting reproduced in the painting corresponds very closely to the strong tonal contrasts to be found in portrait photographs taken by magnesium light, and its overall appearance may be said to be photographic (27). Reviewing the Salon of 1885, the *Journal amusant* described it:

The audience are grouped around a piano. Intimate scene. Very powerful interpretation of nature. But one flaw: they all appear fixed in that pose caused by the 'hold it a second' command of the photographer.

It is not known when Fantin first interested himself in photography, but his earlier portraits – the self-portrait of 1858, the *Hommage à Delacroix* (c. 1864), the *Atelier aux Batignolles* (c. 1870) – are all strongly photographic in character. Fantin's portrait of Manet, painted in 1867, might easily be taken for a photograph (28); his late portrait entitled *Sonia* (1890) is hardly distinguishable from one. There can be little doubt that Fantin owed something to the camera. In both his portraits and studies of still-life he scrupulously eschews all obvious personal or conventional manipulation of the paint, as though to emulate the anonymous surface uniformity of the photograph. Similarly his colour is frequently modulated within a narrow range of grey tonalities.[17]

MANET

To what extent the sharp tonal style in Manet's painting can be attributed to photography is a matter for speculation. There were, of course, other sources too from which the artist may have drawn some inspiration, corroborating at least what was already a stylistic propensity in his work. The most obvious one is in seventeenth-century Spanish painting; interest in that period was much revived by the middle of the nineteenth century. Baudelaire's comparison of his relation to Poe with Manet's to Goya does not exclude the possibility that he got something from Poe and Manet from Goya, even though their initial attractions to those figures depended on ideas already germinating in the minds and works of both poet and painter.

26 (*below*). Daumier: *Don Quixote and Sancho Panza.*
c. 1860. (Oil on panel, grisaille)

27 (*bottom*). Fantin-Latour: *Autour du piano.* 1884

28 (*right*). Fantin-Latour: *Portrait of Édouard Manet.* 1867

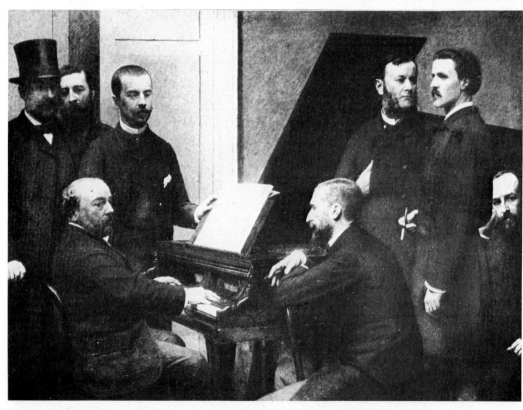

Manet's teacher, Thomas Couture, employed the same tonal juxtapositions as his pupil, and Japanese prints with their flat areas of colour, solid blacks and complete absence of tonal modelling, may also have conditioned Manet's style. One will probably never know what exactly produced the initial impulse towards this characteristic in Manet's work but photography's role must be of some significance.

It has been mentioned that photographs by artificial light were not the only ones in which such a tonal characteristic appeared. Many of those taken in strong sunlight with ordinary plates, before the development of ortho- or pan-chromatic emulsions especially, also contained this feature. Several of Talbot's early views of outdoor subjects are good cases in point, and similar examples in France are easily found. Manet, without doubt, knew of such photographs, and of Nadar's experiments with artificial light. By about 1860 he was acquainted with artists who used photographs. One of Manet's etched portraits of Baudelaire was made from a Nadar photograph of the writer taken by artificial light in 1859 (29, 30). Here, Manet intensified the already considerable dark and light contrasts of the photograph, with little attempt to model the structural

29. Nadar:
Portrait of Charles Baudelaire. 1859

30. Manet:
Portrait of Charles Baudelaire. 1865 (etching)

forms still visible in the shadowed side of the head in the photograph. Contemporary artists, it has been said, called Nadar's artificially lighted portraits

'plaster heads', because the highlights in the face and hands appeared as brilliant as the shirts and cuffs.

Manet is known to have used photographs on other occasions. His portrait etching of Edgar Allan Poe was done from an American daguerreotype. It was probably intended to illustrate Baudelaire's translation of the *Histoires extraordinaires d'Edgar Poe*, first published in 1856.

Manet's note to Isabelle Lemonnier in 1880 asking for her photographs so that 'I can catch you more surely when I want to do a sketch' suggests that some of his water-colour portraits of her, executed that summer, were made directly from photographs. The tonal characteristics of his portraits at the time, in his small painting of the actress Jeanne de Marsy entitled *Spring* (1881), for example, and in the pastels of Mme Jules Guillemet made that same year, are photographic in essence. There, the characteristics of the non-panchromatic emulsion occur. Lady Eastlake's juxtaposition of such photographs with the paintings of the 'Spanish school' was made with good reason. In Manet's portraits, too, the darkest and lightest areas predominate and within them only the slightest modulations of tone are perceptible. In the brightest parts espe-

31. Manet: *Portrait of Méry Laurent*. 1882 (pastel)

cially, the physiognomic structures are only implied by notations of delicate, evanescent tints high up in the tonal scale. This peripheral means of suggesting the solidity of forms is a common feature in portrait photographs for which no special lighting effects were employed to render the volumes of the face more comprehensible. It is clearly apparent, for example, in photographic portraits taken of Manet and his friends. By utilizing this peculiarity intrinsic in the photograph, by eliminating the whole range of middle tones, thus tending to flatten the forms, a very effective pictorial reconciliation could be brought about between the subtly articulated photographic image and the planar patterns of Japanese prints.

Manet's portraits of Méry Laurent, executed in 1881 and 1882, convey the same tonality (31) and it is not surprising to learn that *Méry Laurent accoudée* was made directly from a photograph, the picture in turn used as a sketch for the portrait which appears in the background, left, of the large painting in the Courtauld Institute Collection, the *Bar aux Folies-Bergère* of 1881–2.[18]

THE EXECUTION OF THE EMPEROR MAXIMILIAN

Théodore Duret, Manet's friend and one of his earliest biographers, writing of the artist's series of paintings, *The Execution of the Emperor Maximilian*, stated that the head of Maximilian alone had been painted in a conventional manner after a photograph. Duret was referring, principally no doubt, to the large finished canvas in the Mannheim Museum (32). It can be shown, however, that Manet used several photographs, in addition to relying on news dispatches from Mexico, to authenticate these paintings. Probably the first version, now in the Boston Museum, was made before the artist could lay his hands on exactly relevant material, though it clearly relates to the first, somewhat obscure, information telegraphed to Europe in July 1867, weeks after the execution had actually taken place.

The first news of Maximilian's capture on 15 May 1867 arrived soon after that date, but it is unlikely that Manet even considered this as a theme for painting until late in June when it became known to a shocked and disbelieving Europe that the Emperor had been sentenced to death – that news reaching the Continent after he had already been executed. It is difficult to know to what extent Manet, a Republican sympathizer who had good cause for grievance against Louis Napoleon, conceived of these paintings as a criticism of the regime and its cowardly part in the Maximilian affair. Like his earlier painting the *Battle between the Kearsage and Alabama* it may have been intended principally as a straightforward history painting of an important contemporary event. In either case photographs would have been very relevant documentary material and in using them Manet was acting in accordance with the tradition of

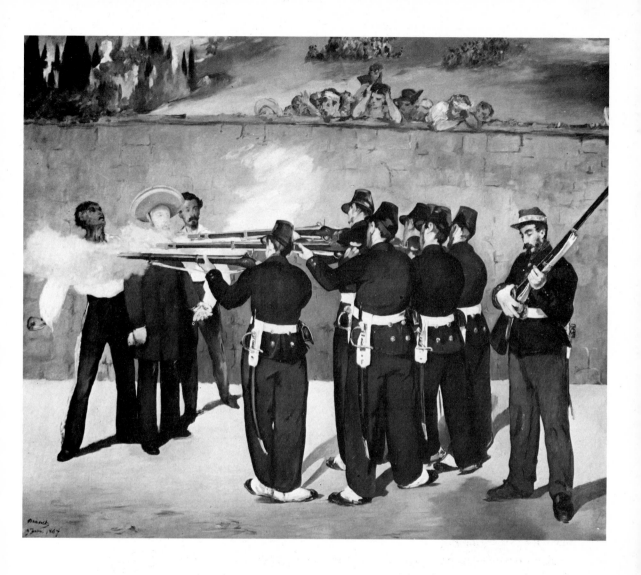

32. Manet: *The Execution of the Emperor Maximilian.* 1867(?)

reportage in modern painting in which literal accuracy, exacerbated by the camera, had become imperative.

In 1910 the painter Max Liebermann, coming across an album of photographs in Hamburg connected with Maximilian's tragic death in Mexico and remembering what Duret had written, was struck by their apparent relationship to Manet's paintings. Among the Hamburg photographs were the portraits of Maximilian and those of Generals Miramon and Mejia, all of whom had been executed at the same time. They show clearly that not only was Maximilian's head based on a photograph (33, 34); but that the representation of Miramon too (at the Emperor's left) corresponded to a photographic likeness (35, 36). The third figure of the condemned group, that of General Mejia, who is painted with his head thrown back, having just received the fatal volley, also resembles the photograph reproduced by Liebermann in the peculiar structure of the nose, and the shape of the head (37, 38). Photographs of Mejia were just as available in Paris as those of Miramon, but in foreshortening the head Manet may have been forced to distort the features; the darker complexion certainly corresponds to the general knowledge that Mejia was an Indian.

There is one other likeness in the Mannheim painting: that of the sergeant on the extreme right, preparing to deliver the *coup de grâce*. Undoubtedly, it is that of General Porfirio Diaz. It is unlikely that he was present at the execution

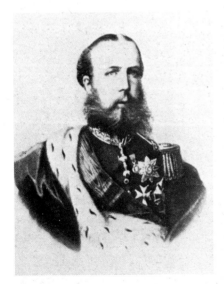

33 (*above*). Photograph of the Emperor Maximilian

34 (*right*). Manet: *The Execution of the Emperor Maximilian*. 1867(?) (detail)

35 (*below*). Photograph of General Miramon

36 (*right*). Manet: *The Execution of the Emperor Maximilian.* 1867(?) (detail)

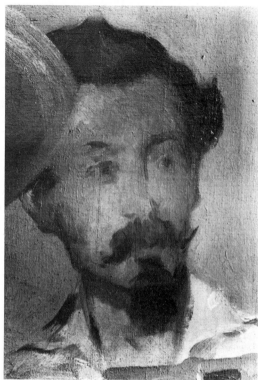

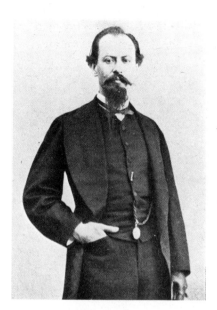

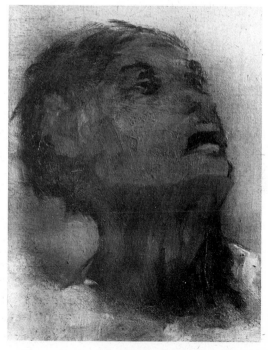

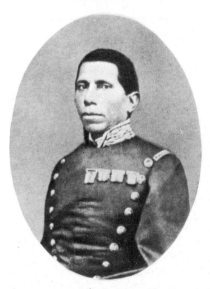

37 (*above*). Photograph of General Mejia

38 (*right*). Manet: *The Execution of the Emperor Maximilian.* 1867(?) (detail)

in Queretaro which took place on 19 June, for during the following two days he led Juarez's Republican troops in the capture of Mexico City from the Imperial government. The structure of the head and face, the hair swept forward, the type of beard and moustache are the same features to be found in a photograph of Diaz also contained in the Hamburg album (39, 40). Why Manet included him in his paintings is unknown. Perhaps it was a reference to

39. Photograph of General Diaz

40. Manet: *The Execution of the Emperor Maximilian.* 1867(?) (detail)

Diaz's refusal to come to terms with Maximilian when offers were made earlier in the campaign. Perhaps, considering the rather pensive expression of the figure in the paintings, the artist meant to convey the regret of the famous general when he learned of the execution; a story to that effect was circulated soon afterwards. Diaz's portrait may also have been included to represent the opposition army simply because he was the best known and most popular of all the Republican generals and very likely his photographs were easily available in Paris.

A view of the cemetery showing a great stone wall where Maximilian and his generals were shot (near a high wall according to a trustworthy contemporary report) is included among the Hamburg photographs. But the most important photograph contained in the Hamburg collection, and particularly relevant in the problem of dating Manet's paintings, is that of one of the firing squads (one officer and seven men) which carried out the sentence (41). A more or less

official report from Mexico in August that year stated that the executioners for each of the condemned men numbered four, with one in reserve. But because of the clumsy misfiring and wounding of Maximilian in the first fusillade, it was said that a sixth and possibly seventh soldier attempted to complete the deed.

In number, Manet's executioners follow the photograph rather than the Press report. In the Mannheim painting there are also one officer and seven

41. Photograph of the firing squad in the execution of Maximilian. 19 June 1867

men – if the top of the *képi* shown between the third and fourth figures from the right of the composition, and the curious line occurring between the legs of the third figure from the right can be counted as indications of another soldier. In fact, the small Copenhagen painting as well as the lithograph made of the subject each contain a total of eight figures for the executioners.

Photographs of Maximilian and others involved in the Mexican campaign were not difficult to find in Paris before the Queretaro incident. *Carte* portraits had been taken of Maximilian earlier in the 1860s by Mayer and Pierson, by Mulnier, by Bingham (after 1862) and by others. Furthermore, the A. Liébert Company in Paris (13 boulevard des Capucines), specialists in American photographs, certainly distributed portraits of the belligerents from 1862, when active hostilities began against the forces of Juarez, though Maximilian did not accept the Mexican throne until 1864. Other portraits were taken in Mexico by the photographers Merille, Aubert and Valleto, and with little doubt were

sold on the European market in the 1860s before the execution. Immediately after the news of the execution the demand for such photographs must have increased. It may have been at this time that a photographer named Ducacq, or Desacq, sold, in Paris, *carte*-sized photo-montages of Maximilian, Miramon, Mejia and another unidentified military figure, possibly either Castillo or Avellano, two ranking officers in Maximilian's command. Manet would not have had far to look for photographic likenesses of those present at the execution once their identities were known.

By mid July, three or four weeks after the so-called 'drama of Queretaro', photographs of the firing squad along with others could have reached Paris, supplying a morbid iconography of the event (42). They would therefore coincide with the first comprehensive and less contradictory reports published in the popular Press. It could not have been much before that time that Manet began to paint the subject. The date, 19 June 1867, in the lower left corner of the Mannheim picture is of course the actual date of the execution and not that of the completion of the canvas. It was not, however, until August and even as late as October that the most trustworthy sources of information elaborately spelled out the gruesome details concerning the dispositions of the troops and their victims, the clothing worn by Maximilian and his generals, the number of witnesses and all the other macabre minutiae of the situation. It was probably

42. Disderi(?): Composite *carte* photograph relating to the execution of Maximilian. Probably 1867

not until mid August, for example, that it became known in France that Maximilian had actually worn a large sombrero in his last moments – a feature followed by Manet in all his versions of the subject. It was not until October, it seems, that information clearly stated that the condemned men, with Miramon in the middle, were separated by three paces and that the three firing squads were about sixteen feet from them – which Manet ignored. However, earlier reports in July and August noted that Maximilian was in the middle, the three men holding hands, that Miramon and Mejia were forced to remove the blouses of their uniforms and that the 'shooting parties' were 'within a few paces of the prisoners' – just as they appear in Manet's canvases.

An astounding photograph apparently taken the moment before the order to fire was given was probably sold in France during the latter part of 1867. Though in some respects it corresponds with the later, more sober descriptions in the Press, in other ways it contradicts them. Very likely, it was a composite photograph manufactured to meet an obvious demand for a record of that fatal moment (43). Crowds of onlookers are awkwardly placed in the foreground behind the ring of soldiers surrounding the scene, despite reports from Mexico which clearly indicated that the population of Queretaro were prohibited from accompanying the cortège to the Cerro de las Campañas, the hill on the out-skirts of the town where the execution took place. In the distance stand

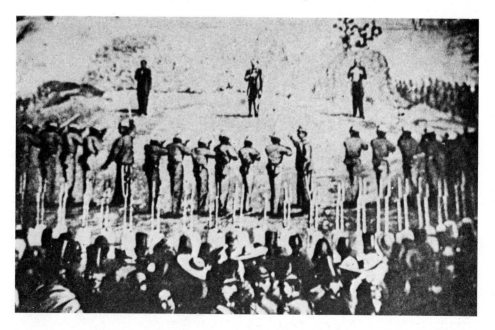

43. *Carte* photograph (composite?) showing the execution of Maximilian, Miramon and Mejia, 19 June 1867. n.d.

Maximilian, Miramon and Mejia, facing three firing squads who aim their muskets. Manet's arrangement of the scene has nothing in common with this photograph nor, considering his stylistic propensities, would it have been feasible pictorially for him to follow such an undramatic composition. His is much closer to Goya's painting of 1814, *The Third of May 1808*.

Whether Manet intended exhibiting one of the Maximilian canvases in his private show near the Pont de l'Alma that year to coincide with the large Exposition Universelle is open to question. In any case, it is unlikely that his ultimate version of the event would have been finished in time to make a showing possible before both his own and the Paris exhibition closed at the end of October. Furthermore, there is still some ambiguity concerning the official suppression of his paintings. It is certain that an interdiction was placed on his lithograph of the subject which may well have deterred him from exhibiting one of the canvases, if indeed there was still time to do so. The distribution in France of photographs relating directly to the execution seems also to have been prohibited and it is said that Disderi was sentenced to one month in prison for circulating photographs of the clothes in which Maximilian was shot.

It has been suggested that the uniforms of Manet's executioners were those of the French army at the time and thus symbolized the perfidious complicity of Louis Napoleon and his Ministers in deserting their puppet Emperor in Mexico. But as the Hamburg photograph of the firing squad shows, in comparison with the illustrations in the 1866 publication, *Album photographique des uniformes de l'armée française* (44), the short-bloused uniforms in Manet's paint-

44. Photo-painting from *Album photographique des uniformes de l'armée française*. 1866

ings are more like those of the Mexicans than of the French; the Mexicans too wore *képis*, the French military head-dress. Despite the fact that the artist's friend, the Commandant Hippolyte Lejosne, provided a squad of soldiers from the Pépinière Barracks near the Gare Saint-Lazare to act as models, Manet's soldiers in number and uniform are undoubtedly based on the Mexican photograph, but their appearance is somewhat altered by the inclusion of white gaiters which, as part of the French uniform, might have been used to point up the incrimination. Still, it is doubtful that the prime consideration was given to their pictorial relevance as also has been said of the improbable proximity of the troops to the victims.

It follows, then, that Manet had access to more than the one photograph mentioned by Duret, and that whatever symbolic or purely pictorial meanings his pictures were meant to convey, they were to a significant degree accurate documents of a tragic event.[19]

WORK FOR ARTISTS

Notwithstanding the contention that ultimately a painting was superior to a photograph, for economic reasons alone it was inevitable that in the taking of likenesses the lens would supersede the brush. Once portrait painters could earn a living, but photography has ruined this, complained a dejected artist in 1860 to Arsène Houssaye, editor of *L'Artiste*, the painter having therefore become a photographer instead. 'One knows that photography has harmed painting considerably, and has killed portraiture especially, once the *gagne-pain* of the artist,' commented the painter-photographer Henri Le Secq in 1863. Like the miniaturists, many artists now had to retouch portrait photographs for a living. In this way the painter James Smetham was said to have been victimized by photography.

Early in his career [we are told], he had depended chiefly on portraits for the certain part of his income, which was pretty well assured and satisfactory. But this source was cut off to him, as to many others, by the invention of photography.

The placebo offered to displaced portrait painters by Ford Madox Brown in 1868, though vaguely describing some stylistic escape-hatch, is nevertheless an indication of the general feeling that in portraiture something different had to be done.

Photography has taken the place of portraiture [he said], but a revival must ere long take place. Photography is but the assistant (saving the artist and sitter time) of portrait painting, which can never exist but by the effort and will of genius. The professed portrait painter, now becoming extinct, would be enabled to return from photography to a more simple and artistic style of picture than hitherto in vogue,

and on rational-sized canvases, and assisted by photography, *now* the natural hand-maiden of portraiture, we might hope to see a school arise interesting in itself.

In 1854 it was carefully explained that even in portraiture mere counterfeits of nature were not enough to produce a painting of merit. And though

the many advantages in many different ways, resulting from Photography, are yet but imperfectly appreciated [wrote John Constable's friend and biographer, C. R. Leslie R.A.], it confirms what has always been felt by the best artists and the best critics, that facsimile is not that species of resemblance to Nature, even in a portrait, that is most agreeable.

In a reference probably to Hill's photographs, Leslie continued:

while the best calotypes remind us of mezzotint engravings from Velasquez, Rembrandt, or Reynolds, they are still inferior in general effect to such engravings: and they thus help to show that the ideal is equally a principle of portrait-painting as of all other Art; and that not only does this consist in the best view of the face, the best light and shadow, and the most characteristic attitude of the figure, for all these may be selected for a photographic picture, but that the ideal of a portrait, like the ideal of all Art, depends on something which can only be communicated by the mind through the hand and eye, and without any other mechanical intervention than that of the pencil. Photography may tend to relax the industry of inferior painters, but it may be hoped and reasonably expected that it will stimulate the exertions of the best; for much may be learnt from it if used as a means of becoming better acquainted with the beauties of Nature, but nothing if resorted to only as a substitute for labour.

Yet the painter of portraits, even more than the painter of landscapes, must have felt harassed by the public and its insistence on 'likeness seeing', exacerbated as it was by almost two decades of photography. With relative impunity one could alter the shape and position of a tree or of a line of hills, and still render it more or less with the fidelity of the photograph. But only by risking his reputation, or being declared hopelessly astigmatic, would an artist in the mid nineteenth century venture to change the contours or dislocate the features of his subject. The obvious way to circumvent this difficulty, for painters who were compelled to honour the ordained proportions of the human form and yet wanted to convey its spiritual and symbolic character, was to increase the subjectivity of colour and handling, even while utilizing certain salient features of photographic form, and only with the greatest care modify the natural physiognomic dimensions. To do more than that would then have been considered an act of impertinence. It could only happen later when those artists after Impressionism found it expedient to take the calculated step away from the representation, to the interpretation, of visual appearances.[20]

3. Landscape and genre

Landscape artists were of course governed by the same pressures exerted on portraitists. Poetry had to have a basis in fact. Painters of architectural views especially were obliged to render their subjects with a high degree of verisimilitude. Too much liberty taken with the actual geography of a scene or with the fenestration of some palazzo on the Grand Canal, too careless a reproduction of structural or decorative elements brought swift reprisal from that section of the public which could now invoke the photograph against the excesses of the imagination. The photographic image became the yardstick with which pictorial representations of natural objects were gauged. 'What shall be the measure of truth in painting?' asked a writer in the *Quarterly Review* of 1846, examining German landscape paintings to assess their accuracy.

One standard . . . there does exist, and one from which there is no appeal, for it rests upon demonstration, and not upon opinion. . . . We mean the beautiful and wonderful Calotype drawings – so precious in every real artist's sight, not only for their own matchless truth of Nature, but as the triumphant proof of all to be most revered as truth in art. Every painter, high and low, to whom nature has ever revealed herself, here finds his justification.

The persuasive power and the growing authority of the photographic image were bound to subvert any ideas about the more metaphorical representation of nature.

In France it was the momentary sensation of nature, the general impression of truthfulness, of ephemeral light and atmospheric conditions, which predominated in landscape painting from about 1850. In England after Turner, especially under Ruskin's omniscient scrutiny, the additive compilation of facts, of skill, industry and particularized knowledge characterized the production of landscape painting until late in the century. Philippe Burty's distinction in 1861 between the English and French styles in photography applied equally well to painting:

English photographers, like English painters, look for precise renderings, for the hard-edged contour . . . in a way they penetrate the pores of the skin, the texture of a

45. Benjamin B. Turner: Landscape photograph, *c.* 1855

46. Henri Le Secq: *Sunset in Dieppe. c.* 1853 (calotype)

stone, the hide of an animal, the bark of a tree (45). In France, on the contrary, photographs are much broader, less precise in appearance: it is obvious that above all the concern is with lighting, with the forms and projections of the face or in landscape with the relative values of the masses (46).

In each case photography provided painters with the appropriate images. By mid century, certainly, it was clear that the photographer was able to make 'duplications' of a landscape scene in either soft or sharp focus. In other ways, too, he could determine the character of the representation. Impressions of nature were produced with the camera in which an almost tangible flux, composed of atmospheric light, blended all objects in view with a consistency of tone which had long eluded even the most observant and persevering artist. The camera also gave pictures of more statistical relevance; the exact shapes of natural forms were clearly defined, often over a great depth of field: every leaf, it seemed, every blade of grass could be counted. Above all, despite their great differences, the images in each case were invested with objectivity, with that cherished, impersonal truthfulness for which a great number of artists had so long sought.

Most of the subjects which came before the lenses of the new photographers were the same as those which prevailed in the other visual arts. Outdoor views, natural and architectural monuments like the ones found in such abundance in the popular publications of picturesque places now engaged the photographer. As in painting, the architecture, landscape and *genre* scenes of the Near East became especially important. Certain other categories of painting – antique mythology, religious and historical compositions, period *genre* themes – were at first excluded from the new art, but only for a short time. Within a decade after the appearance of photography the first essays in 'High Art' photography dealing with such subjects were attempted.

Under increased pressure to augment paintings or drawings with the factual material provided by the lens, the imprecise descriptions and sketches of travellers, or vague reconstructions from the memory, no longer sufficed. Once the public had tasted the truth of the camera image it demanded the same of art. Many apparently authentic paintings of the Near East had previously been executed though the artists had never been within 1,000 miles of their subjects. This point is made in a letter of 1841 sent from Alexandria by the painter, Sir David Wilkie: 'My object in this voyage was to see what has formed the scenes of so many pictures – the scenes of so many subjects painted from Scripture, but which have never been seen by the painters who have delineated them.'

Even for those fortunate enough to have made the voyage, photography would have been of immense assistance. The Bristol painter, William James Müller, between 1839 and 1843, concentrated almost entirely upon Egyptian

47. Beyrouth, Lebanon, 1839 (from engraving on daguerreotype
plate). From Lerebours, *Excursions daguerriennes*. Paris 1840–42

subjects: slave markets, shepherds, intimate views of life in Cairo. In 1839 in
Cairo he described the multitudinous street scenes of the city with the utility of
the new invention in mind. 'Let us imagine the poor artist,' he said, 'with his
feelings of enthusiasm properly kindled, in such a crowd, and anxious to sketch.
Poor devil! I pity him. He longs for some photogenic process to fix the scene
before him.'

When Müller wrote this, two other painters, Horace Vernet and his pupil,
Frédéric Goupil-Fesquet, were in Egypt preparing to photograph scenes of the
Orient. It was the fulfilment of a prophecy made earlier that year by Jules Janin
in *L'Artiste* when he wrote that the daguerreotype would be a faithful record of
landscapes everywhere; the indispensable companion of the traveller and of the
artist who did not have the time to draw. On 6 November 1839, less than three
months after Daguerre's process was revealed, Vernet, in Alexandria, noted in
his journal that he and Goupil-Fesquet were daguerreotyping 'like lions'. And
the next morning they were scheduled to demonstrate the new process before
the Pasha who wanted to know more about the discovery that he had already
heard of. Many photographs were taken by the artists in the environs of Cairo,
at Gizeh and in Jerusalem (47). Most likely, they were executed as part of an
agreement with the optician Lerebours, who had similarly commissioned others

48. Gérôme: *The Muezzin. Evening.* 1882

49. Gérôme: *Oedipus. Bonaparte before the Sphinx.* 1886

to make daguerreotypes in various parts of the world from Niagara to Moscow. More than 1,200 views were thus collected, from which a number were selected, engraved, with figures and other appropriate objects added, and published in Paris from 1840–42 as the *Excursions daguerriennes* (61). These precisely detailed engravings, their exactitude guaranteed by the camera, were well received by artists and public, both having eagerly awaited the first photographically authenticated views of remote and exotic regions. The artist had something to learn from them, noted the *Spectator*, calling the *Excursions* 'beautiful as works of art'. Already a basis of artistic instruction, it was pointed out that the daguerreotype demonstrated correct aerial perspective by showing that the brightest parts of a view were in the foreground and not in the clouds or other parts of the sky as was thought to be the case by some artists. Vernet described the peculiar distortions in perspective seen through the lens 'when you stand too close to the landscape motive that you wish to represent'.

Photographs of that kind must have been of tremendous advantage to Orientalists like Vernet and Decamps. The former's predilection for detail and precision was notorious. 'Who knows better than he the correct number of buttons on each uniform, or the anatomy of a gaiter or a boot?' wrote Baudelaire in 1846 in a scorching attack on this painter with 'a memory like an almanac'. Vernet's punctilious technique was linked more than once with the photographic image. Charles Blanc, for instance, said that

Vernet's eye was like the lens of a camera, it had the same astonishing character, but also, like Daguerre's machine, it saw all, it reproduced all, without selection, without special emphasis. It recorded the detail just as well as the whole – what am I saying? – much better, because with Horace Vernet the detail always took on an exaggerated importance, so that inevitably it reaches a point where no trouble is taken to subordinate it, to give it its proper place and value.

Another painter of the picturesque ethnography of the Near East was Jean-Léon Gérôme, first a pupil and then a friend of Delaroche. His city scenes, landscapes and his mildly erotic pictures – glimpses into Oriental baths and harems, grand white eunuchs and Arab slave markets, with their splendid decorative architectural settings – are recorded with the rigorous objectivity of the camera (48, 49). Théophile Gautier's panegyric in *L'Artiste* of 1856 already makes this clear. Writing of earlier Orientalists and conscious of the perfection now made imperative by the existence of photography, he praises Gérôme's ability to combine the exactitude of the photograph with a keen awareness of the piquant view. He characterizes the artist's studies made during a recent trip to Egypt.

Photography, pushed today to the perfection that you know, relieves the artist from copying architectural and sculptural monuments, by producing prints of an absolute

fidelity, to which the happy selection of the point of view and moment of time can give the greatest effect. Is that not also the direction in which Gérôme has taken his work; his powerful studies as a history painter, his talent as a draughtsman, fine, elegant, exact yet with lots of style, a special feeling which we would call ethnographic and which will become even more necessary to the artist in these days of universal and rapid travel when all people of the planet will be visited in whichever distant archipelago they may be hidden, all these things make Gérôme more suitable than any other to render that simple detail which up to now they have neglected, for landscape, monument and colour, modern explorations of the Orient – and man!

'Given the same predilection for precision,' wrote a friend of the painter, 'it is not surprising that Gérôme should have appreciated photography. In his youth he was carried along at a heightened pitch of enthusiasm by the first trials of the daguerreotype and his personal admiration only increased with the years.' Gérôme did indeed paint with the help of photographs throughout his career. He too had his own camera in Egypt in 1868 (if not earlier) when he both painted and took photographs. The camera had become an important, exceedingly useful, part of the equipment of artists like Vernet and Gérôme.[21]

FENTON AND BRADY

As an instrument of propaganda the photograph can hardly be surpassed. While the first attempts at camera *reportage* were made shortly after the appearance of

50. Roger Fenton: *Valley of the Shadow of Death*. The Crimea. 1855

the new art, about a decade later, when Roger Fenton's astonishing views of the Crimean campaign reached Europe, and in the early 1860s with the appearance of Mathew Brady's photographs of the American Civil War, this potent faculty of photography, for good or bad, was clearly recognized (50, 51). Through Fenton's photographs, Omar Pasha, Marshal Pelissier and Lord Raglan, and the Allied encampments at Balaclava, came alive. Through Brady's strange and horrifying scenes of the conflict between the States, surpassing the most lurid verbal accounts and the dubious veracity of prints and engravings, the war and those personalities involved in it must have taken on startling substance. To photographs of that kind may be attributed the importance attached to modern history painting in the nineteenth century. The success of subject paintings of the Crimean campaign, like those of Augustus Egg and Thomas Barker, was largely due to their use of Fenton's photographs. The necessary pictorial authentication of public figures, social events and social catastrophes was inevitably augmented by the camera. In conjunction with the growth of a popular Press the demand for such pictures was considerably increased. Barker's portrait of Garibaldi, believed to have been painted from photographs, became the Royal Academy Picture of the Year in 1861. Fenton's portrait of W. H. Russell of *The Times* was used by J. H. Lynch for his drawing *Our Special Correspondent* (lithographed and distributed by Colnaghi's). Lynch later submitted a lithograph of Sir Lacy de Evans to an R.A. exhibition, the

51. Mathew Brady or assistant: *Missionary Ridge, Gettysburg*. 1863

52. Fox Talbot: Calotype of trees. Early 1840s

catalogue candidly noting that it was executed 'after a photograph'. From the 1850s so acceptable was this practice in the execution of lithographs and engravings that such catalogue entries can often be found, the sources of the pictures undisguised.[22]

EARLY LANDSCAPE PHOTOGRAPHY

Contrary to the notion that landscape photography was of little account before the 1860s, it had in fact been practised on a significant scale long before. Some of Talbot's calotypes, taken about 1842, are among the earliest photographs of

landscape subjects (52). His *Haystack* was taken in 1842 and published two years later in *The Pencil of Nature*. From 1842 to 1846 Talbot executed many landscapes and city views. In 1845 he published *Sun Pictures of Scotland*, another book illustrated with actual photographs.

In addition to his portrait photographs, David Octavius Hill executed calotype views of rural and urban subjects as early as 1844. The members of the Calotype Club in Edinburgh are known to have taken landscape photographs in the early 1840s. In Lady Eastlake's journal entry for 19 December 1844, she wrote of having seen Hill's 'wonderful calotypes'; one of Durham being 'most exquisite', the view of the city with its 'wreaths of smoke' reminding her of Turner. Hill published twenty-two photographs in 1846 as *A Series of Calotype Views of St Andrews*. An album of 100 calotypes containing landscape photographs taken by Hill and Adamson was purchased by the academician, Clarkson Stanfield, who inscribed it with the date, 1 October 1845. In December 1847 a Calotype Society of twelve members was formed in London. A notice in the *Athenaeum* refers to their many landscape photographs. Describing the activities of this club, the *Art Journal*, in 1849, indicated that much interest was shown by artists, and the photographs produced by its members delighted some of the most eminent landscape painters who were aided by these copies of nature. Landscape photographs were taken by the painter, Philip Henry Delamotte, a member of the Old Water Colour Society, and by his father, George, also a landscape artist, from about the late 1840s when both father and son began to practise the new medium. The younger Delamotte gave classes in photography at King's College in London from about 1853, a few years later becoming Professor of Drawing there. His books are illustrated with both photographs and drawings. In 1857 he published the first issue of the *Sunbeam*, one of the earliest magazines containing actual landscape photographs. Among the contributors was F. R. Pickersgill A.R.A., another painter who had taken up the camera.

Many landscape photographs produced in the early 1850s can be described. In England, they include those of Dr Llewelyn, whose calotypes of forest scenes date from as early as 1851. Utilizing the new collodion-on-glass technique, T. L. Mansell's pictures of foliage and rock formations, taken with the sharp focus typical of Pre-Raphaelite paintings, date from the early 1850s. Benjamin B. Turner's excellent landscape photographs were made from 1844 until about 1860 (45); his *Old Farm House*, *Scotch Firs* and *Church Oak* were praised by the *Art Journal* in 1853. Among landscape photographers in the London Photographic Society (formed in 1853) was the former miniature-painter William Newton, whose views of the Isle of Wight and calotypes of Burnham Beeches date probably from between 1850 and 1853 (53).

53. William J. Newton: Calotype view of Burnham Beeches. *c.* 1850–53

In France many of Daguerre's earliest views were of Paris. He himself does not seem to have taken to the country – understandably, considering the large array of cumbersome equipment necessary to produce daguerreotypes. Though the calotype process also required several pieces of apparatus, the equipment was more easily portable and was more appropriate for operation in the countryside.

This does not exclude the possibility that some of the first landscape photographs were known in France. As early as February 1839 Hippolyte Bayard was taking his photographs on paper and by 1840 he was already responsible for some of the earliest outdoor views made in that country. Before his method was published in 1840, the Académie des Beaux-Arts gave its approval, and a report made at its request (in the late autumn of 1839) indicated the superiority of Bayard's process over the daguerreotype from the point of view of 'travellers', especially since his technique allowed for sensitized paper to be kept for some weeks if shielded from the light. An extension of the use of the camera obscura, the idea had already occurred that a photograph could serve

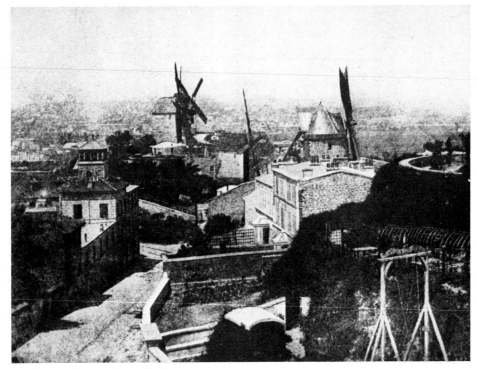

54. Hippolyte Bayard: *The Roofs of Paris from Montmartre.*
1842 (direct positive on paper)

as a base for a drawing or painting, and in the Academy's report was the suggestion that faint photographic images could be used that way. Bayard took many remarkable landscape photographs in the first five years after the publication of his method (54). Among them are studies of plants which may also have been intended for the use of artists. And even in daguerreotype many photographs of architectural and natural monuments, often including landscape views, were distributed in France in the 1840s. Among these are the *Excursions daguerriennes* and Girault de Prangey's photographs of Italy, Greece and Egypt (published in 1846). Several of his daguerreotypes of Paris taken in 1841 and 1842 are still preserved.

The extent to which English landscape photographs taken in the 1840s were known in France is not exactly certain. Calotypes taken in France during that decade, however, are not unknown. By the mid 1850s the number of landscape photographers operating in France must have equalled that in England. Blanquart-Évrard's rocky seascapes and his studies of trees date probably from between 1851 and 1854. Charles Marville's photographs of plants are dated 1852, and his early views of the Forest of Fontainebleau were taken about 1851–4. Henri Le Secq's landscape and marine photographs were made in the

55. Photographic study used by
Theodore Robinson for *The Layette. c.* 1889–90

56. Theodore Robinson:
The Layette. c. 1891

first half of the 1850s (46). Baldus's calotypes of Fontainebleau appeared in the early 1850s, as did Bayard's views of Normandy, and Charles Nègre's calotypes of the French provinces date from about 1851. Gustave Le Gray, especially known for his sea and sky photographs, had taken calotype views of the French provinces as early as 1851; some of them probably among those submitted to the jury of the Salon of 1850–51[23] (91).

COROT AND THE BLURRED IMAGE

In addition to the soft, chiaroscuro effects natural to the calotype, a blurring of the image is often to be found in early photographs of moving foliated objects (52). A somewhat similar appearance is also caused by an effect called 'halation' in which light areas encroach on adjacent peripheral parts of darker forms (55, 56). The consequent loss of definition in these forms, eaten away as they are by the erosive power of the light, resembles the new, one can say Impressionist, style which appeared suddenly, and for no apparent reason, in the work of Camille Corot in the late 1840s. This peculiarity in photographs is most noticeable from about 1848 to 1851, from the time in fact that glass plates began to be widely used as supports for photo-sensitive emulsions. Halation

occurs when the light penetrating the emulsion strikes the uncoated side of the glass and is refracted back through the emulsion from behind.

John Ruskin was certainly aware of the phenomenon of halation in landscape photographs. He criticized it as a distortion of natural form. Because of the 'chemical action of the light', he wrote in 1857, in his important *Elements of Drawing*, that light is seen to extend 'much within the edges of the leaves'. No photograph, he added, however still the trees, will 'draw' it truly and the same applies to any other form against a bright sky. If the artist, he said, could overcome the difficulty of drawing the extremities of foliation because of the dazzle caused by the brightness of the sky, obliterating the clarity of outline, he will have proved his superiority over the photograph.

In the same year Lady Eastlake described the effect on trees in photographs taken by the slower paper process. They are black, she wrote, 'and from the movement uncertain webs against the white sky, – if by collodion [i.e. on glass], they look as if worked in dark cambric, or stippled with innumerable black and white specks; in either case missing all the breadth and gradations of Nature'.

The results both of the movements of trees during a lengthy exposure and of halation are not difficult to find in early photographs, in the latter case especially where the natural light was unusually intense. Its effects are very apparent, for example, in a few photographs taken of Corot painting out-of-doors in Switzerland (*c.* 1855) and in the environs of Arras (*c.* 1871). Additionally, the insensitivity of early photographic emulsions to the colours of the spectrum, often necessitating the under-exposure of the terrestrial forms, resulted – as in portraits – in a characteristic massing of light and shadow areas into flat, unarticulated planes, virtually unknown in earlier landscape painting except in the most distant parts of the scene. All these features appear in Corot's paintings from the late 1840s (57). Though they are anticipated in a few of his earlier canvases, photography may have served to bring these forms from relative obscurity into stylistic dominance. It may be more than coincidental that the radical and quite sudden change from Corot's hard-edged earlier style, to the use of blurred forms, occurred about 1848, about the time when coated glass plates began to be used in photography, soon superseding both the daguerreotype and the calotype.

The association of Corot and other painters of Barbizon with photography is made with good reason. These artists could hardly be expected in the late 1840s and 1850s to ignore the work of contemporary photographers who, after all, must have been setting up their tripods next to the painters' easels in the leafy recesses of the Fontainebleau Forest and in other choice landscape sites. Nor is it likely that the painters would have denied themselves at least a close look at

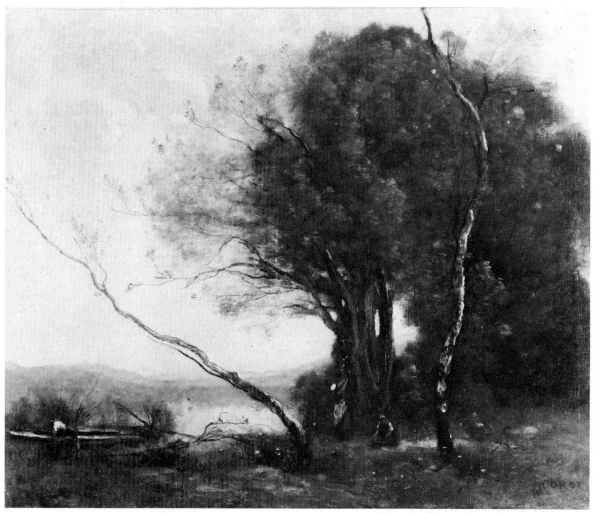

57. Corot: *The Bent Tree. c.* 1855–60

those fascinating calotype and collodion prints with which inevitably they would have to compete.

At Corot's death in 1875 more than 300 photographs were found in his studio. Two hundred of these were described by Robaut as different subjects, '*d'après nature*'; most of the others were after paintings and sculpture. Though an attempt has been made to trace them, their present location is unknown but is it not probable that most of them were of landscape subjects? Corot can be connected with at least two photographers at the beginning of the 1850s. Through his friendship with Constant Dutilleux, a painter with a large studio in Arras, he met Adolphe Grandguillaume and Adalbert Cuvelier; the former

a Professor of Drawing at the Arras Academy, the latter a talented amateur in the Dutilleux *atelier*. Both were said to be 'passionately' engaged in photographic experiments, and from 1852 took many pictures of the peripatetic Corot who visited this town in north-east France almost regularly each year from about 1851. Moreau-Nélaton wrote of Cuvelier as a businessman who 'gave himself up to photography'. Only one landscape photograph has thus far come to light which may have been executed by Cuvelier. Hitherto ascribed to an 'unknown French photographer', it is signed 'A. C. 1852' and bears such a striking similarity to Corot's paintings of the period that, while lacking absolute proof, it may reasonably be attributed to Cuvelier, the initials suggesting no other French landscape photograper of the time (58). The date corresponds exactly to Corot's early friendship with the Arras group, and the remarkable resemblance between photograph and paintings points as much to the influence of the painter on the photographer as it does to that of the photographer on the painter.[24]

MILLET, ROUSSEAU, DAUBIGNY, DUTILLEUX

Eugène Cuvelier, Adalbert's son, a landscape painter and also a photographer, once a pupil in the Dutilleux *atelier*, was a link between Arras and Barbizon. He often spent his summers in the little village in the Forest of Fontainebleau. Millet wrote to Rousseau from Barbizon in 1861 saying, 'you must have seen Eugène Cuvelier. He showed me some very fine photographs taken in his own country and in the forest. The subjects are chosen with taste, and include some of the finest groups of timber that are about to disappear.' The younger Cuvelier was a member of the Société française de Photographie in whose Salons he exhibited landscape views of the forest around Barbizon and of the environs of Arras. By 1861 at least two new photographers were working in Arras : Pierre Dutilleux, the son of the painter and Charles Desavary, who was responsible for photographing many of Corot's paintings.

Millet too had been closely acquainted with photographers among whom were Nadar, Étienne Carjat and the artist's old friend, Félix Feuardent. Millet's attitude towards photography is known from letters and from a young American painter, Edward Wheelwright, who visited him in Barbizon in 1855 and 1856, recording his discussions with the older artist. They saw each other almost daily. Millet 'thinks photography a good thing', wrote Wheelwright,

and would himself like to have a machine and take views. He would, however, never paint from them, but would only use them as we use notes. Photographs, he says, are like casts from nature, which can never be equal to a good statue. No mechanism can be a substitute for genius. But photography used as we use casts may be of the greatest service.

58. Adalbert Cuvelier(?): Photograph taken in the environs of Arras(?). 1852

Writing to an anonymous correspondent (date unknown), Millet clearly proposed employing photographs:

Please send me some of the photographs which I saw in an album at your place. I think that some of them would be useful to me. We haven't found anything worthwhile in Switzerland, in regard to views, and they want to charge us crazy prices for them.

And the artist wrote to Feuardent on 7 April 1865:

So you are off for Italy at last! If you should happen to find any photographs, either of the well-known antiques or of paintings, from Cimabue to Michelangelo, which are not too exorbitant in price, buy them. . . . As for the old masters, be sure only to buy photographs that are taken directly from the originals, and not from the engravings. . . . In short, bring whatever you can get there – works of art or landscapes, human beings or animals. Diaz's son who died brought home some excellent ones of sheep among other subjects. In buying figures, you will of course select those that have the least flavour of academic art and models. But get whatever is good, ancient or modern, proper or improper. Enough! Send us your little ones.

Commenting on the state of landscape paintings in the 1855 Salon, Edmond About found that one was like the next. Originality, he suggested, had been sacrificed at the altar of photographic truthfulness. A dreary homogeneity of style prevailed. In About's estimation, Corot, Rousseau and a few others were exceptions, but the rest he believed were no better than photographers. One artist would say to the others, 'we will copy literally whatever happens to be in front of us; we will abstain from all composing; we shall take care not to move a tree or a mountain; we will make a carefully controlled, coloured photograph of nature'.

Though Corot was spared, it seems, from similar accusations, Rousseau was not. Baudelaire criticized him for his blind love of nature, and by implication for succumbing to the influence of the camera. Émile Zola's accusation was more direct:

He wants at one and the same time to be precise and to make something striking; a highly coloured photograph must be his ideal. There is some analogy here with those English painters who sent to the Exposition Universelle pictures of wheat-fields where all the ears were counted, cloths of gold spread out in full sunlight.

Daubigny's 'objective' eye was the source of much comment, sometimes with the implication that his style was photographic (59, 60).

59. Daubigny: *Les bords de la Seine.*
Salon of 1852

60. Nadar: Satire on Daubigny's
Les bords de l'Oise exhibited in the Salon of 1859

A statement made by Dutilleux in 1854 reveals the sensitivity of landscape painters who, though they served poetry no less than reality, were apprehensive because of the constant possibility that their works would be related to photographs. Despite the importance of producing perfect copies from nature, he wrote, originality of style must predominate:

the reproduction we make of nature is never an exact, mathematically precise copy such as one can expect from a machine like the daguerreotype. It can only, and should

only, be an interpretation in which the artist brings to bear his knowledge, his skill, but above all his temperament, his own ideas and inner responses; his feelings!

Those magic words: interpretation, temperament, feelings, their currency unquestionably augmented by the growing influence of photography, were destined to mark a transformation in the art of the nineteenth century.[25]

JOHN RUSKIN

Quite the opposite view was held by John Ruskin at least until about 1856. Originality of style was wickedness. His whole concern with photography (he refers to it consistently in his voluminous writings) was in its utilization to effect a greater truthfulness in artistic representation. But ultimately, because of the competition from photography itself, because of a widespread mechanical adherence to his principles, and not least because of the dilemma his ideals inevitably presented in a camera-conscious world, he forswore his earlier pronouncements.

References to Ruskin's initial associations with photography were made in retrospect in *Praeterita*, published in three volumes from 1885 to 1889. He recalled the time about 1841 when he had first seen daguerreotypes. It coincided with the period he had become enamoured of Venetian art:

61. The Grand Canal, Venice. Engraving on daguerreotype taken 1839–42

Strangely, at the same moment, another adversity first made itself felt to me – of which the fatality has been great to many and many besides myself. It must have been during my last days at Oxford that Mr Liddell, the present Dean of Christ Church, told me of the original experiments of Daguerre. My Parisian friends obtained for me the best examples of his results, and the plates sent to me in Oxford were certainly the first examples of the sun's drawings that were ever seen at Oxford, and, I believe, the first sent to England. Wholly careless at that time of finished detail, I saw nothing in the Daguerreotype to help or alarm me; until now at Venice [probably 1841] I found a French artist producing exquisitely bright small plates, which contained, under a lens, the Grand Canal or St Mark's Place as if a magician had reduced the reality to be carried away into an enchanted land [possibly a reference to Lerebours's *Excursions daguerriennes*, then being made in Venice and elsewhere (61)]. The little gems of pictures cost a Napoleon each; but with two hundred francs I bought the Grand Canal from the Salute to the Rialto; and packed it away in thoughtless triumph. I had no time then to think of the new power, or its meanings; my days were over-weighted already.

In *Praeterita* Ruskin also recalled that in 1842, the year in which he had discovered Turner, he 'made the last drawings ever executed in his old manner', a sketchy, linear style derived probably from Samuel Prout. The 'new power' and Turner had had their effect upon the young artist.

Ruskin's many architectural and landscape drawings, mostly of Italian subjects (he visited Italy almost yearly then), now took on a naturalistic tonal quality (62). He had found a way to surpass the works of earlier masters:

I believe that Gentile Bellini's Church of St Mark's is the best Church of St Mark's that has ever been painted, as far as I know; and I believe the recognition of true aerial perspective and chiaroscuro with the splendour and dignity obtained by the real gilding and elaborate detail, is a problem yet to be accomplished. With the help of the Daguerreotype and the lessons of colour given by the Venetians, we ought now to be able to accomplish it.

He compared the work of Canaletto unfavourably and unreasonably with the daguerreotype. Canaletto's accuracy is so lacking, he wrote, that *one* inch of the daguerreotype equals three feet of a Canaletto painting:

The mannerism of Canaletto is the most degraded that I know in the whole range of art . . . and this I say not rashly, for I shall prove it by placing portions of detail accurately copied from Canaletto side by side with engravings from the Daguerreotype . . . there is no texture of stone nor character of age in Canaletto's touch; which is invariably a violent, black, ruled penmanlike line.

Ruskin eagerly collected daguerreotypes of French and Italian architecture as well as of landscape views. He carefully analysed them in an attempt to duplicate in his own drawings their delicate tonal gradations and wealth of detail. His *Landscape at Sens* of 1846 and many wash drawings which he made of Venetian and Pisan buildings were dependent on photographs. By 1845 he

conceived the idea of writing a study of the architecture of Italy, and illustrating it with his own meticulous drawings made with the help of photographs. He wrote to his father on 7 and 8 October 1845, telling him of daguerreotypes which he had purchased

of the Palaces I have been trying to draw . . . every chip of stone and stain is there, and of course there is no mistake about proportions. . . . Daguerreotypes taken by this vivid sunlight are glorious things . . . anyone who had blundered and stammered as I have done . . . and then sees the things he has been trying to do . . . done perfectly and faultlessly in half a minute, won't abuse it afterwards . . . if I can get a few more [daguerreotypes] I shall regularly do the Venetians – book them in spite of their teeth. . . . Amongst all the mechanical poison that this terrible nineteenth century has poured upon men, it has given us at any rate one antidote – the Daguerreotype.

In a diary entry of 27 May 1846 Ruskin described his drawing of St Mark's as being like a daguerreotype, and two days later in Padua he wrote that in a sheet of drawings of the capitals on the Doge's Palace he had solved the difficulty of rendering both shadows and stains in the leafage, as it is shown by the daguerreotype (63).

It was, however, in this year that doubts began to creep into Ruskin's mind as to the ultimate benefit of the daguerreotype for art, though he still used it and continued to advocate its use. He considered that his drawings were truth

62 (*left*). Ruskin: *The Chapel of St Mary of the Thorn, Pisa.* 1872.
Ruskin wrote of this drawing: 'an old study of my own from photograph'

63 (*right*). Photograph of the Ducal Palace, Venice, in Ruskin's collection

to the very letter: 'too literal, perhaps; so says my father, so says not the Daguerreotype, for it beats me grievously. I have allied myself with it . . . and have brought away some precious records from Florence. . . . As regards art, I wish it had never been discovered, it will make the eye too fastidious to accept mere handling.' He declared that the artist must rise above the mechanical means of the daguerreotype and calotype, even while employing them.

From 1846 until about the mid 1850s Ruskin gathered both written and visual material to be used in his books on architecture. Despite his now slightly jaundiced view of photography, he continued to rely heavily on it, devoted as he was to the imitative principles of naturalistic art. In the preface to *The Seven Lamps of Architecture* (1849) he apologized for the coarseness of his illustrations, but hastened to add that the plates were valuable, 'being either copies of memoranda made upon the spot, or enlarged and adapted from Daguerreotypes, taken under my own superintendence'. In *Examples of the Architecture of Venice* (1851) his drawings are entirely in the tonal style. His debt to the daguerreotype is acknowledged and its usefulness to artists is still endorsed. Studies, he wrote,

made on such a system, if successful, resemble Daguerreotypes; and those which I have hitherto published, both in the 'Seven Lamps' and in the text of the present work, have been mistaken by several persons for copies of them [i.e. photo-mechanical copies] . . . but I have used the help of the Daguerreotype without scruple in completing many of the mezzotinted subjects for the present series; and I much regret that artists in general do not think it worth their while to perpetuate some of the beautiful effects which the Daguerreotype alone can seize.

The Stones of Venice was published in three volumes from 1851. Ruskin had at first considered the possibility of using actual photographs – 'the beautiful calotypes lately made at Venice' – to illustrate this work. But because of deficiencies he had already observed in the photograph – the loss of detail in the shadow areas particularly – he decided to use his own drawings and the engravings of an assistant. While many of these are linear in style and schematic in presentation, especially in the descriptions of cornice profiles and arch constructions, others are mezzotinted and look like photographs.

Ruskin's determination to make photography serve solely as a handmaiden to art is clear. In many subsequent references in his writings he supported the use of photographic material. In the *Elements of Drawing*, first published in 1857, he suggested that artists make use of photographs taken from the sculptures of French cathedrals for their studies of drapery folds: 'copy some piece of that; you will then ascertain what it is that is wanting in your studies from Nature'. And in the same work, on sketching from nature, he wrote that photographs of 'some general landscape object' would be of value in 'producing delicate

gradations'. Here also he spoke of 'multitudes of photographs' taken from the
drawings of the Old Masters and recommended their use as studies. In his
Educational Series of the 1870s Ruskin referred to photographs for the use of the
art student who is learning to draw, as he did later in *The Rudimentary Series*. In
the latter work he described his 1878 water-colour study of a tomb in Verona
(probably that of Can Mastino II, the north gable) in which 'every touch of
the drawing is bestowed with care and, with the help of the photograph, will
sufficiently explain the character of the monument'. In one of his letters from
Brantwood, dated 17 March 1887, he told the artist Frederick Harris that he
had literally no end of photographs to put at Harris's service but, he warned,
put them under glass when ordinary pupils are at work on them.

Despite his advice that artists utilize the photograph, Ruskin's growing dislike
for photography is hardly disguised. In his inaugural lectures on art, delivered
as the Slade Professor at Oxford in 1870, he reversed his previous convictions
about the usefulness and beneficial effects of photography: 'almost the whole
system and hope of modern life are founded on the notion that you may
substitute mechanism for skill, photograph for picture, cast-iron for sculpture.
That is your main nineteenth-century faith, or infidelity.' The use of photo-
graphs, he said, which appear to give absolute truth and 'unapproachable
subtilty' might be thought to have diminished the need for studying and
sketching from nature, but,

let me assure you, once for all, that photographs supersede no single quality nor
use of fine art, and have so much in common with Nature, that they even share her
temper of parsimony, and will themselves give you nothing valuable that you do not
work for. They supersede no good art, for the definition of art is 'human labour
regulated by human design', and this design, or evidence of active intellect in choice
and arrangement, is the essential part of the work . . . [photographs] are invaluable
for record of some kinds of facts, and for giving transcripts of drawings by great
masters; but neither in the photographed scene, nor photographed drawing, will you
see any true good, more than in the things themselves, until you have given the
appointed price in your own attention and toil . . . they are not true, though they
seem so. They are merely spoiled nature.

Other statements and letters by Ruskin in the 1870s and 1880s follow a similar
pattern: photographs are false, they are only a matter of ingenuity, while art is
one of genius; the artist must use them with extreme caution, though they may
serve some of his needs; portrait photographs are 'horrid things', though there
is much truth in the facial expressions of instantaneous photographs.

Ruskin's dilemma was that of many of his contemporaries in both England
and France whose over-zealous belief in naturalism could only result in a similar
conflict with photography. Virtually denying his earlier aesthetic principles,

late in life, in *Praeterita*, he lamented the 'microscopic poring into' the visible world of nature which the invention of photography served to intensify. 'The use of instruments,' he warned, 'for exaggerating the powers of sight necessarily deprives us of the best pleasures of sight.' In 1868 Ruskin revealed his new preferences for a style in art which had far more in common with Turner's late paintings than with the ideal Pre-Raphaelite representation. This change in his conception of nature was undoubtedly brought about by the existence and inevitable effects of photography.

Fifteen years ago [he wrote], I knew everything that the photograph could and could *not* do; – I have long ceased to take the slightest interest in it, my attention being wholly fixed upon the possibility of wresting *luminous* decomposition which literally *paints* with sunlight – no chemist [i.e. no photographer] has yet succeeded in doing this; – if they do, the results *will* be precious in their own way.

The irony of this! Unsuspected by Ruskin, Turner himself had in his last years consulted photographs with probably the same luminous effects in mind.

Earlier, while still devoted to the dictates of hard-rock naturalism, and trying to reconcile Turner with the objective eye, Ruskin attempted to prove the topographical truthfulness of Turner's drawings by comparing them with the photograph. Indeed, Turner's vision was superior to that of the lens, he claimed. 'A delicately taken photograph of a truly Turnerian subject, is far more like Turner in the drawing than it is to the work of any other artist.' But a Turner drawing, like the *Yorkshire Richmond* (in the England series called *Richmond from the Moors*) is better, he asserted, 'than a photograph of the ground, because it exaggerated no shadows, while it unites the veracities both of model and photograph'.

To Ruskin's mind, the very best thing an artist could do before going out to face nature – and this would mitigate the contradictions between the camera and the artist – was to study the combined virtues of both the photograph and of Turner.

Take a small and simple photograph [he instructed in the *Elements of Drawing*], allow yourself half an hour to express its subjects with the pen only, using some permanent liquid colour instead of ink, outlining its buildings or trees firmly, and laying in the deeper shadows, as you have been accustomed to do in your bolder pen drawings; then, when this etching is dry, take your sepia or grey, and tint it over, getting now the finer gradations of the photograph. . . . And now at last, when you can copy a piece of liber studiorum, or its photographic substitute, faithfully, you have the complete means in your power of working from Nature on all subjects that interest you.[26]

64. Daguerreotype of the Niagara Falls. *c.* 1854.
A later photograph conveying probably what Turner saw in those of Mayall

65. J. M. W. Turner: *The Wreck Buoy*. Begun probably 1808–9, extensively reworked 1849

TURNER

We know very little about Turner's own response to photography. Sir William Blake Richmond R.A., a young contemporary of the artist, records Turner's sensitivity to the effect of photography on art when, on being shown a daguerreotype, he exclaimed, 'This is the end of Art. I am glad I have had my day.' But Walter Thornbury, Turner's contemporary and biographer, describes the painter's interest in 1847–9 in J.E.Mayall's photographic studio in Regent Street. Turner's 'thirst for knowledge in his old age' brought him into frequent contact with Mayall who performed several experiments in photography at his request. The 'curious effects of light' on prepared plates, photographic recordings of the spectrum, and especially the appearance of a rainbow spanning the Great Falls of Niagara, in photographs belonging to Mayall, impressed him. Mayall obliged by explaining what he knew of these things and, with Turner as the model, took photographs under a number of unusual conditions[27] (64, 65).

CRITICISMS OF PRE-RAPHAELITISM

In 1851, about six months before Turner's death, Ruskin took up the defence of the Pre-Raphaelites. In his pamphlet, *Pre-Raphaelitism*, he continued to preach the gospel of imitative art. He praised the 'particularized truth'. He insisted that the 'grandest style' in art would be one in which a perfect imitation of nature, 'down to the smallest detail', was effected. The artist, he wrote, should go to nature, 'rejecting nothing, selecting nothing, and scorning nothing'. The artist should be a recorder of nature, an observer and an imitator. His function was 'to convey knowledge to his fellow men, of such things as cannot be taught otherwise than ocularly'. Originality, invention, imagination, he insisted, should be repudiated.

For such declarations he was understandably accused of promoting the acceptance of a photographic style. Attempts to define the natural domains of both painting and photography inevitably expressed hostility to Pre-Raphaelite principles. It was futile, said many photographers, to attempt to imitate nature with the microscopic precision of which only their medium was capable. The province of art was not in the imitation of nature any more than photography's was in its spiritual interpretation: 'Fine art and photography cannot be compared, because photography never can reach the *poetry of nature*, neither can any manual exertions attain the extraordinary and beautiful detail of photography.'

Not surprisingly, critics of the Pre-Raphaelites suggested that these painters actually copied photographs. In response to the 'calumnies and absurdities' levelled by the Press Ruskin again defended the young artists in his Edinburgh lectures on architecture and painting delivered in November 1853:

The last forgery invented respecting them is, that they copy photographs. . . . It admits they are true to nature, though only that it may deprive them of all merit in being so. But it may itself be at once refuted by the bold challenge to their opponents to produce a Pre-Raphaelite picture, or anything like one, by themselves copying a photograph. . . . Pre-Raphaelism has but one principle, that of absolute, uncompromising truth in all that it does, obtained by working everything, down to the most minute detail, from nature, and from nature only.

Richard and Samuel Redgrave, in their book on the English school, took exception to the pontifical tone of the Edinburgh lecture. Though agreeing with the fundamental principles of the Brotherhood, it was Ruskin's insistence on 'uncompromising truth'. which they objected to. This, they believed, resulted not in art, but merely in 'topographical truth'. They criticized the painting, *Jerusalem and the Valley of Jehoshaphat*, executed by Thomas Seddon (a follower of the Pre-Raphaelites) in 1854, insisting that it was simply a photograph with colour, containing every – even the minutest – detail of the scene (66). It was lacking in poetry, they wrote, and was merely 'mapped and catalogued'. The Redgraves' suspicions may have had some basis in fact. A photograph had been

66. Thomas Seddon: *Jerusalem and the Valley of Jehoshaphat from the Hill of Evil Counsel.* 1854

used by Seddon in the execution of *Jerusalem*. The sale catalogue (1882) listing the contents of Rossetti's studio following his death, includes lot number 326: '*A photograph*, beautifully painted, framed and glazed, by the late Thomas Seddon in preparation for his picture of "Jerusalem" now in the National Gallery.' During the year the canvas was painted Seddon joined Holman Hunt and the photographer James Graham in Jerusalem and it is not unlikely that the photograph in question was taken by Graham.

Ruskin, however, still held the refractory view that the photograph was deficient in its reproduction of nature, and that artists, true to the principles of Pre-Raphaelitism, could surpass the camera. In 1856, to prove that this was so, he compared a daguerreotype of the towers of the Swiss Fribourg with drawings which he made of the subject (67). The details, lost in the lightest and

67. Ruskin: Drawings and a daguerreotype of the towers of the Swiss Fribourg. 1856. 1. Drawing in the 'Düreresque' style which he supported. 3. Drawing in the 'Blottesque' style which he rejected

darkest areas of the photograph, are accounted for in one of the drawings. While the photograph only suggests the textured character of the stone and the tiled roof, and the foliage and the windows are almost completely obscured in the shadows, the drawing describes all these with much greater precision. Ruskin wrote of his experiment:

The other day I sketched the towers of the Swiss Fribourg hastily from the Hôtel de
Zähringen. . . . I have engraved the sketch . . . adding a few details, and exaggerating
the exaggerations. . . . The next day, on a clear and calm afternoon, I daguerreo-
typed the towers . . . and this unexaggerated statement, with its details properly
painted, would not only be the more right, but infinitely the grander of the two.
But the first sketch nevertheless conveys, in some respects, a truer idea of Fribourg
than the other, and has, therefore, a certain use. For instance, the wall going up
behind the main tower is seen in my drawing to bend very distinctly, following the
different slopes of the hill. In the daguerreotype this bend is hardly perceptible.

He then pointed out other characteristics of the subject which though sensed by
the observer could not be effectively realized in art without meaningful exag-
geration 'so that the hasty sketch, expressing this, has a certain veracity wanting
altogether in the daguerreotype'.

Despite the apparent truth of Ruskin's demonstration, photographers were
not disposed to yield to painters one of the most important assets of their
medium: the ability to render absolutely precise detail. They continued to
insist on the inherent superiority of the photograph, and could indeed produce
views taken with such care as to bring into focus, over a great depth of field,
a profusion of objects, their details sharply and clearly defined. In an article
entitled 'Photography in its relation to the Fine Arts', published in 1861, it
was asserted that 'Wherever literal truth, accurate detail, perfect imitation is
of value in art, there photography takes honourable prominence, for the most
painstaking pre-Raphaelite may emulate in vain its wondrous precision.'

Another kind of accusation levelled at the Pre-Raphaelite painters, in 1857,
was that their works were *not* true to nature, failing as the daguerreotype failed,
by presenting frozen, lifeless objects unlike those seen with normal vision. This
appears in the novel, *Two Years Ago*, by Charles Kingsley, himself an amateur
photographer. Though the criticism centres on portrait painting, it must also
have been the immobile forms in pictures like Holman Hunt's *Hireling Shepherd*,
Millais's *Ophelia* and Brett's *Stonebreaker* that provoked, in Kingsley's novel, the
conversation in an art gallery between Stangrave and the artist Claude Mellot
as they inspect a Pre-Raphaelite painting. Claude, critical of these artists,
maintains that they, in fact, did *not* copy nature. Nature is beautiful, he insists,
and the paintings of this Pre-Raphaelite are 'marred by patches of sheer
ugliness'. If the artist *had* copied nature, explains Claude, the painting would
have been beautiful. By painting every detail, every wrinkle, every horrible
knuckle, he sees life, not naturally, through his eyes, but unnaturally, as though
through a microscope. Stangrave objects: Didn't you say that the highest art
copies nature? Claude: Exactly. And therefore you must paint, not what is
there, but what you see there. They forget that human beings are men with

two eyes, and not daguerreotype lenses with one eye, and so are contriving and striving to introduce into their pictures the very defect of the daguerreotype which the stereoscope is required to correct. Stangrave: I comprehend. They forget that the double vision of our two eyes gives a softness, and indistinctness, and roundness, to every outline. Claude: Exactly so; and therefore, while for distant landscapes, motionless, and already softened by atmosphere, the daguerreotype is invaluable . . . yet for taking portraits, in any true sense, it will always be useless, not only for the reason I last gave, but for another one which the Pre-Raphaelites have forgotten . . . what I mean is this: [the daguerreotype] tries to represent as still what never yet was still for the thousandth part of a second; that is, a human face; and as seen by a spectator who is perfectly still, which no man ever yet was. Claude reinforces his argument by describing the beauties and the optical logic of the softened wrinkle and the blended shadow. The only way, he continues, of realizing the Pre-Raphaelite ideal, would be 'to set a petrified Cyclops to paint his petrified brother'.[28]

THE PRE-RAPHAELITES' USE OF PHOTOGRAPHY

Ruskin's injunctions about painting from nature alone seem to contradict his other recommendations that photographs could be of some limited advantage to artists. But he meant them to be used for study or drawing, never to be painted from directly. For photographs revealed certain subtleties of contour and tone which might escape the eye, and he admitted that much could be learned from them. Their convenience, when working up a painting in the studio, should not be underestimated. With this in mind one may note a certain amount of evidence which indicates the use of photographs by the Pre-Raphaelites, their friends and followers. Though it is difficult to discover the exact manner in which they employed photographs, there are some documents which prove, or strongly suggest, that in this respect their practice was no different from that of most other artists.

Ford Madox Brown, for example, wrote in his diary (12 November 1847) that he 'went to see Mark Anthony about a Daguerreotype: think of having some struck off for the figures in the picture, to save time'. The camera was a convenient means of collecting studies of costumes and models and could save the artist the cost of several sittings. Edward Burne-Jones and William Morris posed a model in a suit of armour, 'to be photographed in various positions'. Millais, who occasionally used photographs for his portraits and who is known to have commissioned Rupert Potter to provide him with photographic material both for portraits and for landscape backgrounds, insisted that in his later landscapes like *Chill October* and *Murthly Moss* (68) every touch was painted from nature. Yet the character of these paintings and of others like *The Old Garden*

68. Millais: *Murthly Moss*. 1887

69. Emerson and Goodall: *Gunner Working up to Fowl*.
Photograph from *Life and Landscape on the Norfolk Broads*. 1886

and *Lingering Autumn* strongly suggests, if the artist had not consulted photographs, that indirectly the camera had insinuated itself into his work (69). It is difficult to believe that *Murthly Moss* had little to do with photography when it is known that before commencing the picture Millais and his son Geoffrey, described as an able photographer, spent a few days looking around Murthly Waters for a suitable point of view and photographing those which seemed promising. The artist, it is said, could then see, 'side by side, the various views that specially attracted his attention, and finally . . . select what he thought best'. Did Holman Hunt, possibly like Seddon, make use of James Graham's photographs on their trip to the Holy Land in 1854? Several of the artist's drawings of Jerusalem that year, strangely fortuitous in composition, suggest that he did. Rossetti owned many photographs of Jane Morris which may have served him for drawings and paintings in which she is the model. On country walks with Frederick Sandys at Northiam and Tenterden, Rossetti, like Millais, would note 'the best spots for painting, and order photographs of them to be made'. He wrote to his mother in 1864:

Dear Mamma, Would you give Baker the photograph of *Old Cairo* which hangs in your parlour; and, if there are any stereoscopic pictures, either in the instrument or elsewhere, which represent general views of cities, would you send them too, or anything of a fleet of ships? I want to use them in painting Troy at the back of my Helen.

Just as Cairo might do for Troy, Siena could be substituted for Florence. There is evidence which indicates that the background of one of Rossetti's versions of the *Salutation of Beatrice* was to some extent based on photographs of Siena sent to the artist by Fairfax Murray. The backgrounds of other paintings like the late *Dante's Dream* strongly suggest that here, too, photographs were consulted.

Forever faithful to the Pre-Raphaelite ideal, John Brett, in 1889, read an interesting paper, 'The Relation of Photography to the Pictorial Art', to the Camera Club in London. He reiterated the old axioms of the P.R.B.: 'The basis of all good pictorial art consists of a reproduction of natural images or views. . . . The painter's art is founded on correct representation of real things . . . [he should] exalt natural appearances.' And though Brett believed that, for these purposes, his 'equipment' was superior to that of the photographer, he conceded that 'photography is an invaluable servant, and', he added, 'an invaluable teacher to the artist'.[29]

COMPOSITE PICTURES

In English pictorial photography, from about the 1850s, it was sometimes the practice to compose a photograph from a number of views taken under a variety of conditions. Oscar Gustave Rejlander's famous large photograph, *Two Ways*

70. H. P. Robinson: *Women and Children in the Country.* 1860 (composite photograph)

of Life, for example, was fabricated from more than thirty different negatives, and H. P. Robinson's many photographic compositions were made in the same manner (70). When Rejlander's composite picture was criticized for being constructed in this way, the *Art Journal,* approving of the technique, defended him:

the photographer artist does no more than the Royal Academician does: he makes each figure an individual study, and he groups those separate 'negatives' together, to form a complete positive picture.

The procedure was repudiated in France, and the Photographic Society there prohibited its members from exhibiting photographs made by this method. Similarly rejecting piecemeal composition, Charles Meryon made it clear that the uncritical use of photographic studies endangered the consistent formal appearance of a picture. According to Philippe Burty, the Duke of Aremberg saw Meryon's views of Paris in 1855 and 1856 and the following year sent for the artist, asking him to reproduce certain picturesque places in the neighbourhood of his château:

He bought for him a daguerreotype camera, and made him take lessons at Brussels in the management of what was then a novel instrument. . . . Meryon had taken a few photographs, the selection of which showed the special taste which he displayed in everything. One sees the château . . . beyond a park watered by a lake – a Pavilion built in the pure Italian style – first photographed entire, then only as to the portico – then a clump of trees: 'These trees remind me of Leonardo da Vinci', he said, speaking of the effect of light. 'But after all', he continued, 'however seductive these studies may appear, in reality they are useless. For how can you complete the whole when, as in this instance, it is incomplete, save as to a third, which if you change, all the rest falls to pieces? . . . a photograph ought not to, nor even can, enable an artist to dispense with a sketch. It can only aid him, whilst he works, by assurance and confirmation, by suggesting to him the general character of the actuality which he has studied, and oftentimes by discovering to him minor details which he had overlooked; but it can never replace studies with the pencil.

Traditionally, the composite fabrication of paintings did not presuppose the loss of pictorial unity. Indeed, it had been incumbent upon the artist to weld all elements, however diverse their sources, into one homogeneous statement. But the apparent disregard for formal cohesiveness in so many Pre-Raphaelite and Victorian paintings could not but be aggravated by the prevailing attitudes concerning the use of photographic studies. In Millais's portrait of Ruskin the subject stands on a rocky ledge before a background wealth of carefully delineated natural forms, on which the figure appears to be superimposed. Not so much as a shadow unites it to its surroundings. In his *Autumn Leaves* (1856) the foreground objects appear separated from the background, the incisive, light contours around the figures cut them off from the distant landscape. Ruskin noted in 1870 that some photographs 'reveal a sharp line of light round the edges of dark objects' and earlier, in 1859, methods for avoiding it in photographs were discussed. Paintings of this kind resemble some of the pieced-together photographic compositions by Robinson. These latter very often lack consistent formal integration. They produce the fragmented effects of montage – which in fact they were. Notably absent in combination photographs, though visible in nature and normally found in ordinary photographs, are the soft unifying aureoles of light attending contrasting tones and colours which blend almost imperceptibly into adjacent areas.

'Cut-out' figures placed against backdrops, anomalies in light sources, tonal scale and focus can be found in Millais's paintings, *Spring (Apple Blossoms)* (71) and *The Woodman's Daughter*. The appearance of bas-relief in these canvases is due to the artist's propensity for painting into the foreground figures from the background in order to obtain a crispness of contour. By using deep colours to do this, the resulting dark outline (rather than a light aureole as, for example, employed later by Seurat) has the effect of severing the figures from the land-

71. Millais: *Apple Blossoms*. 1856–59. Exhibited as *Spring* in 1859

scape. Arthur Hughes's painting, *The Sailor Boy's Return*, a picture altered at least twice between 1856 and 1863, is extremely awkward in the scale of the figures, and the tonal character of the foreground is utterly incompatible with that of the distance with no logical pictorial transition made between the two. Such abrupt breaks in aerial perspective can be found in Frank Dicksee's paintings – in *Harmony*, for example. Madox Brown's *Stages of Cruelty* and *Work*, both of which were executed over periods of several years, are piecemeal in their appearance, and suggest the careless use of daguerreotypes. Other examples in English painting are not lacking. By virtue of their general softness and tonal consistency, Rossetti's works on the whole, despite his use of photographic studies, have – like those say of the Barbizon painters – a more cohesive appearance.

In many ways it was more expedient for the painter to work entirely from single photographs, whether or not nature was to be consulted directly, than to paint from snippets of a large file of photographic *aides-mémoires*. Some artists took up photography especially to be able to compose their own photographic 'sketches' prior to painting from them. The *Journal of the Photographic Society* in London is illuminating in this respect and there one reads, for example, a statement by Newton which makes it clear that his photographs were intended primarily as studies for paintings. He describes the manner in which he manipulated the camera, throwing objects out of focus, recording only the large

masses of light and shade, and otherwise making the photograph come as close as possible to the image intended for the painting. He would photograph a subject several times under different conditions 'until one was found entirely suited to the group of figures about to be painted'.

In France, Charles Nègre, once a pupil of Delaroche and Ingres, and a member of the Photographic Society in Paris, often intended his photographs

72 (*above*). Charles Nègre: *Market Scene on the Quais*. Paris (oil on canvas)

73. Charles Nègre: *Market Scene on the Quais*. Paris 1852 (calotype)

to be complete studies for paintings, which were exhibited at the Salon until
about 1864. His *Scène de marché*, painted directly from a photograph which he
took of a Paris quay in 1852, reproduces the broad tonal masses almost exactly
as they are in the photograph and the figures are uniformly absorbed in the
overall tonal flux (72, 73). His *Joueur d'orgue*, shown at the Salon of 1855, was
entirely painted from one of his calotype photographs of urban *genre* scenes (24).
A contemporary, Ernest Lacan, himself a painter who then devoted most of his
time to the advancement of photography as an art, wrote in 1856:

In copying faithfully from this photograph, M. Charles Nègre has produced a charm-
ing picture which was shown at the last Salon. Why should not other painters
follow his example! One easily sees all the advantages they would gain in reproducing
the groups of figures that make up their subjects, by means of photographs. In such
a way they would have an exact sketch taken from nature which, if necessary, they
could modify on the canvas.

Newton and Nègre, and other painters who followed the same practice, had
a wide range of formal effects available for their photography. An account of
'the discovery of a variety of very curious and most interesting' photographic
processes in England was given in 1848, in the *Art-Union*. Included among the
inventions were the catalysotype, the ferrocyanotype and the chrysotype, the
amphytype, the chromotype and in a few years one could add the albumen-on-
glass method, the ambrotype and, most consequential, the new collodion-
on-glass process which became as important in France and other countries as
it did in England. Though the lens was still less flexible than the brush, the large
variety of photographic techniques possible by the mid century, plus a number
of mechanical and retouching methods then known, enabled the photographer
to exercise a significant degree of control over his medium in keeping with his
aesthetic preferences. As photography became more versatile, an artist with his
camera, it was said in 1853, could 'plunge into Pre-Raffaelism, or Rembrandt-
ism, or Reynoldsism' as he chose and especially advantageous, if these photo-
graphs were to become the bases of paintings, he could hide the fact of having
used them at all.[30]

CLOUDS

The difficult problem of painting cloud formations with meteorological accuracy,
not to say poetry, was an old story in art by the time it appeared that the
photograph could be of assistance. Ruskin laid so much stress on the inclusion
of clouds in landscape painting that the index for the five volumes of *Modern
Painters* contains almost three pages of entries under that heading. The impor-
tance he gave to clouds, and his views about the service photography could

render, contributed, no doubt, to the growing eagerness of artists to obtain good photographic specimens of these fugitive forms. C. R. Leslie, honouring the memory of John Constable, deplored the indifference of both landscape painters *and* photographers to 'the beauty that canopies the earth'. Writing in 1854, Leslie claimed to have seen only two calotypes of skies, erroneously believing that landscape views with cloudy skies were already within easy reach of the ordinary photographer. But the photographing of clouds, particularly if the landscape was also to be included, was then a very difficult matter. Different exposure times were necessary if both the expanse of light sky and the darker tones of the land below were to be recorded correctly. In practice, either the sky was over-exposed and the definition of cloud forms lost in the brightness, or, if the exposures were set for the sky, the terrestrial forms would be under-exposed. There were many complaints about this in the photographic and art journals of the 1850s. The most obvious method proposed to circumvent the difficulty was that of taking separate pictures of land and sky and piecing together the negatives from which prints could then be made. Another was simply to paint the clouds in. At a meeting of the London Photographic Society in the summer of 1853, Mr Henry Cooke, described as a painter-photographer, announced that he had developed a means of photographing both the sky *and* the landscape simultaneously. Yet Cuthbert Bede in his amusing book, *Photographic Pleasures* (1855), observed that photography could not yet make clouds. And the following year, the *Art Journal* carried a review of the 1856 exhibition of the Photographic Society, in which the need for cloud studies was mentioned: 'How valuable to the artist would a good series of photographic cloud studies be, since few know how to paint them.'

Though a few successful cloud studies can be found earlier, the credit of producing the first was given in 1856 to Gustave Le Gray. His dramatic photographs of the sea and sky were taken usually at those hours of the day when the sun was low on the horizon, with clouds casting shadows upon clouds in sharply contrasting tones (91). That was one solution to the problem. His photograph, *Brig upon the Water*, exhibited that year in cloud-hungry London, was acclaimed with much enthusiasm as the first successful photograph of this kind. Still, even at the end of the century complaints were made that photographs were being pieced together, composite landscapes with cloudy skies 'taken at noon, above a quiet landscape taken in the morning or evening'. Some of these were disparagingly described, 'with clouds hung low above still water in which they had no reflections, and over which they cast no shadows'. By that time, however, the meteorological character of cloud formations represented in paintings, some of which had rarely, if ever, been known in art before photography, either

resulted directly from the use of photographic studies or had become, indirectly,
the expression of obeisance to the camera.[31]

JOHN LINNELL

John Linnell's paintings of particular cloud and weather effects were done with
more concern probably for their dramatic intensity, than for their meteoro-
logical accuracy. He was interested in the appearance of the Italian landscape:
in a letter of 1861 to his son in Italy he wrote that

> many go to the grandest scenery in the world, and they bring home capital infor-
> mation, not so good, however, as photos. I would rather have some good photos of
> Italian Romance – the wildest – wilder than any modern pictures of Italy I have
> seen. It will be wise of you to get all the photos you can of scenery and figures, such
> as are only to be seen in Italy. As for the wonderful skies that young ladies talk of, I
> never expect to see them on canvas.

Though Linnell was praised by Ruskin for his 'elaborate' and 'skilful' forest
scenes and for his meticulous painting technique, how disappointed the cham-
pion of Pre-Raphaelitism would have been had he known that the painter's
typically English landscapes, with their glowering skies and bucolic subjects,
may not have been authentic, nor done entirely from nature, but were possibly
composites of English and Italian scenery. In another letter to his son in Italy
three years later, Linnell wrote:

> Thanks for the *fotografs*, as the Italians spell it. Very few of the best things seem to
> be done. Are there no *fotos* of the wonderful bulls, rustic waggons and figures, or are
> we to have those in words only? I hope you will not return without studies and fotos
> to back up your description. . . . I should be glad for once to see something to corre-
> spond to the boasted Italian sky; the pictures sent – though very nicely finished – are
> only English skies.

Linnell may have contemplated practising photography himself possibly like
Newton and Nègre, to use it for his paintings. He seems to have written to
Cornelius Varley, the well-known designer of optical instruments and himself
a water-colour painter, expressing a desire to learn the photographic technique.
Varley's letter to Linnell of 2 July 1853 suggests that the latter wanted Varley
and his sons to fit up the apparatus for him as he was 'determined to go heartily
into play with the sunbeams, the most glorious associate the arts ever had'.[32]

PICTORIAL TRUTH AND ALTERNATIVES

That the character of contemporary painting had been conditioned by photo-
graphy was admitted 'upon all hands' as one commentator concluded in 1858.
Walter Thornbury, a few years later, suggested that photography was largely

responsible for the preoccupation with high finish and detail as in Pre-Raphaelite painting. Derisively, and with abundant justification, it was said that many artists were content to paint entirely from photographs, and that was believed to be fatal to artistic progress: 'there is a winning charm about photography which may well seduce the artist from his true path'. Yet even the President of the Royal Academy, Sir Charles Eastlake, who was also the first President of the Photographic Society, praised photographs like those of Newton, saying that 'artists would greatly benefit by studying them'. With unremitting persistence eulogies to the 'truth to nature' were invoked. Exhibition reviews, especially in England, were full of phrases glorifying the 'careful execution of accessories', the 'skill', the 'fastidiousness', and the 'scrupulous truth' of the works shown. The most essential ingredient in painting it was insisted – indeed, its very reason for being – was the 'perfect imitation of reality'.

The ambiguous qualifications placed on the use of photographic material must have served to heighten the confusion of artists. Philip Hamerton, like Ruskin, criticized the inaccuracies of photographs (which no photographer would admit). He reprimanded artists for working too closely with the photograph, describing how he himself had abandoned the camera. The proper use of photographs, he insisted, was only as 'an obedient slave for the collection of memoranda' to be used to give liveliness to the foregrounds. Even more antipathetic to the use of photographs, Frederick Leighton categorically declared that on principle the artist should reject, as he had, their use; in taking shortcuts he would do injury to his creative spirit. Another academician, Edward Poynter, decried the 'trivial and photographic studies of nature which pass for pictures among the younger school of landscape painters'. And William Orchardson believed that the camera was of little use to the artist, that

photography, even photography in colour, cannot help the painter to achieve greater successes, either in draughtsmanship or in the interpretation of colour and tone, than have already been achieved by hundreds of . . . great painters who lived . . . before these scientific developments were so much as thought of.

What were the alternatives?

In France, during the latter part of the 1880s especially, the vexing questions provoked by the relation of photography to art were seriously debated concurrently with the growing interest in the abstract significance of form and colour, the representation of movement, and the theories of scientists and others concerned with physiological and psychological optics. There, the validity of a highly conceptual art was being expounded. The permissible extremes of the use of the imagination, and other ideas wholly antagonistic to the precepts of nineteenth-century naturalism preoccupied many artists.

In England, Whistler notwithstanding, no such situation existed. Whatever their attitudes about photography, artists and critics still insisted on the primacy of naturalistic representation. The founding of the New English Art Club in 1886, though it signalled a change in English art, was essentially a transplantation of French Impressionism. Orientated to naturalism, it was still viewed with suspicion by Ruskin-dominated, Franco-phobic critics and artists. With few exceptions, not until the present century did English artists begin to discard the long and tenacious devotion to imitative art and thus free themselves from the apparently insoluble dilemma created by the appearance of photography.[33]

4. Delacroix and photography

Eugène Delacroix was among those artists in the nineteenth century who welcomed the discovery of photography, seeing in it something beneficial for art. On occasion, he helped pose models for some of his own photographs; at least for a few years he used the facilities of an active photographic studio in Paris. He was a charter member of the first photographic society in France. He supported the efforts of photographers to have their works included in the yearly Salon exhibitions. His journal and essays contain some extremely perceptive references to the subject, and with no misgivings he utilized photographs in the execution of some of his paintings and drawings.

Delacroix's first recorded observations on the meaning of photography for art were made in 1850 (the lacunae in his journal deprive us of knowing his reactions before 1847). They appeared in his review of Elisabeth Cavé's publication, *Drawing without a Master*. Mme Cavé, for many years an intimate friend of the painter, had devised a method by which an artist could enhance his visual memory. Here, accuracy of observation was considered essential before the 'spirit' could be allowed to enter into the creative process. By a system of copying and correcting, not unlike the technique developed later by Horace Lecoq de Boisbaudran, perceptual acuteness, it was hoped, would significantly increase.

In Delacroix's opinion it was of fundamental importance that nothing concerning his subject should be neglected by the artist. He should acquaint himself with the true character of light and shade, observe the subtle nuances of tonal recession, initiate himself into all the other 'secrets of nature'. The photograph, Delacroix believed, was a perfect vehicle for this kind of training:

Many artists have had recourse to the daguerreotype to correct errors of vision: I maintain with them, and perhaps against the opinion of those who criticize teaching methods employing tracing through glass or lawn, that the study of the daguerreotype if it is well understood can itself alone fill the gaps in the instruction of the artist; but to use it properly one needs much experience. A daguerreotype is more than a tracing, it is the mirror of the object, certain details almost always neglected in drawings from nature, there – in the daguerreotype – characteristically take on a great importance, and thus bring the artist into a full understanding of the construction. There, passages of light and shade show their true qualities, that is to say they appear with the precise degree of solidity or softness – a very delicate distinction without which there can be no suggestion of relief. However, one should not lose

sight of the fact that the daguerreotype should be seen as a translator commissioned to initiate us further into the secrets of nature; because in spite of its astonishing reality in certain aspects, it is still only a reflection of the real, only a copy, in some ways false just because it is so exact. The monstrosities it shows are indeed deservedly shocking although they may literally be the deformations present in nature herself; but these imperfections which the machine reproduces faithfully, will not offend our eyes when we look at the model without this intermediary. The eye corrects, without our being conscious of it. The unfortunate discrepancies of literally true perspective are immediately corrected by the eye of the intelligent artist: *in painting it is soul which speaks to soul, and not science to science.*

This idea of Mme Cavé's is the old quarrel between the letter and the spirit: it criticizes those artists who, instead of taking the daguerreotype as a reference work, like a kind of dictionary, make it into the picture itself. They believe they are getting much closer to nature when, by much effort, they manage in their painting not to spoil the result obtained mechanically in the first place. They are crushed by the disheartening perfection of certain effects they find on the metal plate. The more they try to imitate the daguerreotype, the more they reveal their weakness. Their work then is only the copy – necessarily cold – of a copy, itself imperfect in other respects. In a word, the artist becomes a machine harnessed to another machine.

The artist, Delacroix believed, must compromise with what is traditionally of value and not be misled by the truth. In art everything is a lie, and the facts of external reality are only a means to the greater guidance of the instincts.

Two days after the publication of his essay, Delacroix was visited by a group of acquaintances including the painter François Bonvin. It is likely that photography was discussed for they aroused their host's interest in a large number of daguerreotypes, some of the male nude, which had been taken by the artist, Jules-Claude Ziégler, once a pupil of Ingres and Cornelius. 'I will go and see him,' noted Delacroix in his journal, 'and ask him to lend me some.' It was Ziégler possibly who introduced Delacroix, about four months later, to the newly formed group which called itself the Société Héliographique, the first of its kind in France, for in the society's publication, *La Lumière*, his name is listed as one of the founding members who in addition to photographers included painters, writers and scientists, among other professions.

Delacroix does not seem to have been active in that organization at the time. But in 1853, apparently after he became better acquainted with the photographer, Eugène Durieu in Dieppe, his interest in photography increased. In February that year he sent a note of thanks to someone, probably Durieu, 'for the splendid photographic prints which I prize so highly (74, 75, 76). These beautiful examples,' he wrote, 'are treasures for the artist.' In May, using photographs given him by Durieu, Delacroix subjected some dinner guests to an interesting experiment which a few days earlier he had tried on himself:

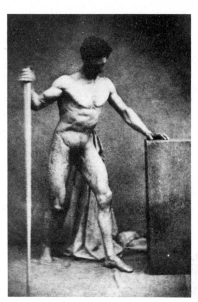

74–6. Eugène Durieu: Photographs of male nude from album belonging to Delacroix. Probably 1853

77. Delacroix: Sheet of sketches made from photographs taken by Durieu. *c.* 1854

78. Marcantonio Raimondi:
Adam Enticing Eve.
After Raphael. Early sixteenth century.

after they had studied these photographs of nude models some of whom were poorly built, oddly shaped in places and not very attractive generally, I put before their eyes engravings by Marcantonio. (78) We all experienced a feeling of revulsion, almost disgust, for their incorrectness, their mannerisms and their lack of naturalness, despite their quality of style – the only thing one could admire. Yet at that moment we could no longer admire it. Truly, if a man of genius should use the daguerreotype as it ought to be used, he will raise himself to heights unknown to us.

In October an entry in the journal reiterates the artist's conviction that photography is potentially a blessing for art. If only that discovery had been made thirty years ago, he wrote, perhaps his career would have been fuller. The information given by the daguerreotype to a man who paints from memory is of inestimable advantage.

The *genre* and history painter, Léon Riesener, was concerned with the propriety of using photographs taken by someone else and came to see Delacroix about it one evening in November 1853. He spoke of the great care with which Durieu and an assistant took their photographs, and felt that their success was undoubtedly due to the seriousness with which they were executed. He suggested that Delacroix publish his sketches as photographs. He had already thought of doing so. And then Riesener confessed that, trembling with anticipation, he had asked Durieu and his associate whether without indiscretion and without being accused of plagiarism he might use their photographs for painting pictures.

The year 1854 is perhaps that of Delacroix's greatest involvement with photography, and several sessions spent in Durieu's studio are recorded in the

journal. There, it seems, he advised and assisted his photographer friend in the arranging and lighting of his subjects. Sometimes, with the models posing for only a minute or two, both photographs and sketches were made of them. In August and September Delacroix was in Dieppe, having brought with him Durieu's photographs from which to draw. These he shared there with the painter Paul Chenavard. Deposited in the Bibliothèque Nationale in Paris is an album of thirty-one photographs which once belonged to Delacroix and which can be shown to have served the artist for several drawings and for at least one painting. Very likely these include some of the 'anatomies' which accompanied the artist on his holiday to the north coast that summer. The photographs in his album are of nude and partly draped men and women, most of them posed in a manner reminiscent of the artist's own style. It is probably useful to try to construct a provenance of that album although some of the facts in the matter are slightly obscured.

After Delacroix's death in 1863, his devoted housekeeper, Jenny (Jeanne-Marie le Guillou), sent Constant Dutilleux the manuscripts of the journal and a number of books which had been in the artist's possession. Among these volumes may have been the album of photographs for it appears to be the one referred to in Dutilleux's *notes inédites*, part of which was published in 1929 by Raymond Escholier as follows:

Delacroix admired photographs not only in theory, he drew considerably after daguerreotype plates and paper prints. I have an album made up of models, men and women, in poses which were set by him, and photographed right in front of him. Incredible things! The choice of figures, the positions, the lighting, the tension of the limbs are so extraordinary, so deliberate, that one would say of many of these prints that they had been taken after originals by the master himself. The artist was in some way the lord and master of the machine and of the subject-matter. The radiating sense of the ideal that he had, transformed the models into vanquished and dreaming heroes, into nervous and panting nymphs, at three francs a session.

After the death of Dutilleux in 1865, Philippe Burty received the artist's papers, perhaps also the album, though an inscription scribbled in it, signed 'Ph.B.69', claims that the album was purchased by the writer at the post-humous sale of the Delacroix *atelier* held in 1864, and that a 'considerable number' of pencil studies made from these photographs were found in boxes in the artist's studio. On Burty's death his papers, which included those of Dutilleux, passed into the hands of Maurice Tourneux who presented the album of photographs to the Bibliothèque Nationale in 1899.

In any case, the '*études au crayon d'après ces photographies*' described by 'Ph.B.' must include some sheets of sketches now in the collection of the Bayonne Museum (77). At least ten of the figures drawn on them are unmistakably

124

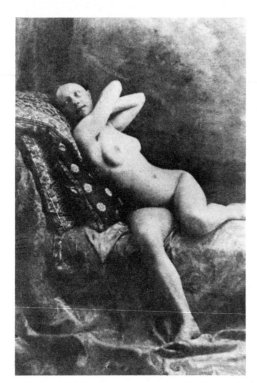

79 (*left*). Photograph of female nude from the Delacroix album

80 (*below*). Delacroix: Sheet of drawings

81 (*below left*). Photograph of female nude from the Delacroix album

82 (*below right*). Delacroix: *Odalisque*. 1857. (12 x 14 inches)

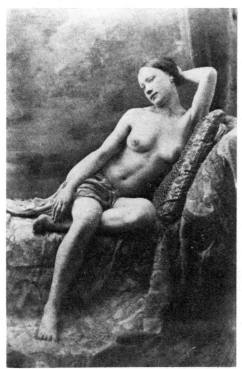

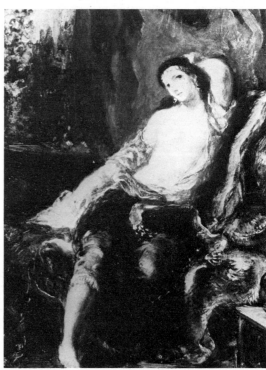

based on photographs of the muscular male model to be found in the album. The drawings are linear, and from their appearance should leave little doubt that, in this instance, Delacroix used the photographs as anatomical studies, though he may well have been intrigued by the strange tonal delicacy with which the forms are described. Again in Dieppe in October of 1855, Delacroix must have brought with him photographs like those in the album, for he wrote that he looked 'enthusiastically and without tiring at these photographs of the nude men – this human body, this admirable poem, from which I am learning to read – and I learn far more by looking than the inventions of any scribbler could ever teach me'.

Delacroix executed a small painting of an odalisque which is signed and dated 1857 (82). It depends obviously on one of the photographs in his album (81). The painting, now in the Niarchos Collection, may be the odalisque which he began in October of 1854, after his return from Dieppe that year, and which he described as being made '*d'après un daguerréotype*'. It is conceivable that tiring of the painting before it was finished (the artist wrote in 1854 of working on it a little 'without much zest'), Delacroix picked it up again three years later and completed it. The reference to working from a daguerreotype does not necessarily rule out the use of a paper print since 'daguerreotype' was then very commonly used as a generic term for photographs of all kinds.

In his catalogue of Delacroix's works, Robaut called the painting *Femme d'Alger dans son intérieur* and he made an interesting observation about it, though there was no reference to the use of a photograph: 'the nonchalance of the movement,' he wrote, 'is accentuated by the position of the legs, which have a perfectly natural air of relaxation'. Indeed, that very quality of 'naturalness' which Delacroix found so striking in Durieu, and so lacking in Marcantonio, characterizes his *Odalisque*. The peculiar, even awkward, turn of the foot with the toes splayed out in such an ungainly way, the clumsy cramping of one leg under the other, the all too natural tilt of the head and steadying of the hand makes a strange contrast with the traditional elegance of such a pose: the Delacroix kind of pose, which still emerges from beneath the photographically conditioned superficies. And, of course, these features are all to be found in the photograph. And some of its forms are so impossibly true, so naturally crude, that the artist must have altered them deliberately, elongating, for example, the foreshortened thighs, credible enough in the photograph but which would become too unbelievable in the painting.

What Delacroix wrote in his essay of 1850 is fulfilled in the small *Odalisque*: 'the daguerreotype [is] only a reflection of the real, only a copy, in some ways false just because it is so exact. . . . The eye corrects.'[34]

5. The dilemma of Realism

STYLE BE DAMNED! *VOILÀ L'ENNEMI!*

In France, between 1850 and 1859, a 'school' of Realism appeared which advocated an extreme of pictorial objectivity feasible only with the photographic camera. During the same period, photographers proposed investing their pictures with the spiritual attributes, with the subjective qualities, ordinarily associated with painting. The coincidence of those anomalous ideas was bound to upset many previously held notions about art and photography. It precipitated a flood of vituperation resulting in an inquiry into the nature of art and reality in relation to the photograph.

Gustave Courbet's calculated *pronunciamientos* about the impartiality of his vision must have served to confirm the opinions of those for whom Realism and photography were one and the same thing. 'I assure you,' the artist is quoted as saying, 'I look at a man with the same interest as I look at a horse, a tree or any other object in nature.' 'Where I place myself is all the same to me,' he declared elsewhere, 'any location is good as long as I have nature before my eyes.' Other postulations advocating the merit of the innocent eye had been made earlier by Constable, for example, at the same time by Ruskin and later by Monet. But while Constable admitted the impossibility, and even questioned the desirability, of a total disengagement between what one saw and what one knew, Ruskin and the French painters adopted a more absolute attitude. Courbet would have liked to see museums of painting closed down; Monet, to have been born blind, his sight restored later in life, in order to guarantee the complete objectivity of vision.

Though to us it is apparent that Courbet's work was more highly conditioned by convention, his eye less blind to the works of earlier masters, than his statements would lead us to believe, he was generally thought by his contemporaries to have sprung from nowhere, his style uninfluenced by any school. However much they may have disliked what he represented, both Delacroix and Ingres were struck with his ability and independent style. To Ingres, commenting on the reality of Courbet's work, may be attributed the source of that statement which was frequently encountered in the last half of the nineteenth century: *'ce garçon-là, c'est un œil'*.

Consequently, Courbet's paintings, and those of other realists, either directly or by implication, were often equated with photographs and said to be as vulgar or as ugly, as artless, as feeble, as were the images produced by the machine. The great error, his critics asserted, was to believe that veracity was truth. Art, as Delacroix insisted, was not simply the indifferent reproduction of the object but a matter of intellectual and visual refinement, often of wilful exaggeration to place the lie at the service of the truth. Courbet's critics objected to his disregard of the traditional rules of art, to his lack of propriety, to his perversion of the 'true' meaning of realism by his insistence on depicting even a stark and ugly Nature. His *Return from the Fair*, a rather innocent painting of a group of peasants and their animals, exhibited at the 1850–51 Salon was described as 'a banal scene worthy only of the daguerreotype'. His enormous canvas, *The Burial at Ornans*, which scandalized visitors at the same Salon, was likewise belittled by comparing it with a photographic image. Insulted by its commonplace subject, infuriated by its spectacular size, completely oblivious to its merits, the critic Étienne-Jean Delécluze wrote: 'In that scene, which one might mistake for a faulty daguerreotype, there is the natural coarseness which one always gets in taking nature as it is, and in reproducing it just as it is seen.'

Courbet's irrepressible bombast too must have put doubts in the minds even of those who had finally come to admire the landscape realism of the Barbizon painters and the gentle *genre* subjects of artists like Isabey, Bonvin and, later, Legros and Amand Gautier. His extension of that realism to include unpleasant and seemingly trivial subjects made his detractors shudder in anticipation of an ultimate artistic decline. The sacred edifices erected to 'Beauty' and 'the Ideal' which had so well weathered the vagaries of time and style were now threatened by the so-called cult of ugliness. Realism was the new enemy of art and it was believed that it had been nurtured and sustained by photography.

The taste for naturalism [complained Delécluze], is harmful to serious art. . . . It ought to be said, that the constantly increasing pressure exerted during approximately the last ten years, on imitation in the arts, is due to two scientific forces which are fatal in action, that is to say the daguerreotype and the photograph [i.e. on paper], with which artists are already obliged to reckon.

The intellect and the eye of the naturalist painter, he continued,

are transformed into a kind of daguerreotype which, without will, without taste, without consciousness lets itself be subjugated by the appearance of things, whatever they may be, and mechanically records their images. The artist, the man, renounces himself; he makes of himself an instrument, he flattens himself into a mirror, and his principal distinction, is to be perfectly uniform and to have received a good silver finish.

That savage sort of painting, the critic warned, results in a debased and degraded art and has been proposed, with a temerity bordering on cynicism, by M. Courbet. The principle that the exact imitation of nature is the aim of art and that the choice of subject has little importance so long as it is faithfully reproduced is exaggerated by the daguerreotype and the photograph, he concluded, added to which the indifference of the public to an elevated art has reduced art to the simple imitation of natural appearances, the sole aim of the *genre* painter.

Increasing in intensity, criticisms of that kind erupted with each subsequent Salon. Edmond and Jules de Goncourt, reviewing the exhibition the following year, felt it necessary to defend the idea of realism – to which they were partial – against artists like Courbet who professed, so they said, the ridiculous belief that *le beau c'est le laid*. Realists do not search exclusively for ugliness, they insisted. Even the public do not really demand the 'slice of life' in art. Look at their favourites in painting and literature. These were Realists and not mere copyists.

By the time of the 1853 Salon it was apparent that the threat to art came not from the Realists *per se* but from the general insinuation of the photographic image into *all* schools of painting. With remarkable perspicacity the critic Frédéric Henriet observed that though superficially there appeared to be a great diversity of styles in that exhibition, there was in fact a fundamental similarity in the mechanical manner ('*le procédé*') with which different kinds of subjects were rendered. For fifteen years, he complained, the idea of a facile, mechanistic technique had gained favour with artists; the greatest danger of techniques is that they lead one's judgement astray. Who would dare to maintain, he asked, that this mentality is not 'intimately in harmony with the spirit of an age that discovered photography'? Because of photography and its seduction of the public, Henriet believed, Courbet and the school of Realism triumph without any serious opposition. Whichever way I turn my eyes, he cried, I see nothing to threaten Realism. There are those who protest against it, but only as a rival school. Their own work, that of Gérôme, Hamon and Picou, for example, though in the 'neo-Greek' or 'exotic idealist' style, is equally concerned with illusion, with figures painted like sculpture, and it lacks the liveliness or imagination to be found in the work of their master, Ingres. The form of these pictures has little in common with their subjects. These artists may represent an ideal world in their paintings but they render it more or less as it might have been found in real nature.

With the 1853 Salon Courbet's reputation as a purveyor of ugliness had become firmly established. Artists apparently aspiring to nothing beyond the camera's capacities were inevitably to be compared with its most abominable products. For notwithstanding the lofty aims and the superb products of

talented photographers, the photograph had become a symbol of vulgarity, a weapon with which to slander the advocates of Realism, in literature as in art. The hilarious buffoonery and the vengeful recriminations which accompanied each exhibition of Courbet's work are well known. And behind every accusation of ugliness, with each reference to varicose veins and nudes as hefty as Percherons, lurked the irrepressible association with the photographic image.

Rather than producing a truthful image, wrote Henri Delaborde in 1856, photography gives us a brutal reality. By its own character it is the negation of sentiment and of the ideal. It produces sad effigies of human beings, without style and resulting in what today is called Realism. Its vulgar images seduce many people. Its application to art is becoming more widespread and though photography is of service to painters its images must never be considered absolute types.[35]

NUDES AND OBSCENITIES

Often in the literature of the nineteenth century references can be found criticizing some subject or model, as did Holman Hunt in 1854, for being 'as ugly as a daguerreotype'. It is recorded that a duel was considered when Clésinger's *Femme piquée par un serpent* (Salon of 1847) was derided as being a daguerreotype in sculpture (see note 34). Even a daguerreotype of a group of people drinking in a restaurant was said to have invited public protest because of the commonplace realism of the subject. The greatest obscenities, to be sure, were photographs of nudes. These outraged public notions of rectitude to such an extent that in 1861, in England, a court case was initiated because 'provocative and too real' photographs had been displayed in public places. An instructive reference was made in 1864 in which, it was said, the erotica of Japanese art were easily surpassed by that of the West where photographs circulating in Paris, London and other places would easily take the palm. Not infrequently, notices of 'immoral' photography appeared in both art and photographic journals about 1860. 'Obscene photographs' in Britain were denied the privilege of the open post. In France, Disderi, in 1862, complained of the manufacture of obscene photographs. He described 'those sad nudities which display with a desperate truth all the physical and moral ugliness of the models paid by the session . . . that unwholesome industry which occupies the courts of law' rather than being dismissed simply as bad art. And yet, it seems, the art-loving public in the last two or three decades of the nineteenth century was not particularly distressed by the substantial yearly quota of erotica which crowded the walls of the Salon. For however suggestively disposed, however inventively exposed, propriety was satisfied so long as pornography was made palatable by the convenient remoteness of the antique, of history or some other exotic setting.

Despite the protests of the virtuous, photographs of nude subjects proliferated from the early 1850s (though examples are known as early as 1841), providing, equally, information for artists and pleasure for voluptuaries. Discreetly, they were called Académies, Études Photographiques, Études Académiques and Services des Élèves de l'École des Beaux-Arts. They could be purchased cheaply, thus reducing models' fees. They became permanent and readily accessible reference material in the painters' studios. Like Delacroix, though not always with his pertinent reservations, many other artists were served by them. In his instructive book on photography in 1856 Ernest Lacan suggested that by utilizing such photographs the artist 'is able to amass in his files Académies giving all the positions, all the characteristics, all the diversities of nature'.

Among the photographers who were occupied in producing nude studies for the *ateliers* of Paris was Julien Vallou de Villeneuve. As a painter and lithographer in the 1820s and 1830s he enjoyed an international reputation through his large lithographic productions of *Les jeunes femmes*, a series of anaemic, erotic scenes of feminine intrigue and despair, of would-be lovers hidden in boudoirs and other piquant episodes in the daily life of the young female. From about 1842 Villeneuve took up the camera, more or less continuing in the same *genre* his subjects in costume or in the nude. This special reference to Villeneuve is made because it is quite likely that Courbet knew and used his photographs

83. Courbet: *L'Atelier.*
1855 (detail)

84. Villeneuve: Nude study. Photograph.
Bibliothèque Nationale, Paris.
Acquisition date, 1854.

85. Courbet: *La femme au perroquet*. 1866

86. Nude study. Photograph, anon. n.d.

in the 1850s. Introduced to these, it appears, in 1854 by his friend and patron from Montpellier, Alfred Bruyas, the artist, in November that year, asked Bruyas to send him 'that photograph of the nude woman which I have mentioned to you. She will stand behind the chair in the middle of my picture' he explained, referring to his large painting, the so-called *Atelier* of 1855. This photograph is probably one of a series taken by Villeneuve in 1853 and 1854. The pose, with the drapery held to the breast, is close to that of the painting and the features of the head, the hair style and the characteristic proportions of the body in both painting and photograph are with little doubt those of the same model (83, 84).

Other documents and visual evidence point to Courbet's use of photographs. In Frankfurt (1858–9) the artist showed his work to Otto Scholderer who then wrote to Fantin-Latour describing Courbet's small *Venus* as a 'nude woman reclining on a kind of bed, with a view through a window on to a landscape; he painted it from a photograph'. Other nudes by Courbet, his *Woman with a Parrot*, for example (85), and the notorious *Bather* of 1853 (87), can be related to photographs which are very much like the paintings in composition, in the naturalism of even the somewhat affected poses and in the impersonal tonal rendering of the figures (86, 88). Though, admittedly, the possibility of finding

87. Courbet:
Les Baigneuses. 1853 (detail).

88. Villeneuve: Nude study.
Photograph. Aquisition date, 1853

fortuitous similarities here is high, the photographic appearance of many of Courbet's paintings and the frequency with which he is known to have employed photographs cannot be overlooked.

In its rendering of pose and gesture photography offered the first comprehensive alternative to forms fixed by antique tradition. Despite the fact that in posing their subjects photographers were as much governed by conventional criteria as were painters, the inevitable vulgarities of real life – the inelegances, the misproportions, the coarse blemishes – ludicrously asserted themselves on the sensitive plates. The crudities of actuality in photographs of nudes especially did not blend very elegantly with the antique, and photographs of this kind were an effrontery to men and women of good taste.

To artists like Delacroix and Courbet, photographs of nudes were neverthe-less invaluable for discovering some of the essential virtues of naturalism, and probably in the case of Courbet they produced a ready-made means of con-founding the widespread preoccupation with Classical Antiquity. For notwith-standing his bombastic proclamations in the name of Realism, a kind of obtuse antiquity, despite its capacious buttocks and dimpled thighs, is still apparent in the poses and gestures of his colossal Aphrodites. As in Delacroix's *Odalisque*, the rather crass intrusion of photographic naturalism on the underlying lyrical conception of Courbet's paintings is quite apparent. What, I think, was so annoying to Courbet's critics was not the *absence* of the Ideal in his work, but its *presence*. When Louis Napoleon thumped the *Bather* on the rump, it may not have been done because she was nude, nor even because her gigantic posterior and other proletarian attributes were visually distressing. She was spanked by the outraged Emperor because, nude *and* proletarian, she was masquerading as a nymph. Almost always, Courbet's nudes assume attitudes derived from antique conventions; though they are never garnished with the obvious archaeo-logy of his Neo-Classical contemporaries, their settings are no less traditional. The degradation of the Ideal was guaranteed by coupling it with the real: with vulgar photographic naturalism. One suspects that this irreverent means of corrupting a sacred tradition, the awkward miscegenation of the synthetic and the real, was quite deliberate on the part of the artist. In nineteenth-century terms, Courbet's sacrilege was tantamount to painting a moustache on the *Mona Lisa*.[36]

OTHER PHOTOGRAPHS USED BY COURBET

Photographs also served the artist for some of his portrait paintings and, in the case of landscape, one example at least can be shown to have been based on a photograph. In a letter to the critic Jules Antoine Castagnary the artist requested photographs of Pierre-Joseph Proudhon, after the philosopher's

death, to assist in the completion of that abortive painting of Proudhon and his family; Courbet later intended utilizing another photograph of Proudhon to illustrate the frontispiece of a special edition of the Socialist journal *La rue*, but the issue was suppressed by the government. In the artist's last years, during his exile in Switzerland, one of his canvases (dated 1874) of the Château of Chillon was undoubtedly painted from a photograph taken earlier, in 1867, by Adolphe Braun. A comparison shows the painting to be executed with very much the tonality of the photograph, from exactly the same viewpoint. It describes the forms of trees and embankment as they were in 1867, in the Braun photograph, and not as they are later shown to be in Courbet's other paintings of the same subject executed probably *in situ* (89, 90). Apparently Courbet had no mis-

89. Adolphe Braun:
Le château de Chillon.
Photograph. 1867

90. Courbet:
Le château de Chillon.
Signed and dated 1874.

91. Gustave Le Gray:
Sky and Sea.
1860 (photograph)

92. Courbet:
Seascape. n.d.

givings in employing those dreaded vulgar images which his paintings were
said so much to resemble. Apart from the obvious photographic form underlying
the bravura surface of Courbet's land- and seascapes, many of them are in
subject and composition remarkably close to photographs taken in France from
about mid century. Gustave Le Gray's well-known camera views of the south
coast, like his *Grande Vague* of 1857, with their strict horizontal compositions,
crashing waves and large areas of intensely dramatic skies filled with dark
ominous clouds, anticipate the paintings of Courbet[37] (91, 92).

Apart from the fact that Courbet made use of photographs and that in several respects his work contains characteristics attributable to photographic images, what ultimately is of more importance here is why realism was said to demean the spirit, how photography contributed to such an attitude and what arguments the Realists offered in their own defence. To the literary exponents of Realism fell the task of disproving the accusations against them; of convincing their critics that there was a special virtue in representing nature as it really is rather than as it was thought to be or ought to be. No artist, they insisted, and least of all Courbet, could ever completely suppress his spirit and turn himself into a machine.

In this way the writer, Champfleury, for a time the leading advocate of Realism, defended that school against attacks made during the 1853 Salon. He took issue with any criticism that automatically attached the label 'daguerreotype' to any work of art or literature which was executed with a high degree of truthfulness. He described an artist whose excellent studies from nature were to no good purpose because, in his studio, he used them to paint a finished, idealized landscape: 'if that man had reproduced nature in his pictures, such as he had reproduced it in his sketches, he could certainly have become a painter'. The daguerreotype was a machine, insisted Champfleury; the artist is not nor could he be. 'The reproduction of nature by man will never be a reproduction or an imitation, it will always be an interpretation.' To prove that this was so the writer proposed a rather improbable though instructive situation in which ten photographers and ten landscape painters were engaged in making pictures of exactly the same view. On comparing the completed photographs, one finds, he wrote, that they have copied the landscape exactly, 'without any variation among them'. On the other hand, the paintings finished, 'not one resembled another', though each artist had tried to copy the scene with the greatest exactitude possible. Each of the paintings, submitted Champfleury, reflected the particular mood and temperament of the artist, and accordingly they were different, one from the other. 'Thus,' he concluded, 'it is easy to affirm that man not being a machine, cannot render objects like a machine.' When the Realists are accused of lacking imagination they are wrongly accused; their works cannot with justice be called photographic!

Edmond Duranty, like Champfleury, believed that the deliberate seeking after style, after imagination and the Ideal in art was a kind of aesthetic villainy. It was far more admirable, he said, to approach nature with as much impersonality as possible. Art for the Realist, he wrote in his short-lived periodical, *Réalisme*, in December 1856, was an actual, a visible, a palpable thing. One should not paint what one could not see. Duranty acknowledged Champfleury's

ideas, reiterating the principle that however unpremeditated the artist's approach, he could never be equated with a camera, and in the face of nature his particular temperament was always somehow expressed.

Proudhon's defence of Realism, and what may have been the first comprehensive Socialist theory of art, was made about 1863 in his book, *Concerning the Principles of Art and its Social Destiny*. More detached, less passionately involved than either Champfleury or Duranty, he not only countered the calumny of the daguerreotype label in respect of Courbet's paintings, but he also insisted that photography itself was capable of expressing the Ideal. It was impossible, he declared, for either painters or photographers not to interpret their subjects, not to idealize them each according to his predilections. Everything is interpretation. The terms realism and idealism are inseparable in art. If one thinks that the aim of the artist is to reproduce the material appearance of things, an imitation of nature, a copy, a forgery, it would be better that the artist abstain. Artistic expression is the excitement to a sensitivity which inspires idealism. This is the aesthetic faculty. In a portrait, he wrote, one wants an accurate resemblance, but one requires as well the character, the thought habits and the passion of the subject: 'those things which art will give you better and more surely than the daguerreotype which can only seize a face instantaneously and consequently with the minimum idealization'.

Later in the book Proudhon reiterated his theme. A portrait, he said, ought to have both the exactitude of a photograph and, more than that, the intimate thought characteristic of the subject.

The photographic image is a crystallization made between two pulse beats; the portrait made by the artist in a series of sittings, by long observation, gives one weeks, months, years of the life of his subject. A man is much better known through painting than through photography.

Defending Courbet's *Return from the Fair*, the painting accused of being as banal as a daguerreotype, Proudhon praised its truthfulness and the way in which it communicated the character of its subjects: 'in its entirety and in its details the scene is so true, and so ingenuous, that one is tempted to accuse the painter of a total lack of invention and of having produced a daguerreotype for a work of art'. But far from being that, he continued, it was a profoundly observed picture, and one of Courbet's best. Because the painter was in a better position to know and study his subject, insisted Proudhon, he should therefore be able to surpass the camera. But, he concluded, a photograph would be preferable to a so-called Realist painting which was only a simple imitation of the subject and the photograph would only cost fifty centimes.[38]

The year 1855 was an auspicious one both for Courbet and for photography. Under the banner, or the label, of Realism Courbet's first independent exhibition was held; the earlier Société Héliographique became the new Société française de Photographie with the main purpose of establishing photography as an art. Just as Courbet held his private exhibition as a declaration of artistic intentions and as a protest against the exclusion of some of his works from the Salon, the photographers on their part organized a large exhibition asserting their position in the hierarchy of art, attempting to overcome the resistance to their works being shown in the official Salon. Neither the Realists nor the photographers were unaware of the significance of such a portentous conjunction.

In the wake of these events came swells of protest against Realism and, as before, the usual derogatory references to photography. Having expressed their disdain for Courbet's kind of realism a few years earlier by characterizing the photographer as a blind man with a camera 'who stops to sit down [and take a picture] wherever there is a dunghill', the Goncourt brothers now describe a deaf man who replies to the Realist manifesto: 'To be sure . . . the daguerreotype is a fine invention! The realists of the good old times, the Ostades and the Teniers, what a mistake they made without knowing it! If they had thought of christening their works with a scholarly label, what a tough time the humble LeNains of our century would have to build up their reputations.' These critics, having already shown themselves in favour of realism, resented the exaggerated form it had taken and the noise that was made about it by Courbet and his band of '*enfants terribles du matérialisme*' as they were described. They chaffed at the presumptuous oratory of the Realists in which it was pronounced that they were the guardians of real and truthful art. The Goncourts accused the Realists of claiming no more than '*je suis chambre noire*'. Yet it was too facile to lay the blame for all the photographic mediocrities which occupied the walls of the painting exhibitions each year on Courbet and his followers. However convenient it was to accuse photography, *ipso facto*, of vulgarity and of being the root of all this evil, such denouncements tended to obscure the larger issues at stake.

It is not surprising then that photographers who were trying to enhance their reputations and that of the photographic art in general should begin to organize in their own interests. The members of the Société française de Photographie included some very outstanding and talented personalities of the day, many of them artists with the brush as well as with the camera. Among them were a score of painters who were regular contributors to the Salon exhibitions; Delacroix being the most distinguished. Additionally, the photographers Eugène Durieu

(President), Nadar, Bayard, Blanquart-Évrard, Cuvelier; the writers and critics Benjamin Delessert, Count Léon de Laborde and Théophile Gautier could be counted in the Société's membership in 1855 and 1856 which increased at a prodigious rate in the years following. Champfleury's name, included among those belonging to the earlier Société Héliographique, is now conspicuously and for obvious reasons absent.

Much of the initial effort of the new photographic society was devoted to organizing the large exhibition of photographs to be held in June and July (1855) and to establish rules for the entrants. These 'immigrants' to the Fine Arts, zealously loyal to artistic conventions, not content even with the standards of propriety which governed the Salon exhibitions, inserted a clause in their rules which stated that 'nudes in general, and without exception, will be refused'. To enhance the dignity of photography and calling to mind the denunciations of Caravaggio's paintings and Ruskin's disapproval of Constable's subjects of 'a low order', the photographic jury had rejected a picture of a man cutting his corns. Furthermore, photographs which were either coloured or obviously retouched were also to be excluded: 'works that are mixtures of photography and painting are as fatal to photography as they are to painting'.

Nadar addressed a letter to the Société on 21 November 1856 indicating that photography had not been included in the coming Salon of 1857. Durieu reminded those present that it was not the first time the subject of photography's place in the Salon exhibitions had been raised. In 1850, for example, his fellow member Gustave Le Gray sent the jury of the 1850–51 Salon nine photographs: landscapes, portraits and reproductions of works of art. The first issue of *La Lumière* (9 February 1851) had carried the story. The jury was embarrassed and unable to classify these photographs; they could not decide whether they were to be called works of science or of art. They were finally designated *livret* and exhibited with the lithographs. Durieu felt that the question of photography in the Salon should be pursued, though there seems to have been some objection from those who preferred that the Société hold its own separate exhibitions. A committee composed of Delacroix and six others, including Gautier, was chosen to prepare and submit a report. In 1857 the photographic exhibition was not held in the Palais des Champs-Elysées as had been hoped but in the large galleries at 35 boulevard des Capucines which later became the studios of Nadar and which, in 1874, were used by the Impressionists for their first independent exhibition.

The 1855 exhibitions of Realism and Photography, held in the general excitement of the Paris world fair, provoked a nastier kind of criticism, and on a larger scale, than had any earlier one. The *Revue universelle des arts* published an article in which a specious attempt to distinguish between a photograph and

a work of art was made. The author proffered the well-worn arguments. A photograph is not a work of art. It has no style. The artist selects, rearranges and brings his inspiration into play; he uses his imagination: 'the daguerreotype, armed with all its mechanical perfection, will never triumph except over mediocre painters devoid of all inspiration'. But the photographers were not without their defenders. The painter Jules Ziégler, for example (whose photographs had interested Delacroix), wrote a *Compte rendu de la photographie à l'Exposition Universelle* in which he not only insisted that photography could 'claim a place among the arts of imitation, just as well as lithography and other forms of graphic art' but that photographs could reflect *l'esprit humain* and were not to be relegated solely to the role of reporting or copying. Henri Delaborde, antipathetic towards photography, challenged Ziégler, insisting that ingenious as photography was, it could not express sentiment and the personality of the photographer.

The proponents of artistic photography found it expedient to deprecate not only the Realist painters but also those photographers who fell into the error of producing purely imitative pictures. With the help of the painter Philippe Rousseau and Count de Laborde, Durieu compiled a report of the 1855 photographic exhibition. Photography had risen in the estimation of many, he wrote:

As it reproduces pictures of nature with extreme accuracy, and often with a perfection and finish that the cleverest draughtsman would not know how to achieve, those who see in art only an imitation of nature have had to accept photography as the final and most complete expression of art. Many, therefore, have allowed themselves to be seduced by this idea and applying themselves to the mechanical side of reproduction, they believe that they have in photography reached the extreme limits of perfection, when they have managed to fix on the paper a sharp, clear image, finely detailed, of some scene. The more exact the copy is, the more it seems to them they have succeeded.

Of course, continued Durieu, this is a fallacious approach.

Subjectivity, he believed, was essential to art. Art demands the sign of the hand as in the work of the Masters, he declared. Public opinion protests against photographic art. For photography, as for other 'drawing processes', it is the communication of the sentiment which an aspect of nature excites in us that counts. Imitation is neither the means nor the aim of art. Durieu believed that the photographer as well as the painter could choose a viewpoint, could concentrate interest on the principal subject, control the distribution of light and in other ways be as selective as any other kind of artist: 'it is by those means that photography will take a more and more elevated position. The camera is not

a simple optical contraption which responds mechanically to the first comer who cares to try it out, but an instrument that the photographer can direct and control according to his personal feelings.'

Finally, Durieu described in glowing terms the *épreuves artistiques* of the photographic exhibition, which he believed demonstrated the fulfilment of these principles. He compared some of the photographs with works by earlier Masters : the figures in landscapes by M. Pesmes resembled the work of Watteau; the compositions of M. Humbert de Molard recalled Teniers and van Ostade. Indeed, he wrote, many of the photographs on exhibition were executed by artists who also worked in other media : Adam Salomon (sculptor), Bertall, Carjat and Nadar (caricaturists), Alophe, Berne-Bellecour, De Lucy, Philippe Rousseau, Le Gray and Belloc (painters).

Count de Laborde was of an even more extreme opinion. In the following year he declared that photography would replace realist art. Though he was in sympathy with those, like Delacroix, who believed that used judiciously photography could have an excellent influence on art, he pointed out the great lesson that must be learned from it : photography would be responsible for the return of art to the 'higher regions of the mind', art's true domain. As for realism : 'When one can make, after the first session of instruction, or when one can buy for a few pennies, inimitable imitations of all scenes of nature, clever men who have a propensity for realism will relinquish their struggle with the machine; they will thenceforth struggle only with the ideal.'[39]

93. Nadar: *Photography Asking for Just a Little Place in the Exhibition of Fine Arts.* From *Petit Journal pour Rire.* 1855

6. The power of photography

THE EXHIBITION OF 1859

In 1859 the French government finally yielded to the consistent pressure applied by the Société française de Photographie and its supporters. Authorized by the Minister of State and the Imperial Director of Fine Arts a Salon of photography would now form part of the yearly exhibitions held in the Palais de l'Industrie. Though with its own entrance, the photographic Salon occupied an area *tout à côté* that reserved for painting and sculpture. According to a contemporary account, the attendance figure was about 20,000. Nadar, probably the most effective force in engineering photography's new triumph, symbolized the victory in a caricature showing anthropomorphic forms of a camera and palette, their arms linked in friendship, described by the legend: 'Painting Offering Photography a Place in the Exhibition of Fine Arts' (95).

94. Nadar: *The Ingratitude of Painting, Refusing the Smallest Place in its Exhibition, to Photography to whom it Owes so Much.* From *Le Journal amusant.* 1857

95. Nadar: *Painting Offering Photography a Place in the Exhibition of Fine Arts.* Paris 1859

With 1,295 entries, some from as far away as Brazil and Palestine, the exhibition was eminently successful and the reviews more than sympathetic. The photographs were described as though they were works executed by hand, inevitably compared with paintings, and the same standards of appraisal applied to them. Decamps and Fromentin could not have been very happy with Burty's favourable association of photographs of Algerian scenes with their own canvases hung in the adjacent Salon. And a landscape photograph by M. Margantin, noted the same critic, had the 'elegant look of a Théodore Rousseau'. Another writer found certain similarities between photographs and portraits painted by the academician Flandrin, Hébert and others. M. Graham's *Voyage à Jérusalem* was identified with the pictures of his friend Holman Hunt. The photographs were praised for their individuality and for their many distinctive styles. Here was proof, it was said, that the camera was not merely a simple mechanism. Even if photography was not a complete art, wrote Burty, the photographer certainly had the right to be considered an artist.

On the other hand, undoubtedly aggravated by the new advance made by photography, criticisms of the photographically conditioned paintings exhibited that year were of the utmost severity. Describing the successful penetration of the new art into the aesthetic sanctuary, Ernest Chesneau scolded painters for not acknowledging their debt to the camera, especially when their pictures so clearly advertised the fact:

This ingratitude is obvious when one knows that the majority of painters today use photography as their most precious aid. They won't deprive themselves of it. I find the proof of this use in the general toning down of the colour range during the last few years.

If painting has lost in brilliance, in strong contrasts and violent effects, wrote Chesneau facetiously, it has gained in truthfulness.

With a little practice the eye recognizes the passages taken from photographs in most landscape paintings and sees that the artist has copied scrupulously from the daguerreotype image, or that he has simply borrowed the backgrounds or the foregrounds – foregrounds above all, that reef on which fashionable and lazy painters perish.

'Down with corrupt art!' he decreed.

But of all the criticisms of photography's malignant influence on art, none was so scathing, or so foreboding, as that which appeared in Charles Baudelaire's Salon review of 1859. Like an avenging angel he swooped down upon the artistic sinners of the day, reproaching them for their small-mindedness, for their preoccupation with technique and blind love of nature. Deploring the state of French painting with its abominably sentimental, miserably philosophical,

irritatingly witty titles like *Love and Rabbit Stew* (*Amour et Gibelotte*) or *Flat to Let* (*Appartement à louer*), Baudelaire saw the inanity of attaching such trifling appendages to what might otherwise have been passable paintings. If the artist has stupefied the public in this way, the public in turn has paid him back in similar coin:

In these lamentable days a new industry has arisen, which contributes not a little to confirming stupidity in its faith and to ruining what might have remained of the divine in the French genius. This idolatrous crowd postulates an ideal worthy of itself and appropriate to its nature, that is perfectly understandable. As far as painting and sculpture are concerned the current credo of the sophisticated public, above all in France . . . is this: 'I believe in nature and I believe only in nature. . . . I believe that art is and cannot be other than the exact reproduction of nature (a timid and dissenting sect wishes that repugnant natural objects should be excluded, things like chamberpots or skeletons). Thus the industry that could give us a result identical with nature would be the absolute form of art.' A vengeful God has granted the wishes of this multitude. Daguerre was his messiah. And now the public says to itself: 'Since photography gives us all the guarantees of exactitude that we could wish (they believe that, the idiots!), then photography and art are the same thing.' From that moment squalid society, like a single Narcissus, hurled itself upon the metal, to contemplate its trivial image. A madness, an extraordinary fanaticism, took possession of all these new worshippers of the sun. Strange abominations appeared. In arranging and grouping together buffoons male and female, tricked up like butchers and washerwomen in the carnival, in begging these heroes to be so good, during the time necessary for the operation, as to hold their smiles for the occasion, the photographer flatters himself that he is rendering scenes of ancient history, tragic or noble. . . . Shortly after the rise of photography thousands of eager eyes were glued to the holes of the stereoscope as if gazing through the skylight to infinity. The love of obscenity which is as active in the natural feelings of man as self-love did not allow so splendid an occasion of satisfying itself to escape. And let it not be said that children coming out of school are the only ones who take pleasure in these follies; they are the craze of society. I have heard a fine lady, a lady of high society, not my society, reply to those who discreetly hid such pictures from her, taking it upon themselves to be modest on her behalf: 'Keep passing them; there is nothing too strong for me.' I swear that I've heard that but who would believe me? . . . As the photographic industry was the refuge of all *peintres manqués*, of too slender talent or too lazy to complete their studies, this universal craze bears not only the mark of blindness and imbecility, but also has the flavour of vengeance. That such a stupid conspiracy, in which one finds as in all others, evil-doers and fools, could succeed in an absolute fashion, I do not believe, or at least I do not want to believe; but I am convinced that the ill-applied progress of photography has contributed much, as do indeed all purely material advances, to the impoverishment of French artistic genius already so rare. Modern stupidity can well groan and belch up all the rubbish and vomit out all the indigestible sophistry that a recent philosophy has stuffed us with from top to bottom. All that is going to collapse because industry, in breaking through into art, has become its most mortal enemy and the confusion of art and industry impedes the proper functioning of both. Poetry and

progress are two ambitious creatures who hate each other instinctively. And when they meet on the same road one of the two must give way to the other. If photography is allowed to stand in for art in some of its functions it will soon supplant or corrupt it completely thanks to the natural support it will find in the stupidity of the multitude. It must return to its real task, which is to be the servant of the sciences and of the arts, but the very humble servant, like printing and shorthand which have neither created nor supplanted literature.

Following this magnificent philippic Baudelaire enumerated the proper functions of photography: for record-making, as a note-taking tool and for scientific investigation. But if photography is allowed to encroach on the domain of the impalpable and the imaginary, he insisted, on all that is of value because man puts his soul into it, then we face a great misfortune! From day to day art loses its self-respect, prostrating itself before external reality, and the painter becomes more and more inclined to paint not what he dreams, but what he sees. That was probably one of the most significant and influential documents in the critical literature of the nineteenth century. In writing it, in giving voice to an anti-naturalist movement, Baudelaire was acting in direct consequence of the new and powerful position photography had assumed in the world of art, symbolized by its entrance into the Salon.

Whether or not Delacroix was motivated by his friend's savage denunciation of photography when he wrote his essay, 'Realism and Idealism', is not known, but there is every likelihood that the stimulation came from the general preoccupation and the heightened misgivings that year about photography and its relation to art. But unlike Baudelaire, and consistent with his earlier beliefs that, if used sensibly, photography could be an asset to painting, Delacroix again tried carefully to explain the pitfalls of photographic form:

When a photographer takes a scene, you never see more than a part cut out of the whole view: the edge of the picture is as interesting as the centre. . . .The subordinate parts are as dominant as the main subject. One must make more allowances for the distortions in a photographic reproduction than in a work of the imagination. The most striking photographs are those in which the very imperfections of this medium for giving a completely exact rendering, leaves some resting places for the eye which allows it to focus on a small number of objects only. If the eye had the perfection of a magnifying glass, nature would become unbearable: one would see all the leaves on a tree, all the tiles of a roof and on those tiles the mosses, insects and so on. And what do we make of the startling appearance of true photographic perspective, defects perhaps less shocking in landscape where areas in the foreground can be enlarged, even disproportionately, before the viewer will be as upset as in the case of the deformation of human figures? The obstinate realist will therefore rectify in his picture this authentic perspective which falsifies appearances by being correct.[40]

Every subsequent Salon exhibition in the next decade, at least, provoked some response to the irritating question of art and photography. In his *Abécédaire du Salon de 1861*, Théophile Gautier pointed out the extent to which photography had conditioned painting by suggesting facetiously that the Salon jury should have awarded a decoration to photography. Commenting on the paintings of Charles Nègre, Gautier observed:

one can guess from the crispness of the details, from the mathematically correct placing of the shadows, that he has taken the daguerreotype as a collaborator. The daguerreotype, which has not been named and which hasn't received any medal, has none the less done much work at the exhibition. It has provided plenty of information, spared many models from posing, furnished lots of accessories – settings and draperies – so that all that was necessary was to copy them in colour.

Armand Gautier, a friend of Manet and Fantin-Latour, he noted, had even given his portraits the peculiar format of the photographic *carte-de-visite*. Auguste Bonheur, history painter and brother of Rosa, had produced some absolutely *trompe-l'œil* effects duplicating the three-dimensional illusionism of the stereoscope. Penguilly-l'Haridon's *Les Rochers du Grand-Paon*, the writer observed, had been executed with the exactitude of the daguerreotype, the scene reproduced with scrupulous truthfulness.

Photographs taken of the exhibition by Richebourg amply confirm Gautier's criticisms. The extreme realism of the many battle paintings exhibited, some of gigantic dimensions, authentically rendered to the last man in the regiment, was caricatured by Nadar. Several are shown on one wall with the smoke of battle rising out of them and drifting across the room (96, 97).

Writing in 1864, Paul Huet decried the pernicious practice of copying from photographs and the high premium placed on the exacting detail of the 'daguerreotype'. In his notes, *On Painting after Nature*, he attacked the predilection of painters for minuscule detail:

many artists are pretentious enough to reproduce nature exactly, thus they lack a sense of what is genuinely natural. . . . The daguerreotype has troubled a lot of heads: nothing is more false nor more dangerous than the extreme perfection of this instrument. It can be used for reference where a detail is concerned, but one ought to guard against allowing oneself to be seduced by this impossible rendering, this false perspective. One should pass the magnifying glass over to science; the eyes are sufficient to appreciate the beauties of the landscape. There is something in an artist's work which no instrument can give. No matter how perfect a photograph, one will never find in it the quivering hand that drew Rembrandt's etchings, nor even a Gothic church by Bonington.

Art, continued Huet, demands imagination and invention. Is nature too great? Is it photography one should copy? Art has no longer to do with feeling; it is

96. Nadar: Satire on the battle paintings shown in the Salon of 1861 (lithograph)

97. Yvon: *Solferino*. Salon of 1861 (detail)

a *tour de force*. He warned that the man jealous of the machine becomes a machine and ultimately, dispensing with studies from nature, paints only for the connoisseurs with their magnifying glasses, whose appreciation of art consists mainly in the assiduous examination of paintings in a search for blemishes. This type of art, Huet declared, is not the art of the people but that of the 'awakened *parvenu*'.

In 1866, when Émile Zola wrote *Mon Salon*, his first review, his reaction was much the same as Baudelaire's in 1859. Reality must be subordinated to the temperament, he insisted: 'Art is a human product.' Critical of François Bonvin's excessive meticulousness in the portrait, *La Grand'maman*, Zola accused the painter of loving truth too much.

The individual element, man, is infinitely variable; as much in his creations as in his temperaments. If temperament had not existed, all paintings would have of necessity to be simple photographs.

In his subsequent Salon reviews he deprecated the 'mediocrities' which persisted in each yearly exhibition and the impoverished adherence to the exact reproduction of nature. As Baudelaire had, in 1846, criticized Horace Vernet for having a 'memory like an almanac', so Zola found fault with Vernet's 'imitative faculty'. In his Salon review of 1867 he reiterated his views attacking, it may be recalled, Théodore Rousseau whose ideal, he said, would have been a mere coloured photograph.

Charles Blanc, the editor of the *Gazette des Beaux-Arts*, in *Grammaire des arts du dessin* (1867), attempted to dispel what he believed to be the prevailing notion that good art and fidelity to nature were synonymous. Writing of the drawing of gestures and moving forms, he asked:

What is drawing? Is it a pure imitation of form? If it were that, the most faithful of drawings would be the best, and consequently no other copy would be preferable to the image fixed on the daguerreotype plate or traced mechanically or drawn by means of the diagraph. However, neither the diagraph, nor tracing, nor the camera, will give you a drawing comparable to that by Leonardo, Raphael or Michelangelo.

Drawing is not a simple imitation, he insisted, a mathematical copy conforming to the original, an inert reproduction. Drawing is an expression of the spirit, of a thought and of a feeling, and is superior to literal truth.[41]

THE MAYER AND PIERSON CASE

By this time, almost every critic of note had shown some concern for the problematical question of art's relation to photography. In almost all cases it was made clear that the province of the artist was somewhere in the realm of

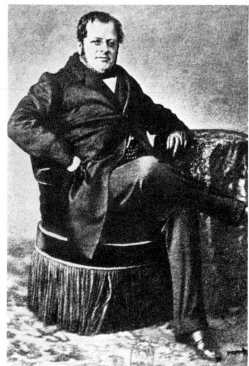

98 and 99. Mayer and Pierson: *Carte* photographs of Lord Palmerston and Count Cavour. 1861

the spirit, while that of the photographer was more in the world of reality, in objective nature. But photographers certainly were not going to forfeit their hard-won position. They too, as has been seen, believed themselves capable of transmitting imagination and feeling through their pictures. For photography to be considered an art it became necessary to settle the question of whether or not it was possible for the photographer to manipulate his medium in the way that a painter could his. To what extent was it within the photographer's power to control the light, organize the composition, elaborate or suppress parts of his subject as his thoughts and his feelings dictated? To what extent could he alter natural appearances? It was often stated that the photograph was incapable of poetry, blind to the world of the spirit, as Charles Blanc believed. Could the photographer separate what was beautiful from what was common? The accusation that photographers were not able to produce genuine works of art was often disputed, and not infrequently by artists themselves. Menut-Alophe, for example, who had once produced lithographs for *Le Charivari*, and who had become a photographer, wrote a brief essay in 1861 entitled *Le passé, le présent et l'avenir de la photographie*, in which he claimed photography was an art, though he carefully

distinguished between the artist-photographer and the mechanic. The feelings of the photographer, he pointed out, could be translated on to the print as he wished, just as the artist could convey *his* feelings in his pictures.

This question became the central theme in an important case in the French courts in the years 1861 and 1862. The photographers Mayer and Pierson had accused another photographic team, Betbeder and Schwabbe, of pirating their prints of Lord Palmerston and Count Cavour (98, 99). Pictures of famous people often guaranteed a lucrative return to the photographers, and the plaintiffs therefore claimed the protection of the French copyright laws of 1793 and 1810. Since, however, these applied only to the arts, photography had first legally to be declared an art before it could be protected. This, Mayer and Pierson probably thought, would automatically be the case; but their optimism was premature. The court's first decision went against them. This was on 9 January 1862, and by 10 April they were once more before the Imperial Court with their appeal against the first decision. This was undertaken by their attorney, M. Marie, whose presentation not only resulted in the establishment of a legal description of the new art, but provides us with an excellent aesthetic barometer of the period.

Is photography an art? he asked. Is it true that in these works the instinct, sentiment, taste and love of the artist are without purpose? Can a mechanical procedure alone produce these effects?

What then is art? Who will define it? Who will say where it begins and where it ends? Who will say: you may go just so far and no further? I put these questions to philosophers who have dealt with them, and we can read with interest what they have written about art in its different forms.

Art, they say, is beauty, and beauty is truth in its material reality.

If we see truth in photography and if truth in its outward form charms the eye, how then can it fail to be beauty! And if all the characteristics of art are found there, how can it fail to be art! Well! I protest in the name of philosophy.

Continuing, M. Marie suggested that according to the tribunal, painting and photography were not the same thing. The painter observes, imagines, conceives and creates; he has both the material world and that of the spirit before him. The ideal world is said to be closed to photography. But the painter does not always invent. He often *reproduces* nature and people. To do this he must copy.

He couldn't be happier than if he were able to imitate exactly, and he would be quite convinced that he had produced a work of art by coming as close as possible to this nature which charms him and which he admires.

Is the painter any less of a painter when he reproduces exactly?

Truth and beauty are the same for the photographer as for the painter and sculptor. The painter believes his eye is like a camera which records nature and in his own way he fixes it as chemistry fixes the photographic image. Is the

photographer only a hand that manipulates the machine? If this is so, how then can he produce all his effects? Doubtless, the photographer must be as inventive as the painter, with a picture first of all in his mind, composed by his imagination. Then, with his camera, he can take that which his intelligence has conceived, and thus transmit it to his work.

Concluding this clever argument, M. Marie asked that photography's rights of reproduction be guaranteed by the law of 1793. A decision was rendered on 4 July 1862 by the Attorney-General, M. Rousselle, who declared for the court that photography was an art and that it would be protected by the same statutes governing other arts.

On 25 May 1862, after Mayer and Pierson's lawyer made his effective appeal, Daumier published a lithograph in Carjat's journal, *Le Boulevard*, in which his friend Nadar is seen in the nacelle of a balloon, taking photographs of Paris, probably, in which the word 'Photography' is lettered across every building. The title, *Nadar Raising Photography to the Height of Art*, was a reference to Nadar's balloon photography (he had taken such views for some years), but it may also have been inspired by the current litigation in which victory seemed certain (100).

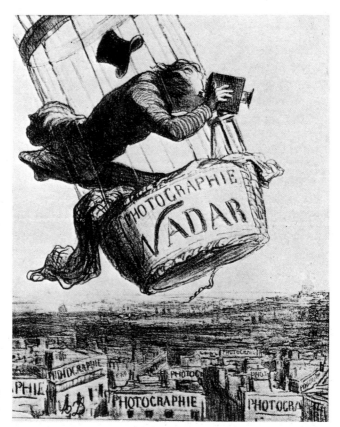

100. Daumier: *Nadar élevant la photographie à la hauteur de l'art.* 1862 (lithograph)

The Mayer and Pierson case was not yet concluded, however, for that autumn a petition was presented to the court, protesting at its last decision. It was signed by an impressive list of artists headed by Ingres and followed by Flandrin, Fleury, Nanteuil and other members of the Institut; also included were Jeanron, Troyon, H. Bellange, Philippe Rousseau (who had been a member of the Société française de Photographie), Isabey, Puvis de Chavannes, Vidal, J. Bourgeois and several others. The petition read as follows:

Whereas, in recent proceedings, the court was obliged to deal with the question of whether photography should be counted as a fine art, and its products given the same protection as the works of artists;

Whereas photography consists of a series of completely manual operations which no doubt require some skill in the manipulations involved, but never resulting in works which could *in any circumstance* ever be compared with those works which are the fruits of intelligence and the study of art – on these grounds, the undersigned artists protest against any comparison which might be made between photography and art.

Ernest Lacan added a footnote to the article reporting this petition, saying that much to his satisfaction he had learned that both Léon Cogniet and Delacroix had refused to sign, and that it would be right to believe that many other artists, whose names did not appear on the list, thereby indicated their reluctance to fall in line with Ingres and the other signatories and by implication harboured a more generous attitude towards photography.

On 28 November 1862 the court rejected the petition and upheld the previous decision. In its statement it declared, much as M. Marie had argued, that photographs *could* be the products of thought and spirit, of taste and intelligence, and could bear the imprint of the personality. Photography could be art.

No doubt echoing the defeat of the petition and the enmity of Ingres, Flandrin wrote in June 1863 that the works exhibited at the Salon that year demonstrated the neglect of good drawing. Where now, he lamented, can one find good drawing, that spirit of life which we admire in the Masters? 'Isn't it through drawing that everything noble in art is expressed? Perhaps I am mistaken but I am very much afraid that photography has dealt art a mortal blow.'

The victory for photography in the rejection of the petition served, it seems, to heighten Ingres's already intense antipathy for that or any other mechanical process or scientific idea which threatened to weaken further the kind of art he professed. Neo-Classicism was engaged in a struggle for its survival. In 1863 (the year of the Salon des refusés) Count Nieuwerkerke, Director-General of Fine Arts in France, submitted a report to Louis Napoleon calling for the reorganization of the École des Beaux-Arts. Quite likely the drastic recommendations for changes in its structure were designed, at least in part, to break the stranglehold

that the Académie had on it. On 13 November the Emperor issued a decree ordering that Nieuwerkerke's proposals be implemented. In his privileged rank of senator, Ingres wrote a sharp rebuttal to the report. It contained an attack on Romanticism with the implication that the advocates of that school fostered new ideas which would result in the corruption of art and the destruction of the antique style:

Now [he warned] they want to mix industry with art. Industry! We do not want it! Let it keep its place and not come and set itself on the steps of our true temple of Apollo, consecrated solely to the arts of Greece and Rome!

In a pamphlet written a few months later, Chesneau protested against the one-sidedness of the Académie. He enlightens us about the things which irritated Ingres. Why not, he suggested, make use of the ideas of Charles Blanc and others whose recent discoveries were suppressed in the École des Beaux-Arts? Why not teach Chevreul's laws of the simultaneous contrast of colour? Chesneau quoted from Ingres's rancorous words on art and industry, and said that the academician was jealous of a small exhibition of industrial techniques which could be applied to art, such as that of photo-engraving. No doubt, this was a reference to the Paris Exhibition of 1863 in which the photographic Salon, among other things, featured some of the first successful photographs in natural colour and an elaborate method by which even sculpture could be produced with the assistance of photography. Industry indeed! Ingres's fears were not without foundation.[42]

ARTISTIC PHOTOGRAPHY

Several books on photographic technique appeared in 1861 and 1862 which, if not calculated to increase the apprehension of artists, could not, with their assertive views on artistic photography, have been very reassuring. Mayer and Pierson's book, *La photographie* (1862), was intended not only to prove the legitimacy of their claims that year (they were also defendants in a case in which they were accused by the photographer Quinet of infringing on his patents for a type of stereoscopic transparency and viewer), but also to establish beyond any doubt the importance of photography among the arts. The photographic image had been so thoroughly assimilated by the public, they wrote, that great artists were compelled to surpass themselves. Photography makes the existence of mediocre art impossible, and the impression of light that it records, more sensitive than the human eye, provides useful material for the photographic album of the artist. No artist today, they explained, would execute a portrait without first having photographs taken of his model. The variations in photographic styles compare with the differences in those of the Masters.

Another book published in 1862, *L'Art de la Photographie*, was written by
Disderi who also described the artistic means at the disposal of photographers,
comparing their studio techniques with those of Ingres, Delaroche and other
painters. The camera, he insisted, could be manipulated like the painter's brush.
And though he regretted the 'revolting masquerade' of pictorial subjects

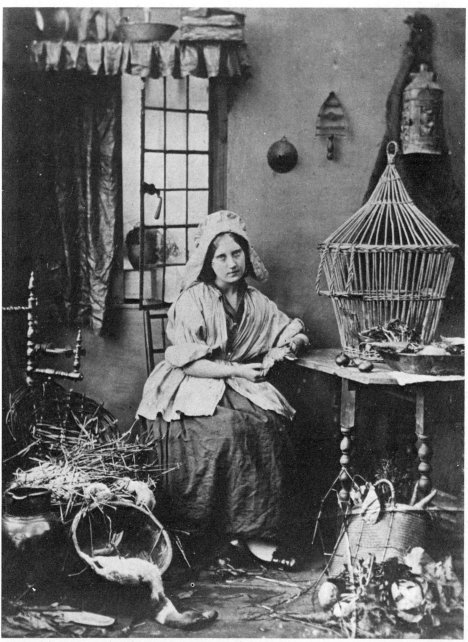

101. A. Beer: *The Fisherman's Daughter*. Before 1860 (photograph)

rendered in photography, he still maintained that the photographer might attempt any subject possible to the painter, except those in which colour was of prime importance. Why should the photographer not create compositions

like the battle scenes of Salvator Rosa or the *kermesse* of Rubens; and may he not show interiors like those of van Ostade, of Peter de Hooch, of Chardin, of Granet; experiment with all kinds of *genre* compositions on the scale and in the taste of le Ducq, Terborch, the Teniers, or with the fantasies of Watteau and Diaz? May he not seek feeling like Scheffer, and style like Ingres? May he not treat history subjects like Paul Delaroche . . . great compositions like Veronese (101, 102)?

102. Dr Diamond: *Still-life*. 1850s(?) (photograph)

In England, in 1861, Alfred H. Wall's *Manual of artistic colouring as applied to photographs* was issued. The author, once a portrait and miniature painter, now devoted himself to pictorial photography. The 262 pages of instruction read like a nineteenth-century Cennino Cennini. Painting over photographs, Wall assured his readers, was no more illegitimate than the earlier practice of Leonardo, Titian and others, of painting over the *abozzo*. If the fact that an artist copies a photograph by pouncing or by tracing his picture is accepted at public galleries, why not then paint directly over the photograph? The writer may have had in mind an embarrassing and revealing case at the Royal

Academy exhibition that year. Critical of the exclusion of photographs from the R.A. and other exhibitions, especially since painters who were known to work over faint photographic images were admitted, the *Photographic News* quoted with relish an 'indisputable authority' who reported that not only had the R.A. unknowingly accepted a 'coloured photograph' for their exhibition but that it was hung 'on the line'. In Wall's *Manual* techniques are described for glazing, scumbling and even for impasting colour, either with a brush or with the palette-knife, though for this last the author warns against any exaggeration of the painted surface. The artist, he stated, rejects coloured photographs because they are not paintings; the photographers, because they are not photographs. But why, he asked, 'should an art which combines the truth of the one with the loveliness of the other' be so categorically censured?

Photographers often represented themselves as having the same problems as painters. Sensitive to the argument that the time and effort expended in the execution of a painting bore some relation to its value, the advocates of pictorial photography tended to emphasize the amount of labour spent in the creation of their pictures, sometimes citing composite images fabricated from several negatives. It was said, for example, of H. P. Robinson's *Bringing Home the May* that 'the time and expense indispensable to the production of such a photograph, or rather set of photographs, can scarcely be less than what would be necessary to the painting of a picture of the same size'.

From at least the early 1850s photographers produced more or less elaborate *genre* pictures in imitation of those of painters. By about 1860 the practice of 'High Art' photography had noticeably increased; its techniques, 'like the painter's brush', included a considerable variety of retouching methods. For the International Exhibition in England in 1862, where photographs were to be shown, the patrons of artistic photography insisted on its classification as a Fine Art. The *Art Journal* published a note of the Photographic Society's complaint that for this exhibition the Commissioners had placed photography 'amongst carpenter's tools and agricultural implements'. The Photographic Society, it explained, had been founded chiefly with a view to promote photography in connection with both science *and* the Fine Arts, 'and the members interest themselves about photographic apparatus in the same manner only as a Raphael or a Reynolds might select and use the most convenient easel, the best brushes, or the most appropriate and enduring colours'.[43]

ENGRAVING VERSUS PHOTOGRAPHY

By the early 1860s the threat to engravers and lithographers from photography had become imminent. Though the history of photo-mechanical reproduction methods begins most likely with Niepce in the 1820s, its consistent progress in

the two decades after 1839 justified the fears of artists that the professions of engraving and lithography would soon be eclipsed. The practice of reproducing works of art by means of the photographic print, rather than by the traditional use of engravings or lithographs had become widespread by the mid 1860s. Many books on art were illustrated with actual photographs in those years. The advantages in both the accuracy and speed of the photographic process were almost universally acclaimed. As to the cost, engravings were often prohibitive in price while the photograph, which could be reproduced in infinite numbers, was within the reach of all but the poorest classes. Benjamin Delessert's price for one of his facsimile photographs of Marcantonio Raimondi's engravings was only 2 francs, while an original print would have cost between 1,000 and 2,000 francs, and an engraving made from the original, far more than the price of the photograph. In 1845 the *Art-Union* printed a letter in which the writer complained of the high prices charged for engravings from paintings by modern artists. The prices of three and four guineas for engravings by George Harvey and Edward Duncan, he stated, have made them inaccessible except to the wealthy.

Alinari, Anderson and MacPherson were in the mid 1850s among the first photographers to engage in the wholesale distribution of reproductions of Italian art. A notice in the *Athenaeum* describing Alinari's recent photographs of the Campo Santo frescoes in Pisa compared them with the work of the eighteenth-century engraver, Lasinio. Quoting from, but not agreeing with, a contemporary review, it reported that

no work of Lasinio's can be trusted for *anything*, except the number and relative position of the figures. All masters are by him translated into one monotony of commonplace. In all artistic points he is utterly valueless.

Ruskin, too, had similar sentiments about Lasinio. He regretted having copied a Ghirlandaio from 'one of Lasinio's execrable engravings'. On another occasion he complained that he had again been 'forced to copy from Lasinio, who leaves out all the light and shade, and vulgarizes every form'. It was, incidentally, Lasinio's engravings from the Campo Santo that the young Pre-Raphaelites admired in August 1848, at the founding of their Brotherhood. What has been said of that poor wretch, Lasinio, can be repeated *ad nauseam* about the engravings made from other works of art which filled the pages of art journals and pictorial magazines until they were superseded by photo-mechanical reproductions.

At the beginning of 1863 a meeting of painters, engravers and publishers was held at the French Gallery, Pall Mall. They were there to protest against an Act of Parliament, passed in its last session of 1862, which, following the decision

in the Mayer and Pierson case, extended the statutes that protected painters to include photographers. But the new Copyright Act did not sufficiently protect engravers. Pirated photographic copies of engravings were exhibited at that meeting alongside the originals which included Holman Hunt's *Light of the World* and Rosa Bonheur's *Horse Fair*, two very popular pictures.

It is almost unnecessary to say [read the report], that the genuine production and the spurious imitation in every case so closely resembled each other as to be scarcely distinguishable, although the fair price of the one might be half a guinea, and the other could easily be sold for a shilling.

Among those addressing the meeting were an 'art publisher' whose name is not given, John Rogers Herbert R.A. and the engraver Thomas Landseer, brother of Sir Edwin. William Powell Frith R.A., who could not be present, sent a letter which was read:

The recent Act is efficient as regards the copying of pictures, but while the remedy of the publisher, who has paid liberally for a copyright, is not secured to him by law against photographic piracy, he will be neither willing nor able to pay for copyright as heretofore; and, if that should happen, the class of art I practise will almost cease to be followed.

Frith's *Ramsgate Sands*, engraved on a large plate, was sold in 1856 for £4,000. Sir Edwin Landseer often asked as much as £2,500 to £3,000 each for copyrights of paintings. For the copyright of *A Dialogue at Waterloo* he was paid about £3,600. And for that of four paintings exhibited in the Academy in 1846 he received probably more than £10,000 from a publisher of engravings. Landseer's brother Charles's celebrated pun, that 'sun pictures were a *foe-to-graphic* art', was very understandable indeed.

Later in 1863, concurrent with the report in France on the École des Beaux-Arts, Parliament requested that an inquiry into the state of affairs of the Royal Academy be held. A Royal Commission was selected and a section of their report was devoted to the position of engravers in the Academy. Under the original constitution of the R.A., as established in 1768, six engravers were entitled to admission with the status of A.R.A. (i.e. Academic or Associate members). In 1856 the laws were changed to allow two engravers full Academic titles, and another two those of Associates. The question of whether photography had superseded engraving, making the inclusion of engravers in the R.A. redundant, was considered in the hearings. On 20 March 1863 George Thomas Doo R.A.E. was interrogated:

Q. You do not think, then, that the present condition of photography is at all such as ought to lead the Academy to afford less encouragement to the art of engraving?
A. I do not.

Q. The necessary conditions of photography, so far as we yet know, will never permit its productions to take the place of engravings?

A. I should say only to a very limited extent; but as yet it has done nothing to affect engraving, except in the class of book illustration, and even in that direction it has made comparatively little progress.

Q. It is the business of the engraver, is it not, to translate a picture into black and white, preserving the general effect of the light and shade, and, at the same time, the general effect of the contrast of colours, and to do that simply by means of lines on the copper?

A. I think that the business of the engraver is to translate the painter, that is to say, faithfully and artistically, in a word, substantially, as the painter himself would translate his own work, or the engraver's art is not worth anything; so that a person taking engravings from a portfolio would say, this is a Paul Veronese, that is a Raffaelle, this is Domenichino, or any other master; he should faithfully render his master both as to letter and spirit.

Q. In the present condition of photography, does not the fact that certain colours come out dark and light, not according to the light or shade in the picture copied, but according to the colours, necessarily prevent a photograph from an original picture from rendering or translating faithfully the artist?

A. I think photography, though I am a great admirer of the discovery, is wholly incompetent to render a picture, and probably never will be competent to render a picture faithfully, inasmuch as there are colours for which it is physically impossible to give an equivalent, and, which as delivered by photography are often represented in antagonism with the fact. Again, photography is incapable of correcting the faults of a picture, bad drawing, want of keeping, etc., but copies *all* the *vicious* with the *good*.

Following more discussion along these lines, Doo was finally asked:

Q. To sum up the whole, in your opinion there is nothing in the relative position of photography and engraving at the present time which goes to show that the former ought to supersede the latter, or to cause us to wish to dispense with it in art?

A. Nothing whatever.

In the circumstances Doo's show of confidence was to be expected, but the fact remains that, in addition to the development of several photo-mechanical reproduction methods, photographs themselves (despite their shortcomings) rather than engravings were increasingly employed in the reproduction of works of art and were sold in an expanding market.[44]

PHOTOGRAPHIC REPRODUCTIONS OF WORKS OF ART

Among the earliest books on art in which photographs were used as illustrations is Sir William Stirling Maxwell's limited edition, *Annals of the Artists of Spain*. This was published in 1847 in four volumes, the last containing sixty-six calotypes by Talbot, mostly of prints, some of them by Goya. In the 1850s outstanding photographic reproductions of prints, drawings and paintings included

the Bisson brothers' publications of Rembrandt's works (*c.* 1853–5). Delacroix wrote in 1853 of having seen photographs of works by Rubens at the Galerie Vivienne. Cotton's books on Reynolds (1856 and 1859) were illustrated with photographs, and from 1856 an Islington company began to produce their *Photographic Art Treasures* by a process called 'photo-galvanography'. Delessert's Marcantonio engravings were produced by photography first from 1853 to 1855 and again in 1858 and 1863. In 1857 Colnaghi published photographs of the Manchester Art Treasures exhibition. In 1859 the Oxford collection of Raphael drawings was sent to the South Kensington (Victoria and Albert) Museum to be photographed, the prints to be sold to the public. At that time the museum photographed drawings by Michelangelo for the same purpose. In the early 1860s 400 MacPherson photographs of Roman painting, architecture and sculpture were on view and sold in London. The Bissons' Dürer photographs were published in 1861. Géricault's works by Colin appeared in 1866. And by 1868 Adolphe Braun had photographed and published a great number of important works from all the major galleries in Europe. The new possibility of being able to see and compare relatively accurate representations of works of art from the most diverse sources was not only bound to speed up the whole process of stylistic change but also to create hybrid styles independent of particular artistic traditions. The accepted method of the study of the history of art was to be radically altered, the emphasis put on formal rather than iconographic considerations, with a no less significant influence on contemporary art.

Henri Delaborde in 1856 compared works engraved after paintings with photographs in an attempt to justify his conviction that those executed by the human hand were superior. He believed Desnoyer's engraving of a Virgin after Raphael to be preferable to photographs of Raphael's *Stanze* and of Leonardo's *Last Supper*. The photograph only multiplied works of art, wrote Delaborde, while the burin interpreted them. Other comparisons were made by the writer to demonstrate the indifference and the consequent distortions of the camera medium. The work of engravers did not exclude the important possibility of interpreting colour and light values, and of making other alterations necessary to translate the artist's original intentions successfully.

Nevertheless, many contemporary artists were having their drawings and paintings photographed rather than engraved and sold in different formats. In 1853 Delacroix recorded a discussion in which it was proposed that Durieu might publish his sketches by means of photography. Courbet intended having some of his paintings photographed and prints of these were to be sold at his private exhibition in 1855. In 1856 the Bissons were reproducing and exhibiting photographs of contemporary works of art. Goupil & Company published Delaroche's works photographed by Bingham from 1857, and those of Meis-

sonier between 1857 and 1866. In 1860 Louis Martinet published two volumes of photographs of principal works of contemporary art. Even Ingres, in 1861, agreed to have his works photographed by Bingham and sold to the public.

Charles Blanc, in 1863, wrote in the *Gazette des Beaux-Arts* that the best and most noble use of photography was in the reproduction of great works of art. And though, he added, referring to paintings, the camera still distorted the tones of colour, this 'infallible machine' reproduced works of architecture, sculpture and prints with an incomparable veracity.

Photo-galvanography (also called the Pretsch process) appeared amongst other new photo-mechanical techniques invented in the decade 1855–65. That photo-engraving method, employing permanent ink, was one of the earliest of a series of processes which was inevitably to revolutionize the whole system of the printing and distribution of pictorial reproductions. The side-effects on art, as André Malraux so cogently argues, have been prodigious. As early as 1876 Odilon Redon recognized the implications. Almost anticipating the *musée imaginaire*, he wrote:

Photography used solely for the reproduction of drawings or bas-reliefs seems to me in its proper role, used for the art which she aids and supports, without leading it astray. Imagine museums reproduced in this way. The mind boggles at estimating the importance that painting could suddenly take – thus put on the same footing with the power of literature (the power residing in the fact of multiplication) and a new security assured in time. . . .

The *Art Journal*, reviewing the Pretsch process in 1856, reacted with admirable, though futile optimism:

We have no apprehension that, under any circumstances, it will supersede the labours of the engraver. Nature, to be pictorially represented, always requires some assistance from art, and must come under the laws which regulate the latter.

Despite such assurances many engravers soon became mere 'handmaidens' to photography for, from the 1860s, much of their employment consisted in the engraving and retouching of photographic plates for the new and profusely illustrated pictorial magazines which then appeared in both England and France. Late in the century photo-mechanical reproduction reached such a degree of efficiency that it was able to render the earlier function of the engraver almost obsolete.

The antagonism directed towards photography from the 1860s owes much to the displacement of human handicrafts by machine methods. Paul de Saint-Victor's repugnance for photography was typical when he protested that 'photography ruins art, it prostitutes taste and vision, it discourages the engraver whose slow and careful tool cannot fight against its dexterity and its legerdemain contrivances'. And in the *Gazette des Beaux-Arts* Burty wrote of

engravings shown in the Salon of 1864 which were among the last examples, he believed, of an art which had already been profoundly afflicted by photography. Maledictions on photography were made in an article of 1865 also published in the *Gazette*. The author, M. de Sainte-Santin, named '*la photographie, la bête et vile photographie!*' as the cause of the destruction of engraving, lithography and other arts by its 'ravaging invasion'. He too insisted on the advantages of the concept over those of the facsimile: the print of the engraver or the lithographer is an 'interpretation', while that of the photographer is only a mirror, a brutal emanation of the external world.

Burty grasped the significance of the photographic Nemesis. In 1867, in a review of the Royal Academy exhibition in London, he wrote of the absence of graphic work:

This year there is almost nothing in this room, no engravings, no lithographs except portraits. Doubtless photography is making the same ravages on this side of the Channel as it is with us.

But photography, he concluded, will never mortally affect the *original* engravings of painters. 'Why then do we see here only a few landscapes by Hamerton or Payne or Redgrave, and nothing by masters like Seymour Haden, Whistler or Legros?'

For engravers and lithographers whose reputations were made by their ability to transcribe nature or art, photography undeniably was disastrous. But, by the same contingency, inventive work in the graphic media found new advocates and thus was revived the quiescent belief that drawing was a dynamic, highly selective, probing activity.[45]

7. Impressionism

THE CLANDESTINE USE OF PHOTOGRAPHY

The young Impressionist painters appeared in Paris in the early 1860s in the thick of the battle between photography and art. It is hardly possible that they were not affected by it. They were on one hand the progeny of a long tradition of naturalism culminating in an absolutist conception of realism; on the other they were heirs to a legacy of cynicism towards all imitative art. Both attitudes were undoubtedly germinated and exacerbated by the existence of photography. The apparent dichotomy in Impressionism, the concern with both imitation and expression, the attempt to reconcile truth with poetry was by no means new in art. But in the context of the struggle between art and photography this dualism was likely to be exaggerated and, at some point, to undergo a qualitative change. Baudelaire's warning that photography and poetry were irreconcilable is pertinent here and, because of this conviction, he not only anticipated but helped nurture the essential concepts on which Post-Impressionist styles were formed.

The paucity of references to photography in the notes and letters of the Impressionists is no guarantee that they did not use it. Indeed, the silence may be entirely relevant considering the growth of photography as an art and the commensurate antipathy artists felt for it. Artists found it expedient to hide the fact of their use of photographic material or its influence upon them. Only one of Delacroix's status and literary propensities would be likely to express candidly and in detail his opinions on the subject, and to confirm his use of photographs. But, by implication at least, critics in France and in England demonstrated that there was an obvious correlation between the use artists made of photographs and their reluctance to admit it. How many painters exhibiting in the 1861 Salon would dare to confirm Gautier's observations without the fear of losing face?

I do not propose [declared Joseph Pennell when asked later to comment on the use artists made of photographs], to give away the tricks of the trade. By refraining I have no doubt I shall receive the silent blessings of the multitude of duffers among whom I find myself.

Artists did not publicize their use of photographs, it was said, because 'they have a notion . . . that they would lose caste with the picture-purchasing

public'. Sickert's view on this question, in the words of a music-hall ditty, was that 'some does it hopenly, and some on the sly'.[46]

THE IMPRESSIONISTS' USE OF PHOTOGRAPHY

In these circumstances it is difficult to know the exact extent to which the Impressionists made straightforward use of the camera image, though certainly its oblique influence is detectable. Admittedly sparse, and not always of immaculate provenance, there are nevertheless certain examples which show that these artists sometimes utilized photographs directly. The uncompromising naturalism to which they aspired – Monet in particular, and particularly in the earlier years – their dedication to painting only before nature; the great emphasis on the objective eye; their desire to record the transitory character of natural light and shade, amounted to a kind of perceptual extremism which was germane to photography itself, and would not necessitate – indeed would obviate – copying from photographic prints. But by the same token it is most likely that in their own interests they would scrutinize the work of contemporary photographers.[47]

THEODORE ROBINSON

Certainly other artists who associated themselves with the idea of Impressionism did not scruple to use photographs. For example, Theodore Robinson, called the first American Impressionist, frequently employed them as a mature artist while painting in France from 1887 until 1892. Robinson was not a pupil of Monet as is sometimes believed; he knew Monet as a close associate, if not an intimate friend, in those five years when both artists were working in Giverny. There, according to Robinson's biographer, John Baur, many evenings were spent together discussing art and it is hardly likely that Robinson's partiality for the photographic *aide-mémoire* was not communicated and his photographs (several of which survive) not shown to Monet. Some of the entries in Robinson's diaries are extremely pertinent. It was right for a 'realist', he wrote, to utilize the impartial vision of the camera: 'Painting direct from nature is difficult, as things do not remain the same. The camera helps to retain the picture in your mind.' Furthermore, 'a photo would have saved me time as I would have made fewer changes,' but, 'I must beware of the photo, get what I can out of it and then go on.' In defence of the artist Baur suggests that he was not so much a slave to photography as his diaries would lead one to believe: his pure landscapes were painted directly from nature as often were his figurative works. Robinson did get what he could from photographs and 'then go on', but in some ways he was quite dependent on them, if the examples reproduced by Baur can be thought of as typical. As a number of Robinson's paintings and the

photographs on which they were based survive, it is worth examining them in detail. In the absence of similar comparisons in the work of the other Impressionists, one may here discover certain things applicable to Impressionist painting generally in relation to photographic images.

Not unlike other landscape views at that time, Robinson's photographs are characterized by the intense contrasts of dark and light areas, the general suppression of middle tones and the consequent loss or diffusion of details in the flat patches of dark and light. In them are found the effects of the non-panchromatic emulsion, of halation and of blurring through movement: those aberrations of tone and form frequently found in nineteenth-century landscape photographs which were so strongly abjured by Ruskin and other critics. Here, as in the photographs taken of Corot, the foliated areas are reduced to shimmering masses of ambiguous form, identifiable only by the general contexts and by the clues provided in a few legible botanical objects appearing in sharper focus mostly in the foregrounds.

In Robinson's paintings, as in those of the French Impressionists, these features are not only conveyed in the manner of the photographs, but are grossly exaggerated. Even the clearly recognizable forms in the foregrounds of the photographs, which traditionally artists had carefully described so that their meanings could be implied in the more schematic ones further in depth, are suppressed. Robinson makes everything in the picture subservient to a single, highly articulated and uniform handling, irrespective of either the individual structures of objects or their textural characteristics – as though the scene was viewed from its reflection on the agitated surface of a river.

In his canvas, *Two in a Boat* (1891), no careful distinction is made between the water in the foreground and that in the back and the brushwork is the same for water, boats and figures (103). In *The Layette* of 1892 there is, similarly, one homogeneous and scintillating surface (56). In that respect Robinson did exceed the photographs, expressing the same palpable, painterly quality generic in the work of all the other landscape Impressionists.

By another kind of comparison between Robinson's paintings and his photographs, one discovers the more objective and rational side of Impressionism. To give his paintings the structure which could support the abstract brushwork, Robinson might well have felt obliged to render certain forms in his pictures with a great degree of photographic truthfulness. Sometimes, even, some of the details which were obliterated in the photographs, those in the figures especially, were restored in the paintings (55). Accuracy in the proportions of objects, and in their relative scale, seems to have been imperative for him, just as it was for other Impressionist painters. His care in transferring their dimensions from the photograph to the canvas, which was sometimes done by

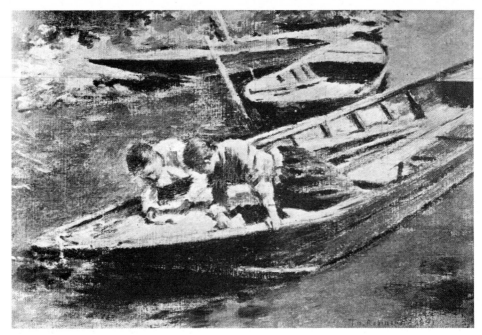

103. Theodore Robinson: *Two in a Boat.* 1891.

104. Photographic study used for Robinson's *Two in a Boat. c.* 1890

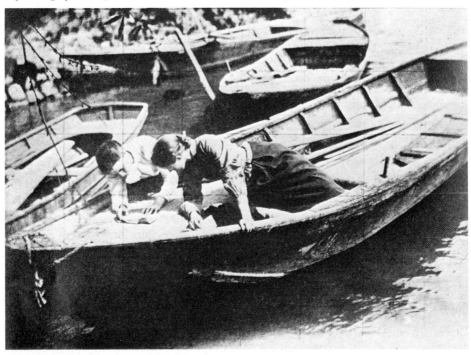

means of a grid, contrasts significantly with the fluid and subjective use of paint (104). This coexistence of the personal and the impersonal, at once contradictory and complementary, may well have been a way out of the dilemma posed by the intrusion of photography in naturalistic pictorial representation.[48]

THE BLURRED IMAGE

As early as 1842, fully two decades before Impressionism took root in France, alternatives were offered to the imagery of the photographic camera in a little-known yet significant article which appeared in the *Spectator*. The apparent inability of the new medium to reproduce natural colours or to record kinetic effects was seized upon as an example of the greater latitude open to painters and cited as a guarantee of their ultimate ascendancy over the lens.

Not all the delicate truth of photographic delineation can supply the want of colour: by imitating the local colour and atmospheric effect alone can landscape painters hope to stand against such a formidable rival as Nature. Therefore it behoves them to study with redoubled assiduity the influence of atmospheric light upon the individual hues of objects and the general tone of the scene; and also to strive to imitate the appearance of movement in figures and foliage, water and clouds.

But the exasperating precocity of the photographic medium must often have made artists despair as it became clear that neither the representation of movement nor even the recording of natural colours was entirely beyond the power of that process. Photographers had always professed their desire to be able to arrest the motion of animated forms, to immobilize those images on the sensitized plate. The first photographs of urban scenes had an eerie, unnatural, sometimes surrealist quality about them. For though they were taken in full daylight, they were strangely depopulated, with no signs of life (105, 106). Only the inanimate objects in view were registered on the plates. In and out of the visual field of the lens passed the pedestrians and the horse-drawn vehicles. Here and there, only the most anonymous smears or ghostly vestiges faintly recorded some moving form or something that had suddenly moved off during the long exposure (107). Later, with faster emulsions and more efficient techniques, the populations of the cities appeared in the streets. Though they now took on more substance, their vestigial images becoming more apparent, they still remained more or less indefinable blurs spread out in the direction of movement. Among such images can be found the most incredible oddities of photographic truth: horses with two heads, legs without bodies, bodies without legs; men with multiple limbs and featureless faces, figures frozen in immobility

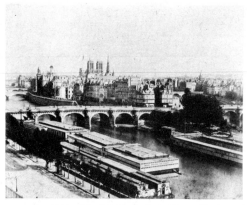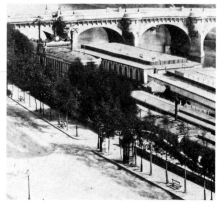

105 and 106 (detail). Achille Quinet: *View of Paris. c.* 1860 (photograph)

with their exact likenesses rising from them like preternatural wraiths. Like the human optical system the camera too has its own kind of persistence of vision; but unlike the eye it retains more. The eye is incapable of seeing more than the most immediate continuity patterns of moving objects; the camera can preserve the whole spectrum of animation. Blurred images of pedestrian forms moving at an ordinary rate of speed, such as were recorded by the sluggish mechanisms of early cameras, cannot be duplicated by the human vision. This feature common in photographs before the development of more sensitive plates and faster shutter systems, is one of the innovations attributable to Impressionist painting. The adumbration of pedestrian figures by a kind of blurred notation seems to be entirely new in art. It was the urban counterpart to the landscapes represented by some of the Barbizon painters. Corot set the countryside in motion; Monet the city.

At least one contemporary critic, Ernest Chesneau, recognized the visual significance of the blurred form. He described, in 1874, Monet's painting of the boulevard des Capucines:

never has the amazing animation of the public thoroughfare, the ant-like swarming of the crowd on the pavement and the vehicles in the roadway, the movement of the trees in the dust and light along the boulevard; never has the elusive, the fleeting, the instantaneity of movement been caught in its incredible flux, and fixed, as it is in this extraordinary . . . *Boulevard des Capucines* (108).

It is unlikely that Chesneau, an avowed enemy of photography, would give that medium the distinction of being a possible source of Monet's imagery. And so far as is known, no other critic, however insulted or baffled by this painting, associated the blurred forms, even derogatorily, with the most obvious empirical evidence to hand: photographs, many of which even in the 1860s and 1870s still contained these aberrations (109). Louis Leroy, in his satirical dialogue on the

107 (*below*). Achille Quinet:
The Pantheon, Paris.
1860s(?) (photograph [detail])

108 (*right*). Monet:
Boulevard des Capucines. 1873

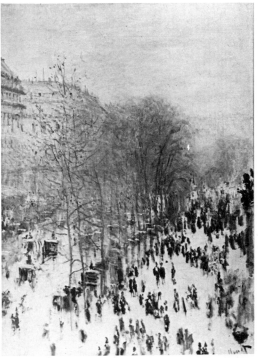

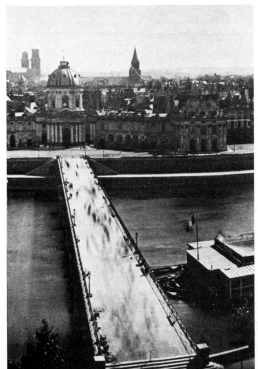

109 (*left*). Adolphe Braun: *The Ponts des Arts.*
1867 (detail from panoramic photograph of Paris)

110 (*above*). Monet:
Boulevard des Capucines. 1873 (detail)

first independent exhibition of the Impressionists, in which Monet's painting was shown, had a perplexed landscape painter call the blurred figures 'black tongue-lickings' ('*lichettes noires*'), pretending not to understand what they represented. He refused to accept these images partly because they had no basis in artistic tradition despite their existence in photographs. Despite the authoritative position commanded by photography, if it contradicted aesthetic conventions – as often it did from that time – it would not be used as a standard of measurement for pictorial truth.

It was, in most cases, optical truth which was used as evidence against the excesses of Impressionism. They were facetiously called 'the school of the eyes'. Who could see things the way they did? 'Do I look like that when I walk along the boulevard des Capucines?' cried Leroy's annoyed painter. Corot too had been criticized about 1850 by a contemporary because of the manner in which he represented trees. No one ever sees them that way; 'they are not trees, they are smoke'. Predominantly, both Corot and Monet represented their subjects, not as the eye would see them but as they might be recorded by the camera. As far as the photographic process was concerned, Monet's representations particularly were anachronisms. For despite the fact that such blurred images continued to appear in photographs long after the first so-called instantaneous photographs became popular about 1860, Monet – if indeed he was motivated by photographs – reverted to what was already a rather archaic form. Corot's and Monet's perception of nature was not, strictly speaking, instantaneous, as Chesneau stated (the exact meaning of that word was somewhat ambiguous in the 1860s and 1870s), but more like halated images or photographic time exposures during which the definition of moving forms was partially or wholly obliterated. Monet himself, later, used the term 'instantaneous' in a more deliquescent sense to describe the effect of changing light he despaired of catching: '. . . I seek: "instantaneity", especially the "*enveloppe*", the same light spreading everywhere . . .'[49] (111).

In other ways, too, innovations peculiar to Impressionist painting closely approximate to the characteristics of snapshot photographs. The apparently fortuitous distribution of figures in their city-scapes, cut by the frame, are often found in those stereoscopic views produced in vast quantities from about 1860. This feature, though occasionally discovered earlier in art, certainly had no precedents in the immediate tradition of nineteenth-century European painting before Impressionism and it was completely unknown to painters like Giuseppe Canella or to those many engravers who specialized in urban views (112). Degas's use of such compositional devices, undoubtedly stimulated in large part by photographic prototypes, will be discussed in the following

111. Monet: *Poplars at Giverny. Sunrise.* 1888

112. *Le Pont-Neuf.* Engraving on daguerreotype plate published in *Excursions Daguerriennes,* 1842

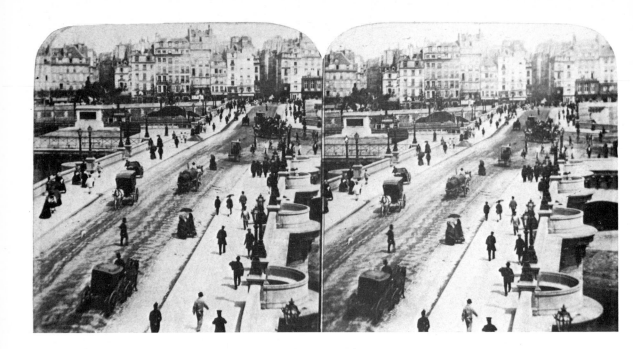

113 and 114 (detail). Hippolyte Jouvin: *Le Pont-Neuf*. 1860–65 (stereoscopic photograph)

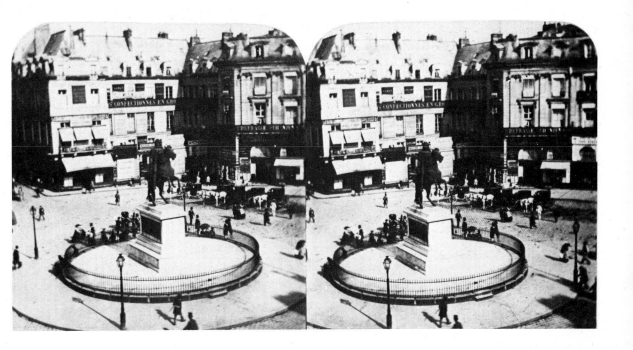

115 (*above*). Hippolyte Jouvin:
Place des Victoires.
1860–65 (stereoscopic photograph)

116 (*right*). Gustave Caillebotte:
Un refuge, boulevard Haussmann. 1880

chapter. The unusual viewpoints too, particularly elevated ones, typical of many Impressionist paintings, have far more in common with photography than they do with art. And here one can point to the paintings of Gustave Caillebotte, that avid, more than amateur patron of Impressionism who in his exuberance sometimes exceeded even the compositional innovations of Degas, from whom undoubtedly the initial stimulus came. Caillebotte's canvases like *Un refuge, boulevard Haussmann* (1880) may well be compared with the stereoscopic photographs, for example, of Hippolyte Jouvin (115, 116). The viewpoint of his very unusual *Boulevard, vue d'en haut* (117), also of 1880, is rare even in photography where, to my knowledge, only a literary reference of the early 1860s exists describing the startling bird's-eye photographs of pedestrian traffic taken by Count Aguado, well known in photographic circles. This is hardly to be seen again in photography until 1913 in Alvin Langdon Coburn's almost perpendicular views of New York and in the 1920s in those taken by László Moholy-Nagy in Berlin. Even Nadar's now well-known balloon photographs of Paris in the late 1850s and 1860s are not exactly comparable because of the greater elevation from which they were made – though very likely they and others of the kind were of some importance in promoting this type of pictorial view of the modern urban complex (118).

It might also be suggested that to some extent the idea of painting the sequential light and atmospheric effects on one immobile object, as in Monet's series of the Rouen Cathedral and Sisley's of the church at Moret, was in part

117. Gustave Caillebotte: *Boulevard, vue d'en haut.* 1880

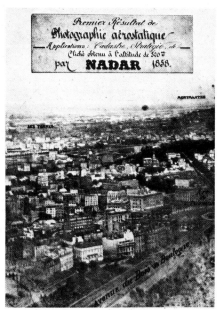

118. Nadar: Aerial photograph taken from a balloon. 1858

stimulated by photography. Certainly in art, in the popular visual entertainments especially, a number of ingenious means had been invented by which the temporal modulations of light could effectively be represented on a single picture surface. Daguerre's Diorama, first shown in 1821, was probably the most astounding of all such illusionistic techniques. With the advent of photography and a few judicious modifications, a degree of realism in the pictorial articulation of natural light was approached which was surpassed only later with the invention of cinematography. Firmly rooted in the tradition of the popular visual arts of the nineteenth century was an interest in cinematic representation, not only of the transitory nature of light but also – in the form, for example, of the phenakistiscope, the zoëtrope and the many devices which sprang from them – in the animation of objects. In the 1880s the possibility of modern cinematic projection was established and much excitement was generated by the experiments of its pioneers. Thus, in painting his series of haystacks, poplars and cathedrals, Monet not only acted in accordance with this tradition but he may also have reflected the great current preoccupation with cinematography, a sequential series of instantaneous images.[50]

NATURAL COLOUR

The obvious advantages of colour appealed to artists who wished to be free of the competition from the monochromatic photograph. Many painters, however, did not much heed warnings of the kind published in the *Spectator* and persisted, out of a useless quixotism or spiritual inertia, in rendering their subjects in a more or less monochromatic photographic style, so roundly condemned, for example, by Chesneau in 1859.

Yet, as efficacious as a heightened colour-consciousness may have seemed in the 1840s and 1850s, by the 1860s the potency of naturalistic colour alone in painting may well have been doubted. For not only had it always been possible for photographers to paint over their images and from about 1860 not infrequently over photographs printed on canvas, but the discovery of a natural colour process after mid century appeared inevitable. By the 1850s reasonable successes in this technique at least indicated that such a process was not impossible. At the Paris exhibition of 1863 – the same in which the Salon des refusés was held – photographs in natural colour were on display, though they were not yet permanently fixed. Taken by Niepce de Saint-Victor, they were said to have excited much interest, though they could only be shown briefly at half-hour intervals. A contemporary report described their bright colours,

especially a fine yellow . . . the scarlet is also vivid. There are pinks, blues, greens, and some other tints. The general effect of the pictures is similar to that of an un-fixed Daguerreotype, the image being embedded in a kind of film.

Some of the problems of printing and fixing natural colours in photography were soon overcome. There are photographs of that kind surviving to this day: a montage of plant forms taken in 1869 by Louis Ducos du Hauron, for example, and his landscape view of Angoulême in 1875. On learning that du Hauron had published a work on colour photography in 1867, Charles Cros, a friend of Manet and, later, of Seurat, deposited a sealed envelope with the Académie des Sciences describing his own method, which subsequently proved to be practicable. But even earlier, in 1861, James Clerk Maxwell had already demonstrated his colour process successfully: his photograph of a rosette ribbon is in the collection of the Kodak Museum, Harrow. Fixed colour photographs ('polychrome prints') by Vidal were on exhibition in the Palais de l'Industrie in 1874, the colours said to have a strong effect in the shadow areas.

The advances made in colour-processing threatened to close the already narrow gap between naturalist painting and photography, at least in the estimation of those who did not see sufficient differences between them to guarantee a happy coexistence. As early as 1864 a writer in the *Quarterly Review* described the consequences if natural-colour photography ever became a reality. There can be little doubt, he warned, 'that in such a case the camera would have undisputed possession of all actual scenes and existing objects, and the easel and canvas would be restricted exclusively to imaginative painting'. When that day arrives, he concluded, photography will have done 'the good service of exterminating bad painters and of aiding good ones'.

In the 1870s photography in natural colours appeared menacing enough to provoke this comment from Horace Lecoq de Boisbaudran, the well-known teacher of the memory method in art:

Truth in art is not photographic truth, as many people seem to think nowadays. Numbers of painters seem, under the influence of this idea, to be entering into a rivalry with the camera, as laborious as it is futile. I grant that in the direction of detail and illusion they have achieved results such as the great old masters neither dreamt of nor tried for. Yet to appreciate this triumph of the moderns at its proper value, let us suppose for a moment that photography were to succeed one day in reproducing and fixing colour. In that case where would the most detailed and most successful imitation be in comparison with pictures of nature that were similar to a reflection in a looking glass? While the works of great masters . . . would not only not lose by comparison with the mechanical pictures of photography, but would appear all the finer. What makes real art would then be far better understood, and it would be admitted beyond question that art is not just nature, but is the interpretation of nature through human feeling and human genius.

The *Écho de Paris* in 1895 arranged an interview with Gauguin who, not without a consciousness of colour photography, asserted his right to use colour and form in an arbitrary way and to distort nature as had the artists of past centuries:

Shall I tell you what will soon be the most faithful work of art? A photograph, when it can render colours, as it will soon be able to. And you would have an intelligent being sweat away for months to achieve this same illusion of reality as an ingenious little machine?

Though it was not until the very first years of the present century that most of the problems inherent in the reproduction of natural-colour photographs were satisfactorily surmounted, they had frequently been almost solved during the preceding forty years. Just how sensitive the Impressionist painters were to the imminence of colour photography in those decades, or how alert they were to warnings like those sounded by Lecoq, is very difficult to know. Yet it is hard to believe that they could have been totally indifferent to such a momentous possibility.

Inevitably, the untenable relation between naturalistic art and photography became clear. However much other factors may have contributed to the character of Impressionist painting, to photography must be accorded some special consideration. The awareness of the need for personal expression in art increased in proportion to the growth of photography and a photographic style in art. The evolution of Impressionist painting towards colours one ought to see, and the increased emphasis on *matière*, can well be attributed to the encroachments of photography on naturalistic art. Impressionist paintings may be seen as *mirrors* of nature, but above all they convey the idea that they are *paintings* of nature.[51]

119 and 120 (detail). Hippolyte Jouvin: *Boulevard de Strasbourg.* 1860–65 (stereoscopic photograph)

8. Degas and the instantaneous image

INSTANTANEITY

Just as photographers had always attempted to perfect a natural-colour process so they hoped to solve the problem of recording objects in motion. In the flush of enthusiasm which accompanied the first appearance of the photographic camera, the aspirations of the new photographers far exceeded their possibilities. The extravagant claims made were more significant for what they anticipated than for what could then be accomplished. Daguerre, as an example, announced in 1844 that he could photograph galloping horses and birds in flight, the technique for which was not effectively possible until the 1870s. The description, 'instantaneous', applied to photographs was of course only a relative one. Writers in the early art and photographic journals were at pains to define its precise meaning. In fact, only later, from about 1860, when the camera could fix moving objects in positions which were inconceivable, when it froze them in attitudes completely foreign to the customary ways of seeing, could it correctly be said that photography had solved the first problem of instantaneity. Another, and very important, stage was reached in the 1870s when photographs could be taken of even faster moving objects, immobilizing them in postures which not only defied convention, but which were actually beyond the capabilities of the unaided eye, however keen that eye might be.

There were early experiments, some of them successful, in which objects moving at high velocity were arrested by the camera. In 1851 Talbot using the intense light of an electric spark was able to 'stop' a rapidly revolving disc on which a copy of *The Times* was mounted so that the print could be read with ease. But efforts of this sort were principally confined to the laboratory or were otherwise exceptional and for practical reasons could not be employed in the manner and on the scale feasible after the development of more highly sensitized plates and more efficient shutter systems.

In 1858 exposures at 1/50th of a second were possible; they marked the appearance of the 'snapshot'. With the introduction of instantaneous photography, a vast number of city views, most of them taken with stereoscopic cameras, were offered for sale in what seemed to be an insatiable market (119, 120). It was then that H. P. Robinson produced his photographs of the streets of

Leamington which record the 'passing objects of the day', and the London Stereoscopic Company, in 1861, those which show 'omnibus horses with up-lifted legs without a blur, and foot passengers in every stage of action perfectly defined'. The precision in detail of views of Paris also taken in 1861 was said to be absolutely marvellous:

Walking figures, running figures, falling figures, equestrian figures and vehicles, all caught in their acts without the slightest appearance of movement or imperfect defini-tion. Here is a lad transfixed in the act of falling, flying forward, as something has tripped him up; he remains on the slide doomed neither to fall farther nor rise again.

To the physiological sciences instantaneous photography was of great impor-tance and, in one interesting case, of immediate usefulness. For in their revelations of the complicated mechanism of walking, such photographs helped to solve the difficult problems in effectively designing artificial limbs for the amputees victimized by the American Civil War.

We have selected, [wrote Oliver Wendell Holmes in 1863], a number of instantaneous stereoscopic views of the streets and public places of Paris and of New York, each of them showing numerous walking figures, among which some may be found in every stage of the complex act we are studying.

And following an analysis of those movements, Holmes observed, as did many others in the following two decades, that 'no artist would have dared to draw a walking figure in attitudes like some of these'[52] (121).

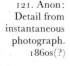

121. Anon: Detail from instantaneous photograph. 1860s(?)

It was therefore as daring as it was imaginative for Edgar Degas to translate the strange images of the instantaneous photograph – as undoubtedly he did – into an entirely modern means for depicting an urban society. For it is highly probable that the many compositional innovations and peculiarly natural poses which appear in his work have their source, not in traditional art, nor solely in Japanese prints, nor purely in his imagination but largely in photography. Far from being simply an imitator of the fortuitous images of the instantaneous camera, as has sometimes been suggested, Degas made them function as new pictorial conventions in the calculated accidents with which he pictured the contemporary scene.

His artistic career almost exactly parallels the instantaneous period in the development of photography, and since most of its characteristics are intrinsic to the process it is highly unlikely that he could have influenced it. In his known letters, Degas was as suspiciously silent about photography as his Impressionist associates. There seems to be only one comment by the artist, a letter to the singer Élié Faure in 1876, asking for photographs, in this case belonging to the famous choreographer, Mérante (122, 123, 124). Degas gives only a hint that he will use them for a picture. But the testimonies of some of his friends and acquaintances describe both his interest in, and use of, photographs. Other evidence, some of it indisputable, records the fact that occasionally he employed them directly.

122–4. Disderi: Series of *cartes-de-visite* showing Mérante, Coralli, Terraris and Louis Fiocre in the costumes of the ballet, *Pierre de Médicis*. Probably 1876

Degas described his use of photographic material to Ernest Rouart, and Rouart's friend, Paul Valéry (who also knew the artist), wrote that Degas 'loved and appreciated photography at a time when artists despised it or did not dare admit that they made use of it'. Valéry quotes Rouart as saying that he had gone to the artist's studio where he was shown a canvas 'which he had sketched out in pastel, in monochrome, after a photograph'. He was among the first artists, said Valéry, 'to see what photography could teach the painter – and what the painter must be careful not to learn from it'.

In a tribute to Degas soon after his death in 1917, the artist Jacques-Émile Blanche noted the precocity of his old friend in having used the special characteristics of the instantaneous photograph:

His system of composition was new [declared Blanche]: Perhaps he will one day be reproached with having anticipated the cinema and the snapshot and of having, above all between 1870 and 1885, come close to 'the *genre* picture'. The instantaneous photograph with its unexpected cutting-off, its shocking differences in scale, has become so familiar to us that the easel-paintings of that period no longer astonish us . . . no one before Degas ever thought of doing them, no one since has put such 'gravity' . . . into the kind of composition which utilizes to advantage the accidents of the camera.

Comments on Degas's 'photographic eye' were frequent in the decade immediately following his death. His biographer, Lemoisne, for example, among other paintings compared the pose of the *Danseuse sur une pointe* (1875–6) with the arrested motion to be found in the instantaneous photograph. And singling out *Le Foyer de la Danse* of 1872 (in the Camondo Collection), Gustave Coquiot believed it had – and unfortunately so – many of the attributes of a photograph (125). Coquiot disliked the painting intensely and wrote disparagingly of it:

All these dancers, in this huge empty room, make a composition that would serve very well for a photograph; nothing more. The picture is correct, frozen; it is well balanced; but a skilful photographer would easily have managed a similar arrangement.

He believed the *Répétition d'un ballet* of 1874 (Camondo Collection) to be of the same kind:

Yes, truly, it is impossible, before a photographic reproduction of the second picture, not to imagine that one has before one's eyes an actual photograph. . . . Degas may have been a fine draughtsman, but he was not a painter.

Julius Meier-Graefe, more appreciative of the artist's talent, described the second picture aptly. The dancers, he noted, look perhaps like 'mobile puppets which have been photographed on a brown background'. But elaborating on the observation of the painter Max Liebermann, who earlier had said that 'the

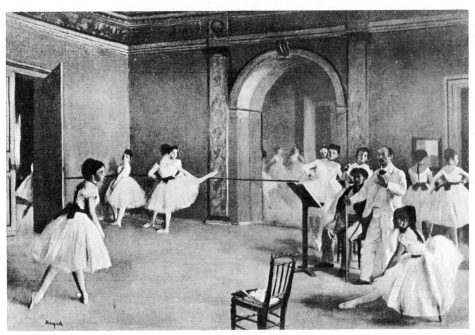

125. Degas: *Le Foyer de la Danse.* 1872

first impression created by the pictures of Degas is that created by a snapshot', Meier-Graefe insisted that Degas 'knows how to compose his picture in such a way that we do not notice it is composed at all'. Echoing Blanche's fears that the artist's reputation will decline as the photographic image becomes more commonplace, he carefully pointed out that 'by the acuteness of his vision [Degas] has seized upon a point of view with which we have become familiar from photographs', but his 'peculiar angle of vision' and his decentralized compositions, protested Meier-Graefe, come from Japanese art instead.

If Coquiot could have seen that Degas went as far beyond photography as Rodin went beyond Madame Tussaud's waxworks, and Meier-Graefe had not thought it remiss to utilize those special features of the photograph, we might have got closer to the truth. But in the 1920s 'photography' was still a tainted word to many artists and critics and could, as they chose, be maliciously invoked or judiciously ignored.[53]

DEGAS'S USE OF PHOTOGRAPHS

Perhaps the earliest indication of Degas's use of a photograph can be found in one of his sketch-books deposited in the Bibliothèque Nationale, Paris. It is a drawing of two women in crinolines dating probably about 1860 or 1861 and inscribed '*Disderi photog.*'. A brush drawing of about 1860, a portrait of his

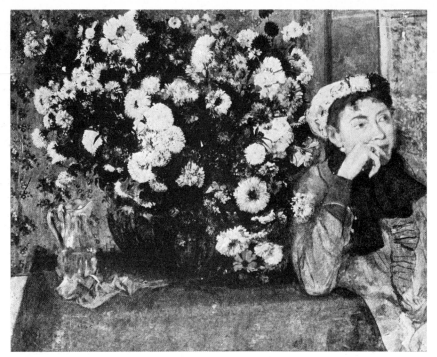

126. Degas: *The Woman with the Chrysanthemums* (Mme Hertel). 1865

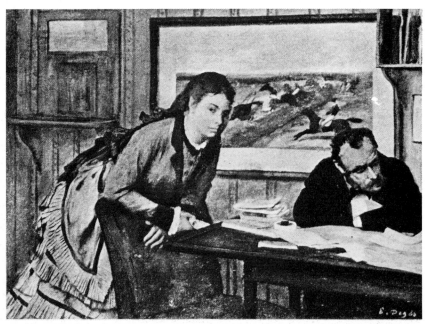

127. Degas: *Bouderie*. 1873–75

younger brother René, appears to be 'clearly copied after a photograph dated 1857', the same photograph possibly related also to one of the artist's etchings.

The peculiar decentralized compositions used by the artist in *La femme aux chrysanthèmes* (1865) (126) and *Bouderie* (1873–5) (127) and the odd angle of vision of the latter are quite distinct from normal pictorial convention. Placed at the edge of the picture space, the figures appear to communicate with something outside, enhancing the fortuitous character of the subjects and creating an implied space external to the paintings – 'in the wings', so to speak. These are entirely germane to snapshot photographs of the time, or for that matter any time. Both paintings are said to be based on photographs though, in the case of the former, only for the portrait. Pierre Cabanne writes of these two pictures. 'Some years ago in London the photos were found which he had used for the portrait of Mme Hertel: *The Woman with the Chrysanthemums*' and for the canvas entitled *Bouderie* (Sulkiness), 'he posed Mme Arthur Fontaine and M. Poujaud himself; the photograph exists and shows us that Degas followed it exactly for the composition'. In a later photograph of this couple, taken by Degas, the poses are reminiscent of the *Bouderie* (128).

In the case of Degas's small portrait of the Princess de Metternich (National Gallery, London) there is positive evidence of the use of a photograph. It is a *carte-de-visite* taken by Disderi in 1860: the Prince de Metternich, shown in the

128. Photograph of Paul Poujaud, Mme Arthur Fontaine and Degas, posed by the artist in 1894

129. Disderi: *Carte* photograph of the
Prince and Princess de Metternich. *c.* 1860

130. Degas: *Portrait of
the Princess de Metternich*

photograph, was suppressed in the painting (129, 130). The artist, Suzanne Eisendieck, discovered it some years ago and John Rewald published the information suggesting, quite reasonably, that though the artist was not acquainted with the Princess, the photograph was used because he was attracted to her striking physiognomy. The marvellous subtleties to be found in the poses of such photographs, in the strangeness of the fixed expressions and in the delicate and unexpected tonal structures would undoubtedly have interested an artist of Degas's sensitivity.

His self-portrait of about 1862, *Degas saluant*, was probably executed from or based closely on a photograph. Among photographs of the artist known today there is a small *carte-de-visite* which is similar in several respects, but what is most revealing in the painting is that the usual mirror reversals common to self-portraits are absent. As in the photograph the hair is parted on the right and the waistcoat buttons left over right; the disposition is similar to that in Ingres's late painting of himself (131, 132).

In the 1890s Degas owned a camera and took many pictures; in several he used his characteristic compositional and lighting techniques. He probably became interested in taking his own photographs in the mid 1880s through his acquaintance in Dieppe with a photographer named Barnes who worked for him and his friends. Degas sent some of Barnes's photographs to the young

131. *Carte* photograph of Degas
taken probably 1862

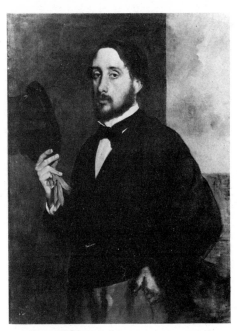

132. Degas: Self-portrait,
Degas saluant. c. 1862

Walter Sickert. At that time in Dieppe Degas may well have known the painter
Fritz Thaulow, who was said to use the camera extensively in taking landscape
views. Guérin suggested that some of Degas's late landscapes were executed
from photographs, probably his own:

in the boxes in his studio were found enlargements of photographs of places in the
environs of Saint-Valéry [sur-Somme] which were certainly direct references
photographed by him and used for his landscapes; some of these enlargements bear a
striking relationship to the artist's landscapes of that period.

Guérin also described other photographs found in Degas's studio after his death:
landscape views and a few of women ironing, taken presumably by himself or
under his direction.[54]

PROBLEMS OF PERSPECTIVE

In his book, *Le secret professionel* (1922), Jean Cocteau wrote:

Photography is unreal, it alters tone and perspective. . . . Among our painters Degas
was the victim of photography as the Futurists were the victims of cinematography.
I know photographs by Degas which he enlarged himself and on which he worked
directly in pastel, marvelling at the composition, the foreshortening, the distortion
of the foreground forms.

Degas's singular attitude to one of the most firmly established and tenacious conventions in Western art, the system of rational perspective, may well be ascribed to photography. His frequent use of looming *repoussoirs* in the foregrounds of his pictures and the dwarfing of objects slightly farther in depth is sometimes said to have been inspired by Japanese prints. But the kind of perspective scale typical of a large number of his paintings and drawings springs, most likely in the first instance, from so-called aberrations of the photographic image.

Abundant references were made in the nineteenth century to 'distortions' of this kind. It was due to an excess of sphericity in the painter's eye wrote Louis de Geofroy in 1850, in a criticism of one of Meissonier's paintings: 'The pupil in his eye fulfils absolutely the role of the lens in the daguerreotype, enlarging for him out of all proportion the foreground objects.' Nadar ridiculed Charles Marschal's painting, *Le frileux*, shown in the 1859 Salon, for the same reason. His caricature of one of the subjects sitting on the ground describes a pair of Brobdingnagian feet looming in the foreground, the monstrous distortion attributed to a 'faulty photograph' (133). Sir William Newton warned artists of this 'shortcoming' in the perspective of photographs as did Vernet, Ruskin, John Brett, Philippe Burty, Degas's friend Félix Bracquemond, Paul Huet and a number of others. There are several amusing accounts of this peculiarity. Writing in the *Art Journal*, Francis Frith, a distinguished landscape photographer, observed that ladies of uncertain age and gentlemen with uncomfort-

133. Nadar: Satire on *Le Frileux*, Charles Marschal's painting exhibited in the Salon of 1859

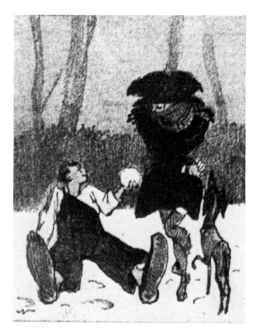

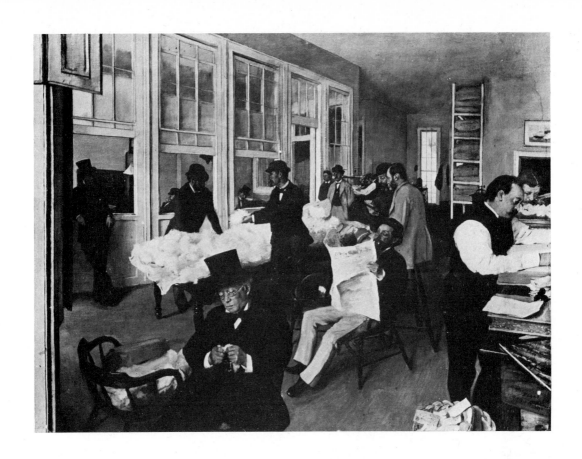

134. Degas: *Portraits dans un bureau, Nouvelle Orléans.* 1873

ably large noses had 'taken pains to spread abroad in the public mind an alarming theory about spherical *aberration*'. He placed the blame on the type of lens usually employed by portraitists, recommending instead those used for landscape.

This feature often present in photographs of interior views is particularly noticeable in Degas's *Cotton Bureau* of 1873 (134). Similarly, Robert Tait's painting of Thomas and Jane Carlyle in their drawing-room, called *A Chelsea Interior*, demonstrates the same extremes in perspective scale. Jane Carlyle had good cause to complain of this painting when she wrote, 'I wish Tait had not painted Nero [the Carlyle hound in the lower right foreground] as big as a sheep! *That* is what provokes me; more than being transmitted to Posterity in

135. Robert Tait: *A Chelsea Interior*. Exhibited R.A. 1858

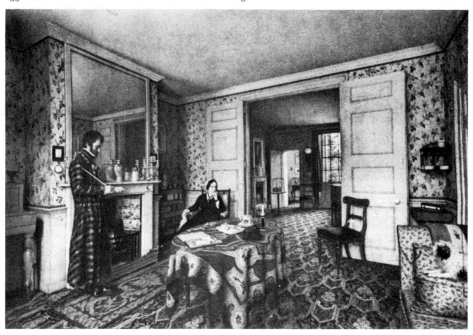

wrong perspective and with a frightful table cover!' (135). This 'wrong perspective' was called by George Frederic Watts 'the modern error'. Photography, he protested,

has unfortunately introduced into art a misconception of perspective which is as ugly as it is false. It is false in so far that it presents a foreground which makes it possible for the spectator to see the whole of the principal figure without moving his eye, and at such a distance the eye must be so far removed from the subject that sharp perspective becomes an impossibility.

But Watts's 'modern error' was a modern truth. Delacroix knew this and, as he noted, the camera faithfully reproduced such deformations in nature, literally true but artistically grotesque. Joseph Pennell provides a clear and pertinent description of this characteristic in photographs. For a series of drawings of English cathedrals he had at first used photographs of these buildings enlarged on drawing paper over which he worked in ink, the residue of the photograph being bleached out later. When, however, on visiting one of the actual sites Pennell saw how much the photographs had distorted the perspective, he destroyed the drawings already made, determined to execute the series entirely on the spot. 'When I measured the front of the cathedral as given in the photographic enlargement,' he explained, 'and compared this with the more distant portions on the enlargement, the photograph was worthless, the distance being absurdly reduced by photographic perspective.' Pennell then suggested that the photograph showed what in fact existed. But, like Delacroix, he believed that for the sake of artistic expression liberties had to be taken with what was actually there:

Now, I do not mean to say decidedly that this photographic view is incorrect. It is quite possible that it is literally correct. But artistically it is absurd. At any rate, if it is correct, it destroys all feeling of size, impressiveness, and dignity.

He then described the work of other artists, associating their use of perspective with the camera image:

That this perspective may be correct, as I say, is possible since architecturally trained draughtsmen who have not drawn from nature to any extent render objects with photographic perspective. So, too, did some of the old Dutchmen. There was a notable example of this in the last exhibition of Old Masters at the Academy, in Ver Meer's *Soldier and Laughing Girl*. But I think it extremely likely that Ver Meer used the camera lucida, if it was invented in his time, for it gives the same photographic scale to objects (136).

Questioning the objectivity of a system of perspective in use since the Renaissance, Arthur Parsey, a specialist in that field, explained in *The Science of Vision* (published in 1836, before the discovery of photography was announced) that if artists painted and drew in *correct* perspective the unusual appearance of their works would be condemned by the public. And in a second edition of his book, published in 1840 after the arrival of photography, Parsey was vindicated. The photographs of Talbot and Daguerre and their 'natural images', he exclaimed, had proved that his earlier observations were right.

In 1892, after a half century of debate on the causes of these photographic aberrations, a useful experiment was performed in which three photographs

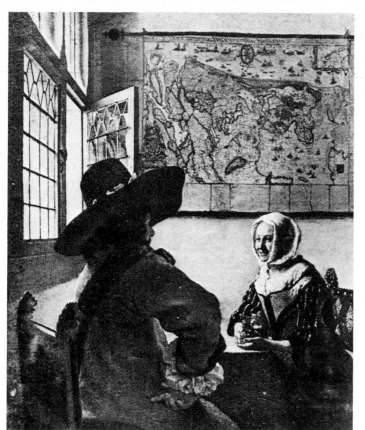

136 (*left*). Vermeer:
Soldier and Laughing Girl.
c. 1657

137 (*right*). Streintz:
Photographs demonstrating differences
in perspective scale
according to lens and viewpoint. 1892

were taken of the same landscape subject using three different types of lens. One was made with a lens of only a 6° angle of vision, another with that used in ordinary tourist cameras of 25° and the third with a wide-angle lens of 73°. The resulting perspective was different in each case (137). The variations thus produced in the perspective scales depend on the viewpoint necessitated by the angle of vision in each lens. The farther removed the lens from any measurable foreground object, the less steep the perspective between it and more distant forms; the closer, the more exaggerated will be the scale. Cinema directors have long exploited the expressive possibilities of the wide-angled lens. Carl Dreyer used it in *Vampyre* (1931), Orson Welles in *Citizen Kane* (1940) and it was extraordinarily effective in David Lean's *Great Expectations* (1945). The relevance of the wide-angled lens in films like *Gulliver's Travels* is obvious.

Quite possibly Degas was entirely aware of this photographic peculiarity and of its consonance with his ideas about pictorial form, not only late in life – as Cocteau relates – but from the time it first appears in his work. It is unlikely, I believe, that it crept in simply as a result of the 'innocence' of his eye. Indeed, among his written notes of about 1868 to the early 1880s he suggests representing things from close-up, 'as one sees them passing by on the street'. Other comments in the notebooks, no less precocious and modern, make it unthinkable that he could have ignored the equally startling images of instantaneous photographs. Like several of his other compositional innovations, this exaggerated perspective offered the potential of creating a new spatial scale with a temporal undertone entirely consistent with the accelerated growth of Paris from the 1850s into a busy and crowded metropolis.

The determination with which other artists repudiated such images reiterates the point, so clearly shown in the similar resistance to certain postures revealed by the instantaneous camera, that under pressure even artists committed to optical truth will fall back on convention. Thus, by the power of its convincing images, photography served, in these and in other respects, to undermine any ideas of an immutable perception of nature.

Ernst Gombrich has laid the stress not on convention but on the operation of built-in *constancies* which cover 'the totality of those stabilizing tendencies that prevent us from getting giddy in a world of fluctuating appearances'. In other words, the rejection of sharp perspective is not just a sign of obedience to established concepts of form, but to psychological imperatives which demand that things be seen in certain fixed relationships. According to Gombrich, the greatness of the discovery of Renaissance perspective was not that it conformed to optical truth but that it embodied something more fundamental: the need to see the world that way.[55]

The association between Degas's compositions and those of Japanese artists was made at least as early as 1880 when Huysmans described the way figures in the paintings were cut off by the frame, 'as in some Japanese prints'. There are indeed many examples of this feature in such prints, particularly in those of the nineteenth century, though it was by no means common in all styles and periods. Quite as many examples could be cited in which cutting-off and the decentralization of composition was avoided. But in the popular *ukiyo-e* woodcuts by Hokusai, and especially in those of Hiroshige, that technique was employed. In the case of the latter artist, for his *Hundred Views of Yedo* (1858–9), it is found in a most exaggerated and unconventional manner. And there is reason to believe that these last works of Hiroshige may themselves owe something to photography (138). Often, as in Hokusai's fourteen-volume *Mangwa*, cutting-off occurs more by accident than design, and certain compositions and subjects of large size spanned two facing pages which, if viewed singly, would appear in that fragmented form. As these prints became popular in Europe it is likely that many illustrated books were taken apart and disposed of as separate prints. Other compositional devices employed by the Japanese, like looming foreground forms and steep perspective scales, occur but not, it seems, as frequently as they occur in photographs. However, as far as the looming figures themselves are concerned, Utamaro's many prints of women seen in half-length and Sharaku's portraits of actors and especially certain compositions of Hokusai and Hiroshige may well have served as models.

But before a more precise assessment can be made of their influence, more will have to be known of the exact dates such prints reached the artists in Europe, and how they were interpreted after they arrived. Though a small number of Japanese prints made their way to the West long before the Impressionists were on the scene, the first reference to their connection with them seems to be a somewhat vague story about Bracquemond's acquisition of one of the *Mangwa* volumes about 1857 from a wood-engraver in Paris named Lavielle. The history of that volume in the following five or ten years, however, is rather obscure. Edward Strange records 'very few landscapes by Hiroshige' from *The Hundred Views of Yedo* in Dante Gabriel Rossetti's Collection, acquired in Paris about 1862 or 1863, probably at the Porte Chinoise of Mme Desoyes which first opened in 1862. He does not describe them. Popular colour prints by contemporary Japanese artists were displayed in the 1862 International Exhibition in London. In the Paris Exposition Universelle of 1867 such prints were shown in the Japanese Pavilion. They included the work of Hiroshige's favourite pupil, Shigenobu (Hiroshige II). Lemoisne claims that Degas himself owned a number of Hiroshige prints, though the dates of acquisition are not given. The list of

138. Hiroshige: *The Haneda Ferry and Benten Shrine*. 1858. From *One Hundred Views of Yedo*

examples, of course, grows as the high period in *japonisme* is approached in the 1870s. But what should be said here is that rather than being mutually exclusive influences on Degas, photography and these woodblock prints were mutually reinforcing ones. The propitious conjunction in the early 1860s of both Japanese prints and instantaneous photographs must for Degas have been of fundamental importance. Appropriately, Edmond de Goncourt in his book *Outamaro* (1891) compared the fortuitous qualities of the poses and gestures in the work of the *ouki-yo-yé* artists with similar forms to be found in photographs.[56]

CUTTING-OFF AND CINEMATIC PROGRESSION

On the other hand, not only were the typical forms of instantaneous photographs to be found earlier in photography, but in the astronomical number of instantaneous views (mostly anonymous) published from about 1860 these peculiarities very frequently occur (139). An excellent album in the collection of André Jammes, for example, contains 197 stereoscopic photographs called *Vues instantanées de Paris*. Taken probably between 1861 and 1865, these were put on sale by the photographer Hippolyte Jouvin. The cutting-off of figures,

139. Instantaneous photograph of the Borough High Street, London, taken in 1887 under the direction of Charles Spurgeon Jun.

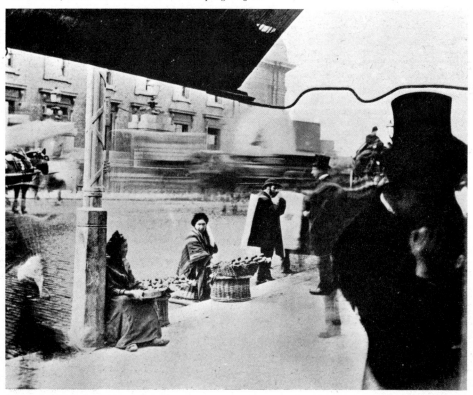

140. Degas: *Place de la Concorde (Vicomte Ludovic Lepic and his Daughters). c.* 1875

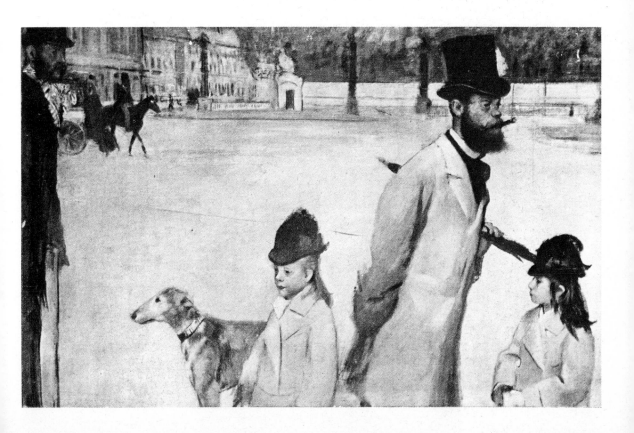

141 and 142 (detail). Hippolyte Jouvin:
Boulevard des Capucines. 1860–65 (stereoscopic photograph)

143 (*opposite*). Degas: *Carriage at the Races.* 1873

horses and carriages can be found very often throughout the series. Here are several views of the Pont-Neuf from exactly the high viewpoints as in some Impressionist paintings of the same subject. In the photographs of the boulevard de Strasbourg, in those of the boulevard des Capucines and the place de la Concorde, and in many others the inevitable dissevered pedestrians occur. In some of them, horses and carriages are cut off in much the same way as is Degas's vehicle in his pictures of a *Carriage at the Races* (141, 142, 143). Indeed, it seems that one of these pictures 'was derived from a photograph'. Mocking the photographs of Disderi, the caricaturist Cham, in *Le Charivari*, December 1861, appears to demonstrate his awareness of these forms – and this immediately preceding their appearance in the work of Degas. One of his drawings is of a standing omnibus, the back end alone visible, the remainder cut off not just laterally, but also at the bottom where no more than one third of the wheel shows. Furthermore, anticipating a device which appears later in Degas's work, the lower legs only of the passengers riding on top are visible, the upper portions of the bodies cut by the frame. Though compositions of this kind are not unknown in magazine illustration of the 1850s it is still a new convention and Cham's cartoon seems a deliberate comment on the ridiculous forms found in snapshot photographs (144).

There is no cutting-off in Degas's earliest pictures of racecourse scenes. Probably he first uses it in his *Jockeys à Epsom* of 1862 in which the head of one horse is neatly, and perhaps naïvely, severed where it joins the neck. From 1862 it becomes a constant feature in his work, particularly when the subjects

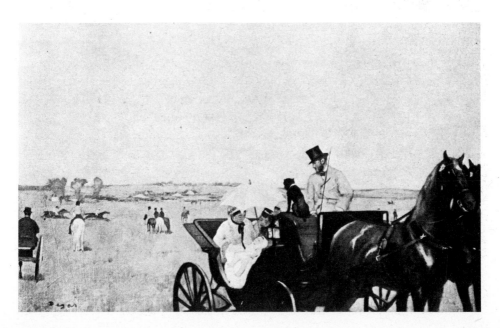

144. Cham: Detail from page
of caricatures and satire on Disderi.
Le Charivari. December 1861

145. Degas: Dancer in sequential poses.
n.d. (Lemoisne's date 1899)

are horses or dancers. In pictures like the well-known *Place de la Concorde* (*c.* 1875), for example, it is used with great skill (140).

The way in which Degas presented a kind of cinematic progression, particularly in his compositions of dancers, had seldom before been tried in painting. The juxtaposition of like subjects, and in some cases the same subject, to simulate the appearance of a single, animated figure recorded in more or less consecutive phases of its movement even antedates the photographs of Eadweard Muybridge. And in a later work (after Muybridge) like the so-called *Dancer Tying her Slipper* (1883?) (146) Degas represents, literally, *one* figure, not in sequential positions but in the same one, or two, as it would be seen from different viewpoints – as one would see it by reading a Muybridge plate vertically instead of horizontally (147). It may be worth noting that Muybridge himself sometimes organized his photographs in this way. An earlier parallel, however, can be drawn between Degas's kinetic compositions and other contemporary photographs. Disderi, for example, in the early 1860s, had taken many *carte-de-visite* series of ballet-dancers and other subjects, and a group of his photographs arranged more or less sequentially are not unlike Degas's pictures and could have contributed to their inspiration. As early as 1860 cameras were in operation which could be used to take several successive poses of the same subject on a single plate. Disderi's *cartes* were often produced in this more economical way, the plate then processed and the prints either left intact or, more usually, cut into separate images. Several examples of uncut *cartes-de-visite* have survived, most of them by Disderi (148). In 1862 he described his '*Châssis*

146. Degas: *Dancer Tying her Slipper.* 1883(?). (Lemoisne's date *c.* 1893–98)

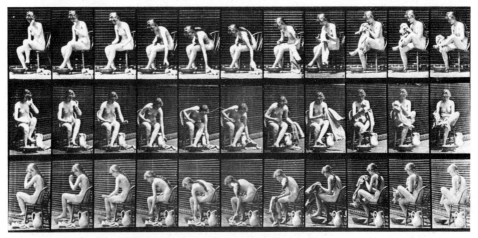

147. Muybridge: *Female, lifting a towel, wiping herself . . .*
Consecutive series photographs from *Animal Locomotion.* Published 1887

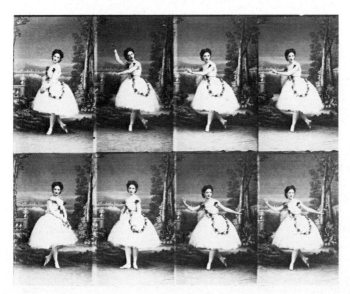

148. Disderi: Martha Muravieva
in dancing costume. 1864.
Uncut sheet of *cartes-de-visite*

multiplicateurs', a camera with four lenses which could be adapted to produce eight images on the same plate. Before long similar cameras were devised which contained up to fifteen and more lenses. Though these, more likely, were copying cameras used to multiply, simultaneously, a single image, they (like Disderi's camera) could easily have been modified to take a series of different poses.

The idea of organizing sequential images to make moving pictures was certainly in the air about 1860. In the early 1830s devices like the phenakisti-scope, the stroboscope and the zoëtrope had been invented. By means of these instruments, drawings or lithographs, utilizing the phenomenon of the persistence of vision, could be made to impart to the subjects the appearance of movement. After the coming of photography it was only a question of time for photographs to replace the drawings in these early moving-picture viewing machines, and about 1851 the new stereoscopic photographs were so used in a contraption called the 'bioscope' which reappeared in a modified form in 1860. In 1861 Dumont took out patents in France for a photographic camera

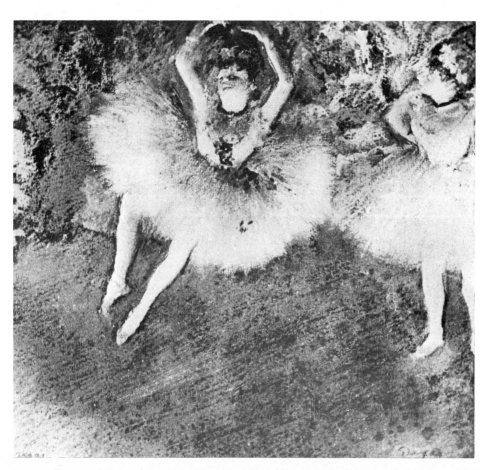

claimed to be capable of recording rapidly successive phases of movement. In 1864 du Hauron patented a similar device. But the idea of producing consecutive photographic images for their own sake, without intending to animate them, occurred at least as early as 1862 when a novel technique was contrived to take a set of photographs in a 'progressive series' while a lady was delivering a lecture.[57]

DEGAS'S HORSES

In two of Degas's pastels on monotypes, *Scène de ballet* and *Le pas battu*, both dated about 1879, the dancers are shown caught in mid-air with their legs completely off the ground (149). Their execution at this time, exactly coincident with the arrival and publication in Paris of the unprecedented instantaneous photographs of Eadweard Muybridge, is probably more than fortuitous. The first, and perhaps the only ones, of their kind to be found in Degas's known work, it is not unlikely that they reflect the intense interest of artists and critics in the extra-instantaneity of the Muybridge photographs (150).

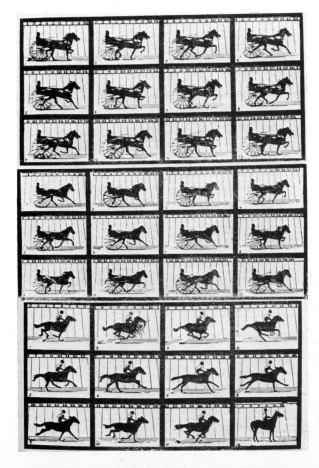

149 (*far left*). Degas:
Le pas battu.
c. 1879 (pastel on monotype)

150 (*left*). Muybridge:
Consecutive series photographs
showing phases of movement
in a horse's trot and gallop.
1877–78. Published in
La Nature. 14 December 1878

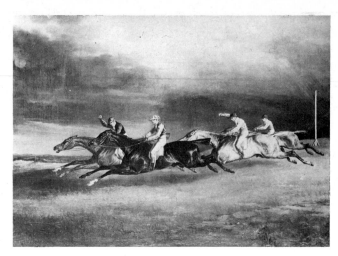

151. Géricault:
Course de chevaux à Epsom,
le Derby en 1821

'Muybridge's photographs reveal clearly the mistakes that all sculptors and painters have made in their representations of the different gaits of the horse,' wrote Valéry, and Degas, he said, 'was one of the first to study the true appearance of the noble animal by means of . . . Muybridge's . . . photographs'.

Despite Degas's precocious draughtsmanship, in a sketch-book of 1860–61 several horses are drawn in the stylized manner of English sporting prints, like Géricault's animals in his paintings of the Epsom Derby (151). In *Cavaliers sur une route*, an early painting of about 1864–8, and in other works of that period, Degas's horses are shown in this so-called flying-gallop position. In *Le faux départ* (*c.* 1869–72) and in the *Carriage at the Races* (*c.* 1870–73), where the distant background contains a lateral view of two galloping horses, he again uses the old convention. He uses it too in the *Trois cavaliers* of about 1875–77 and in *Les entraineurs* of about 1880. Clearly, before about 1880, Degas rendered all the fast equestrian positions in the already outmoded traditional way. But after this date, for the first time in his work, running horses appear in the accurate positions of instantaneous photographs. In several pictures executed in the 1880s the differences from the earlier works are immediately apparent and, after Muybridge's photographs became available in France, figures of the horse in the conventional gallop no longer appear in the work of Degas. Though the extent of the artist's reference to Muybridge is not known it can be demonstrated that in some cases direct use was made of his photographs. Several of Degas's drawings in charcoal and pastel were literal transcriptions of the horse, Annie G., to be found in volume 9 of *Animal Locomotion*, Muybridge's most extensive collection of consecutive series photographs published later, in 1887 (152, 153, 154). Some of Degas's sculpted horses also relate closely to other photographs in *Animal Locomotion*.

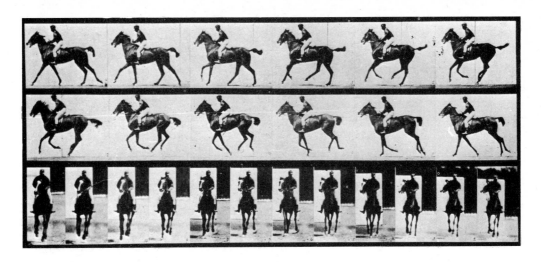

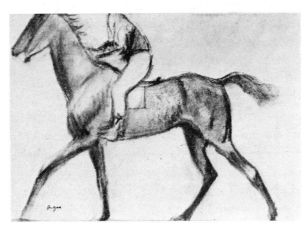

152 (*above*). Muybridge: *Annie G. in Canter*.
From *Animal Locomotion*. 1887

153 (*left*). Degas: *Jockey vu de
profil* (actually, Annie G. in Canter).
1887 or after (charcoal)

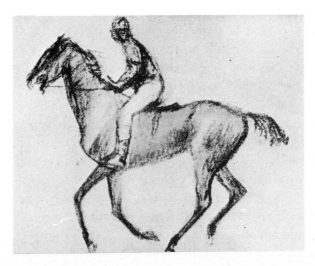

154. Degas: *Annie G. in Canter*.
1887 or after

The drawings indicated above are all dated about 1881–5 by Lemoisne, but they must be advanced to a date after the appearance of *Animal Locomotion*. Though some of the horses photographed earlier are to be found in this later work, Annie G. was not among them, all of the earlier subjects being named. Annie G. was probably one of the animals photographed by Muybridge in Philadelphia between 1883 and 1885, making her début in *Animal Locomotion*. Thus the *terminus ante quem* may be fixed at 1887. Degas's letter to Bartholomé, probably of 1888, in which the artist wrote: 'but I still have not done enough horses. The women will have to wait in their fountains' (the last, it seems, referring to a work in sculpture which he had been contemplating) is very likely a reference to his occupation at the time with the new edition of Muybridge photographs.

A significant difference might be described between the way in which Degas and the battle painters used these photographs. The latter drew on those images which obviously conveyed the new facts of locomotion yet did not too radically depart from forms they had used a decade or so before. Their animals, charging over the battle-scarred terrains to the furious sound of trumpets, were rendered in the most extravagant, the most melodramatic way (158, 159). But Degas, whose art was so carefully contrived to conventionalize the unexpected, whose cunning formulations rather promise than describe action, chose those photographs which in themselves could not easily convey the particular gait of the horse: the awkward, the peculiar intermediary positions. Though his drawings are based on the correct positions of the canter or gallop, they only indicate movement and do not make it apparent which movement it is. They provide perhaps a clue to the subtle working of his mind in extracting a formal imagery from instantaneous photographs.

Inevitably the reality of photography was criticized for its lack of style. Artists who copied literally from photographs, repeating all the inelegant accidents of nature, were severely treated by critics for their negation of the Ideal. But this uncompromising reality is in its very lack of art, in its *stylelessness*, one of the most potent elements inherent in the mechanical image. Many examples could be shown, both in the past and even today, in which paintings and drawings copied from photographs lose their force because they are not literal enough. The *non-selective* character of the lens gives certain photographs an ascendancy over paintings which otherwise, because of the more palpable nature of paint and other characteristics beyond the scope of photography, they would not have. Often, it is the very *lack* of order, the *unnaturalness*, and even the distortions in form which provide photographs with a special power. Often, the artist corrected the very things which, in the photograph, produce the great impact.

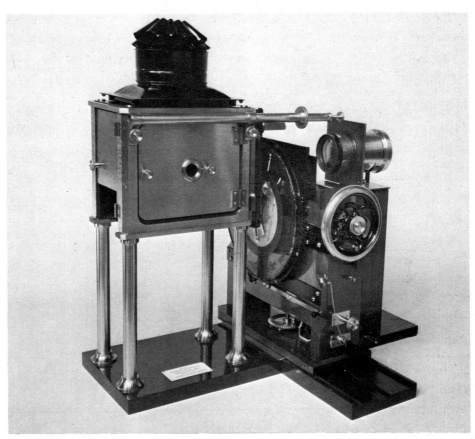

155. Replica of Muybridge's zoöpraxiscope, 1880

He tried to transform the photograph, to give it pictorial logic, when its strength resides in its lack of logic. Few artists in the nineteenth century fully understood or utilized this fundamental attribute of the camera; the force of convention was too intimidating. Degas created something new in painting from such photographic images. The Classical vestiges which lingered on in the work of Courbet and others, vanished in Degas's pictures. The deformities of his subjects, the uncouth poses and gestures, the commonplace and even ugly expressions, the apparently artless accidents of composition, are paralleled only by the images of the instantaneous camera. They are not, as some of his critics maintained, the results of a passive submission to the photograph. Degas made these things pictorially feasible, fabricating a style from sources which had no style.

Valéry's acute estimate of this process is worth repeating. Degas tried, he wrote, 'to combine the snapshot with the endless labour of the studio . . . the instantaneous given enduring quality by the patience of intense meditation'.[58]

9. The representation of movement in photography and art

MUYBRIDGE

The vast visual vocabulary of animation produced by Muybridge, the scrupulous scientific methods employed in its execution, surpassed anything of that nature previously attempted in photography. And the great interest and delight with which his photographs were received, the consternation they caused in Europe and America, augured significant consequences for art. Not only did the Muybridge photographs contradict many of the most accurate and up-to-date observations of artists, but phases of locomotion were revealed which lay beyond the visual threshold. The meaning of the term 'truth to nature' lost its force: what was true could not always be seen, and what could be seen was not always true. Once again the photograph demonstrated that for many artists *truth* had really been another word for *convention*.

The actual positions of a horse's limbs during its different strides had long interested artists. But they eluded them. During the eighteenth and nineteenth centuries many studies were undertaken in hopes of solving the difficult problems of animal locomotion. Géricault, Horace Vernet and Meissonier, among others seriously concerned with such investigations, had come to disbelieve the conventional means of representing equestrian movement, rejecting, for example, the so-called flying-gallop position. But their own observations, while more correct, were still faulty. From about the mid nineteenth century particularly, several books on the locomotion of the horse were written by veterinarians, cavalrymen and animal physiologists, and usually the intention was as much to provide the artist with visual material as it was to establish new and more accurate information for science. *Traité des courses au trot* by E. Houël appeared in 1842. Émile Debost's *Cinésie Équestre* was published in 1873 partly for the use of artists. In 1874 Lieutenant-Colonel Émile Duhousset brought out *Le Cheval* which described his preliminary discussions with the teachers at the École des Beaux-Arts and several other distinguished artists. He reproduced letters from his friends, the painters Gérôme and Eugène Guillaume, the latter Director of the École, urging him to publish this work. 'I believe that you would render a significant service to art', wrote Gérôme; and Guillaume, indicating the difficulty with which artists had to interpret the phases of animal

movement, stated that only the absolute truth would do in the study of the gait of horses. Duhousset recalled a discussion he had in Vernet's studio in which the artist despaired of being able to reproduce accurately the rapid movements of the horse, despite the reputation of his 'photographic' eye. The artist, however, hopefully explained that he had none the less improved upon this since his father's time. Meissonier, commented Duhousset, put aside his standing as an artist to become a student again, and with an indefatigable appetite for work photographed, so to speak, each movement, each interval, of the horse's gait in order to construct those wonderful positions one finds in his remarkable painting the *Retreat of 1814*, painted about 1863. In it the representation of the horse is of such merit, he said, that it ought to become a work of reference for artists who wish their pictures to be strictly in accordance with the truth.

Continuing, Duhousset surveyed representations of the *'cheval de bataille'* since the Greeks, pointing out the many erroneous positions and attributing them to artistic *naïveté*. He laboriously analysed works by Géricault, Vernet, Meissonier, the Bonheurs and others, finding most of them faulty. Though he wrote that certain positions were hardly perceptible to the eye, he had in fact been able to discover the actual positions of the gallop. It is unlikely that this was done with the help of photography, though photographs were used for one or two of the illustrations of horses in static poses. Most probably Duhousset used information derived from recent mechanical, so-called chronographic, recordings of horses' gaits by the distinguished physiologist, Étienne-Jules Marey. Despite the fact that his illustrations are almost exactly correct, Duhousset still believed that ultimately the camera would supply the correct and irrefutable answers.

There is no indication that he knew of Muybridge's work in California, where as early as 1872 the first successful though somewhat ill-defined photographs of horses in their most rapid gaits were obtained. However, during the year of publication of *Le cheval*, Gaston Tissandier, scientist, balloonist, photographer and editor·of the scientific periodical *La Nature*, wrote in a book called *The Marvels of Photography* (Paris 1874) that photographs of horses in gallop were now possible:

Certain technicians have taken photography along a new path, by the remarkable feat of obtaining instantaneous proofs. The point has been reached where a horse can be photographed in full gallop.

Tissandier did not describe them, but it is just possible that advance news of Muybridge's astounding photographs had reached him in France.

Muybridge, an English photographer in the U.S. government service, attempted to prove with the help of instantaneous photography that at a certain moment of the horse's trot all four legs were off the ground at once. The prevailing

opinion was to the contrary. Though the first of such photographs were taken in 1872 it was not until 1877 and 1878, after an approach to Leland Stanford (the Governor of California) for financial backing, that by using wet collodion plates and shutter speeds of about 1/1000th of a second, he was able successfully to produce a more comprehensive collection of photographs, not only of the trot and gallop but of the whole range of equestrian gaits. By ingenious arrangements of clockwork and electrical circuit-breaking mechanisms, the shutters of batteries of cameras were often articulated by the animals themselves as they tripped thin wires stretched across the track, producing consecutive images of the phases of the animals' locomotion. These photographs clearly demonstrated that during the trot, the canter and gallop, all four legs were indeed off the ground; in the last, just after the forelegs were retracted following their forward stride. The positions revealed by the cameras must have appeared ludicrous. They contradicted almost all of the previous representations made by artists. The most startling thing about the gallop was that, unlike the traditional flying gallop in which all four legs were shown off the turf, spread out like those of a frozen rabbit, they were at one moment proved to be jack-knifed beneath the body of the animal. Henry Alken's description in 1816 of the proper means to represent the gallop clearly points up the differences between the old and the new:

All the legs should point straight forward, and appear to act with ease to themselves . . . [the horse] should seem to glide over the surface of the ground without any symptoms of violent action.

The results of Muybridge's investigations were published internationally in many periodicals during 1878 and 1879. Tissandier reproduced a few of Muybridge's plates in *La Nature* on 14 December 1878. The horses were shown in lateral positions silhouetted against a light background grid (150). The long-standing problems, he explained, involving the different gaits of the horse were finally to be solved. He informed his readers that the actual photographs from which the illustrations were made were deposited in Paris: '*chez MM Brandon et Morgan Brown, 1 rue Laffitte*'.

A sizeable response and many requests for photographs indicated the interest of readers, among them Marey, who for many years had been conducting experiments in several kinds of physiological motion. Because of the limited results produced by mechanical measuring instruments like the odograph and chronograph, Marey had been tinkering with the idea of using photography. On seeing the Muybridge article he must immediately have been convinced that photography was the most efficacious means of advancing his researches. Keenly interested in Muybridge's techniques he wrote an enthusiastic letter which was published in *La Nature* a fortnight later. He asked to be put in touch

with the photographer, eager to discuss the problem of photographing the flight of birds. It had, in fact, been Marey's earlier work on animal mechanism which inspired Muybridge to resolve the problems of the horse's locomotion by means of photography. The letter was sent to California and a correspondence followed which resulted in a visit to France by Muybridge and Stanford in 1881.

Marey predicted a revolution in art when painters were 'provided with the true attitudes of movement, those positions of the body, momentarily stabilized in transition, which no model could hold'. It is incontestable, he stated, that at the present day artists make great efforts to represent the horse with truthfulness, and many of them succeed, but the gallop still leaves much to be desired. Artists ought to study physiological facts, for the public will soon demand them. The relations of time, he wrote, are already apparent; we must now become acquainted with the relations of space. The scientist described the strange appearance of Muybridge's photographs of a fast-trotting horse and how absurd and wholly unexpected they looked. His observations were confirmed by others to whom the artistic implications were apparent. The new visual forms were so antagonistic to those established by tradition that no artist, it was said, could have shown horses that way without being accused of being untrue to nature and of indulging the fantasies of his imagination.

To Muybridge it must have been clear that the discrepancy between photographic fact and artistic convention would precipitate a number of difficulties.

If it is impressed on our minds in infancy [he wrote some years later], that a certain arbitrary symbol indicates an existing fact; if this same association of emblem and reality is reiterated at the preparatory school, insisted upon at college, and pronounced correct at the university; symbol and fact – or supposed fact – become so intimately blended that it is extremely difficult to disassociate them, even when reason and personal observation teaches us they have no true relationship. So it is with the conventional galloping horse; we have become so accustomed to see it in art that it has imperceptibly dominated our understanding, and we think the representation to be unimpeachable, until we throw all our preconceived impressions on one side, and seek the truth by independent observation from Nature herself. During the past few years the artist has become convinced that this definition of the horse's gallop does not harmonize with his own unbiased impression, and he is making rapid progress in his efforts to sweep away prejudice, and effect the complete reform that is gradually but surely coming.

The reactions of Meissonier, when first shown Muybridge's photographs in 1881, were described by Georges Demenÿ, Marey's *aide*:

The great painter Meissonier . . . came to our laboratory concerned with the gaits of the horse which he was trying to represent exactly. When he saw the first photographic analyses that we presented to him, he gave a cry of astonishment and accused our camera of seeing falsely. When you give me a horse galloping like this one – and he

showed one of his sketches – then I shall be satisfied with your invention. But photography has proved the painters wrong and they have had to modify the gaits of their horses and like the others, Meissonier obeyed the photograph in the end.

Meissonier had an enormous reputation for artistic fidelity. His small and incredibly exacting canvases earned him both praise and the abuse of caricaturists and critics who accused him of being a master of 'microscopic art', of painting mere '*tours de forces*', and of necessitating the use of a fictitious 'multiplicotograph' with which visitors at the Salon were obliged to examine every minute detail of his tiny *cartes-de-visite*. Undoubtedly Meissonier had been in the habit of using photographs though, as an admirer stated, only 'as Molière consulted his servant'. It was said that he surpassed even the realism of the camera. He had even gone to the extreme of constructing, parallel to a racing-track, a miniature railway on which, in a small trolley, he could propel himself at the same speed as that of a galloping horse on the adjacent track in order more accurately to observe and sketch the most subtle articulations of the animal's limbs. It was not surprising that Meissonier considered himself and was considered the foremost living artist to have spurned the conventional modes of representation and to have rediscovered the truths which, he believed, only the Assyrians had known before him. He even broke down one horse in an effort to understand the gallop which had constantly eluded him. In 1881 Stanford visited the artist in Paris, asking him to paint a portrait of his wife. Meissonier at first refused but when the Californian offered to show him hundreds of photographs, not only of horses in motion, but of oxen, stags, dogs and men, the artist could not resist and painted his portrait, and presumably one of his wife also. The hundreds of photographs with which Stanford enticed Meissonier were published that year in a limited edition without text. Each volume bore the title *The Attitudes of Animals* and consisted of about 200 photographs by Muybridge, obviously the one shown open on a table in the portrait of Stanford.

In November 1881 Meissonier gave a reception in his studio for the famous photographer, inviting a large number of distinguished artists and writers to attend. *Le Figaro* reported the exciting event:

Yesterday in Meissonier's studio we witnessed a most extraordinary spectacle. M. Muybridge, an American photographer whom M. Leland Stanford former Governor of California has taken under his patronage showed to an audience of painters, sculptors and men of letters, a series of projections by electric light of a novelty which was truly fantastic. It is an artistic revolution and the spectators invited by Meissonier were well entertained.

These projections, produced with an ingenious instrument called a zoöpraxiscope, were cinematic and, though sequentially projected photographs were

known earlier, they can be counted among the forerunners of the cinema (155). Those present included the painters Berne-Bellecour, Cabanel, Detaille and Gérôme in all of whose work the influence of Muybridge becomes increasingly apparent. After having seen the Muybridge photographs in 1881, Duhousset published a revised edition of his earlier book in which the photographer was mentioned. He reproduced a letter from Marey praising the new relationship between art and science:

Give to artists a series of figures where the truthfulness of the attitudes of a horse in motion is combined with accuracy of form, and you will have done a great service. Some masters have already, in this respect, enlightened public taste; once instructed, the public will no longer accept either convention or caprice.

In 1881 and 1882 Stanford published *The Horse in Motion*, illustrated with lithographic drawings made from Muybridge's photographs and containing a proper text by J. D. B. Stillman.

If Art is the interpreter of nature, as is claimed [the writer insisted], she is false to her mission when she wilfully persists in perpetuating a falsehood . . . the error of the old theory of the gallop becomes so manifest, that artists will no more be able to claim that they represent nature as she seems, when they depict a horse in full run in the conventional manner, or in the mythical gallop.

But not all artists or critics were happy with the current artistic revelations or with the dicta of writers like Stillman. In 1882 a reaction against Muybridgitis appeared in the February issue of the *Gazette des Beaux-Arts*.

To the great surprise of photographers and of all those who saw these prints, the attitudes are, for the most part, not only disgraceful but of a false and impossible appearance . . . the Americans haven't refrained from giving the lie to Géricault and to Vernet . . . they have pretended that the Muybridge photographs were a kind of revelation which should overthrow all accepted notions about drawing the horse.

Even in the Vienna Academy, the writer (Georges Guéroult) noted scornfully, a professor already recommends the use of these photographs to his students. Ocularly, they are false because they present us with an image

at the moment when, because of its speed and the persistence of impressions on the retina, we should be unable to see anything but a blurred image, the shape of which being made up at one and the same time of the preceding and the following positions. Considering the way the human eye is constructed, it is certain that it cannot see and will never see the galloping horse as it is shown in these pictures.

The spinning-wheel in Velasquez's *Las Hilanderas*, and rain which is represented by lines were offered here as more truthful images of moving forms. Not, in short, what was there, but what the eye saw there.

Guéroult's antagonism for the Viennese professor could soon have been directed against targets closer to hand. A special meeting of the Académie des

Beaux-Arts was held in November that year during which a lecture by Édouard
Cuyer, painter and prosector at the École des Beaux-Arts, was given on the
gaits of the horse. The work of both Muybridge and Marey was described and,
using some of the first photographs taken by Marey, Cuyer showed a moving
picture of the different gaits of the horse in order to clear up the remaining
obscurities in the details of its positions. Reporting this event the *Gazette des
Beaux-Arts*, taking no special side in this argument, noted how useful Cuyer's
methods of demonstration would be to artists and what a real service it would
be to the student in helping him observe nature. In 1883 and 1884 several new
books and articles appeared, based on the Muybridge photographs, repeating
tediously the clichés of the truth of movement.[59]

ANIMAL LOCOMOTION

Leaving the Continent, Muybridge went to England where he was received
with much interest. On 13 March 1882 he appeared before a special meeting
of the Royal Institution. The notices of the proceedings are of particular value
in view of the scarcity of information at that date concerning Muybridge's own
views on his work. In the form of verbatim notes, they reveal his under-
standing of the more profound issues involved. At that meeting, to the delight
of the audience, he again used his 'photo-praximoscope' (zoöpraxiscope), the
same device employed in Meissonier's studio, by which a series of consecutive
photographs could be seen as one continuous movement. After a brief discussion
of past interest in the action of horses (Aristotle was cited among others), of the
use of the excessive projections of the limbs to symbolize speed (said to have been
an Egyptian convention), and a demonstration of the errors in contemporary
paintings, Muybridge, perhaps sensitive to the criticism in the *Gazette des
Beaux-Arts*, made these discreet observations:

The ambition and perhaps also the province of art in its most exalted sense, is to be
a delineator of impressions, a creator of effects, rather than a recorder of facts.
Whether in the illustrations of the attitudes of animals in motion the artist is justified
in sacrificing truth, for an impression so vague as to be dispelled by the first studied
observation, is a question perhaps as much a subject of controversy now as it was
in the time of Lysippus, who ridiculed other sculptors for making men as they existed
in nature; boasting that he himself made them as they ought to be.

Muybridge also demonstrated his photographs in the lecture theatre of the
Royal Academy which was 'filled to overflowing'. Sir Frederick Leighton
P.R.A., most of the Academicians and Associates and a large number of guests
were present. In June he repeated his lecture for the Society of Arts in London.
The *Magazine of Art* that year published an article on instantaneous photography
supporting the idea that these photographs would be of use to the artist: 'such

things are sketches, it is true, but they would be invaluable to any painter of the life and manners of our metropolis'. Following Muybridge's visit to England several publications appeared in which his photographs were reproduced or discussed.

Muybridge returned to America, and from 1883 to 1885 he continued and greatly expanded his work under the auspices of the University of Pennsylvania. The painter, Thomas Eakins, Head of the Pennsylvania Academy Schools (attached to the University), had for some years promoted the idea of a comprehensive work of this kind and helped convince the University authorities that Muybridge's work was worth financing. On first learning of Muybridge's photographs in 1879, Eakins communicated with him and acquired a set, which he may have used in his classes. A photographer as well as a painter, Eakins was absorbed by the problems of animal locomotion. He found fault, however, with the technique employed by Muybridge and about May 1879 wrote to the photographer, suggesting what he believed to be a more accurate method – that of photographing the phases of movement from each viewpoint on a single plate – one of the methods, in fact, which Marey later adopted. Muybridge apparently refused to change his technique, and Eakins, in August 1884 deriving no satisfaction from his criticisms, modified his instantaneous photographic apparatus and, concurrently with Muybridge's work in Philadelphia, carried out his own investigations. While at the University, Muybridge lectured at least twice at the Academy Schools, in 1883 and 1884. By the spring of 1885 Eakins, far enough advanced with his photographs, himself lectured to the Pennsylvania Academy on the motion of the horse, illustrating his talk with a zoëtrope. Muybridge must have remained antipathetic towards Eakins, for the latter's name does not appear among those members of the University of Pennsylvania whose 'generous assistance' he later acknowledged.

Muybridge completed his work in Pennsylvania in 1885 and, in 1887, it was published with the full title: *Animal Locomotion, an Electro-Photographic investigation of consecutive phases of animal movements*. This vast collection of photographs was eagerly received by artists and scientists, who were now well aware of Muybridge's activities. A later and less extensive edition, published in London in 1901 (*The Human Figure in Motion*) contains a list of subscribers to the 1887 publication in the form of facsimile signatures. These include many of the most prominent personalities in the arts and sciences of several countries: Leighton, Watts, Herkomer, Alma Tadema, Luke Fildes, Poynter, Orchardson, Dicksee, Sargent, Du Maurier, Millais, Holman Hunt, Whistler, Ruskin, Huxley, Edison, F. von Uhde, Franz Lenbach, Menzel, Kaulbach, Helmholtz, Henry Thode, Meissonier, Gérôme, Bouguereau, Detaille, Aimé Morot, Puvis de Chavannes, Rodin, Tissandier, Marey. The entire list is much longer.

The photographs were intended principally as studies for artists: an extensive atlas of human and animal locomotion; a nineteenth-century equivalent to the medieval pattern-book. Published by the University of Pennsylvania, *Animal Locomotion* contained 781 plates, with a total of more than 20,000 figures in almost all stages of human and animal activity or, as the catalogue puts it, 'actions incidental to everyday life'. The price was enormous. One hundred plates (reproduced by photo-gelatine printing) cost 100 dollars and, with the purchase of 600 plates, the remaining 181 were included without additional charge. Photographs taken from 1872 to 1885 were used. The size of the plates varied from 9 by 12 inches to 6 by 18 inches. Up to twenty-four cameras were employed for the lateral views and others were so placed and co-ordinated by timing devices that each series could be taken simultaneously from different viewpoints. The interval and exposure times were accurately noted in the catalogue. These were varied in each group to conform to the subject and its natural rate of movement. Some exposures were made with shutter speeds as high as 1/6000th of a second, then possible with the new dry-plate. The human models were carefully divided according to age, physical type and occupation. Even marital status was taken into consideration. In short, the whole project was carefully designed to produce a comprehensive visual cross-section of society in motion. The descriptions in the catalogue are precise: 'walking and turning around rapidly, a satchel in one hand, cane in other'; 'stepping out of bath-tub, sitting down, wiping feet'; 'base-ball, catching and throwing' and even 'chickens, scared by torpedo' – this last, number 781, the final plate in the series, illustrated an experiment using explosive force to set off a clockwork motor and simultaneously to provoke the nervous reaction of the subject.

Stringent laboratory conditions were imposed in making the *Animal Locomotion* photographs. Wherever possible, each set of pictures was taken before a large

156. Muybridge: *American Eagle Flying*. From *Animal Locomotion*. 1887

157. Muybridge: *Cockatoo Flying*. From *Animal Locomotion*. 1887

numbered background grid so that both the lateral and vertical distances through which the subjects moved could later be calculated. Abnormal movements were also included, providing even today's artists, like Francis Bacon, with images astounding – if not for their instantaneity – for their aberrations of the human form. Locomotor ataxia and spastic gaits, the movements on and off a chair by a boy with double amputation of the thighs were recorded as were the lumbering motions of a terribly oedematose female. Several animals and birds (156, 157) formed part of the series, most of them taken at the Philadelphia Zoo: the lion, tiger, elephant, camel, baboon, kangaroo, pigeon, hawk, vulture, ostrich, stork and swan. Horses predominate and many types are presented in every conceivable action. It is only to be expected that following the date of this (Muybridge's most important) publication, artists whose subjects were in any way locomotive should find it expedient to consult it as a final and most convenient authority for the representation of humans and animals in movement.

A sizeable list could be compiled of painters who were in one way or another influenced by these photographs. Aimé Morot's galloping cuirassiers, in his *Charge of Cavalry at Reischoffen*, executed in 1887, ride on horses which depend (at least for the new version of the flying gallop) on the Muybridge photographs. Edouard Detaille's animals in *En batterie*, exhibited in the Salon of 1890, are in positions shown by these photographs (158). In Stanley Berkeley's battle-piece, *For God and the King*, in the 1889 R.A. exhibition, the horses of the cavalrymen are in instantaneous positions more or less according to Muybridge (159). The galloping horses in John Charlton's *Balaclava*, also shown at the R.A. in 1889, rely on the Muybridge publication for their accuracy.

Muybridge produced a few series of hands and forearms only, in one of which one hand alone is shown moving rhythmically to music; in another, both hands

158 (*left*). Detaille:
En Batterie. Exhibited
in Salon of 1890

159 (*below*). Stanley Berkeley:
For God and the King. 1889

in the act of clasping. Their positions, their thin, bony, elegant structure and the articulation of light and shade on the surfaces, are strikingly similar to some of Rodin's sculptures of hands. Though Rodin was critical of the way in which the Muybridge photographs depicted movement, and though the initial stimulus for his groups of hands came most likely from the many fragments which were kept in his studio, he may also have been moved by the Muybridge photographs (a set of which he owned) to give these fragments a new artistic relevance.[60]

MUYBRIDGE: PROS AND CONS

In 1889, more popular than ever, Muybridge was back in London giving illustrated lectures to the Royal Society, the Royal Academy, the South Kensington Art School (now, the Royal College of Art) and to other, no less distinguished groups. His audiences seemed delighted with the new game of discovering the errors in earlier paintings. They were amazed to learn that North American Indians had long represented horses more or less correctly in the gallop, with their legs tucked up beneath their bellies, and that Japanese artists had represented birds in flight with their wings in the down-stroke. From all indications it appears that both artists and public were already well conditioned to Muybridge's visual revelations and not only would painters now dare to represent their subjects in accordance with those photographs but would jeopardize their reputations if they did not. 'The chief use of the camera to the artist,' said John Brett, 'lies in its power of securing images of rapidly moving animals', and he urged his colleagues to show their gratitude to Muybridge.

Some speculation arose about the origin of the flying gallop, one view being that the optical system could more easily record the extreme positions in the extension of the limbs, and even though they were not coincident in time, they were the longest in duration compared to other positions and thus more observable. In fact, during the leap, horses assume a position very close to that of the flying gallop at a moment when the pace is considerably reduced (160).

160. Muybridge: *Pandora jumping hurdle*. From *Animal Locomotion*. 1887

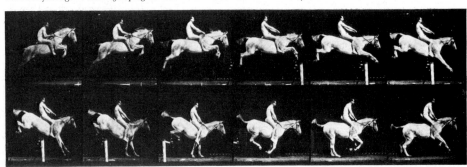

There is some merit in the argument that the expanded form of the flying gallop itself induces a greater sense of motion than do others in which the legs are contracted, and that it was through understanding this that the convention first arose. This idea, however, may be disputed in its own abstract terms. The equilibrium of forms in the flying-gallop position would negate rather than enhance the feeling of movement, while the apparent oscillation patterns of the animal's legs in the photographs at least conveys the sense of incompleteness and of continuity which a movement in terminus does not. Furthermore, and of most relevance, one cannot easily divorce the form from its context and still hope to retain the original meaning. The knowledge of what a horse actually does in the gallop, the belief that the photograph is correct, may just as convincingly produce in that kind of representation the sensation of movement as did earlier the belief in the pictorial correctness of the flying gallop. Before that, the 'rocking-horse' convention in which the hind legs were planted firmly on the ground, the forelegs parallel and pointing upwards, must quite successfully have symbolized movement. The curious Chinese flying gallop with both pairs of legs trailing behind like streamers in the wind was probably no more, no less, an efficacious sign for movement.

Inevitably, Muybridge's photographs and the great hullabaloo over them precipitated some critical thinking about the visual imagery of movement, and opposition opinions arose. Photographers, no less than painters and sculptors, objected to instantaneous photographs. Some thought them false because they often contradicted what would be seen with the naked eye. Others, because *artistically* true images of motion could be created which were superior either to the photograph or to optical logic. What is the good of taking a photograph of a train going sixty miles an hour when in the print it looks like it is standing still? asked the photographer, P. H. Emerson, in 1889. The artistic photographer should represent what he sees and no more, he insisted.

The impression of the quick exposures should be as seen by the eye, for nothing is more inartistic than some positions of a galloping horse, such as are never seen by the eye but yet exist in reality, and have been recorded by Mr Muybridge.

Another photographer that year, Captain W. de W. Abney, explained that the human vision was more responsive to positions of movement which were as near rest as possible. Among the photographs of Muybridge, he asserted, that kind of position struck one as being most truthful. It may have been because of this, he continued, that earlier artists described the gaits of the horse as they did. Like the critic in the *Gazette des Beaux-Arts*, he also discussed the importance of the persistence of vision and came down on the side of the blurred image.

A few years later Joseph Pennell criticized a painting (probably one executed by his old master, Eakins) at a conference of photographers in London:

if you photograph an object in motion [he said], all feeling of motion is lost, and the object at once stands still. A most curious example of this occurred to a painter just after the first appearance in America of Mr Muybridge's photographs of horses in action. This painter wished to show a drag coming along the road at a rapid trot [most likely *The Fairman Rogers Four-in-hand* painted in 1879]. He drew and redrew, and photographed and rephotographed the horses until he had gotten their action apparently approximately right. Their legs had been studied and painted in the most marvellous manner. He then put on the drag. He drew every spoke in the wheels, and the whole affair looked as if it had been instantaneously petrified or arrested. There was no action in it. He then blurred the spokes, giving the drag the appearance of motion. The result was that it seemed to be on the point of running right over the horses, which were standing still. And in that condition he was forced to leave the picture, as the intelligent art patron, who had ordered it, wanted to have his horses' legs shown.

An interesting and perceptive argument against Muybridgism comes from Auguste Rodin. In conversations with Paul Gsell, the *St John the Baptist* was compared with instantaneous photographs of walking figures. The manner in

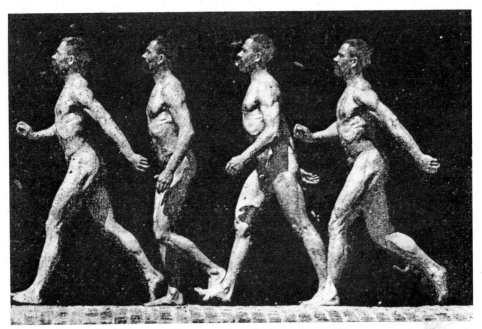

161. Marey: Chronophotograph of walking figure. *c.* 1887

which such photographs arrest movement is described by Gsell: 'They never seem to advance. Generally, they seem to rest motionless on one leg or to hop on one foot' (161). And Rodin agreed, pointing out that the striding St John has both feet on the ground, inconsistent with photographic truthfulness but

162. Rodin: *St John the Baptist*. First conceived 1878 (bronze)

which, as art, more successfully conveys the idea of a progressive development
of movement (162). The sculptor was then asked how he reconciled his belief
that the artist should copy nature with the greatest sincerity, with his inter-
pretation of movement which is at odds with photographic veracity.

No [answered Rodin], it is the artist who is truthful and it is photography which lies, for in reality time does not stop, and if the artist succeeds in producing the impression of a movement which takes several moments for accomplishment, his work is certainly much less conventional than the scientific image, where time is abruptly suspended.

And well aware of the literal-minded application of Muybridge photographs in the ranks of the battle painters, Rodin continued: 'It is that which condemns certain modern painters who, when they wish to represent horses galloping, reproduce the poses furnished by instantaneous photography.' He then defended Géricault's use of what in French is called the *ventre à terre* (the belly to the ground) position, referring particularly to his *Epsom Derby*: 'Now I believe that it is Géricault who is right, and not the camera, for his horses *appear* to run', and though false in reality are nevertheless true because of the way in which the spectator observes the gallop and believes it to be.

Probably the most effective depreciation of the instantaneous image in art, against Muybridge's photographs especially, came from the scientists and philosophers who were concerned with Plateau's theory of the persistence of vision: the prolongation of one image on the retina even while the eye is taking in another.

In 1878 the philosopher Eugène Véron discussed the representation of movement in art and photography. That was the same year in which the first Muybridge photographs had appeared in Paris, though *after* Véron had recorded his views. He criticized the frozen images of the academics from the schools of David and Ingres, saying that 'the theories of those who approve immobility in drawing' reduce it to no more than photography. The recent discovery of the persistence of vision, he insisted, has finally undermined the Neo-Classicists. Photography could not render movement, 'simply because it is only able to seize absolutely stationary attitudes. This is one of the chief of the disabilities which will always effectively prevent it from usurping the place of art.' Reality, he added, should be represented 'as it presents itself to our visual sense [not] as it is'. Painting ought to be in accord with the physiological nature of man.

Ogden Rood, the American scientist whose book *Modern Chromatics* (1879) was of major importance in the colour theories of the Neo-Impressionists, made some useful observations in the same book on the duration of the impression on the retina. Like after-images (complementary images) of colours which allow optical colour-mixing, he noticed that *spots* of reflected sunlight on water in motion actually appeared as elongated streaks and it is in that way that we interpret the differences between the forms of large water masses and small moving waves. Instantaneous photographs, he said, which give the momentary appearance of light, though true appear false:

waves breaking on a beach appear to us different from their instantaneous photo-
graphs: when viewing the real waves we obtain an impression which is made up of
the different views rapidly presented during several minute intervals of time, whereas
the photograph gives us only what takes place during *one* of these small intervals.

This, he continued, applies also to other moving water and

explains the transparency of rapidly revolving wheels. Owing to the same cause,
the limbs of animals in swift motion are only visible in a periodic way, or at those
moments when their motion is being reversed; during the rest of the time they are
practically invisible. These moments of comparative rest are seized by artists for
delineation, while the less discriminating photograph is as apt to reproduce inter-
mediate positions, and thus produce an effect which, even if quite faithful, still appears
absurd.

The advocacy by philosophers and scientists of physiological optics in artistic
representation, especially in the representation of fast-moving objects, was
bound to encourage the acceptance of the blurred form. Thus, the appearance
of Muybridge's photographs, by this irony, by forcing the arguments of the
physiologists, may have helped to guarantee the more positive response towards
Impressionism at the end of the century. And yet, by a further irony, the most
unremitting naturalists, the proponents of literal over optical truth, helped to
establish the conditions for the modernism of Neo-Impressionism, of Cézanne,
Cubism and Futurism.[61]

MAREY

Through the astounding versatility of the photographic technique, images were
produced which in some ways satisfied literal, optical *and* artistic truth at the
same time. This, I believe, can be said of the photographs taken by Marey.
Stimulated by the work of Muybridge, the scientist largely abandoned his
mechanical processes about 1881 and developed photographic devices by which
the articulation patterns and the trajectory paths of moving bodies could be
recorded.

In a communication to the Institut of 5 May 1882 Marey described
his 'photographic gun', as much a forerunner of the ciné-camera as was
Muybridge's zoöpraxiscope that of the ciné-projector. Marey also developed
what was called a chronophotographic technique much like that of Eakins.
The resulting images, though lacking the clarity of those by Muybridge,
surpassed them by showing each phase of the movement in its correct spatial
position relative to all the other phases recorded on the same plate (163).
Furthermore, the contiguous and superimposed images of the chronophotograph
revealed the continuity patterns of the movement itself. Marey seemed more
interested in the measurable graphic signs of movement than in the internal

163. Marey: Chronophotograph of the flight of a bird. 1887

changes in the anatomical structure of the subject. He contrived to have the mobile figure record both its own trajectory paths and the oscillation patterns of its movement. His report on the '*Locomotion de l'homme*', presented to the Académie des Sciences on 2 June 1885, was illustrated by stereoscopic photographs of linear trajectories made during a slow walk and a slow run. The techniques for making these and other analytical photographs were suggested by Eugène Chevreul. With the shutter of the camera held open, a bright spot attached to a figure dressed in black was recorded during its movement across a black field. Also, by means of white strips running the length of an arm or leg, the shutter of the camera being activated intermittently, Marey was able to obtain oscillation graphs of his moving subjects (189, 192).

These abstract signs were to become the visual schemata in a new language of motion. Trace images behind moving objects, so commonplace in the work of our modern cartoonists, are rarely to be found before photography and only very occasionally antecede Marey's chronophotographs. As has often been the case, popular graphic artists, caricaturists especially, less inhibited by convention, exceeded painters in inventiveness. In the work, for instance, of the German satirical draughtsman, Wilhelm Busch, a brilliant power of observation is demonstrated in a few sets of drawings, executed in the 1860s and 1870s, which for their effectiveness depended on images undoubtedly derived from the multiple exposure of photographs. His subject in a photographer's studio, unable to withstand the rigours of posing, performs the same service as did Marey's animated models. Their prototypes were probably among those early 'unsuccessful' photographs of excessively long exposures in which blurring and

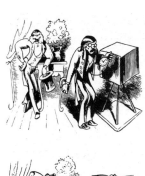
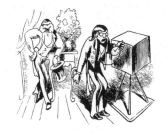
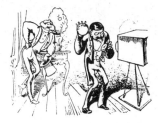

164. Wilhelm Busch:
Der Photograph. 1871

so many oddities of superimposition occurred (164). Busch's frantic pianist, hammering away *fortissimo vivacissimo*, with several extra digits on each hand, prefigures the widespread use of residual oscillation patterns in the art of this century. In the 1880s and 1890s, paralleling Marey's photographic investigations, similar examples in the popular arts can frequently be found.[62]

SEURAT

Possibly employed by Seurat, these new symbolic forms which represent movement were later to have a special significance in the work of Marcel Duchamp and the Italian Futurists. Though in his earlier paintings Seurat's principal interests were in the luminous effects of light and colour, later he concerned himself with other visual phenomena as well, among them the optical and expressive properties of movement. The stimulation for this probably came from a scientist friend, Charles Henry, who, among other things, proposed in his writings some brilliant-sounding theories on the expressive nature of directional lines. Seurat was introduced to Henry about 1886. That began a close association between the two, with the artist applying himself assiduously to the theories of his friend. Henry's book, *Cercle Chromatique*, published in 1888–9, was a profusion of formulae, diagrams and numerical calculations, with one section devoted to what the author called a general theory of *dynamogénie*: a treatise on contrast, rhythm and measurement, and their application to aesthetics. In discussing progression patterns of the articulation and velocity of parts of the human body, Henry referred to Marey's work in that field. He noted specifically the report made in 1885 to the Académie des Sciences

describing the technique for recording paths of movement by stereoscopic photography. Marey was more than a footnote in Henry's book and there is every likelihood that Henry was well acquainted with the whole range of Marey's investigations and with the photographs and diagrams used in them. Seurat's painting, *Le Chahut*, executed in 1889–90 just following the appearance of *Cercle Chromatique*, was in part an attempt to apply Henry's dynamogeny theory (165).

Parts of *Le Chahut* are strikingly similar to Marey's chronophotographs and his diagrammatic charts based on them (166). The superimposed sequence of dancers and the repeated folds of their costumes approximate to the patterns found in Marey's photographs. Was it because of wanting to maintain a visual consistency in the pattern of the dancers' legs that Seurat painted them all as female, despite the fact that two of them are male? One finds here, prefiguring the Futurists, what may be a representation of trace images external to the moving forms, interspersed between the lower feet of the dancers. Though these

165. Seurat:
Le Chahut. 1889–90

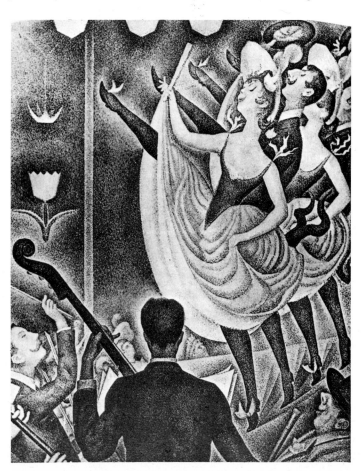

images conform to Henry's three-pronged radiating pattern of expressive lines denoting gaiety, they do not coincide with any tangible form as do other symbolic lines in Seurat's late paintings. It has been suggested that they may represent the shadows and penumbrae cast by footlights. But autonomous or not, it is hard to escape the conviction that this was both dynamogeny and Marey wrapped up as one, and very similar forms will be found, for example, in Marey's diagram of a running figure published in September 1886. Theo Van Gogh recognized the novel manner in which *Le Chahut* expressed the sensation of movement. He wrote to his brother on 19 March 1890: 'Seurat is showing a very curious picture . . . in which he has made an effort to express things by means of the directions of the lines. He certainly gives the impression of motion.' Recently, the possibility of a connection between Seurat and Marey has been supported in Jean Renoir's book on his father. He states that it was known that Seurat believed that movement could be studied through photography and that he was very much interested in Marey's 'photographic gun'.[63]

166. Marey: Graph of a figure jumping. 1880s (from chronophotograph)

167. Du Hauron (and others): 'Transformism' in photography. *c.* 1889

10. Photography as art: art as photography

EXPERIMENTS AND 'TRICKS' WITH PHOTOGRAPHY

In 1888 the Kodak camera made its appearance. 'You press the button, we do the rest' soon became the slogan of the manufacturers, and the catch-phrase was not without significance for art. In 1900 it was estimated that for each 100 persons passing through the turnstiles at the Paris Exposition Universelle, seventeen were armed with portable cameras. On days therefore when there were 300,000 visitors, 51,000 cameras were being used inside the exhibition grounds. This democratization of photography must have served to increase the urgency with which artistic photographers wished to demonstrate that, like painting, the camera was capable of producing pictures of aesthetic merit, that the process responded to 'handling', that almost any current style in painting could be paralleled by photography. Such photographers were thus placed in a position similar to that in which they had placed painters a half century earlier and the chain of reactions at the end of the century must have had a profound influence on the new directions painting had already taken.

Purists among the photographers insisted that the true role of their medium was in the simple recording of natural appearances. The artistry of the photographer should be confined to the selection and arrangement of the subject and to other unobtrusive pre-exposure and exposure techniques. Retouching, special effects and dark-room jiggery-pokery were completely inconsistent with their aims. Their opposite numbers favoured an attitude that fostered any means by which the aesthetic character of the photographic print might be enhanced.

It was largely because photographers wanted their art to partake of the same distinctions accorded to painting and drawing that a number of new and unorthodox methods were developed (more often revived) at the end of the century. Their temerity was hardly less than that of painters who ignored the taboos imposed by convention, their dexterity even greater. Just as some artists were beginning to distort the 'inviolable' image of nature, some photographers were working in the same direction.

Louis Ducos du Hauron and his associates, for example, devised an apparatus in 1889 to effect what was called 'transformism' in photography. Like the images produced by distorting mirrors, the physical endowments of a subject could be altered to enhance its aesthetic character. Photography *could* compensate for certain deficiencies in nature. Of course, du Hauron's examples were exaggerated for the purposes of demonstration; though they resemble earlier tricks with mirrors, they were now conceived with the utmost seriousness. To obtain this photographic anamorphosis a system of movable slits was employed in place of a lens. Just as this method can make the model appear ridiculous and ugly, stated du Hauron,

so if one wishes, can it correct and embellish it. Thus, in the case of a photograph, or better still, of the work of an artist which has little regard for the rules of aesthetics – for instance in a face which is too squat – a judiciously calculated setting of the two slitted sections will restore the harmonious proportions, giving the picture the grace and nobility lacking in the original subject (167).

Though photographic 'transformism' promised to make life easier for the hard-pressed photographer whose subjects viewed themselves rather differently than did the lens, it does not seem to have caught on. Instead, the retouching of negatives predominated – a great restorative process which has brought joy to countless millions.

With the changes in attitude towards so-called 'tricks with photography' from about the time of du Hauron's transformation process, parlour pastime photography began to be conceived in quite a new light. Its methods and results, previously relegated to a sub-world of artistic amusements, now, reflecting the great upheaval in Post-Impressionist art, became worthy of the consideration of artists seriously, perhaps desperately, searching for new expressive means. From about 1890 a number of books on 'Photographic Amusements' were published, often in several editions. In them, as in special features in illustrated magazines of the period, surprising anticipations of twentieth-century styles and subjects both in photography and painting will be found. The appearance later of light and magnetic field patterns, of montage and collage, of unusual perspective views, of superimposed and multiple images, may owe something to that form of popular art. The authors of one of those books published in Paris in the early 1890s recommended it to artists as well as photographers in the belief that much could be learned about pictorial form even from such recreational activities.

The idea of art as play, discussed by Kant and then by Schiller late in the eighteenth century and elaborated upon by Konrad Lange at the turn of the nineteenth, became an important consideration in the aesthetics of twentieth-century theoreticians. The spiritual pleasure inherent in the freedom of experi-

mentation was believed by the de Stijl artist, Theo van Doesburg, to be an essential prerequisite of the truly creative process – the *gestaltung* or forming process as he called it. Play, he wrote, 'is the first step of creation'. In *Film as Pure Form* in 1929, characteristically structuring its evolution, he noted that, like other media, photography, having first gone through a period of imitation, then a second stage of experiment and manipulation in the mastering of its technical means, must now (as with film) give way to purely creative expression.

The history of photography shows that very surprising experiments were regularly tried to make the process more responsive to the needs of the artist. For the sake of expression the natural capacities of the medium were often deliberately inhibited. As early as the 1840s, it was suggested that the efficiency of the lens could be counteracted by using faulty ones. Interceding glasses and other translucent materials between the lens and the plate produced a variety of so-called 'harmonious effects'. Diverse printing and retouching techniques further extended the range of subjectivity to which photographers eagerly laid claim. The *Illustrated Photographer* in 1868 described the use of rough drawing paper for photographic prints which losing their detail looked more 'like Sepia or Indian-ink drawings, than photographs'. Mayall developed a method for shading down the peripheries of photographic portraits in imitation of pencil or charcoal sketches by revolving an open disc before the subject. Sarony's photo-crayon process, described in the *Art Journal* in 1871, married photographic truthfulness with the signs of the artist's hand by combining a transparent positive with a crayoned backing. The result, according to a contemporary description, 'is such as to be quite deceptive in the means by which it is produced, and to lead even artists to attribute it to the skill of the miniature painter'.

In the 1890s a considerable amount of space in art, no less than in photographic, journals was devoted to the methods of artistic photography. Highly descriptive articles with titles such as 'The Naissance of Art in Photography' and 'Methods of Suppression and Modification in Pictorial Photography' demonstrated the wide formal range now open to photographers. It included techniques like that proposed by du Hauron, also vignetting procedures, the use of sprays, the air-brush, and processes for washing away pigmented, photosensitized gelatine.

The air-brush, which appeared about that time, was as useful technically as it was meaningful symbolically. Employed mainly in photographic retouching and for adding background and other forms to the composition, it could produce the subtle gradations of tone required for a consistent photographic appearance. This instrument was very serviceable to artists, graphic artists especially, working in competition with the camera. The 'pneumatic pencil',

168. *The Pneumatic Pencil*. From *The Picture Magazine*. 1894

169 (*lower left*). Drawing made with the pneumatic pencil. From *The Picture Magazine*. 1894

as it was also called, was for some the ultimate weapon in their struggle with the photographer for tonal supremacy: the final rejection of a linear style and capitulation to photographic form (168, 169).

But for artists like Man Ray, Moholy-Nagy and others connected with the Bauhaus it was later to have a new and positive value. The ability to render non-figurative forms with the impersonal tonal delicacy to be found in photographs was vital in the expression of a machine aesthetic, in the repudiation of individuality in art and in the proscription of the conventional idea of Art itself.[64]

ARTISTIC PHOTOGRAPHY

The different kinds of photographic surfaces employed at the end of the century to simulate other works of art are described in A. H. Wall's criticism, in 1896, that

a bad photograph will never be made a good picture by merely printing it upon a uniformly grained surface, or rough drawing paper, or paper with a ridiculously regular staring pattern on it, or paper made to look like canvas.

Perhaps the most revolutionary means by which photography could convey the impression of the artist's hand was the versatile gum-bichromate method in

which the print itself could be altered. Though pigmented light-sensitive emulsions were in effect known much earlier, the favourable conditions for artistic photography in the 1890s seemed to guarantee the revival of that and other half-forgotten processes. In gum-printing arbitrary colours could be introduced into the emulsion itself. The surface could be built up to some extent by the application of thick and successive layers. Even the brush or other instruments could be employed freely, the whole image fabricated to convey a sense of handling. Previously, photography had been incapable of communicating tactile qualities, of inducing in the spectator a sense of the palpability of the surface. This was now overcome – though not entirely. For even with the gum-bichromate medium it is virtually impossible to co-ordinate successfully surface textures with the forms of the different objects described. In 1894 gum-prints by Rouille Ladeveze were exhibited in Paris, and in London with those of Alfred Maskell and Robert Demachy. They were an immediate sensation:

It was at once recognized that a new power had been put into the hands of pictorial workers. . . . At first sight the impression given was of a water-colour or chalk drawing, by the hands of a master.

The gum method, it was said, brought photography into a closer kinship with the art of the pencil and brush than any other that had preceded it.

170. Rudolph Dührkoop: Photograph of Alfred Kerr. 1904 (Bromoil print)

171. Herkomer: *Self-Portrait.* c. 1910 (lithograph)

Robert de la Sizeranne's book of 1899, *La Photographie est-elle un art?*, contains many reproductions of photographs which are almost indistinguishable from lithographs or etchings. Some of these even show plate-marks, and a marine subject is rendered in more than one state. In Paul Bourgeois's *Esthétique de la photographie*, published in 1900, the author stated that with new materials like gum-bichromate and carbon-velours papers, the photographic artist could produce a personal touch. Photography, he said, had become less of an auto-matic manipulation and now involved the mind as well as the hand (170, 171). The subjects as well as the styles of the photographs reproduced in this book absolutely parallel those prevalent in contemporary painting. *Genre* and land-scape scenes, marines, costume-pieces, exotica and erotica, hunting scenes, animal studies and of course *japonaiseries* are among them. Subjects from Antiquity, much like those of Alma-Tadema, ballet-dancers and laundresses like those of Degas, special weather effects, cows grazing on country slopes, nymphs cavorting in rustic glades are shown. Hardly a theme known to the painter is excluded from this compendium of *fin-de-siècle* pictorial photography, and such themes had a wide currency (172, 173, 174, 175).

The same laws that govern painters, wrote Henry Peach Robinson in the 1890s, govern photographers. In portraiture, in landscape and *genre*, photo-graphy can express itself as can painting. Though there are regions of the imagination, he conceded, to which photography cannot soar – implying that here was a more promising sphere for painting – there was no lack of poetry in that medium. Absolute realism never succeeded in any art, he believed, and photographers must put more emphasis on the Ideal in their pictures. Robinson advised them to depict the same incidents of country and seaside life as were to be found in the Royal Academy exhibitions. The titles in the R.A. catalogues are full of suggestions. The time may come, he boldly declared, when the emotive subjects of Holl and Israels shall be successfully rendered by photography.

The claims made for photography in the 1899 edition of *Photograms of the Year*, presumptuous though they may have been, were good indications of the great strength of purpose with which photographers were snapping up the role of descriptive art at the end of the century. It was said, for example, that because landscape painters had been reduced to mere copyists, landscape photographers might lead them back to more noble aims:

Selection – always selection – then should be the photographer's motto. . . . Picture-making is more the aim. . . . No better advice could be given to the photographer than to urge him to examine the work of such men as Corot and Millet, and their great prototype, Constable. . . . It is a bold thing to say, but at the present time there are probably more photographers than painters imbued with the true and instinctive appreciation of the beauty of Nature. The ordinary painter, whose idea of landscape is first cousin to that of a land surveyor, confesses to a feeling of shame when he is set

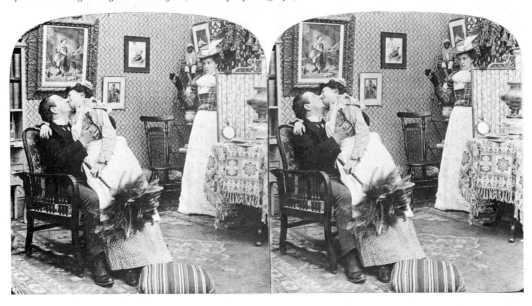

173. *The Oath of the Horatii.*
Late nineteenth century (photograph)

174. *Le triomphe de la République.*
Late nineteenth century (photograph)

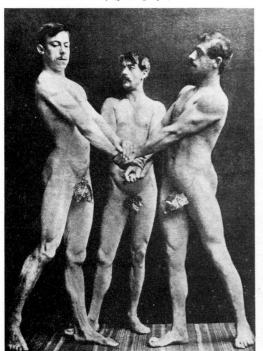 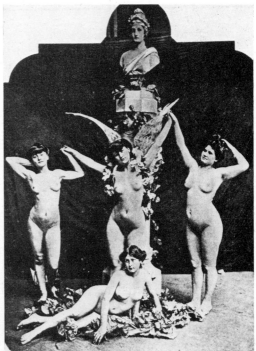

175. Richard Polak:
The Painter and his Model.
1915 (photograph)

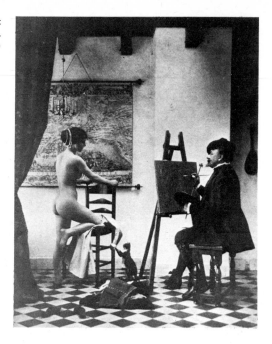

face to face with some of the pastoral scenes that hang in the photographic Salon. Some of the labour of the camera will not then have been lost if the topographical painter is 'spurred on' to higher things. . . . The photographer, then, has it in his power to develop that rare gift of vision which shall place him without challenge in the artistic ranks.

A shift of attitudes was engendered when a group of photographers who banded together as 'Photo-Secessionists' in 1902 gave its unstinting support to every new style of painting and sculpture which appeared in the first decade of this century. Led by Alfred Stieglitz, it probably represents the happiest concordat of photographers, painters and sculptors yet known. Their famous gallery, called '291', was opened at that number on Fifth Avenue, New York City in 1905 and there – in addition to works by many of the best contemporary photographers – sculpture, paintings and drawings were shown by Rodin, Matisse, Toulouse-Lautrec, Henri Rousseau, Cézanne, Picasso and Picabia. Some of the first exhibitions of African sculpture were held at '291'. Photo-Secession also issued *Camera Work* from 1903 to 1917, undoubtedly one of the most influential journals ever published to be concerned equally with art and photography. Among the contributors were Gertrude Stein, Maurice Maeterlinck, G. B. Shaw and H. G. Wells. Their sentiments about the value of photography as an art can be estimated by Shaw's reactions when he saw, for the first time, photographs by Frederick Evans, known especially for his famous portrait of Aubrey Beardsley:

At that time the impression produced was much greater than it could be at present; for the question whether photography was a fine art had then hardly been seriously posed. . . . Evans suddenly settled it at one blow for me by simply handing me one of his prints in platinotype.

Maeterlinck saw in photography's triumph the opening up of new horizons for art:

It is already many years since the sun revealed to us its power to portray objects and beings more quickly and more accurately than can pencil or crayon. It seemed to work only its own way and at its own pleasure. At first man was restricted to making permanent that which the impersonal and unsympathetic light had registered. He had not yet been permitted to imbue it with thought. But today it seems that thought has found a fissure through which to penetrate the mystery of this anonymous force, invade it, subjugate it, animate it, and compel it to say such things as have not yet been said in all the realm of chiaroscuro, of grace, of beauty and of truth.

While the most generous concessions to artistic photography were made by artists and critics whose own works, or those they supported, bore the least resemblance to it, hostility still came from those who would not concede to photography the role of descriptive pictorial representation. 'Perhaps one of the greatest enemies to the realism of the present day,' warned a writer in the *Nineteenth Century*, 'is the steady growth of photography.' Artists working on the fringes of naturalism, benign as they often were towards photography, had special reservations about photographs which were doctored to look like pictures executed with the pencil or brush. Whether this was prompted by solicitude for the cause of photography, by self-protection, or both, is, of course, difficult to know. Joseph Pennell, for example, complained in 1897 that

To fake up photographic prints so that they shall look like drawings or paintings is a sham. . . . The one grievance artists have against photographers: they cheapen and degrade everything, even their own excellent work, when they insist that they themselves are artists.

In 1908 *Camera Work* published a series of interviews with several outstanding artists and writers. They were shown photographs by Steichen, Demachy, Puyo and others and asked to comment on them. All the reactions were favourable, some were enthusiastic and in general there seemed to be little objection to calling those pictures works of art. Yet here, too, the usual reservations were made. Rodin, as an example, declared:

I believe that photography can create works of art. . . . I consider Steichen a very great artist. . . . I do not know to what degree Steichen interprets, and I do not see any harm whatever, or of what importance it is, what means he uses to achieve his results . . . which, however, must remain always clearly a photograph.

And Matisse, in a more guarded statement, said:

If it is practised by a man of taste, the photograph will have the appearance of art [but] The photographer must . . . intervene as little as possible, so as not . . . to lose the objective charm which it naturally possesses. . . . Photography should register and give us documents.[65]

PHOTOGRAPHIC PAINTING

As for the thousands of paintings hung annually in the Salon and Royal Academy exhibitions at the end of the century, no one who has examined the illustrated catalogues and journals in which they were reproduced could deny that photography had had a tremendous influence on them. The fears of earlier critics were not without foundation. Many of these pictures in the black-and-white reproductions are indistinguishable from photographs. Most of them, though recognizable as paintings, are to a significant degree photographic in form. Only relatively few appear to have been conceived without the photograph in mind or in hand.

A contemporary observer with sufficient cause called the French school of painting at the end of the century 'a degenerate one'. It gives us, he said, 'mere coloured photographs without grace, pathos, awe, life or invention'. The paintings are 'as ugly, as crude, as photographic, as unpleasant as canvas and dull paint can make them'. In support of this critic one may cite paintings like those of Jean Béraud and Edmond Grandjean whose pictures of Paris life are so photographic in character that it may well be suspected that they were painted directly over photographs. They are doctored-up mirror images, innocuous illustrations of everyday events in which skill of execution utterly predominates over imagination. Such hybrid images, neither paintings nor photographs, somehow look less real than the more painterly but homogeneous subjects of the Impressionists.

In the Paris Salon of 1899 the canvases of Jan van Beers, of Camille Bellanger, of Benner and Bouguereau are photographic images in paint. Chocarne-Moreau's chimney-sweeps and drunken clown are easily mistaken for photographs in the reproductions, as is Buland's procession of peasants. Gérôme's Fayum figures, though remote in setting, depend heavily on the photograph. The sub-Classical subjects of Courtois and Aublet resemble photographic fin-de-siècle tableaux vivants. Aublet's Leda, recoiling from the approaching swan, might have been snapped in the Bois de Boulogne when nobody was looking.

The Salon of 1900 was no different and one might add that much of the sculpture exhibited there was as photographic as the paintings. The usual quota of sentimentalia and erotica appeared: maternity and children's scenes, saccharine anecdotes from history, meal-time tragedies and parlour follies, genre subjects from all periods; photographic nudes gathering seaweed, loitering

on the banks of rivers, playfully wrestling over flowers or sparking up the *Lunch in a Cairo Harem*. Even if the subjects originated in the imagination, they were mostly painted as though the artist had actually witnessed them or, more precisely, as though he had recorded them with a camera. Popular themes like slave sales and disquisitions of the romantic past were surely the antecedents of Hollywood's great extravaganzas.

Twenty Years of Great Art or the Lesson in Niaisery is the appropriate title of François Jourdain's book on official art in France during the last quarter of the century. The illustrations justify Baudelaire's worst fears. Regardless of subject they testify eloquently to the camera's all-pervading influence. Whether of the Grande Armée or of fascinating *flagrants délits*, whether of Antiquity or of household trials and tribulations, whether religious, moral or historical, the examples chosen by M. Jourdain clearly demonstrate the widespread banality of both subject and execution, the result of an unimaginative submission to photography (176, 177).

176. Dagnan-Bouveret: *Une noce chez le photographe*. Salon of 1879 (painting)

The extent of photography's influence on painting can also be assessed by a pertinent article featured in one of the very first issues of the *Studio* which appeared in June 1893: 'The Camera. Is it a Friend or Foe of Art?' It was a very difficult question to answer, the editor stated, and divergent views had

177. Gérôme: *Grand Bath at Broussa*. 1885 (painting)

to be taken into account in a survey of art from 1839. This 'mechanical artist', he believed, had 'killed the miniaturist, banished the lesser portrait-painters, rendered the wood-engraver obsolete'. It had disturbed the arts as the steam-engine had upset the old systems of ships and coaches. The camera had become a more or less acknowledged item of the artist's equipment. But had photography actually modified the artist's view of nature? Had the public eye been affected, and how, by the image of the camera? And answering his own postulations he wrote:

It is impossible to deny that many modern schools of painting appear to have taken a view of nature as the camera depicts it. The academic composition of landscape or figure subjects is for the moment set aside in favour of more or less haphazard arrangements that show the apparently careless grouping which a snap-shot from a Kodak presents.

The school of Bastien-Lepage, which largely influences English painting, is itself largely influenced by the camera. Such paintings, he warned, only anticipate photography in natural colours. He cited van Beers's *La Sylphide*, the artist having been accused of painting it over a photograph. The dispute became, consequently, the subject of a lawsuit. William Logsdail's painting, *Bank*, was said to be so photographic that the influence of the camera might be

178. William Logsdail: *St Martin-in-the-Fields*. Exhibited R.A. 1888 (painting)

conceded without any hidden accusation that the artist employed it. Animals, the author noted, are illustrated with more accuracy now. Popular prints tend to reject the use of colour in favour of black and white. All of these submit to popular taste which believes that the 'sun cannot lie' (178). Meissonier and the Dutch school are bought because of their scrupulous attention to detail: 'The masses now prize statistics, measurements, and textures more than abstract

beauty, colour harmonies, or decorative composition', he continued, referring probably to the Art Nouveau style for which *The Studio* had an obvious preference.

Views on the 'friend or foe' question were canvassed from a large number of reputable artists and writers in England. The query brought many diverse replies providing us with an interesting document after more than fifty years of the uneasy coexistence of photography and art. Alma-Tadema, Millais and Brett believed that photography had been beneficial to art. Convinced that the camera had had a most healthy and useful influence, Alma-Tadema generously concluded that 'it is of the greatest use to painters'. And Millais, similarly: 'No doubt photography has been beneficial, and is often of value to the artist.' Brett had faith that 'Photography will have a prodigious effect in educating mankind in a habit of truthfulness.'

On the other hand, Pennell, as has already been shown, believed the photographic image to be false and injurious to artists who became dependent on it. In his reply to *The Studio* he erroneously discounted its influence on artists of the 'Modern' school. 'I don't think,' he answered, that 'photography has had any influence on modern art at all – that is, upon the art of men like Whistler, Degas, Chavannes, Rodin, Gilbert, and Gaudeur.' Frith, the painter of *Derby Day* and *Paddington Station*, quite understandably wrote that in his opinion,

photography has not benefited art, and to the professors of certain branches – to wit, miniature painting and engraving – it has been so injurious as, in the form of photogravure, to have nearly destroyed the latter; and by means of coloured prints made to resemble miniatures a fatal blow has been struck at that beautiful art.

Though W. B. Richmond A.R.A. feared that photography can be the 'destroyer of art', not a shade of any effective alternative was offered.

I do not suppose [he stated], there exists in Europe an artist who would not at once admit the value of photography. At the same time there may be some who think that modern exhibitions of pictures display an abuse of it. . . . I have been told that the Kodak has taken the place of the [artist's] note book . . . photography can never be an art, though it may be a valuable adjunct.

Lord Leighton P.R.A. believed simply that 'Photography may be of great use or the reverse to an artist, according as it is used with or without judgement and intelligence.' Walter Crane and William Yeames R.A. advocated the use of photographic studies; so did several others. Little wonder then that John Swan wrote: 'I consider one half of the pictures of modern exhibitions . . . developments of photography.' Walter Sickert who, in another part of the same issue, stated that 'In proportion as a painter or a draughtsman works from photographs, so is he sapping his powers of observation and of expression', had

ironically that same year shown, at the New English Art Club, a portrait (probably that of Mr Bradlaugh) described in the catalogue as 'done from a photograph', and in following years relied heavily on photographic material. In his answer to *The Studio* questionnaire he asked for the impossible, declaring that 'It would be well if the fact that a painting was done from or on a photograph were always stated in the catalogue.' Professor Frederick Brown of the Slade School, also a member of the Impressionist-orientated New English Art Club, believed, like Pennell, that 'photography has had no influence on the best art of today, though it has considerably affected a large number of painters'.

Though the arguments, for and against, might have been seasoned by several decades of experience with photography, the unimaginative judgements of most of the artists queried were in essence no different from those which had been proposed in 1839, the year of the birth of photography. Only artists and writers in agreement with the general principle propounded by the Symbolists and other Post-Impressionists, that art could involve something more profound than mimetics, might have given evidence of a new and important understanding of the half century of struggle with the photographic image. None of the artists responding to *The Studio* gave any indication of this. Their answers in no way postulated the more extreme convictions already expressed in France. They did not grasp, nor did they want to grasp, the significance of photography in the advancement of the anti-naturalist cause in art.

Many examples indeed could be provided to describe the calamitous state of art in the last decade of that eventful century. Perhaps a few more will suffice. For an article in the Academy Number of the *Lady's Pictorial*, letters were sent to all the women who had contributed paintings to the Royal Academy exhibition of 1894 asking them for the sketches used. To the consternation of the editors they received, in a large number of cases, in place of sketches, photographs from life which were identical with the paintings.

The author George Moore, friend and champion of the French Impressionists, devoted a chapter of his book, *Modern Painting* (1898), to the difficult but important problem of photography in its relation to art. Certainly the introduction of Japanese art had influenced our sense of colour, he wrote,

is it therefore improbable that the invention of photography has modified, if it has not occasioned any very definite alteration in our general perception of the external world?

Moore deplored the mentality of the artists of his time who, wanting things made easy, depended so heavily on the camera. He boldly named some of these feckless 'artists of repute': Edward Gregory, Charles Bartlett, Sir Hubert Herkomer R.A., and Mortimer Menpes, all of whose paintings, Moore com-

plained, had declined through their over-indulgence in photographs. He even went so far as to suggest that Herkomer had resorted to photographing his portrait subjects on canvas before painting them. It was probably true that Herkomer had at least copied from photographs in the execution of some of his portrait commissions. In 1898, for example, the same year that *Modern Painting* was published, he is known to have utilized photographs for his portrait of the philosopher Herbert Spencer. The artist's reflections on the camera's influence on portrait painting are worth noting here. The universal use of the camera, he wrote, has conditioned the modern public to a more critical estimate of the likeness. 'Photography has, therefore, trained the public in "likeness-seeing", with the result that the portrait painter has to meet much more exacting criticisms in matters of likeness than the painters of earlier days.' Finally, Moore believed that Menpes was probably the most flagrant example of the artist's misuse of the photograph and he may not have been exaggerating when he suggested that this artist rarely drew from nature any more[66] (179).

179. Mortimer Menpes: *Umbrellas and Commerce*. Japan. 1890s (water-colour)

11. Beyond photography

POST-IMPRESSIONIST REACTIONS

The conviction that art was a matter more of imagination than optics was quiescent during most of the nineteenth century. Revived by the controversies which raged over photography and art, it became an article of faith in the last quarter of that century. Common to all Post-Impressionist styles was the concerted and active rejection of the material world as seen by the camera. Unbounded contempt was expressed in many literary and artistic circles for the mechanistic, unimaginative recording of contemporary life which was itself held in much disdain. The antagonism to the vulgarity of photographic realism in art, as well as in literature, contributed to the deliberate proscription of objective representation and the vindication of the subjective. The artificial and unnatural were extolled. The human touch, the intuition and a more abstract conception of reality were now considered fundamental to art. To exceed the limitations of the lens became imperative.

Of course photography was not the only force to produce this reaction, but it had become a symbol: the most visible, the most tangible expression of a state of mind which, to the rebellious spirits of that age, was offensive. Once the artist attempted to break with his immediate tradition – often aggressively reasserting earlier ones – once he declared the subservience of the visible to the invisible world, he entered into a realm of consciousness which had no bounds and which was to provide subjects which he believed no photographer could discover and no camera record.

What a catalogue of redresses can be compiled to bear witness to the new spirit of revival in art!

The imitator is a poor kind of creature [wrote Whistler in 1878]. If the man who paints only the tree, or flower, or other surface he sees before him were an artist, the king of artists would be the photographer. It is for the artist to do something beyond this: in portrait painting to put on canvas something more than the face the model wears for that one day; to paint the man, in short, as well as his features; in arrangement of colours to treat a flower as his key, not as his model.

The Symbolist poets and artists were unanimous in their aversion to the photographic image. In his Salon review of 1889 Félix Fénéon criticized painters

who loved photographic detail and who 'cynically' produced photographs and called them paintings. Fénéon's friend Édouard Dujardin wrote an appreciation, in 1888, of Symbolist art. The representation of nature, he asserted, was 'idle fancy'. The aim of painting was the expression of sensations, perceived not in the external appearances of things but in their quintessence, in their underlying character. His advocacy of the value of primitive and Japanese art was undoubtedly strengthened by his abhorrence of photographic realism. Why retrace, he wrote,

the thousands of insignificant details the eye perceives? One should select the essential trait and reproduce it – or, even better, produce it. An outline is sufficient to represent a face. Scorning photography, the painter will set out to retain, with the smallest possible number of characteristic lines and colours, the intimate reality, the essence of the object he selects. Primitive art and folklore are symbolic in this fashion. . . . And so is Japanese art.

G. Albert Aurier, another Symbolist writer, friend of Émile Bernard, Van Gogh and Gauguin, wrote similarly:

The myopic recording of everyday anecdotes, the stupid imitation of peep-hole views of nature, straightforward observation, illusionism, the distinction of being just as faithful, just as banal as the daguerreotype, will not satisfy any painter or any sculptor worthy of the name.

Odilon Redon questioned the universal assumption that the photographic image was a transmitter of truth. The artist, he insisted, was capable of extracting a more profound truth from nature. The photograph only records stark fact. It is devoid of life.

The eagerness – stupidity perhaps – the feverish or unbridled passion for success or fortune, have spoilt the artist [said Redon], to the point of perverting in him the sensitivity to beauty. He uses photographs directly and shamefully to obtain the truth. He believes – in good faith or not – that the result is satisfactory when it gives him nothing more than the fortuitous accident of the raw material. The photograph transmits only lifelessness. The emotion experienced in the presence of nature itself will always provide a quality of truth which is authentic in quite a different way, verified by nature alone. The other [factual truth] is a dangerous one.

Like his Symbolist friends Gauguin in 1888 strongly objected to illusionist painting. He saw the new and more imaginative art – he called it 'impressionism' – as an antidote to the camera image, a rejuvenescence of art: 'I consider impressionism an altogether new departure which inevitably diverges from anything that is mechanical, such as photography, etc.' This process, he believed, had been damaging for art: 'The machines have come in, art has gone out. . . . I am far from thinking that photography can be favourable to us.' Aurier wrote in 1891 that Gauguin was one of the first to

understand the futility of the petty little pursuits of realism and of photographic impersonality which is misleading contemporary painters, and to attempt to re-establish in our society, so badly prepared for that revolution, true art, the art of the rebirth of ideas, of living symbols, the art of the Giottos, the Angelicos, the Mantegnas, the da Vincis.

In 1889–90, while living outside Paris in Saint-Cloud, the young Edvard Munch conceived of a radically new programme for his art. Influenced no doubt by Gauguin and the ideas of the Symbolists and, like them, aware of creating something entirely beyond the powers of the camera, he made this declaration:

I have no fear of photography as long as it cannot be used in heaven and in hell. Sooner or later there must be an end to this painting of knitting women and reading men. I am going to paint people who breathe, feel, love and suffer. People will come to comprehend the holiness of it and take their hats off as in church.

This is how Vincent van Gogh described the 'new departure' to Theo (probably in the summer of 1888):

you must boldly exaggerate the effects of either harmony or discord which colours produce. It is the same as in drawing – accurate drawing, accurate colour, is perhaps not the essential thing to aim at, because the reflection of reality in a mirror, if it could be caught, colour and all, would not be a picture at all, no more than a photograph.

And in another letter to his brother (c. September 1889) Vincent stressed the importance of transmitting feeling and individuality to his paintings and of avoiding the barren veracity of the photographic image:

Where these lines are close and deliberate it begins to be a picture, even if it is exaggerated. That is rather what Gauguin and Bernard feel, they do not ask at all the correct shape of a tree, but they do insist that one should say if the shape is round or square – and honestly, they are right, exasperated by the photographic and empty perfection of certain people.

Paul Signac wrote in 1899 that a painter's first thoughts before a blank canvas ought to be concerned with which curves and which arabesques should divide the surface, which colours and tones cover it. 'This case is indeed rare at a time when the majority of pictures are like instantaneous photographs or are futile illustrations.'

Maurice Denis's written works from 1890 contain several references to photography and its relation to art. In retrospect he criticized one of his old drawing masters for encouraging students to copy from photographs. Gauguin, said Denis, had liberated them from 'all the shackles that the idea of copying had fastened on our instincts as painters'. 'Academic naturalism' was Denis's *bête noire*. He equated it with 'photographic naturalism' from which, he declared,

he and his contemporaries had rebelled. That kind of art, he cynically observed, was 'universally held to be worthy of an epoch of science and democracy'. Reminiscing in 1909 he wrote:

Art is no longer simply a visual sensation which we receive, a photograph, however refined it may be of nature. No, it is a creation of our spirit for which nature is only a starting-point. Instead of 'working around the eye, we look to the mysterious centre of thought' as Gauguin said Imagination has thus become, as Baudelaire wished, the Queen of the Faculties.

The resounding cry of emancipation from the tyranny of imitation was echoed well into the twentieth century. In 1914 Clive Bell, on the heels of two important Post-Impressionist exhibitions in London, writing on what he called 'significant form', suggested that photography had assumed much of the previous role of 'descriptive painting'. Scenes like Frith's *Paddington Station* could now, he asserted, be executed by mechanical means and 'Therefore it must be confessed that pictures in the Frith tradition are grown superfluous; they merely waste the hours of able men who might be more profitably employed in works of a wider beneficence.' Bell had already written, in the catalogue introduction of the English group of the second Post-Impressionist exhibition (London 1912–13), that 'We expect a work of plastic art to have more in common with a piece of music than with a coloured photograph.' Bell recorded the response of André Derain when the painter was shown portrait photographs taken by Julia Margaret Cameron: 'It is the perfection of the camera that has spoiled everything.' And referring to his period as a Fauve, around 1905, Derain has further been recorded as saying,

It was the era of photography that may have influenced us and contributed to our reaction against anything that resembled a photographic plate taken from life. We treated colours like sticks of dynamite, exploding them to produce light. The idea that everything could be lifted above the real was marvellous in its pristine freshness. The great thing about our experiment was that it freed painting from all imitative or conventional contexts. We attacked colour directly.

In *The Cubist Painters*, published in 1913, Apollinaire insisted that 'Each God creates in his own image, and so do painters. Only photographers manufacture duplicates of nature.' The Cubist, Albert Gleizes, held photography responsible for the 'disgraceful alteration' in our way of seeing. New ways, he believed, must perforce be antagonistic to the photographic image.

Photography [he complained], has completely distorted the idea of form, even the notion of descriptive form such as was taken up after the thirteenth century. The triumph of photography means that more and more the function of seeing will be reduced solely to that which is taken in by the physical eye.

The Futurists too made a point of saying that what their painting attempted was contrary, and certainly superior, to the imagery of the camera because 'The painter does not limit himself to what he sees in the square frame of the window as would a simple photographer, but he also reproduces what he would see by looking out on every side from the balcony.' And in their manifesto on colour in 1918, the opening statement by Balla is on the relation of photography to art:

Given the existence of photography and of the cinema, the pictorial representation of the truth does not and cannot any longer interest anyone.

In the *Brücke Manifesto*, the German Expressionists also conceded to photography the function of pictorial representation: 'Today photography takes over exact representation. Thus painting, relieved from this task, gains its former freedom of action.' In Wassily Kandinsky's book, *Concerning the Spiritual in Art*, published in 1912, the artist, speaking first of the inner enrichment possible through purely abstract forms, writes that

on the other hand, there exists in art no purely material form. A material object cannot be absolutely reproduced. For better or worse the artist depends on *his eye, his hand*, which in this case are perhaps more artistic than his soul that would confine itself to photographic aims. But the discriminating artists who cannot be content with an inventory of material objects seek to express objects by what was once called 'idealization', and later 'stylization', and which in the future will again be called something else. The impossibility and, in art, the purposelessness of copying an object, the desire to make the object express itself, are the beginning of leading the artist away from 'literary' colour to artistic, i.e. pictorial aims.

In 1920 André Breton began a short statement on Dada and Max Ernst with the observation that

The invention of photography has dealt a mortal blow to the old modes of expression, in painting as well as in poetry, where automatic writing, which appeared at the end of the nineteenth century, is a true photography of thought. Since a blind instrument now assured artists of achieving the aim they had set themselves up to that time, they now aspired, not without recklessness, to break with the imitation of appearances.

As late even as 1942, Matisse described his art as being so intuitive in nature that it completely eluded the efficacy of the camera. 'Why do you paint?' the artist was asked, and he replied, 'To translate my emotions, my feelings and the reactions of my sensibility into colour and design, something that neither the most perfect camera, even in colours, nor the cinema can do.'

The apparent negative character of these remarks, of necessity isolated from their original contexts, should not distort the fact that there were other, equally cogent and quite positive factors which propelled art in these new directions. Photography had to some extent become the scapegoat for a multitude of other

sins committed not only by artists, but by writers and critics, by the prevailing systems of art patronage and by the philistinism of a large section of the picture-going public. It was not the photograph *per se* which nettled the *avant-garde*. Many of them through the nineteenth century and in the twentieth were captivated by the evocative images and the peculiarities of form to be found in photographs. Indeed, photography not only served painters who continued to work in the tradition of naturalism, but it was exploited as well by those who rejected that tradition. What these artists deplored above all was the orthodoxy which had been imposed upon them by an insistence on imitative form, *underwritten* by the photographic image.

In 1900 Walter Crane observed quite perspicaciously that often in its very failures photography had been most interesting and suggestive to artists:

who indeed have not been slow to avail themselves of the help of photography in all sorts of ways. Indeed the wonder is, considering its services to art in all directions, how the world could ever have done without it.

By the 1920s it must have been apparent to the more perceptive critic that almost every fault which could be attributed to the misuse of the camera had become a positive factor in the vocabulary of the modern artist. In 1929, coincident by chance with a large Bauhaus exhibition of *avant-garde* photography, an amusing but none the less revealing compilation of photographic aberrations appeared in a *Punch* drawing. In these so-called 'Holiday Snaps', the kind of photographs never shown to friends, the artist unwittingly presented a most interesting document. Here one finds the oblique view and the looming form cut by the frame as used by Degas, the exaggerated perspective which so many artists involuntarily employed. In the multiple images of a child who moved during the exposure one has the lines of force, the dynamic expansion in space of the Futurists. Their conception of the interpenetration of forms exists in an accidentally double-exposed plate. The disparate juxtapositions in the collages of Dada and Surrealism are much more creative counterparts to another frame in the *Punch* cartoon in which a gigantic hand placed in error in front of the lens is at odds with a tiny figure in the 'spoilt' composition.[67]

12. Beyond art

FUTURISM AND CHRONOPHOTOGRAPHY

For artists working in the tradition of nineteenth-century naturalism the clarity of the Muybridge photographs was preferable to those of Marey. But for those seeking to obscure the literal identity of things, to give precedence to the more abstract realities of nature: the movements themselves rather than the objects in movement, the fundamental rhythms and patterns of the universe – so great a preoccupation in this century – Marey's images served admirably as a point of departure.

Many chronophotographs combined the virtues of both the blurred and the instantaneous image. Like the ripples on a pond when a pebble is dropped into it, the phases of movement in these photographs radiate from more or less fixed points. They give the impression of forms apparently developing in time.

Not only is the sensation of time induced by the lateral patterns of continuity in chronophotographs, but also by their inevitable superimpositions and transparencies in which objects recorded in two or more distinct instants exist simultaneously in the same picture space. The centuries-old technique of creating a pictorial equivalent of time and space, called 'continuous representation' (in which the same subject appears in sequential parts of a narrative incorporated in one compositional scheme) now emerges in the modern form of photography's 'simultaneous representations'. And there is sufficient reason to believe that these idiosyncrasies of chronophotographic form were an influence on several major artists in this century who were concerned – just like their literary contemporaries – with new means of representing time and space.

Revealing juxtapositions can be made between the works of Marcel Duchamp, those of the Italian Futurists and the photographs and diagrams of Marey. Duchamp's painting, *Five Silhouettes of a Woman on Different Planes*, first exhibited in the Salon d'Automne in 1911 clearly shows a propensity for the repeated, superimposed images of the chronophotograph (180). The flexion of the limbs of moving figures, their patterns of oscillation, their trajectories

recorded by lines or dotted curves to be found in chronophotographs (181), must have formed the visual springboard for Duchamp's paintings of a *Nude Descending a Staircase* (1911–12) (182, 183). On several occasions, recalling that period, Duchamp has stated candidly that the idea for his painting came principally from Marey's photographs and others of that kind. The artist is recorded as saying that in 1912 art circles in Paris 'were stimulated by strobo-scopic and multiple-exposure high-speed photographs'. And elsewhere Duchamp not only reiterated this but generously suggested that the Futurists were not so much influenced by his work as they were by that of Muybridge and Marey whose photographs 'they all knew'.

The traditional whipping-stick – the accusation of being photographic – used to chastise artists was now extended to include cinematography. Accurately, though unfairly, contemporary critics of the Futurists denounced them with the vindictive labels: photographic, cinematic. Futurism is 'nothing more than the instantaneous photograph of a sneeze', one wrote, possibly referring to Severini's self-portrait of 1912. Commenting on the artist's *Dance of the Pan Pan* (1911) another said, 'It is a desperate attempt to introduce the sensation of duration into space, and this work reveals the cinematographic tendency of painting.' Even Robert Delaunay accused the Futurists of being cinematic. 'Your art has velocity as expression and the cinema as means,' he wrote privately in his note-book, and he compared their work to the mechanical process and the aspirations of the engineer. Cubist supporters berated the Futurists for being motivated by

180. Duchamp: *Portrait,*
or *Five Silhouettes of a Woman
on Different Planes.* 1911

181. Marey: Chronophotograph
of English boxer. 1880s.

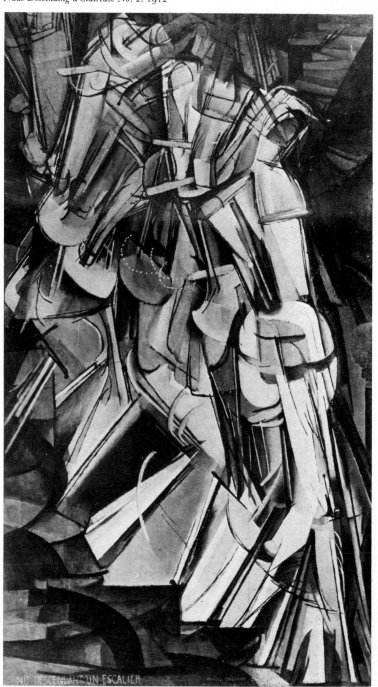

182 (*left*). Duchamp:
Nude Descending a Staircase No. 1. 1911

183 (*below*). Duchamp:
Nude Descending a Staircase No. 2. 1912

184. Paul Richer: Figure descending
a staircase. Drawing based on
chronophotographs. From *Physiologie
Artistique de l'homme en mouvement*. 1895

the cinema. It was the greatest folly, one said, to depict movement, analyse gestures and create the illusion of rhythm by reducing plastic matter to formulae of broken lines and volumes. This, essentially, was the cause of the great antagonism between the Futurists and Cubists and even Apollinaire, in sympathy with the Italian movement, became sceptical of their manner of painting. Disgust with such unjust pronouncements was expressed by Boccioni in 1913: 'Paris and other cities were scandalized. We were called photographers, anti-artists, movie-makers. . . .' One mistaken critic, said Boccioni, believed that

the grotesque assertions like 'a horse that trots has twenty legs . . .' [are] derived from the instantaneous photograph. The instantaneous photograph and its exasperating successor, the cinema – which breaks up life by tossing it about in a precipitous, but monotonous, rhythm – are perhaps the new classics in whose favour the Futurists proscribe the masters of the museums.

Boccioni retorted:

We have always rejected with disgust and contempt even the most distant relationship with the photograph because it is outside the boundaries of art. The photograph has a value in as much as, by reproducing and imitating objectively, it has succeeded in its perfection in freeing the artist from the burden of reproducing reality with precision.

But it is clear that in the Futurist mind a division was made between commonplace photographs and those extraordinary ones resulting from scientific investigation or from the less orthodox exploration of their intrinsic properties. Marinetti, for example, was appalled by conventional literary realism. He saw this as a narcissism linked with the universal adulation of photographic images. Nevertheless he extolled those cinematic images which, without human intervention, divided and recomposed objects, reversed the actions of moving forms and which could increase the speed of a running figure to 'two hundred miles an hour'. Carlo Carrà makes a similar distinction when in 1913, berating anecdotal and particularized painting, he links it with 'pure' photography.

Boccioni's statement about the horse with the multiple sets of legs, made in the *Technical Manifesto of Futurist Painting* of 1910 ('a racing horse does not have four hooves, he has twenty') plus another rather cryptic remark that its movements are 'triangular', makes sense in the light of Marey's photographs and diagrams of horses in motion (185). Quite possibly the eagerness with which his critic seized upon the twenty-legged horse was stimulated by the comic representations of a chronophotographic character frequently appearing in the popular journals of the two or three decades preceding the arrival of Futurism (186, 187, 188). Considering the captiousness of critics who disparaged works of art derived from obvious contemporary sources, without regard for their more intrinsic values, it is not surprising that any ideas which may have been acquired from photography became studio secrets among the Futurists.

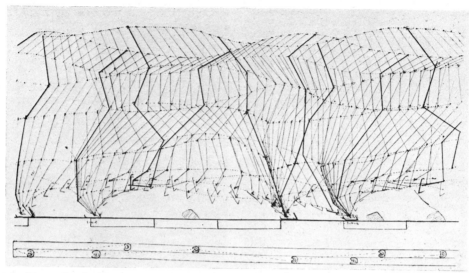

185. Marey: Graph of movements in a horse's walk. 1886 (from chronophotograph)

186 (*above left*). John Tenniel: Danvers the Dancer as Dame Hatley in *Black-Eyed Susan* at the Royalty Theatre. 1875

187 (*above right*). Gibson: *The Gentleman's Dilemma. c.* 1900

188 (*left*). *The Canter.* From the *Picture Magazine.* 1893

189. Marey or follower: Chronophotograph of figure during standing jump.

190. Boccioni: *Unique Forms of Continuity in Space*. 1913

To demonstrate his investigations Marey had some photographs translated into sculpture. A series of superimposed figures in bronze showing the successive positions of the wings of a sea-gull in flight was shown at a meeting of the Académie des Sciences on 21 March 1887. On 13 June that year he showed the flight of a pigeon in the same way. Other séances followed and on 5 September, sculptures of a bird in flight made from photographs taken at 1/50th-second intervals were viewed in a zoëtrope in which the subject appeared in uninterrupted movement. Marey called this the *cinématique* of flight. A notice in *Nature* the following year described his representation of the attitudes of human locomotion by means of sculpture. The figure of a runner was made

from a relief obtained by M. Engrand by means of the photochronograph. It is pointed out that a continuous series of such figures, obtained by this process, would be of great service in determining for artists and physiologists the successive changes of attitude in running and walking.

By this, presumably, was meant the isolation of single figures in sequential positions – like a Muybridge series in three dimensions.

It is not known whether Boccioni was aware of Marey's bronzes of birds in flight, though they are noteworthy anticipations of his work. Anxious to find a

means to express in sculpture the continuity of moving forms in space, he spoke of 'pure plastic rhythms': 'not the construction of bodies, but the *construction of the action of bodies*'. Of even more use to him would have been photographs of gymnasts, some of which are so close to his sculpture, like the *Unique Forms of Continuity in Space* (1913), that despite the rather tenuous connections with chronophotography it is hard to believe that these were only parallel developments (189, 190). The meaning of Boccioni's statements about the necessity of breaking the rigid contours of the figure, of creating a dynamic continuity in space, and of fusing the figure with its environment, in terms of these photographs, becomes rather obvious.

No stranger to photography, as his earlier paintings strongly suggest, Balla's *Girl X Balcony* of 1912 is almost a pastiche of certain Marey photographs (191, 192). His painting, *Swifts: Paths of Movement + Dynamic Sequences* (1913),

191. Balla: *Girl X Balcony*. 1912

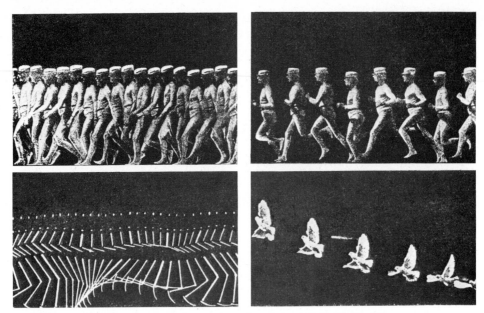

192. Marey: Chronophotographs of walking and running man and bird in flight. 1880s

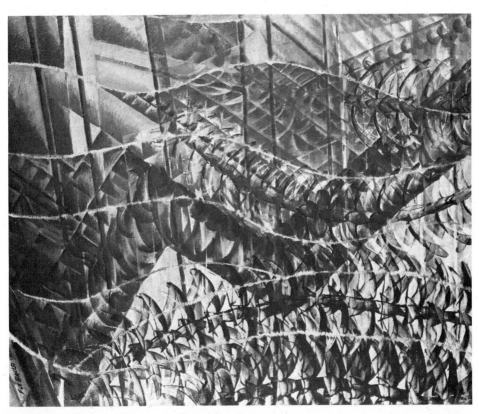

193. Balla: *Swifts: Paths of Movement + Dynamic Sequences*. 1913

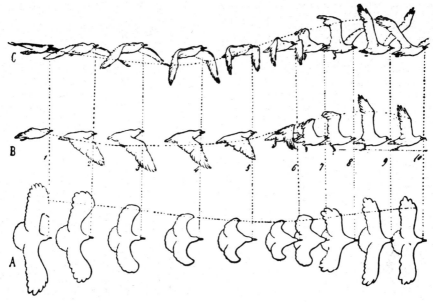

194. Marey: Diagram from chronophotograph of gull in flight. 1880s

the superimposed forms moving along trajectory paths, closely parallels Marey's photographs and diagrams of birds in flight (193, 194, 195).

Certainly many of the titles of Futurist work about 1912–13, such as *Spiral Expansion* and *Interpenetration of Light and Planes*, in addition to those already mentioned, echo the scientific terminology employed by Marey: 'trajectory of a flying apparatus describing a sinuous curve in the air'; 'movements of a curve in space'; 'alternating images for multiplying the number of positions. . . .' Many references in the Futurist manifestoes, sometimes rather abstruse, can be better understood in relation to Marey's work. These artists

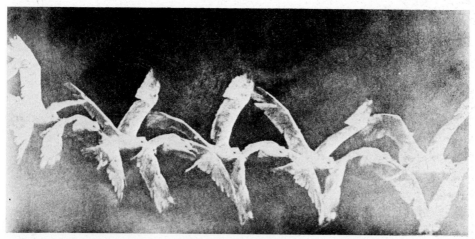

195. Marey: Chronophotograph of the flight of a bird. 1887

declared: 'Thanks to the persistence of the image on the retina, things in movement multiply, are deformed, and follow one another like vibrations in the space through which they pass.' They spoke also of 'lines of force', the penetration of voids into the solids which pass before them, of 'motion and light destroying the substance of bodies'. Boccioni's description of 'form-force', in a letter claiming priority over the Cubists for the conception of simultaneity, corresponds absolutely with the imagery of Marey's photographs: by the use of 'form-force' a delineation of the subject's movements can be created, a continuity emanating from the central form; this 'form-force' acts centrifugally and represents the 'potential', the 'expansive power' of the object. To the spectator is thus suggested the appearance of a continuum: simultaneity (196).

196. Severini: *Dancer at the Bal Tabarin*.
1912 (detail)

It is almost to be expected that the Futurist artists would have a counterpart in photography. From 1910 Anton Giulio Bragaglia and his brother Arturo first experimented with chronophotography and in the years 1911–13 they were closely associated with Balla. In 1911 Marinetti, the literary founder of Futurism, helped organize an exhibition of the Bragaglia brothers' photographs in Rome. In 1913 A. G. Bragaglia issued a manifesto called *Futurist Photodynamism*. Inspired by the *Technical Manifesto* of the Futurist painters, Bragaglia proclaimed the virtues of 'photomovementistics' and 'photocinematographics':

We wish to bring about a revolution in order that photography may make progress and be purified, ennobled and elevated to the level of art. In fact, I affirm that with the mechanical means available it is possible to make an art of photography only if the pedestrian photographic reproduction of the immobile and static object in a moment of time is excluded. In this way the photographic result – having succeeded in acquiring by other means and investigations the expression and vibration of real life and having avoided obscene, brutal and static realism – is no longer the usual photograph but something far superior which we have called Photodynamics.

Bragaglia's photographs are indeed Futurist to the letter. Among them is an amusing one taken in 1911 burlesquing his friend Balla and the now famous painting, *Dynamism of a Dog on a Leash*. The artist, posed beside his picture, has

197. A. G. Bragaglia: Photograph of Balla in dynamic sequences before his painting, *Dynamism of a Dog on a Leash*. 1911

moved during the exposure, paraphrasing the multiple-image effect of the painting (197).

Other kinds of photographs, too, may well have served to support, if they did not initiate, the Futurist idea of simultaneity and the interpenetration of forms. The photographs made by the spiritualists from the 1860s and certainly those

198. A. G. Bragaglia:
Photograph of a cellist. 1911

199. Balla:
Rhythm of a Violinist. 1912

of Wilhelm Röntgen from 1895, called 'X-rays', would be seen by those artists as pictorial verifications of the insubstantiality of solid forms. In a newspaper report on the new X-ray photographs it was stated: 'In contrast with the ordinary rays of light these rays penetrate organic matter and other opaque substances just as ordinary rays penetrate glass. . . .' Was Boccioni referring to spirit photographs when he wrote in 1910: 'Who can believe any longer in the opaqueness of bodies, when our increased sensitivity makes us comprehend the obscure manifestations of mediumistic phenomena?' Immediately following this he declared: 'Why should one continue to create without taking into consideration those visual powers of ours that can give results analogous to those of X-rays?' By producing the effects of the X-ray photograph, the Futurists believed they could double the power of their sight.

The transparent forms, which could convey the Futurist idea of simultaneity and interpenetration, were at first far more within the province of painting and the graphic arts than that of sculpture. Had Boccioni been able to translate into sculpture (as he had in painting) images such as are found in Marey's chrono-photographs, it would have been an act of the most unusual creative precocity. And though he suggested, in the *Technical Manifesto of Futurist Sculpture* (11 April 1912), that sculptors may fuse the object with the environment by using materials such as glass, celluloid and wire to create transparent planes, he himself (despite the occasional use of glass) did not abandon more orthodox means. For all his daring, and his notorious antipathy to tradition, Boccioni was still hampered by his subservience to conventional materials, the opacity of which was contradictory to his professed aims. In order to circumvent his difficulties, he naïvely proposed to shade off, by painting, the extreme projec-

tions of his sculpture to make it appear to merge with the background. To give it, in other words, the same quality of transparency that he was able to get in his paintings and drawings: that found in superimposed and blurred photographic images. Only later, among sculptors like Naum Gabo, through the use of transparent plastics and other materials, was simultaneity and the interpenetration of planes realized in three dimensions (200). And it is worth mentioning, if only in passing, that the metal armature and wire constructions of Gabo and others were prefigured remarkably by some little-known photographs of abstract geometrical form made by Marey with metal armatures and string set in motion (201).

For all their professed love of the machine, for all their hostility to the traditional conceptions of art, the Futurist painters never used photography to demonstrate their *rapport* with modern technology. They were unable to dis-

200 (*left*). Naum Gabo:
Linear Construction.
1942–43.
(plastic with plastic thread)

201 (*below*). Marey:
Stereoscopic chronophotographs
showing geometric forms
engendered by the rotation of a
threaded metal armature.
Probably 1890s

engage themselves wholly from conventional ideas. They were defensive about the taunts of critics who branded them with the photographic label. Nevertheless, through their writings predominantly, they were instrumental in establishing a basis for the machine aesthetic of this century in which photography was to play a new and essential role.[68]

PICASSO

The extent to which Cubism was influenced by photography is difficult to determine, though photographs of a 'Cubist' nature were consulted by Picasso in 1909. A careful examination of certain details in chronophotographs will reveal similarities with some of the paintings of Picasso, Braque and Juan Gris before 1915. The interpenetrations of forms, the transparent superimpositions: the simultaneous occupation of a single area by two different objects, or by two aspects of one object (and the consequent ambiguity of spatial relations) duplicate the effects of the multiple exposure in photographs. (202, 203) An interesting foreshadowing of the Cubist idea of simultaneity, and one which links such images directly with photography, will be found in an illustration appearing in the popular journal, *Le Rire*, in 1901. *Les groupes sympathiques*, with

202. Marey: Chronophotograph of a fencer. 1880s

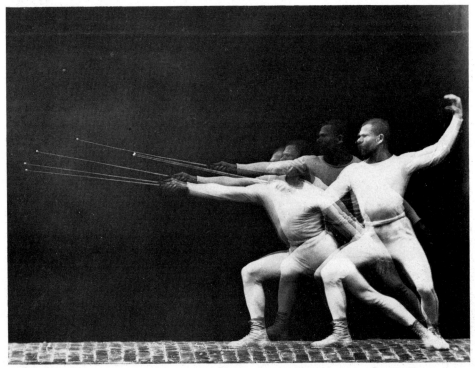

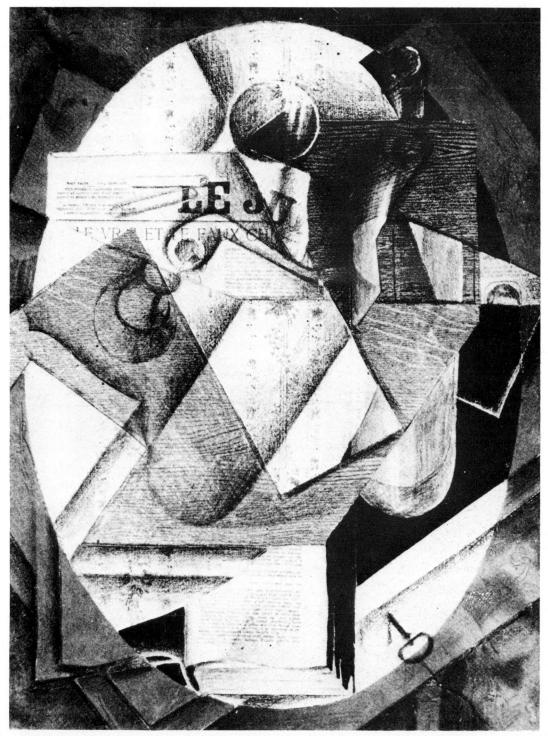

203. Gris: *The Table*. 1914 (coloured papers, printed matter, gouache on canvas)

the caption, 'instantaneous photographs', shows the merging of the frontal with the profile view of a female cyclist in a rather naïve prefiguration of Picasso's later preoccupation with this idea (204, 205).

In *The New Vision*, a review of the principles and techniques of the course of instruction at the Bauhaus, Moholy-Nagy categorically stated that Cubism was intimately linked with photography. He compiled an abbreviated 'dictionary' of Cubist forms which, he believed, showed 'that the technique and spirit of photography directly or indirectly influenced Cubism'. But of the several characteristics enumerated, common to Cubism and photography, only those of simultaneity, superimposition, and possibly the alternation from positive to negative planes and lines, justified this correspondence – and these features appear to relate specifically to chronophotographic form. While the rest of Moholy-Nagy's categories may describe Cubism's distinctive means, their

204. Avelot: *Les groupes sympathiques.*
(Photographies instantanées.) Caricature of double exposure from *Le Rire.* 1901

205. Picasso: Untitled. 1937

relation to photography is somewhat remote. 'Cubism utilized photography in its study of surface values,' writes Moholy-Nagy elsewhere in his book, and 'Photography, in turn, awoke to the possibilities of its own province after a decade of Cubist experiment.' Moholy-Nagy's ingenuous convictions of the importance of both Cubism and photography in modern art may have led to some exaggeration in connecting the two. But even though there is no concrete evidence to show that the similarities are more than fortuitous, certain meaningful analogies may well be drawn between Cubism and photography.

Picasso in several cases made rather straightforward use of photographs, as had Cézanne, Gauguin and Toulouse-Lautrec before him, imposing his own style on the mechanical image. Van Deren Coke discusses the artist's interest in photographic perspective described by the photographer, Edward Weston, in his daybooks written in Mexico in 1924. When one of Weston's nudes was criticized for its 'incorrect drawing', the artist Jean Charlot, who knew Picasso in the 1920s, reassured him that Picasso himself had been inspired by the false perspective typical of amateur photographs. As Coke points out, in Picasso's *Fisherman* of 1918 and *By the Sea*, painted in 1920, the most acute optical distortions of the wide-angle lens are employed. And one might even add the highly stylized, less naturalistic figures of Picasso's *On the Beach* of 1928 to the genealogy of this peculiarly photographic effect. What Degas deliberately took from unconventional photographic perspective, and what many other earlier artists unwittingly imitated, Picasso, consistent with the formal elaborations practised in this century, exaggerated far beyond the limitations of objectivity[69] (206, 207).

ALVIN LANGDON COBURN AND VORTOGRAPHY

The hierarchic distinctions which existed earlier between painting, sculpture and the graphic arts were of much less consequence in the twentieth century. Not only the conventions of subject and form which had governed art, but the very conventions governing the use of its media might now be ignored. Every manner of artistic expression, every experiment, however imaginative, however preposterous or outrageous, was now permissible. Understandably, most photographers at this point tempered their enthusiasm for innovation, not anxious to squander their new inheritance by following painters on their excursions into unexplored domains. Of course they were not satisfied with merely superficial records of the physical world. Imagination and poetry entered into their work as it always had before, but 'life must continue to be a main purpose of all pictorial work' as one photographic spokesman declared, and photographers have the means of representing it.

206 (*left*). W. J. Demorest: *A Photographic Feat.* 1894

207 (below). Picasso: *On the Beach.* Dinard 1928

Some adventurous camera-men [he warned], have already taken lines of their own, and others may well conclude that they are in a position to consider the problems of the future for themselves. They cannot divorce themselves from the general tendencies of art, but it is well that they should study the character and direction of the coming change with a view to their own interests.

These exhortations were set out in the 1916 issue of *Photograms of the Year* when it had already become apparent that the most daring forays were being made into that no-man's-land between painting and photography. One of the adventurous camera-men referred to was no doubt the painter-photographer Alvin Langdon Coburn who had already in 1913 defended his right to manipulate photographic perspective as the Cubists had done in painting. This was reiterated in 1916 when he called for an exhibition of 'abstract' photography. Everyone now has a 'Brownie' he reminded his colleagues, 'and a photograph is as common as a box of matches'. Photography should be alive to the spirit of the time:

why should not the camera also throw off the shackles of conventional representation and attempt something fresh and untried? Why should not its subtle rapidity be utilised to study movement? Why not repeated successive exposures of an object in motion on the same plate? Why should not perspective be studied from angles hitherto neglected or unobserved?

Coburn believed that the great possibilities of the camera had not yet been realized.

The beauty of design displayed by the microscope seems to me a wonderful field to explore from the purely pictorial point of view, the use of prisms for the splitting of images into segments has been very slightly experimented with.

His hope was that photography, like the other arts, may 'do things stranger and more fascinating than the most fantastic dreams'. The following year, one of Coburn's first 'vortographs' was reproduced in *Photograms*. This 'abstract' image, the photographic counterpart of Cubism and the English Vorticist paintings, was taken with a camera through a prismatic complex of mirrors, the original identity of the subject transmuted into striking, purely pictorial patterns. Coburn's contribution to *Photograms* was facetiously received. Thus, 'A very entertaining half-hour might be spent in finding out which way up Alvin Langdon Coburn's "A Vortograph" looks best . . . ' (238).

Ezra Pound and Wyndham Lewis were entirely in sympathy with Coburn's new enterprise. In the introduction to the catalogue of Coburn's exhibition (in 1917) of eighteen vortographs and thirteen paintings, Pound wrote that these photographs reflected the fundamental principles of Vorticism: 'Certain definite problems in the aesthetics of form may possibly be worked out with the vortoscope. . . .' Vortography, he said, has to do with the 'coming aesthetic',

a remarkable prescience of the role similar photographs were to play in the Bauhaus only a few years later.[70]

COLLAGE: PHOTOMONTAGE

To the deliberate visual ambiguities of Cubism from 1909 was added an important new element: segments of real objects were incorporated into the paintings or used to create works in sculpture. The collage technique was first employed by Picasso in a still-life of 1911 in which a piece of photographically simulated chair caning on oilcloth was intricately married to painted objects. In essence it seems that collage reflects some deep and fundamental human instinct and, new though it may have been in the Fine Arts, long before its use in Cubist paintings many humble antecedents can be found in popular and private art. There, the imagination is often indulged in bizarre and enchanting combinations of the most disparate objects. After the invention of photography it is not uncommon to find snippets of photographs juxtaposed with drawings, engravings, newspaper clippings, coloured ribbons, lace, ferns and all kinds of other objects. Nineteenth-century scrap-books and screens are full of them. Gernsheim reproduces a noteworthy example dating from 1873. They appear in photographic magazines, in books on photographic amusements in the 1890s, in postcards from about 1900 and in early cinema fantasies like those of Ferdinand Zecca and Georges Méliès at the turn of the century (208, 209, 210). Of course Picasso handled collage with great understanding, carrying it to a level which transcended the more primitive attempts of homespun artists. His comparison between folk and more sophisticated collage shows his awareness

208. Photomontage
and painting
by Sir Edward Blount.
1873

209. Photomontage. *Giant Roosters and Hens to Provide Large Easter Eggs.*
From *L'Illustration Européene*. Brussels 2 April 1911

210. Ferdinand Zecca: *A la conquête de l'air. c.* 1901 (film still)

of the differences. What good, he said, criticizing a Futurist collage, is a real moustache, used as a moustache, in a collage? If it were used to represent an eye, its effectiveness would be better understood.

There is no clear indication that Picasso or Braque ever employed actual photographs in this way, but certainly they paved a path in art for what had previously been relegated to entertaining pastimes.

Despite the hostile attitude among artists towards the use of conventional photographic images in art, its use in collage and montage was believed to be pertinent and consistent with the nature of modernism. The photographic image had retained its highly persuasive power and, in its fragmented form in combination with other elements of some pictorial representation, it was invested with new meanings.

By 1914 the introduction of real or apparently real objects in collage was already considered to be of such importance that the sage Futurist writer Giovanni Papini took his friend Boccioni to task for wasting his energies eternally brow-beating the public instead of concerning himself with this new and eminently significant process which had entered into art. Why is it, he asked, that these elements are materials of expression and not merely examples of ingenuity or simply throwbacks to realism? But why also is it insufficient that the real things themselves are put in the place of the things to be represented? – a reference to Boccioni's naïve use of a glass eye and hair in a sculpted head. Picasso had already demonstrated to Papini the futility of replacing illusionistic renderings with their real counterparts and Papini argued that the subject was vital, for without a profound grasp of the meaning of collage the Futurists might encourage others to produce blotches of a realism more bestial than that which the *avant-garde* considered justly expired. The elements of reality Papini insisted must be used as *new* materials: transformed, transforming, and without a shadow of conventional meaning. Within a year Carlo Carrà introduced – the first Futurist to do so – a piece of photographic reproduction in the area of the head of a painting of a standing figure. Not very imaginative, it amounted to a genuflection to Papini and his authoritative views. It shows Marshal Joffre on a tour of inspection at the Front and is titled: *French Official Observing Enemy Movements* (211).

Photomontage was an immensely suitable medium for the provocative imagery of Dada. It was absolutely consistent with Dada's promotion of the chance arrangement and the unexpected juxtaposition, the very incongruity of which was a positive, life-eliciting force. Such ready-made *images trouvées*, fragments of reality in the form of photographs and photographic reproductions, gave the Dada artists a most efficacious weapon with which to shock the public. Photomontage, and the possibility of rendering almost instantaneously

irrational images, was pictorial automatism. It was the visual counterpart of automatic writing, the stream-of-consciousness literature so highly prized by Dada and then by the Surrealists. Photomontage was the perfect complement to the random poetry advocated by Hans Arp, Tristan Tzara and Kurt Schwitters.

Photomontage first appeared in the works of the Berlin Dada group about 1916–17. Its invention there is claimed by Raoul Hausmann and by George Grosz and John Heartfield. According to Hannah Höch, who soon adopted this technique and who has consistently used it to the present day, its origins lay in the popular arts of the time. She says that she and Hausmann borrowed the idea from Prussian army photographs of regimental groups on to which had been pasted photographs of the heads of others with the intention of giving to the intruders all the *hauteur* of the original. Elsewhere, she claims also that it was during a holiday on the Baltic that she and Hausmann realized the great potential of the medium after seeing an oleograph showing the genealogical background of Kaiser Wilhelm II into which their landlord had proudly insinuated himself by the simple expediency of a pasted-on photographic portrait. As soldiers on the Western Front, Grosz and Heartfield exchanged collages

211. Carlo Carrà:
*French Official Observing
Enemy Movements.* 1915

on postcards made from the debris of advertising illustrations, labels and picture magazines, the irony of which, unlike messages in words, escaped censorship. This exchange led their friend Sergei Tretjakov to attribute the invention to the 'anonymous masses', a jesting but not meaningless observation.

Despite the disputed authorship of photomontage, its source, as with collage, was undeniably in the popular arts. In his charming and informative book on Dada, Hans Richter quotes Hausmann on the meaning of photomontage. Quite clearly, Hausmann acknowledged its connection with Dada poetry. Photomontage was the true medium of the anti-artist. It was used to attack conventional realism with realism itself. Furthermore, it was, technically speaking, modern in its *rapport* with photo-mechanical reproduction and mass communication and it is worth noting that when exhibiting his original photomontages, Heartfield usually showed with them, the pages of newspapers and magazines in which they had been reproduced. In the developing concepts of a machine aesthetic, these artists fully understood its relevance. Hausmann associated this method of working with that of the engineer, the fitter who in assembling the parts of a picture had a 'construction' for the finished object. That method explains the curious title of Grosz's well-known picture of Heartfield, the

212. R. de Moraine:
Military 'cartouche' for
pasting in photograph.
Late nineteenth century(?)
(lithograph)

engineer, the *photo-monteur* (213). The Berlin group bestowed the sobriquet *monteurdada* on John Heartfield even before it became clear that he would passionately devote himself to that medium for the rest of his life.

213. George Grosz: *The Montage-Paster (The Engineer) Heartfield.* 1920 (water-colour and collage)

Höch stated recently that the major purpose of the photomontage was to 'integrate objects from the world of machines and industry in the world of art' (214). It was this element, its anti-art character, plus its obvious value as

214. Hanna Hoch:
Dada Dance.
1922 (photomontage)

a polemical tool that strengthened the *rapport* between Dada and Russian Constructivism. Incongruous as it may seem considering the predominantly geometrical character of Constructivism, the poster displayed at the famous Dada exhibition in Berlin, 1920, which proclaimed, '*Die Kunst ist tot. Es lebe die neue Maschinenkunst:* TATLINS', is a forthright declaration of the fundamental compatibility of the two ideologies. Hausmann, in addition to Heartfield and Grosz, paid homage to Vladimir Tatlin in a photomontage of 1920 called *Tatlin at Home*, amiably spoofing the preoccupation of the arch-Constructivist with machinery and machine-made products.

As Hausmann and his friends well knew, the greatest range of pictorial devices (he called it 'formal dialectics') was available to the artist using this technique – either by itself or incorporated with drawing, painting and typographical elements. Richter's appraisal of photomontage as a 'kind of motionless moving picture', probably because of the ease with which simultaneously different viewpoints, subjects, repetitions of themes and innumerable other formal stratagems could be effected, is very apt indeed.

The Dada repugnance for an ostensibly rational society debased by war and corruption had in photomontage probably the most telling, the most versatile weapon which had ever come into the hands of pictorial satirists. In the work of Grosz and Heartfield it became a very effective instrument in their impeachment of post-First World War German society. The medium flourished in the turmoil of war and at the time of the great revolutionary upheavals both in Russia and Germany. Heartfield's photomontages did not, however, turn in the direction of social and political satire until 1920, after the success of Bolshevism in Russia and its failure in Germany.

No one else used photomontage as a polemical medium so consistently and with such audacious cunning as he did. The ferocious invective of his work was understandably the response to a grievance-ridden society which by the same token gave rise to a morose literature and a cinema of anxiety and despair. The elaborate pictorial integration of images is characteristic of his work. Often this is accomplished by astutely composing his subjects for photographs with the final montage already in mind and also by the prudent use of the brush and air-brush. But predominantly the effectiveness of Heartfield's imagery must depend on a remarkable facility for the retention of images and a great propensity for shuffling them around in his mind's eye to create his startling metamorphoses. The trenchant symbolism of his pictures is essentially alien to the Dada conception of randomness and fortuitous juxtaposition. There is nothing fortuitous about Heartfield's compositions. The voracious animal, the skull and the hood, the skeleton and the midnight landscape, the snake, the cemetery and the medieval architecture all echo the traditional iconography of German, not to say Western European, art. These Heartfield merges with the iconography of modern militarism and with that of technology and commerce.

The power of photomontage to provoke the most severe reactions lies precisely in its faculty to make the absurd appear true and the true to appear absurd. Heartfield's terrifying commentaries on the German pandemonium would be too ludicrous, too impossible, had they instead been rendered in pencil or paint (215, 216, 217, 218, 219).

Heartfield was hounded unmercifully by the Nazis, even when he took refuge in Czechoslovakia before the German occupation of that country. When his

MILLIONEN

stehen hinter mir

215 (*left*). John Heartfield:
Millions Stand behind Me.
The Meaning of the Hitler Salute.
16 October 1932 (photomontage)

216 (*below left*). John Heartfield:
I, Vandervelde Recommend
Best the Freedom of the West.
3 June 1930 (typophotomontage)

217 (*below right*). John Heartfield:
As in the Middle Ages,
so in the Third Reich.
31 May 1934 (photomontage)

218 (*below*). Police photograph of a
murder victim. Stuttgart *c.* 1929

219 (*right*). John Heartfield: *A Pan-German.
The Bosom from which it Crept is still Fruitful.*
2 November 1933 (photomontage)

EIN PANGERMANE

works were exhibited in Prague, in 1934, under the auspices of a group of
distinguished Czechoslovakian artists, an attempt was made to remove some of
them in response to official pressure exerted by the German Ambassador. In
protest, Louis Aragon, Paul Signac and other French artists organized a Heart-
field exhibition in Paris the following year.

In my opinion, Max Ernst shares with John Heartfield the distinction of
having elevated this collage technique to a highly articulate level. Stimulated
by the evocative juxtapositions of photographs and photo-engravings in adver-
tising brochures and sales catalogues, Ernst saw in them 'a hallucinatory
succession of contradictory images' waiting to be heightened by the addition
of a line, a landscape, a touch of colour, in order as he said to 'transform the
banal pages of advertisement into dreams which reveal my most secret desires'.
The rich and suggestive trivialities of such pages of layout in the *Fliegenden Blätter*
of Munich at the beginning of this century are good examples of the kind of raw
material Ernst and others had at their disposal (220). The famous *Fatagaga*
photomontage with its Bosch-like fish-ship floating eerily in a mysterious
void was produced in Cologne by Ernst, possibly with the help of Johannes
Baargeld and Hans Arp, in 1919 or 1920. The deliberate unintelligibility of its
full title *Here Everything is still Floating/Fabrication des tableaux garantis gazo-
métriques* is wholly in accordance with the incongruity of the image it describes.
Many of Ernst's most outstanding collages were made in this period, and in
subsequent years he continued to employ the technique, utilizing both photo-
graphs and engravings made from photographs, often in combination with

220. Page of advertisements from *Der Fliegenden Blätter.* Munich 1899

221. Max Ernst: *Paysage à mon Goût.* 1920 (photomontage)

other collage elements, drawing and painting (221). The effectiveness of series like the enchanting *La femme 100 têtes* (1929) and *Une semaine de bonté* (1934) depends not only on the mystery and suggestiveness of the images and their pictorial homogeneity, but also on the uneasiness evoked by the peculiar synthesis of photography and engraving (222, 223, 224, 225, 226).

The importance of this kind of collage to Surrealist art was stressed by Ernst. Critics of André Breton's *Surrealist Manifesto* (1924) claimed that since any comprehensible drawing or painting involved a conscious process, there could not be such a thing as Surrealist art. Ernst objected to this, saying that the Surrealists had discovered certain processes by which the elaboration of pictorial form could be so considerably reduced as to free the representation from the undue influence of the conscious faculties. He meant, principally, the use of ready-made images in collage. With such techniques, he wrote, 'it is now possible to photograph either on paper or on canvas the amazing graphic appearances of thoughts and desires'. The fortuitous encounter, as Ernst called it, 'upon a non-suitable plane of two mutually distant realities' and being able to 'draw a spark from their juxtaposition' (paraphrasing Lautréamont's '. . . the chance meeting upon a dissecting table of a sewing

222. Max Ernst: *The Landscape Changes Three Times (II)*. From *La femme 100 têtes*. 1929 (montage from engravings)

223. *A Curiosity Constructed from an Orange.* By H. Thiriat 1889 (engraving from photograph)

224. Max Ernst: *The Sunday Spectre Makes Shrill Sounds*. From *La femme 100 têtes*. 1929 (montage from engravings)

225. H. Thiriat: Engraving from photograph. 1891

226. Photograph from which illustration 225 was made

machine and an umbrella') could have no better means of representation than to come as close to reality as was possible (227). Automatic writing, which

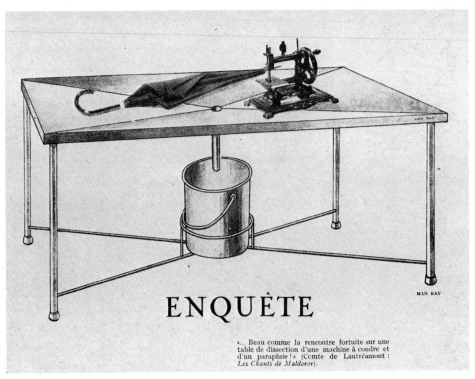

227. Man Ray: Drawing and photocollage elements illustrating Lautréamont's famous words. Published in *Minotaure*. 1933

Breton, in Ernst's 1920 exhibition catalogue, called 'a true photography of thought', was eminently analogous to automatic picture-making in which photographs (ready-made realities Ernst called them) or fragments of photographic images gave substance to the arbitrary thought.

In 1927 Breton insisted on the superiority of Ernst's collage elements over those literal substitutes for canvas and paint used by the Cubists. Ernst's images have a 'relatively independent existence' and photography alone, he said, could participate in the strange logic of his disparate combinations of form. In *Beyond Painting*, Ernst quoted Louis Aragon who tried to distinguish between the kind of collage usually produced by Dada artists and those made by Ernst. The intent of the former was directed more towards self-expression than to discovering the means, the 'system' which evoked the most profound responses. This, certainly, is true of the work of Hausmann, Höch, Tzara and others who seldom

attempted to give to their compositions that extra pictorial cohesion possible through the logic of space, tone, light and shadow, or in other ways which both Heartfield and Ernst found so imperative. To Ernst, Aragon attributed the greatest understanding of the fundamental power residing in photomontage: 'one must pay homage to Max Ernst for it, at least for that which among the forms of collage, is furthest from the principle of *papier collé*: photographic collage and collage from illustrations'. Writing in 1923 of this 'painter of illusions', Aragon stressed the multifarious elements, unprecedented in painting, which photography had given to Ernst who evokes yet other images with them by a process absolutely comparable to that of the poetic image. 'Here is a hedge over which horses jump. It is an illusion: come closer, what you took for a hedge was a photographic print of a bit of knitted lace.' Innocent as this example may appear, it indicates in its essence the inherent vitality of such graphic transmutations.

As with Ernst, in a brilliant essay on John Heartfield, Aragon drew out the essential differences between the *papiers collés* of the Cubists and the photomontages of Heartfield and Grosz. Aragon saw Cubism as a rejection of the photograph which, together with the cinema, made it childish to struggle with verisimilitude. But Heartfield, Grosz and Ernst, he said, not only employ photography in new poetic ways, they use it expressively to destroy its intrinsic property of imitation; the traditional taste for imitation was itself the factor which gave meaning and charm to the photomontage's decomposition of appearances.[71]

228. *A Startling Trick.*
Engraving from *The Picture Magazine*. 1894.
Also published in *La Nature*,
1880: 'Experiment Concerning Inertia

229. André Breton:
*The Comte de Foix about to
Assassinate his Son.* 1929

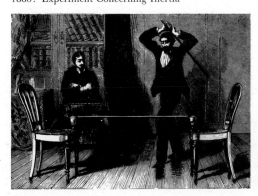

Something of the logic of photographic form will be found in Ernst's fantastic landscapes of the 1920s and 1930s. Indeed, their very irrationality is heightened by the apparent optical veracity and impersonality of the formal rendering. With little doubt, Ernst's systems of 'frottage' and 'decalcomania' – the latter technique introduced to Surrealist circles by Oscar Dominguez in 1935 – serve the same end (230).

Everything that defies plastic figuration [wrote Breton describing the compelling blots of decalcomania], because of its complexity, its minutiae, its instability, artistic imitation of which would seem rather fastidious and childish . . . everything that could be called 'a painter's despair' (or a photographer's) is now returned to us as a result of a recent communication from our friend Oscar Dominguez, in which surrealism is pleased to behold a new source of emotion for *everyone* (231).

Because of the *rapport* of these techniques with photographic or, for that matter, with even more concrete form, a realistic basis is again given to Ernst's anthropomorphic and geological fantasies. A variation of the old method called 'nature printing', Ernst wrote in 1925 of his discovery of frottage, that is, of taking rubbings from relief surfaces – those of wood especially. He indicated that by means of such 'appropriate techniques', by minimizing the personal element in the process – as in automatic writing – the creative, the hallucinatory faculties are left free.

Salvador Dali also expressed a desire to approach 'phenomenal reality' by conveying irrational thought and fantasy with the maximum of *trompe-l'œil* illusionism. By simulating photographs in paint, 'instantaneous and hand-done colour photography' as he described it, his 'concrete irrationality' became feasible. This perhaps explains the strident colours which characterize his paintings as certainly it suggests the source of their extreme verisimilitude.

Though not with Dali's typical extravagance, other Surrealists also subscribed to photographic form. The assiduous elaboration of the descriptive elements, the careful integration of purely formal ones based on photographic reality, would seem to insure that the marvellous and the impossible should appear true. Less remote from actuality and only verging on the impossible, René Magritte's tranquil evocations of the dream-like state have with good reason been called 'painted collages', though it is not clear whether or not photographs have directly helped him (232).

Of the same species as Ernst's frottages is the technique called 'fumage', devised by Wolfgang Paalen in the mid 1930s, at the time Dominguez's 'decalcomanias-without-object' aroused such interest among the Surrealists. The process of depositing an impersonal tonal surface on pictures by the use of smoke from a candle flame was employed at least as early as the first part of the nineteenth

230. Max Ernst: *In the Stable of the Sphinx.*
Frottage from the *Histoire naturelle.* 1927

231. Oscar Dominguez: *Decalcomania without object.* 1937

232. René Magritte: *Time Transfixed*. 1932

century. The Surrealists, however, did not use it to enhance the representation of a subject but, as in decalcomania, they wished to create – through a subtle tonal vehicle alone – a formless but suggestive field in which the spectator is invited to indulge his imagination.

Yet another process can be added to this series. It is called 'flottage' and was introduced by the Surrealist Marcel Jean about ten years ago. This 'means of forcing inspiration', as Jean writes, obtainable by floating oil colours on water then taking prints from the resulting more or less random patterns has, of course, notable antecedents in the old craft of marbling. Its revival or rediscovery was especially appropriate to the Surrealist brand of pictorial egalitarianism.

All these forms of infra-imagery are, in short, Leonardo's stained walls, Alexander Cozens's ink blots, invested with a modern relevance. They are non-images really, and often, as traditionally prescribed, they were transformed into descriptive objects. The interest in such techniques was perhaps stimulated by the photogram which appeared about 1920. Like the photogram they were highly valued because of the absolute impersonality achieved in the tonal rendering through some mechanistic agency. They even went beyond the photogram which, though made without the camera, still depended on a degree of photographic manipulation. For with a minimum of human intervention, impressions as tonally pure as photograms could be obtained without recourse to any photographic process and thus more closely approach concrete reality.

This evolution from nature-printing marks a complete reversal of the Post-Impressionist proscription of photographic form, of tonal nuance especially, and the insistence on expression with its concomitant in the palpable material nature of the work. At bottom, the Surrealist resurrection of fluent tone is an attempt to excite the imagination by the least artistic means. This tonal fluency was still current in the 1940s and is especially evident in the work of artists moving towards the periphery of Surrealism: Gorky and Matta, for instance. Surrealists refrain from making any categorical distinctions between the photographed or the painted or the assembled image, all of which are considered to be equally efficacious as graphic or concrete manifestations of the 'superreal'.[72]

FROM CONSTRUCTIVISM TO THE BAUHAUS

The photograph fitted perfectly in the creative programme of the Russian Constructivists: it was machine-made, it was universally practicable and universally comprehensible and it need not be derivative of artistic styles. They, like the Dada artists, repudiated individualism and self-expression which

they attributed to bourgeois art. Geared to the requirements of the new Soviet State, photography's proximity to accepted appearances made it eminently suitable for the visual propaganda of the poster, for magazine and book illustration and for exhibition murals. Probably through the peripatetic Russian, El Lissitzky, the Dada enthusiasm for photomontage was communicated to Moscow (and to the Weimar Bauhaus) in the very early 1920s, Alexander Rodchenko being one of the first Russians to use the medium in his illustrations of some early publications of Mayakovsky's poems. Lissitzky, who employed photomontage intensively in the 1920s and 1930s, may have been the first to produce gigantic murals in photomontage as part of his designs for the interiors of Soviet pavilions in international exhibitions (233).

Both these artists, among their many other creative activities, also worked in 'straight' photography. Rodchenko was reputed in the 1930s to be an outstanding sports photographer in the Soviet Union, and he contributed to the development of film titling as an art form in itself. Lissitzky's conception of 'irrational space' was based on the new perspective view revealed by the

233. El Lissitzky:
*Tatlin working on the monument
to the Third International*(?)
(drawing and photocollage) 1917(?)

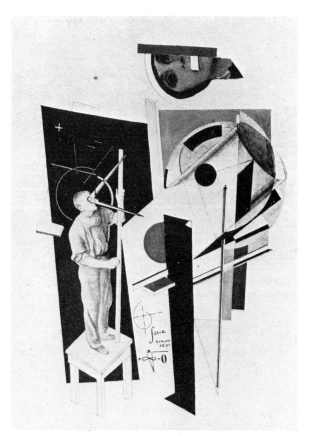

airborne camera. The awareness of this 'new' space and the surprising appearance of the landscape from above had increased in direct consequence of the development of the flying machine and the greater occupation of photographers with the bird's-eye view. With little doubt, the Suprematist Casimir Malevich, in his desire to convey a consciousness of the metallic machine culture and the space age shows, in the stringent geometry of his paintings and drawings, a special interest in that kind of photograph. In his book, *The Non-Objective World*, an elaborate statement on the meaning and sources of Suprematism, he actually singles out and reproduces such photographs as examples of 'the environment which stimulates the Suprematist'. Some of his 'basic Suprematist elements' so-called, formulated on the square, not only reflect but almost represent photographs of squadrons of planes against an open sky and near-perpendicular aerial views showing clusters of buildings as unexpected patterns of terrestrial forms. In his compositions like *Suprematist elements expressing the sensation of flight* (1914–15) and *Suprematist composition conveying a feeling of universal space* (1916) one finds highly abstract references to aerial photographs (234–236).

234. Photographs of aircraft in flight used by Malevich in *The Non-Objective World*. First published 1927. (Bauhausbuch 11, Munich)

235. Malevich: *Suprematist composition conveying a feeling of universal space.*
1916. First published in *The Non-Objective World.* 1927

236. Aerial photographs
used by Malevich
in *The Non-Objective World.*
First published 1927

Lissitzky described the space represented by the cinema as 'imaginary' and he was absorbed by the analysis of cinematic form. This interest had probably been heightened by his knowledge of the work of Viking Eggeling and Hans Richter, two pioneers in experimental cinema whom he met in Berlin about 1921. In propounding his typographical principles, Lissitzky called for 'the continuous page – the cinematographical book'. That possibly is reflected in a work like *The Story of Two Squares* of 1920 (published in 1922) in which, following the titles and the introduction of the two 'actors' (black square, red square), the story runs in visual sequence and even seems to duplicate the cameraman's devices of tracking in and out.

The interest in film form expressed by Marinetti presaged the serious concern with that medium among other Futurists, the Constructivists, the Surrealists and those connected with de Stijl and the Bauhaus. Though the scope of this study does not permit anything but a cursory look at film in relation to the other visual arts it is again worth noting the attitude of Theo van Doesburg in bringing the art of film into the sphere of his creative evolution theory, the conventional distinctions between media giving way to universal criteria of aesthetic progress.

Due largely to the recognized importance of the film, in many areas of creative activity the hierarchical separation of artist and photographer had

become an anachronism. The views of artists like Hans Arp and Moholy-Nagy, that the love of painterly qualities was only a futile remnant of romanticism, the brush an instrument of the past, reflected the growing significance of depersonalization in modern art and the new prominence given to photography and to photographic form. This conception was already implicit in the literature of Futurism and prompted Russian artists like the Rayonnist Larionov to assert as early as 1913 that individuality had no value in a work of art. That view, as already seen, was soon reiterated in the Dada and Surrealist programmes calling for the mechanization of inspiration and it was shared by the Constructivists and the artists of de Stijl. Picture-making and the 'weakness of the hand' was to be superseded by the implementation of an 'objective' means of expression. Art and the machine had come to terms.

In a modified form these concepts were taken up in Germany, at the Weimar Bauhaus in the 1920s. There, influenced by German and Swiss Dadaists, by Malevich, Lissitzky and van Doesburg, form and function were calculated on the new technological and social conditions of modern world culture. The tools, machines and materials of industrial civilization were literally to become instrumental in the formulation of a new art. Moholy-Nagy, who was largely responsible for the foundation course there from the mid 1920s, spoke of a new space created directly with light. The photographic camera thus became the foremost means for producing or recording such images. There, in typographical design, as visualizations for theatrical and film scenes and also for pure statement, photography was an important influence. Moholy-Nagy extolled the virtues of the air-brush and the camera and, like his contemporaries in Russia and the Netherlands, he declared that the painterly surface, the personal touch – vestiges of artistic vanity as he believed they were – should be subordinated, if not eliminated, in works of creative design.

The photogram was the supreme expression of this state of mind. Made directly by arranging objects on light-sensitive paper, photograms became more or less cult objects, cult images, for the technological primitivists first, because they were produced almost purely by physical and chemical means, and second (as the Surrealists appreciated), because Nature was made to transmute her own appearances – instant metamorphoses (237)! Photograms were consistent with Bauhaus, and particularly with Moholy-Nagy's notions about 'a new counterpoint of space', a conception of space composition favouring superimpositions and interpenetrations of form. Moholy-Nagy thought of them as objective light-paintings, as producing a new pictorial space, and they were described in the jargon of the scientific laboratory. *Geometrizing Chiaroscuro Structure* is the title of one; *F 38 1926* of another. Yet it was really the fusion of science and poetry in the photogram which gave it its special appeal.

The photogram made its appearance immediately after Dada's discovery of

The photogram made its appearance immediately after Dada's discovery of the photomontage, and is itself a kind of auto-recorded collage, as in the work of Christian Schad, and auto-recorded assemblages in those of Man Ray, Moholy-Nagy and Kurt Schwitters. The photogram was simply a modern version of Talbot's old photogenic drawing method, and here again, as in photomontage, the process had been employed for the amusement of amateurs in the early years of this century and before.

It is worth noting the more than visual kinship that exists between photograms and Coburn's vortographs, which immediately preceded them (238).

237. Moholy-Nagy:
Photogram. 1923

238. Alvin Langdon Coburn:
A Vortograph. c. 1917

In 1918, a year after Coburn's London exhibition of 'abstract' photography, Schad, a painter connected with the Zurich Dada, resuscitated Talbot's method, substituting for lace and leaf forms new elements consistent with the throwaway character of modern society. Torn and cut paper, ribbon and string, bits of newsprint – material trivia jettisoned by urban civilization – were, like Schwitters's collages, arranged in compelling designs suspended in the dark voids of the photogram's negative image. These, Schad later suggested, could be enhanced by the addition of drawing or painting. They were called 'Schadographs', a term invented, it is thought, by the Dadaist Tristan Tzara who, it seems, may have become the *colporteur* in Europe of the new photographic

discovery. It is not clear whether Tzara communicated the idea to Man Ray and Moholy-Nagy or whether these artists came upon the technique independently about 1920 or 1921. In either case Tzara was on the spot when Man Ray, as a painter and photographer working in Paris, made his first photograms ('Rayographs'). Tzara immediately proclaimed that they were perfect expressions of the Dada spirit. The diversity of interpretations possible with photograms may be illustrated by comparing Moholy-Nagy's appreciation of them with Man Ray's whose enthusiasm was principally due to the deformation of the subject by light and chemistry. That the identity of the original was significantly altered, and a new form created by the violation of the medium, was to him not only positively advantageous, but indispensable to the 'purest realization' of modern art (239).

From the time Paul Klee joined the Weimar Bauhaus at the beginning of 1921, certain new features, and variations of older ones, appearing in his work, suggest a more than casual interest in photography. It is not at all unlikely that Klee's pictures during the 1920s should reflect, to some extent at least, the considerable interest at the Bauhaus in the photograph, and that the more abstract manifestations of that medium should be assimilated into his work. Though earlier, Klee's paintings show him interested in light, clearly structured

239. Man Ray:
Rayograph for the *Champs Délicieux*. 1921

240. Kurt Schwerdtfeger:
Reflected Light Composition. c. 1923

forms against dark grounds, creating somewhat the impression of negative images; his pictures of that kind from 1921, his *Fugues* particularly, more closely than ever approach the character of photograms, just as they resemble photographs of Ludwig Hirschfeld-Mack's and Kurt Schwerdtfeger's kinetic projections called 'reflected light compositions' developed at the Bauhaus from 1921 to 1923 (240). Certainly, from 1923, the date Moholy-Nagy joined the teaching staff there, his colleagues would have been fully cognizant of his photograms and some of them may well have known those produced a few years before. In this context Hirschfeld-Mack's words to Standish Lawder are worth repeating:

At the Bauhaus [he wrote] we 'gave' and 'took' from each other, influencing each other, without giving up identity or originality. I remember that Bauhaus members pointed out to me that Moholy's pictures with their clear-cut shapes in transparencies were derived directly from my Reflected Colour Light Plays. But I rejected these thoughts.

The great confluence of ideas at the Bauhaus must also have included every known form of photographic aberration. Even the singular appearance of solarized photographs, with their strange linear and partial relief effects, used as early as 1920 by the German scientist and expressionist photographer, R.E. Liesegang (241), and from about 1926 by Man Ray, is re-created in at

241. R.E. Liesegang:
Reticulated, solarized photograph.
1920

least one of Klee's paintings, his *Village in Relief* of 1925. Klee's interest in the spatial and temporal characteristics of line, which occupied him in the *Pedagogical Sketchbook* (1925), may in some degree have an antecedent in photography.

242. Marey: Stereoscopic trajectory photograph of a slow walk. 1885

243. Klee: *The Mocker Mocked*. 1930

Could the idea of 'taking a walk with a line', the 'active line on a walk', which he so aptly illustrates in pictures like *The Mocker Mocked* (1930) with its single, continuous linear configuration, a line of light on a dark background, have originated in Marey's trajectory photographs of locomotive figures (242, 243)?

Commenting on his pictures of the *Little Jester in a Trance* (1927–9) Klee told his students at the Bauhaus: 'the jester in a state of trance might be taken as an example of superimposed instant views of movement'. He could as well have been describing a chronophotograph, and though such forms may already have become embedded in pictorial tradition, their deepest roots were undoubtedly in those fascinating photographs taken forty years earlier by Marey. Moreover,

in these pictures, Klee unites, with typical brilliance, both trajectory and sequential images and though they are entirely transformed, a faint but persistent echo of Marey remains[73] (244).

244. Klee: *Little Jester in a Trance.* 1929

Klee's interest in the genesis of a work of art and the process of creation was more than philosophical. He made practical use of the widest possible range of phenomena. Referring to the 'mobility of mind' necessary to the artist, he held it to be advantageous to regard the physical world as a collection of mutable things, and through a really penetrating scrutiny of nature, he believed, the flowering of a great depth of feeling was possible. It was high time, he said, that the artist acquaint himself with the fantastic images of the microscope. Only the 'realist' would find them over-imaginative and incomprehensible: 'coming across such an illustration in a sensational magazine, [he] would exclaim in great indignation: "Is that supposed to be nature? I call it bad drawing".' But the artist, Klee insisted, concerns himself with microscopy, with history and with palaeontology. He does so not to discover in these things literal truth, but to free his thoughts, to enhance his understanding of more fundamental processes (and to develop what Klee would call a cosmological consciousness).

That the microscope was the window to the unseen world and a vehicle to a more profound comprehension of things was in the mind of Samuel Morse when, on seeing Daguerre's primitive photomicrographs in 1839, he wrote enthusiastically to his brother of the possibility of a new universe being brought to light. But art, and the sensibilities of artists, would have had to undergo a great transformation before such images could be considered worthy of exploration and interpretation beyond the literal renderings of scientific illustrators. By the time this extra-perception was permissible in works of art a vast accumulation of microscopic and telescopic images had become familiar to the general public.

Both Daguerre and Talbot had taken photographs through the solar microscope (245, 246) and, probably as early as 1801, similar images were produced, though not rendered permanent, by Humphry Davy and Tom Wedgwood. Daguerre's recording of the moon excited much interest in scientific and artistic circles. As early as 1844, Alfred Donné published a compendium of drawings made from daguerreotypes of microscopic forms. Despite the difficulties posed for telephotography by the interference of adverse atmospheric conditions, which ultimately was mitigated by the use of infra-red emulsions, astronomical photographs were taken in the 1840s in considerable quantities. Those incunabula were followed by photographs of the minute substructures of plants and insects, of the mysterious functions of animalcule life. Biological and entomological studies gained momentum through the photographic record. Some of those marvels of the invisible world, as often they were described, were noted by Burty in 1861: objects enlarged up to 600 diameters among which were fibres made, he said, to look as big as the cables of the Great Eastern. In his very

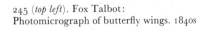

245 (*top left*). Fox Talbot:
Photomicrograph of butterfly wings. 1840s

246 (*top right*). Fox Talbot:
Photomicrograph of botanical sections
taken with solar microscope. 1841

247 (*left*). Warren de la Rue:
Photograph of the moon. 1857

248 (*above*). The nebula in Andromeda
(beyond the solar system). Published in
Marvels of the Universe. 1910

popular *Marvels of Photography* (1874), Tissandier, who introduced Muybridge to Europe, reproduced engravings made from photomicrographs of a flea, of diatoms magnified 450 times and of the surprisingly delicate structure of the stalk of an ordinary reed. So were the organisms living in seaweed revealed, the needles of a spruce, the epidermis of a caterpillar larva and the unexpected appearance of wet, minuscule pebbles.

The photographs of the heavens conveyed the most surprising astronomical and meteorological phenomena. Distant bodies like the Pleiades were recorded with great clarity. Light rays, anticipating by a half century the Rayonnist structures of Larionov, were made visible by the photographic telescope. The remarkable photographs of Warren de la Rue, taken in the 1850s and 1860s, disclosed the parallel striations of the planet Jupiter. Mars and Saturn could now be gazed upon in any nineteenth-century drawing-room. And by the 1860s and 1870s even more detailed photographs of the rough, cratered surface of the moon, taken by Janssen and Rutherford, brought it even closer to tangible reality. Several series of photographs showing the passage of Venus across the sun in 1874 were published in that year. Accurate recordings of nebulae, comets and solar protuberances now extended the iconography of the natural world.

Though Odilon Redon took exception to Huysmans's well-meant insinuation that he consulted a microscope in obtaining the macabre imagery of the infinitely small, there is little doubt that the heightened awareness of the terrestrial and celestial unseen considerably stimulated his imagination. Redon was particularly influenced by his botanist friend Armand Clavaud who used the microscope in studies of minute plant forms.

He was seeking [noted the artist in later years], on the boundaries of a world beyond perception, for a life intermediary between animal and plant; for that flower of the being, that strange element that is animal for some hours of the day only, when it is activated by the power of light.

Redon's sensitivity to the micro-organic world is implicit throughout his work. And paintings or pastels like *At the Bottom of the Sea* and *Sea Horse in Submarine Landscape* reflect this new consciousness of nature.

The extent of the concern with extra-perceptual imagery in art before the end of the century may be assessed by the warning issued in 1893 by the English painter, Wyke Bayliss, in discussing art and science in the *Studio* article on art and photography already referred to.

The microscope adds to our knowledge, but it does not help the artist; it rather conflicts with his sense of proportion. . . . It is quite possible to see too much. . . . Already to the average sight there is more visible than can be expressed in art. To increase the intensity of the vision, therefore, to enlarge its range, is only to add to the

artist's embarrassment and the difficulty of his choice, unless [Bayliss conceded in somewhat vague terms] the increased intensity and enlarged range enable him to penetrate and to grasp the higher as distinct from the lesser truth.

Popular illustrated books on scientific subjects, like the outstanding *Marvels of the Universe*, published in two large volumes in 1910, must have made a strong impact on the public imagination. Its vast assortment of photographs describing the regular and freakish phenomena of the natural world, from the pullulating minutiae of sub-marine life to the glacial tranquillity of the lunar landscape, has lost little of its appeal. Could such extraordinary images not exert a profound influence on art in this century?

249. A. Leal: Photomicrograph of growth on water-weeds. Published in *Marvels of the Universe*. 1910

Certainly, photographers themselves, like Coburn in 1916, were becoming conscious of the beauty which lay in the microcosmic world. The crystalline appearance of his vortographs must have seemed easily consistent with that of certain microscopic forms. The photographs of the evocative structures in the striations of agate taken by Raphael Liesegang before 1915, though ostensibly scientific in purpose, could hardly have been made without some sensitivity to their poetic character.

In 1925 Le Corbusier, in his book on decorative art, mused on the reactions of society to the plethora of scientific publications which 'place before our eyes the cosmic phenomenon: astonishing, revealing and shocking photos, or moving diagrams, graphs, ciphers'. In the dawn of the machine age a new attitude, he said, permeates our spirit. We move towards another kind of aesthetic satis-

faction. Overwhelmed with scientific treatises and documentary images, through books and the cinema, science and life have superseded yesterday's poetry. Now we attack the mysteries of nature scientifically and, 'far from exhausting it, one always digs up something more profound and so we advance. That has become our folklore.'

Le Corbusier's interest in such images is reflected in the philosophy of Amédée Ozenfant with whom he helped establish the aesthetic concepts of Purism. In *Foundations of Modern Art*, first published in 1928, Ozenfant not only reproduced photographs taken through the microscope or telescope – radiolaria and diatoms, Saturn, the moon, the nebula of Andromeda, as examples – but also close-ups of plants, scientific recordings of electric sparks, wave-structures and others which similarly reveal unexpected characteristics of nature. 'It is by studying the stars that we have been able to conceive the structure of atoms', he wrote, quoting from another source. Nature is not what it appears to be. It must, he insisted, be contemplated anew. 'Take in your hand the little creatures that crawl or fly: the velvet moles, tender sparrows, hieratic insects, microscopic necessities of the universe. . . .'

This intense peering into nature had been consciously practised by Redon and his sagacious words on the subject are worth repeating.

I have always felt the need to copy nature in small objects, particularly the casual or accidental. It is only after making an effort of will to represent with minute care a blade of grass, a stone, a branch, the face of an old wall, that I am overcome by the irresistible urge to create something imaginary. External nature, thus assimilated and measured, becomes – by transformation – my source, my ferment. To the moment following such exercises I owe my best works.

That was written in 1909 and, later, a similar awareness is revealed by Ozenfant.

Saturn, trembling in the crystal lens of the telescope, makes us ponder as a glow-worm does a child: so too, the Milky Way generating universes, or a sleeping seed that a touch of moisture brings to life under the microscope. Roses of Jericho, Brownian movements of constellated atoms, no matter what, must be seen under the microscope: and then our gaze must be turned within, upon our own abyss, in search of that ineffable axis which is the abscissa of the vast Whole.

Ozenfant sought to discover consistent elements of form in nature: concordances, laws, a universal and harmonious language of art. Here, indisputably, photography was the vehicle.

The least thing in the world [he wrote], the tiniest note of sound, the smallest form, the least idea, bows its head to a universal injunction. . . . We translate the steps of saline crystal into the great staircase of Versailles. . . . A flower is no longer one of nature's smiles, nor sixpenn'orth at the florist's but magnetic waves directed along certain axes . . .

Not only Ozenfant's saline crystals but all minutiae, down to the fractional parts of atoms themselves, were, within a generation, reproduced and re-reproduced not only by the photograph and the proliferating means of photo-mechanical reproduction, but by the cinema as well. The miracles of the slow-motion and speeded-up film which fascinated Marinetti in 1909 have become the stupefaction of millions who may now watch a flower grow to maturity in thirty seconds, or a bullet shatter a pane of glass with the turgid nonchalance of an underwater swimmer.

The fragmentation and magnification of images on the cinema screen were Fernand Léger's confirmations, in the early 1920s, of a 'new realism' to be found in modern life and its reflection in modern art. He gave a special significance to the rich qualities of form, divorced from subject-matter, discoverable in the smallest parts of otherwise insignificant objects. The new realism, he said in 1935 (at the Museum of Modern Art on his first visit to New York), is found also 'behind scientific microscopes, behind astronomical research which brings us every day new forms that we can use in the movies and in our paintings'.

Among those valuable books by Moholy-Nagy and others published or influenced by the Bauhaus in the 1920s will be found many examples, not only of photographs taken through the microscope and telescope, but others of a scientific nature made with yet newer and more intricate photo-mechanisms. Indeed, the whole cumulative interest in such images, since the advent of photography, must have a great bearing on the kind of photography practised in the Bauhaus which favoured the close-up view of nature and which so profoundly influenced the field of creative photography. By looking for the atoms one may discover the stars, to turn Ozenfant's quotation, and the poetic magnitude of inconspicuous nature is disclosed in the photographs of Edward Steichen, Aaron Siskind, Edward Weston, Ansel Adams, Paul Strand, Albert Renger-Patzsch and Otto Steinert, perhaps the most distinguished exponents of this approach.

In *The New Vision*, published by the Bauhaus in 1928, Moholy-Nagy was explicit about the importance for art of photomicrography. Though his own predilections, and the tendency of the Bauhaus as a whole, favoured the scientific and technological approach, he was certainly aware that the appeal of such photography was not merely scientific. In our age of speed and superficiality, such images serve, he noted, to reawaken a primitive longing to contemplate at length the minute marvels of natural construction. In his view, they were immensely important in directing the attention towards a more intimate experience with the material and its intrinsic characteristics of texture, mass and structure. A reconciliation is thus brought about between a more abstract sensibility for natural objects and an empirical scrutiny of their material substance.

As late as 1947 in *Vision in Motion* (an extension of the content of *The New Vision*) Moholy-Nagy was still expounding the relations between the new photography and art, and the importance of what he called 'intensified seeing'. A great portion of the book is devoted to an astounding array of photographs made by a multiplicity of inventive means. Not only do these demonstrate the variations possible through the manipulation of the medium, but their artistic potential is specifically underlined. The germinal role of the Futurists in giving impetus to late nineteenth-century preoccupations which Moholy-Nagy called 'super-realism' is here acknowledged in his reference to their concern with expressing 'the infinitely small and molecular movements. The poetry of cosmic forces. . . .'

Inspired by books like Moholy-Nagy's *Malerei-Fotografie-Film* (1925) and *The New Vision*, Gyorgy Kepes, once a student of Moholy-Nagy in the Chicago Institute of Design (the 'New Bauhaus'), produced two books which have been immensely influential in the visual arts of the last two decades: *Language of Vision* (1944) and *The New Landscape* (1956). In the latter, a large part of which was based on a remarkable exhibition of scientific photographs held in 1951 at the Massachusetts Institute of Technology, photomicrographs and telephotos, among innumerable others of a similar nature, are given a prominent place. *The New Landscape* was a kind of picture dictionary of correspondences between art and the hidden world of crystal growths, the structures of metallic particles, of smoke, of vaporization, of the graphic patterns produced by the oscilloscope, of strain and pressure diagrams and of atomic disintegration in cloud chambers.

By substituting the camera for the human eye, writes Kepes, by providing permanent records and the ability to sustain visual experience of physical and biological realms beyond normal perception, a new order of objectivity is possible in man's contemplation of the world. Far below the threshold of direct experience, states of matter, fractions of movements a millionth of a second's duration, particles smaller than the wavelengths of light, beyond even the surveillance of the optical microscope, are made visible by the camera.

The beautifully delicate wire sculptures of Richard Lippold, his *Variation Number 7: Full Moon* (1949–50), for example, reflect this sensitivity for the microcosmic world. 'The fragile snowflake [Lippold writes] appears in more variations of form than any kind of "permanent" sculpture. The spider's web is both a jewel for the branch and a noose for the fly . . .' (250, 251).

Referring to his moving constructions ('Mobiles') in 1951, Alexander Calder associated them with the system of the universe. The idea of detached bodies floating in space, of different sizes, colours and densities, and the apparent disparities of their movements, formed the essential conception on which his work was based.

250. Richard Lippold:
Variation Number 7: Full Moon. 1949–50
(brass, chromium and stainless steel wire)

251. Photographs of snow crystals
by W. A. Bentley.
From *Marvels of the Universe.* 1910

In his article, 'The Artist and the Atom', published in 1951, Peter Blanc drew analogies between the works of de Kooning, Pollock, Tomlin and Tworkov – among others – and photographs of sub-atomic particles bombarding electrons of atomic nuclei. He did not say that these artists deliberately sought to imitate the photographs, or that their works are exactly like them. He suggested, and I think reasonably, that the widespread distribution of such photographs from at least 1930 may well have caused those images to insinuate themselves, in a general way, into the consciousness of the artists as other kinds of photographs obviously had in preceding generations.

It is not too much to assume [he wrote], that an intuitive perception of the analogy between the efforts of the scientist on the physical plane to find order in his shattered world, and the perennial effort of the artist to find the spiritual order and unity which characterize the work of art, has led the artist to subconscious exploitation of remembered impressions of cloud-chamber photographs as the common symbol of the search.

In the case of the painter Hans Haffenrichter, once a student in the Weimar Bauhaus, the connection with scientific photographs is much more evident and

of quite a different nature. In the 1940s, during the war, he collaborated with a number of German scientists in order better to convey, by graphic means, complex information relating to the chemical and physical processes of the molecular structures of certain compounds. He executed 'interpretations' of atomic nuclei and their electron peripheries which made the 'bridges', 'chains' and 'lattices' which gave the molecules their forms. His drawings of graphite cells, benzyne rings, plastic and quartz molecules were from magnifications of up to eighty or ninety million times. The sculptor, Max Bill, described Haffenrichter's images in his article of 1948, 'Graphic Art in the Atom World'.

Kepes drew a parallel between a photomicrograph of some sponge spicules and a painting by Hans Arp whose 'automatic expressions resemble the biomorphic realms of nature'. In recent years it has become a commonplace to make such comparisons, and more significant than whether any particular relationships can be proven, is the attempt not to demean them but to bring these new categories of painting into a context of measurable phenomena: into a position where they can be approached through the traditional criteria.

Naum Gabo in 1948 argued the case for developing a kind of aesthetic cardiograph of scientific achievement, reflecting more the spiritual *rapport* of the Suprematist Malevich with modern science and technology than the materialistic programme of the Constructivists. A world, once incomprehensible, he said, is already acceptable to us. We are now familiar with the actions of mass, matter and light, revealed to us as oscillating electrons, protons, neutrons, particles like waves, waves like particles. If the scientist is allowed to show us a picture of an electron and if he is permitted to conceive of an image of the curvature of space, why then should not the contemporary artist be allowed to reveal an image of the world consistent with our new consciousness, regardless of its difference from the art of our predecessors?[74]

ART AND PHOTOGRAPHY TODAY

Photography has contributed very considerably to the present situation in which a heterodoxy of artistic styles can exist simultaneously. This is so despite the pressure from commercial and journalistic clairvoyants who pronounce at regular intervals the demise of one kind of art and the ascendancy of another. Though in the mid twentieth century particularly there has been an unprecedented growth of 'styles', these are no longer part of a narrow evolutionary process, and it would be presumptuous, indeed futile, to insist that they eclipse everything which came before.

In the past the obliteration of unwanted or unfashionable pictures was relatively simple. A coat of whitewash (as in Giotto's Santa Croce frescoes), or overpainting, or relegation to the cellars helped erase them from the memory.

The engraving or the lithograph alone was not a satisfactory record. But after the invention of photography, neither artistic, religious nor political zeal, nor military bombardment (though they might remove the uniqueness of the original) could destroy an image entirely. Courbet's *Return from the Conference* survived the deliberate destruction of the original in a photograph. There are still accurate records of works of art destroyed by the Nazis. Mantegna's works in the Eremitani church live on in illustrated books. Photography perpetuates these images. Since 1839 a continuous accumulation of records of contemporary and earlier art has gone on. Inevitably, this vast stock of images has multiplied the possibilities open to the artist and to the point that he may be victimized by the very freedom of choice.

At the same time the commonplace occurrence of the ordinary photograph itself offers him still further alternatives. Photographic reportage, the cinema and television have produced a lingua franca of universally comprehensible pictures. Almost every photographic aberration is now legible because of its constant recurrence in all the vehicles of visual mass communication. Less subject to the vagaries of arbitrary aesthetic systems, the photograph has thus established a set of pictorial standards which transcend all styles and come closer to a universal language of vision than any previously contrived. In addition to the direct use of the photographic image – that is where recognizable appearances are retained in the painting – the more abstract elements of photographic form are exploited by artists of widely differing stylistic tendencies.

The thorough-going penetration of the photograph into contemporary art is made patently clear in Van Deren Coke's valuable book, *The Painter and the Photograph*. The many illustrated examples are accompanied by significant and surprisingly candid statements by the artists. These clearly demonstrate, as Coke writes, that the camera vision 'has become inextricably a part of the artist's vocabulary'. Shortly after the appearance of this book, the Guggenheim Museum mounted a token exhibition of works which in some degree were based on photographs. Both book and exhibition highlight a situation which is increasingly evident in international art periodicals, periodicals which are perhaps more than ever purely professional journals and as such may well serve to compound the use of photographs. Magazines devoted to graphic design are by their very nature more open to the potential of the photographic image in all its forms and are, in their influence, of no less consequence than those exclusive to the so-called Fine Arts.

The uses of photography set out in Coke's book, the Guggenheim show and the periodicals indicate that the most widespread practice is to work with *fragments*. The variety of ways in which the fragment alone is employed is very great. It has been made simply to provide an area of texture, or to counter-pose

photographic tonality with some other graphic technique. It occurs as a purely formal emotive element with no reference to the initial representation. It occurs as a kind of hieroglyph, its identity changed with its severance from the original context. It is used as an image with specific connotations, retaining its normal iconographic meaning. It is found as an apparently random image, often in incongruous, surrealist-like juxtapositions. And, of course, such fragments have been made to convey many permutations of these uses.

In 1923 Léger expressed his views on the importance of the fragment in contemporary art and life:

The war had thrust me, as a soldier, into the heart of a mechanical atmosphere. Here I discovered the beauty of the fragment. I sensed a new reality in the detail of a machine, in the common object. I tried to find the plastic value of these fragments of our modern life. I rediscovered them on the screen in the close-ups of objects which impressed and influenced me.

An artist like Robert Rauschenberg, in his work of the late 1950s and early 1960s, provides examples of many of the uses of the photographic fragment: in his large-scale works, like the 'combine painting', *Untitled* (1955), or *Bicycle* (1963) and in the smaller *Dante* series (1959–60). The large silk-screen paintings of the 1960s come very close to the hand-made artefact being composed almost entirely of ready-made images. The *Dante Drawings* are more traditional in fabrication, the images being rubbed-off transfers from newspaper and magazine prints. Using analogous subjects, he gives the *Inferno* a modern iconography. His works confirm Richter's characterization of photomontage as a kind of 'motionless moving picture'. The whole discordant palimpsest of photographic realities with which we are daily bombarded is communicated in the microcosm of a single canvas. Things of disparate origins as apparently remote from each other as the Rokeby Venus and an army helicopter or, in another canvas, clouds, key and umbrella, a complex highway system seen from above, a couple of lorries, a galloping mosquito and a crew of missile loaders, are interlocked, superimposed, scattered *images quotidiennes* interspersed with painterly puns and graphic comments. The images are transitive. They merge and shift and reappear so that our sensation of them, as in our day-to-day experience of them, remains somehow peripheral. Unlike the earlier 'combine paintings' they have lost, and probably intentionally so, the substantive quality which actual collage elements can communicate. Only the brushwork, a kind of ironical plea for art, does that.

In a lucid appreciation of Rauschenberg's works, Max Kozloff describes them as isolating or alienating the spectator – even more than newspapers and the cinema do – from the frenetic and uncontrollable activities of the outside world:

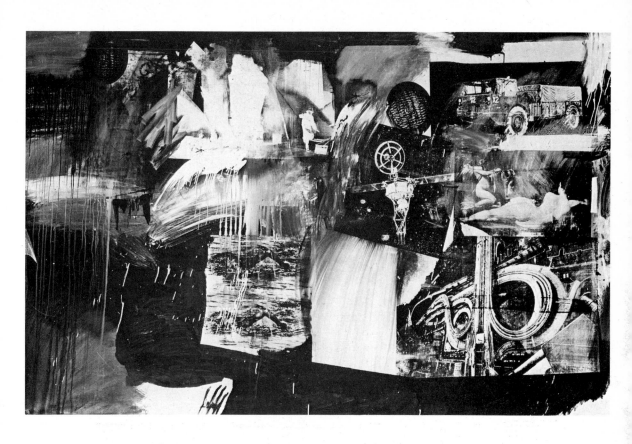

252. Robert Rauschenberg: *Barge*. 1962 (detail) (whole 80 x 389 inches)

The echoing series of negative, print, plate and re-photograph almost duplicate the infinity effect of anything caught between faced mirrors, and there are at least seven (and conceivably ten) stages between Rauschenberg's image and the object 'out there'. It is doubtless as a comment on the way we receive news of the outer world, on how we have automated all communications as mechanized afterimages – the kinescope, the delayed broadcast – that Rauschenberg presents these works which are neither graphics, paintings, nor collages, but a piquant metaphor of all three (252).

The repeated part or repeated whole of a photograph is perhaps a category in itself. Andy Warhol has invented two particularly striking motifs in this manner: the multiple portrait of a popular 'heroine' (Marilyn Monroe, Liz Taylor, Jackie Kennedy) and the multiple image of a modern dramatic event, the car crash. (253) He uses photographic silk-screens on canvas to reproduce the images in a regular grid. Unlike the overt, painterly brushstrokes with which Rauschenberg establishes a surface tension between his fragments, Warhol sometimes discreetly varies the coloration or tone of details from panel to panel, consciously surrendering almost entirely to the mechanical process.

253. Andy Warhol:
Marilyn Monroe.
1962 (silkscreen on canvas)

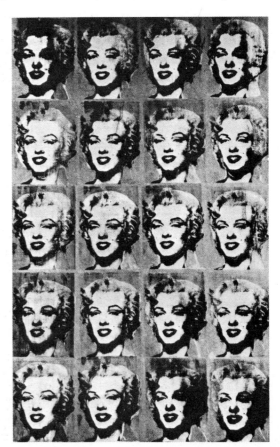

The popularized images of mass-communication media assembled in this way are multiplied until their triviality takes on a compelling quality. The heroines and the cars appear to express the artist's despairing attachment to the mechanically reiterated mythology of contemporary urban life. The irony of taking modern mass culture at face value is expressed in Warhol's mesmerizing films such as *Empire*, *Eat*, *Sleep*, in each of which the same commonplace object or action recurs *ad absurdum* and the audience is abandoned to an eight-hour cinematic Gehenna.

The paintings of the Spanish social realist, Juan Genovés, reflect photographic fragments of another kind. They are the isolated views of the 'lonely man', or the lonely group or mass: almost literally tides of humanity swept by social currents. These are effectively portrayed by focusing on them as though through one of those telescopes, mounted on every tourist-frequented promontory in Europe. Anyone who has felt a *voyeur* in using one of these instruments must know the almost frightening sensation, the thrill perhaps, of fixing on some isolated figure or group of figures and the exhilaration of remaining a remote

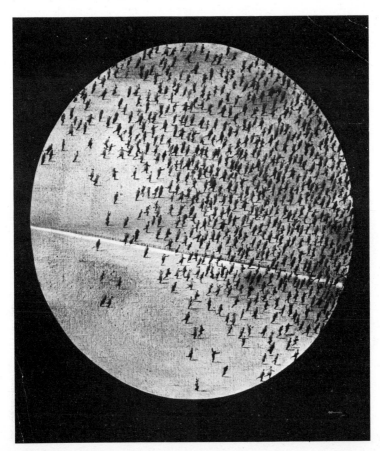

254. Juan Genovés:
Exceeding the Limit.
1966 (oil on canvas)

and anonymous witness. Genovés captures the apparent purposelessness of their movements and the way in which they are severed from their environment in the cold circle of the lens. As in the tourist telescope, the reduction of perspective scale to nought conveys in his paintings the sensation of turgid, dreamlike movements without spatial progression; the kind we see in the telephoto-filmed racing sequences made at Aintree or Longchamps or so effectively rendered in films like Antonioni's *The Red Desert* and Lelouch's *Un homme et une femme*. This, plus the sinister, unseen, anonymous forces which control the movements of Genovés's ant-like masses, echoes Goya's *Disasters* made instantaneous and macabre in the remoteness of the long-distance lens – and long-distance compassion (254).

More assiduously, probably, than most other artists, Richard Hamilton has explored photographic imagery. He has inverted the traditional precepts governing the photographic image, demonstrating the value of visual contradiction. In this way he has asserted the efficacy of the banal image. He has utilized the pictorial logic of the photograph to confound rather than to clarify space. In the contiguity of photographic and non-photographic tones he evokes a bitter-sweet resonance. And by reducing images to mere ciphers, he places them on that provocative threshold between the apparently real and the unintelligible (255 a, b, c, d).

255a–d. Richard Hamilton: Stages in the painting, *People*.
1965–66 (oil and cellulose on photo, $31\frac{3}{4}$ x $47\frac{3}{4}$ inches)

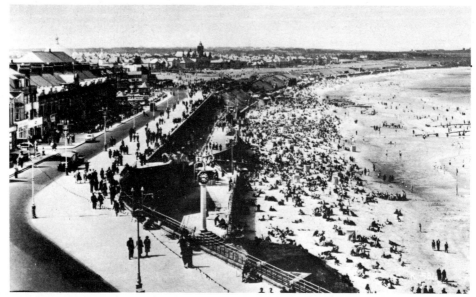

Technically adventurous uses of the photographic image are becoming increasingly frequent among younger and lesser known artists. The pattern of the photo-reproductive screen is enlarged to become a characteristic painting stroke. Exaggerated tonal contrasts, such as Manet used, are now heightened to simulate the dramatic properties of high contrast film. X-ray transparencies and the superimposed image are used as are consecutive series and stroboscopic images. Closely related to these are multiple projections on canvas or paper or even on three-dimensional objects preparatory to painting over them. Representations of the effects of partial relief, such as can be obtained by solarization, photographic relief printing and xerography are also to be found. A new kind of 'environmental' painting has been invented by working over full photographic figures printed or pasted on to plain reflecting surfaces. In these the subject remains constant but is modified by each change in the environment. In other cases the photographic image is used illusionistically in combination with solid objects to negate the spectator's normal perception of space and volume. In short, the whole paraphernalia of the photographic technique and the almost unlimited permutations possible by merging with other media are now at the disposal of the artist – or, for that matter the photographer, for in many cases the line of demarcation between the two becomes rather ambiguous.

The mixing of media, and more especially the ease of applying photo-gelatine to any given surface, has provoked hostility just as the infiltration of the simple photographic image into painting had in the past. The restriction of means, for purist or genuinely critical reasons, is in many respects an effort to establish some order in the confusion where all things are possible.

The direct use of photography seems so obvious as to need little or no comment, yet in a period dominated by abstract art, it is sufficiently in evidence in the work of artists of standing to merit discussion. It bears repeating that the photograph opens up an immense visual field. Natural conditions so transient that they would normally be beyond the reach of even the most skilled draughtsman working from memory; the unselective character of the lens; the fact that the images are accessible in the hand at any time, in a way that nature is not – these are among photography's exclusive characteristics. In addition, aspects of nature and of human situations otherwise completely lost in time past, continue to exert their unique *cachet* through the photographic print. The frozen and remote feeling of the old portrait photograph which repelled artists like Redon has had an intense attraction for others. The subjects, even those in synthetically casual poses, have a rigid alertness that belies their awareness of the camera. Once considered too unnatural, this rigidity now has an appealing

stylistic flavour, as can be seen in Arshile Gorky's painted versions of the photographic portrait of himself as a youth with his mother, and in Jacques Villon's etching of 1927 from an old family portrait in daguerreotype. Over and beyond their biographical content, they seem to indicate a sensitivity to the hierarchic importance attached to the taking of a photograph.[75]

Conclusion

The photograph is now, with art and nature, a permanent source of art. But, through the irrepressible machinery of reproduction, its images soon lose the magic of newness and become commonplace. A certain contempt for the obvious ensues. Every schoolboy knows what the surface of Mars looks like and now he must see Uranus. An appetite for the extraordinary becomes part of a recurring cycle of stimulation and satiation.

In the same way the individual creations of artists are converted, with a devastating rapidity, into public stereotypes. And, as ephemera, they are discarded with as little thought as one gets rid of yesterday's newspapers. It is not without significance that the last chapter in Harold Rosenberg's *The Anxious Object* (1964) is called 'After Next – What?' The artist operates in an atmosphere where a premium is put on new images and new techniques. He functions both in collaboration and in competition with the photograph and photomechanical reproduction.

Malraux's argument in *Le musée imaginaire* can just as well be applied to contemporary art. The museum without precedent, without walls, which photographic reproduction has brought into being, is also a museum of modern art. It is our Salon. The greatest impact of most works of art today is rendered not in the direct experience of them, but through their photographic images reproduced in books, in catalogues, in the pictorial magazines or on the screen. If photography is capable of perpetuating or exaggerating the value of certain works of earlier art by revealing them in juxtaposition with other works outside their natural contexts, by using the close-up and dramatic lighting, by distorting the scale, and by all its other contrivances imparting to them entirely new meanings, so also can this be done with the works of contemporaries. The artist is often compelled to work with the photographic reproduction in mind. His subject-matter, his formal conceptions and even his techniques are therefore open to the influence of the manner in which his work will be presented to the widest audience.

Malraux's museum of photographic reproductions will, he says, cause art to become more intellectualized. Here, the great collective heterogeneity of art

results not in pleasure for the eye but in knowledge of the relationships. Minor artists will thus vie with genius. A new hierarchy, sustained by art history, will be imposed through the photograph. The artist as such will no longer be admired. 'Indeed the mere act of grouping together a great number of works of the same style creates the masterpieces of that style, by constraining us to grasp its meaning.'

Moreover, Malraux's museum is augmented daily to satisfy the demands – to help create the demands – of an ever-growing, 'art-going' public. In *The Anxious Object* Rosenberg writes of 'Art Books, Book Art, Art'. He deprecates these 'substitute images' which inevitably distort the substance and the meaning of art objects. He shrewdly hints that the new art public may in fact prefer the reproduction to the original, that this ready-to-hand art may be entirely consistent with other modes of contemporary existence. Certainly, this substitute art has become, as he suggests, the source material for art historical, anthropological and psychological investigation. Even the *actual* museum, he writes, has to a large extent been converted into an imaginary one where the appreciation of works of art has become dependent on a previous knowledge of them.

Rosenberg rejects as irrelevant both the view that all this is symptomatic of the 'breakdown of "organic" experience in our mass civilization' and that proclaiming the democratization of art and the consequent elevation of public taste. The important thing, he insists, is that the fundamental character of art itself has, under these new conditions, been changed. To redress the imbalance between the photograph and the original he emphasizes the need for more original art in more public places.

Like Malraux and Rosenberg, other writers who have commented recently on this subject, and on the broader issue of 'mass communication' and 'mass culture', agree that photography and photo-mechanical reproduction have altered the context of art and have thus caused essential changes in the ways in which art is regarded. But the value judgements about this change are largely premature and in some cases ill-founded. The situation is now simply different. One cannot say that the context has changed for better or worse. Because of a greater activity around art, a broader cross-section of society than ever before concerns itself with art – and there is as yet no agreed way of measuring the quality of its experience. Nor is it absolutely certain that that experience differs in any fundamental way from that of past eras.

Despite the categorical statements made either by the Jeremiahs about mass reproduction, or the Panglosses, who accept without criticism anything and everything modern technology can offer, it is very difficult, if not impossible, to measure with accuracy the overall effects of the media of so-called mass culture. There is a marked tendency to see these media as monolithic, motivated by a

single entity. The 'public' is seen in the same way: a mass mind moving like hypnotized lemmings to the dictates of some vague (and by implication, sinister) force.

This polarized thinking has generated a great deal of argument. On the one hand it is insisted that because of 'mass culture' Western society, if not mankind altogether, is lurching towards some equally vague abyss. On the other, technological progress and all its manifestations is equated with human betterment. Less often, and with much less dramatic appeal, the modest and far more difficult task is attempted of assessing particular situations without being seduced into the omniscient role of world philosopher. A sharp and clear picture of the effects of the Industrial Revolution on nineteenth-century society still does not exist. It is infinitely more difficult to make an accurate assessment of the immediate past and of the present.[76]

As enlightening in many ways as writers who concern themselves with this question can be, and as stimulating as many of them are as rhetoricians, they tend to fall into a common error. They do not differentiate enough. Their categories are too all-encompassing, too rigid. The attempt to discover some pattern, to build some structure, where otherwise there is disorder, is understandable. But the all-too-human temptation to prophesy inhibits the suspension of judgement so often necessary.

One can certainly point to abuses resulting from the increased activity around art. But one can also describe its benefits. This changed context of art, sustained by photography, has above all given an unparalleled number of people an awareness of art which otherwise they might not have, and through that awareness has provided an opportunity for the shifting of sensibilities into other areas, equally rich and rewarding.

Notes

SOME ABBREVIATIONS USED IN THE NOTES

B.N.	Bibliothèque Nationale, Paris
B.N. Est.	Bibliothèque Nationale, Cabinet des Estampes, Paris
Brit. Journ. Photo.	*British Journal of Photography, London*
Burl. Mag.	*Burlington Magazine, London*
G.B.A.	*Gazette des Beaux-Arts, Paris*
Journ. Photo. Soc.	*Journal of the Photographic Society, London*
M.M.A.	Museum of Modern Art, New York
Photo. Journ.	*Photographic Journal, London*
Photo. News	*Photographic News, London*

INTRODUCTION

Concerning the anticipation of forms, germane to photography, a noteworthy example may be described in the unusual lines emerging from the bags and the trumpets of the Four Winds in the famous eleventh- to twelfth-century *Creation* tapestry of Gerona Cathedral. These rudimentary means for depicting not only the movement and force of the elements but also the intensity of sound reappear, in more sophisticated form, in the work of illustrators and painters of the nineteenth and twentieth centuries as schemata undoubtedly derived from photography.

1. THE INVENTION OF PHOTOGRAPHY

1. (pp. 19–23) *The camera obscura*

Barbaro's description is from *La Pratica della Perspettiva* . . . (Venice 1568–9) ; Porta's from *Magis Naturalis*, vol. IV (Naples 1558 edition).

On the Canaletto and the camera obscura see Zanetti, *Della pittura Veneziana* (Venice 1777) p. 463. Also Giannantonio Moschini, *Della letteratura Veneziana del secolo XVIII*, vol. III (Venice 1806) p. 77, and Mieczyslaw Wallis, *Canaletto, the Painter of Warsaw* (Kraków 1954; in English) p. 12. The strange perspective compression of Bellotto's architectural forms in his Warsaw views suggests the use of a lens with a narrow angle of vision, like a telescopic one. Francis Haskell, *Patrons and Painters* (London 1963), refers to Antonio Conti's *Prose and Poesie*, two volumes (Venice 1736 and 1739) in which Canaletto's accuracy of detail is attributed to the use of the camera obscura '. . . I was convinced that I was in front of the scene itself. . . .' On the use of the camera obscura by Canaletto, Bellotto, Crespi and Guardi see H. Allwill Fritzsche, *Burl. Mag.* (February 1937 review), and J. Byam Shaw, *Drawings of F. Guardi* (London 1951).

On the camera obscura in the seventeenth and eighteenth centuries, and especially its use by amateurs, references will be found in Georges Potonniée, *The History of the Discovery of Photography*, translated by Edward Epstean (New York 1936; first published Paris 1925), and in Raymond Lécuyer, *Histoire de la photographie* (Paris 1945). See also J. Peele, *The Art of Drawing and Painting*

in Watercolours (London 1732, third edition) pp. 10–12, for a very good description of the structure, use and cost of the camera.

On Vermeer's use of the camera obscura see A. Hyatt Mayor, 'The Photographic Eye', *Metropolitan Museum of Art Bulletin* (Summer 1946). Lawrence Gowing also discusses the subject in *Vermeer* (London 1952) as does Ludwig Goldscheider, *Vermeer* (London 1958) which includes Reynolds's comment that 'Dutch pictures are a representation of nature, just as it is seen in a camera obscura'. Charles Seymour's analysis of Vermeer's pictures in relation to this instrument, 'Dark Chamber and Light-filled Room. Vermeer and the Camera Obscura' in the *Art Bulletin* (September 1964) and Heinrich Schwarz's summation and contribution of new material to the problem, 'Vermeer and the Camera Obscura', *Pantheon* (Munich May–June 1966), are well worth consulting.

Leonardo's description of the images of a camera obscura is useful: these '. . . will actually seem painted upon the paper', etc. See Edward MacCurdy, *The Notebooks of Leonardo da Vinci*, vol. 1 (London 1938) p. 243.

The Sandby quotation is from A. P. Oppé, *The Drawings of Paul and Thomas Sandby* (London 1947) p. 31. Thomas Sandby's camera obscura was sold at auction in 1799 (ibid.). Algarotti's 'Spagnoletto of Bologna' is most likely a reference to Giuseppe Maria Crespi. For Samuel Prout's discussion of the camera obscura, of Wollaston's 'camera lucida' and Cornelius Varley's 'graphic telescope' see John Lewis Roget, *A History of the Old Water-Colour Society*, vol. 1 (London 1891) p. 352. For discussions on John Crome and this instrument see W. F. Dickes, *Norwich School of Painting* (1905) p. 53, and C. H. Collins Baker, *Crome* (London 1921) p. 15.

Ruskin's description of the camera obscura image, in volume 1 of *Modern Painters*, is revealing: 'I have often been struck, when looking at the image of a camera-obscura on a dark day, with the exact resemblance it bore to one of the finest pictures of the old masters; all the foliage coming dark against the sky, and nothing seen in its mass but here and there the isolated light of a silvery stem or an unusually illumined cluster of leafage.'

Though at least of peripheral interest to this study, references to other picture-making devices have been omitted.

2. (pp. 23–6) *Daguerre, Talbot, Niepce*

Daguerre's work as a painter is fully described by Helmut and Alison Gernsheim, *L. J. M. Daguerre* (London 1956). Daguerre's own description of the diorama technique accompanies his original manual on the discovery of the daguerreotype which appeared in 1839 as *Historique et Description des Procédés du Daguerréotype et du Diorama* (Paris). Other editions appeared in several languages. For an extensive bibliography on the daguerreotype see Albert Boni, *Photographic Literature* (New York 1962). Contemporary accounts, enthusiastic about the extreme illusionism of the diorama, include reports in *The Repository of Arts, Literature, Fashions . . .* (London 1 November 1823) pp. 302–4: '. . . the most absolutely illusive [effect] ever produced by the improved powers of art'.

Concerning Talbot see Science Museum monograph by D. B. Thomas, *The First Negatives* (London 1964), and Arthur H. Booth, *William Henry Fox Talbot* (London 1965). Talbot's own account of his researches is in the *Proceedings of the Royal Society* (1839), also published by J. E. Taylor early that year – possibly the first book on the subject of photography. For a more complete bibliography on Talbot's processes see Boni (op. cit.). The richest sources in English, contemporary comment on the developments of the 'new art', are the London *Literary Gazette* and the *Art-Union*.

Information on Niepce will be found in Gernsheim (op. cit.) and Victor Fouque, *The Truth Concerning the Invention of Photography*, translated by Edward Epstean (New York 1935; first published Paris 1867). For other sources see Boni (op. cit.).

Arago's efforts to win support for Daguerre's invention are described in the *comptes rendus* of the meetings of the Académie des Sciences (1839).

3. (pp. 26–8) *First reactions to photography*

Among the best sources in the popular Press conveying the initial reactions to Daguerre's invention are the *Gazette de France*, the *Literary Gazette* (London) and *L'Artiste* which featured Janin's views (1839) pp. 145–8. The London *Art-Union* which first appeared on 15 February 1839 mentioned photo-

graphy for the first time in the July issue. Other comments in satirical journals like *La Caricature Provisoire* and *Le Charivari* are worth investigating. It became the theme in all the papers, said the *Moniteur Universel*. The text of Huet's guarded response will be found in Georges Lafenestre, *Paul Huet (d'après ses notes, sa correspondance)* (Paris 1911) pp. 32, 119.

4. (pp. 28–31) *Other inventors of photography*

References to other inventors of photography are in the *Literary Gazette* (2 February and 9 February 1839). A strong case is made for Bayard by Potonniée (op. cit.) who exaggerated an otherwise justifiable argument. Lo Duca's monograph on Bayard (Paris 1943) is well illustrated and the photographer's direct positive-on-paper method is described in detail by Joseph Maria Eder in the *History of Photography*, translated by Edward Epstean (New York 1945; first published in German 1888).

Eder also notes early experiments with the action of sunlight on silver nitrate by Angelo Sala in 1614 and the alchemist Albertus Magnus mentioned the discoloration of silver nitrate when applied to the human skin (and exposed to light). Georg Fabricius in 1565 recorded the light-sensitive properties of hornsilver (silver chloride) but did not attribute it to the action of light. The compound was well known to alchemists in the sixteenth and seventeenth centuries. Wilhelm Homberg in 1694 demonstrated the effect of sunlight on the silver compounds but no attempt was made to produce patterns. Eder credits Johann Heinrich Schultze with the discovery of photography in 1727 on the basis of having produced dark images (letters) by means of a stencil around a bottle of silver chloride. This was followed by Carl Wilhelm Sheele in 1777 and others later who photographed the solar spectrum using the same chemical. Eder's *Quellenschriften zu den frühesten Anfängen der Photographie bis zum XVIII Jahrhundert* (Saale 1913) also supplies elaborate source material on the precursors of photography.

Soon after Daguerre's discovery was officially made public a letter was sent to the Académie des Sciences stating that he had been preceded by the Italian, Marcantonio Cellio who published, in 1686, a method for reproducing drawings solely with the aid of the sun's rays. But on investigation it turned out to be a means of copying the image in a camera obscura.

A letter from Berlin in February 1839 was sent by Alexandre Humboldt to François Arago calling attention to a German pamphlet published in 1835, *Le Soleil comme Graveur* (*Correspondance d'A. de Humboldt avec François Arago 1809–35*) (Paris: E.T.Hamy 1908).

Talbot's method may have been anticipated by the Reverend J.B.Reade of Peckham. See Arthur H.Booth (op. cit.) on Reade's photographs taken through a solar microscope in 1837, and Reade, *Some Early Experiments in Photography* (1854).

A substantial claim has been made for Tom Wedgwood, the youngest son of the potter, and for the chemist Humphry Davy. They were the real discoverers of photography insisted Eliza Meteyard in her *Life of Josiah Wedgwood* (1866) and in her *Group of Englishmen* (1871). In *Tom Wedgwood the First Photographer* (London 1903) R.B.Litchfield lengthily dismissed some alleged earlier discoverers of photography: i.e. Johann Heinrich Schultze in 1727, whose case was argued by Eder (op. cit.), and Jacques Charles, professor at the Académie des Sciences, Paris, known in this context for his 'silhouettes'. Litchfield revived the intriguing Watt, Boulton legend (that between 1790 and 1800 they had discovered photography in their Soho workshop, i.e. the Soho manufactory near Birmingham), only to prove the evidence worthless. And, finally, he demolishes Meteyard's reconstruction of the history as inaccurate, providing his own to establish once and for all the authenticity of Wedgwood as the discoverer of photography before 1800. The imbroglio included the famous Lunar Society of Birmingham and a thorough investigation of the affair may well turn up more than brass farthings.

On these 'early sun-pictures' of James Watt and Matthew Boulton, plus Francis Eginton's photo (?) copies of works by Murillo, West, Angelica Kauffmann by the 'polygraphic' method see the *Art Journal* (1864) pp. 27, 98, the source kindly pointed out by Conal Shields. See also George Shadbolt's notice in the *Brit. Journ. Photo.* (1 May 1863) on Watt's alleged photographs in the Patent Museum and a letter

from the artist Sir William Beechey to the Lunar Society asking that the process be suppressed in the interests of portrait painters. Also worth consulting are the *Photo. News* (1863) p. 193 and later assessments of this situation in *Brit. Journ. Photo.* (12 January and 19 January 1917).

Wedgwood and Davy's *Account of a method of copying Paintings upon glass, and of making Profiles by the agency of Light upon Nitrate of Silver* was presented to the Royal Institution and published by that body in 1802.

5. (pp. 31–4) *Photogenic drawing and the* cliché-verre

For details of the controversy over Talbot's patents see the *Literary Gazette* (March–April 1839).

The *cliché-verre* technique was rediscovered in France about 1853. Delacroix wrote letters to the Arras photographer Adalbert Cuvelier and to his friend the painter Constant Dutilleux on 7 March 1854, expressing his enthusiasm for the process. See Joubin, *Correspondance Générale d'Eugène Delacroix*, vol. III (Paris 1937) p. 195. See also Robaut's publication of twenty-nine facsimile letters of Delacroix to Dutilleux, one of which (26 April 1854) refers to '*les verres*' (see note 34). Corot executed many works in this medium from 1853 until 1874, a year before his death. See Robaut, 'Procédés sur verre', *L'Oeuvre de Corot*, vol. IV (Paris 1905) pp. 129ff., and Moreau-Nélaton, *Histoire de Corot et de ses œuvres* (Paris 1905) pp. 150ff., 186. Germain Hediard, in 'Les procédés sur verre', *G.B.A.* (November 1903), mistakenly credited Barthélemy Pont with the discovery in the 1850s.

George Cruikshank also produced works in *cliché-verre* and possibly as early as 1851 (see Gernsheim, *History of Photography* (O.U.P. 1955) p. 185). Later, Cruikshank was quoted as saying: 'it would have altered the whole character of my drawings; and it is so much easier for me to draw by this method . . . things that I executed on steel, took me so long to etch and finish, specks to burnish out, &c. &c. . . .' (Charles Hancock, *A Handbook for Posterity or Twiddle Twaddle* (London 1896)). This contains sixty-two 'etchings on glass' which Cruikshank completed about 1873. These were reproduced not by making editions of photographic prints but by photographing the image on a metal plate which was then etched in the normal way for printing. Hancock claimed to have introduced this medium to Cruikshank about 1864, erroneously attributing to himself the discovery.

6. (pp. 34–7) *The daguerreotype is made public*

Samuel Morse, founder and first President of the National Academy of Design in New York, was in 1839 Professor of the Literature of Arts and Design at the University of the City of New York. After his return from Europe he taught the daguerreotype technique, devoting himself more to this medium than to painting. Sometimes called the 'father of American photography', he is generally credited with the introduction of the daguerreotype to that country in September 1839. See *S.F.B. Morse, his Letters and Journals*, Edward Lind Morse (New York 1914). On Morse's earlier experiments with the camera see S. I. Prime, *Life of Samuel F.B. Morse* (New York 1875) p. 407. On American photography: Robert Taft, *Photography and the American Scene* (New York 1938).

A more detailed report on the reactions of Daguerre's visitors from Great Britain is in the *Edinburgh New Philosophical Journal*, vol. XXVII (April–October 1839) pp. 155–7. Robison's notes are dated 1 June 1839.

Duchâtel's report is contained in the Daguerre manual which also gives other references to the events directly preceding the official presentation of the invention (op. cit.).

Accounts relating to the meeting honouring Daguerre's achievement are given in the *Art-Union* (15 September), *Literary Gazette* (24 August), *L'Artiste* (25 August). Potonniée (op. cit. p. 48) is worth consulting. Pfau's report is from his *Kunst und Gewerbe* (Stuttgart 1877).

The Académie des Beaux-Arts in 1839 allowed fifty members, fourteen of them the painters: Hersent (President until October 1839), H. Vernet, Garnier, Bidault, Heim, Granet, Ingres, Blondel, Schnetz, Couder, de Pujol, Drölling, Picot and Delaroche. Eight sculptors included Nanteuil and

David d'Angers. Architects (eight), engravers (four), composers and actors (six) and 'free members' (ten) made up the rest.

Delaroche's students included: Charles Nègre, Henri Le Secq, Gustave Le Gray and Roger Fenton, all later distinguishing themselves as photographers.

Chevreul had actually published an earlier pamphlet on the simultaneous contrasts of colours in 1828 which probably was the basis for the comprehensive work of 1839.

For a more complete text of Arago's speech see the *Comptes rendus des séances de l'Académie des Sciences*, vol. IX (19 August 1839) p. 260.

2. PORTRAITURE

7. (pp. 39–41) *First reactions to portrait photography*

Lerebours's *Treatise on Photography* was transcribed by J. Egerton in London in 1843.

In George Cruikshank's *Omnibus* (London 1842) Beard's daguerreotype studio is satirized at length: 'Apollo turned R.A. The other day . . .'. The French caricaturist Bertall published a drawing in his 1843 *Omnibus* in which the sun is shown as a painter at work and included among his pots of colour is a box labelled '*Daguerréotype*'. John Leech's comment on 'the too-faithful portrait' (*Punch* (1850)) reflects the not insignificantly heightened problems of realism versus idealism in the photographic era. But later, Elizabeth Barrett wrote, 'I would rather have [such] a memorial of one I dearly loved than the noblest artist's work ever produced . . .' (see Betty Miller, *Elizabeth Barrett to Miss Mitford* (London 1954)).

8. (pp. 41–2) *Photography as an industry*

Potonniée (op. cit.) and the Abbé Moigno, *Répertoire d'Optique Moderne* (Paris 1847) are sources of information for the early commercialization of photography in France. See also the *Photo. News* (London, 27 February 1863 p. 102, August 1861 p. 370, 27 February 1885 p. 136) for details of developments in England. The 1863 report lists about 400 professional photographers in three principal cities of England and Scotland, these employing over 4,000 assistants. In comparison to the cost of Beard's daguerreotypes, one to two guineas in 1845, I quote some market prices given in the *Spectator* in 1842: bread, 8*d.* to 10*d.* per 4-lb. loaf; butter, 5*d.* per lb.; bacon, 6*d.* per lb.; beef, *c.* 5*d.* per lb.; Cheshire cheese, *c.* 8*d.* per lb. It should be remembered, however, that by the early 1860s the average price for a small photograph on paper was only one shilling. V. F. Snow and D. B. Thomas include an interesting section on Talbot's unprofitable Talbotype business in Reading in competition with the daguerreotype portraitist: 'The Talbotype Establishment at Reading – 1844 to 1847', *Photo. Journ.* (February 1966).

Nineteenth-century comments on the social effects of photography will be found in M. A. Root, *The Camera and the Pencil* (New York 1864): photography helps develop the 'idealistic capabilities' of the masses; 'social affections' are enhanced, 'increasing the knowledge and happiness of the masses', etc. G. M. Trevelyan (*English Social History*, vol. 4 p. 111) quotes from *Macmillan's Magazine* (September 1871): 'Any one who knows what the worth of family affection is among the lower classes, and who has seen the array of little portraits stuck over a labourer's fireplace . . . will perhaps feel with me that in counteracting the tendencies, social and industrial, which every day are sapping the healthier family affections, the sixpenny photograph is doing more for the poor than all the philanthropists in the world.'

9. (pp. 42–7) *Miniature painting*

See Erich Stenger, *The History of Photography*, translated by Edward Epstean (New York 1939) p. 72, and Max Lehrs, *Zeitschrift für bildende Kunst* (May 1917) pp. 181–96, for details on re-employment of German miniaturists. This is also discussed in Gernsheim, *L. J. M. Daguerre*, p. 172. Newton's letter was published in the *Journ. Photo. Soc.* (21 December 1858) p. 119. See also 'Miniature Painting in My Time', *Art Journal* (1889) pp. 154–5; Richard and Samuel Redgrave, *A Century of Painters of the English School*, vol. 1 (London 1866) p. 434. Donough O'Brien's *Miniatures in the XVIIIth and XIXth Centuries* (London 1951) contains illustrated

examples of miniatures painted over photographs. A report on Disderi's income was given in the *Photo. News* (4 October 1861) p. 478. Claudet's defence of photography 'La Photographie et l'Art' was published in *Le Moniteur de la Photographie* (15 November 1865) pp. 132ff. The *Art Journal* (October 1858) p. 318 described Carrick's technique for painting on a photographic base. Carrick exhibited at the R.A.

10. (pp. 47–9) *Portrait sittings*

On sitting for portraits see Frank Howard, 'Photography as Connected with the Fine Arts', *Journ. Photo. Soc.* (21 January 1854). Howard had been an assistant to Sir Thomas Lawrence. A fictitious but none the less meaningful dialogue held in an artist's studio appeared in the *Art Journal* (August 1858). The client of a portrait painter expects to have preliminary photographs taken of him to guarantee a likeness and keep poetry at bay. The disconcerted artist tries to convince his subject that art is superior to photography.

11. (pp. 49–52) *Ingres*

Mirecourt's statement is from 'Ingres' in his series, *Les Contemporains*, p. 24. Known at first as a caricaturist, Nadar (Félix Tournachon) opened his original photographic *atelier* on the rue Saint-Lazare (no. 113) in 1853 though he may have taken up the camera a few years earlier, as Mirecourt's words suggest.

For Ingres's letters cited see Boyer d'Agen, *Ingres d'après une Correspondance inédite* (Paris) 1909). Daguerreotypes once belonging to Ingres are kept in the attic of the Ingres Museum at Montauban and are probably among those photographs referred to in the painter's last testament of 28 August 1866, in which he wills to Montauban 'un assez grand nombre de dessins de moi, calqués dans six ou sept portefeuilles, aquarelles, gravures, daguerréotypes, photographies . . .' (ibid). None of these, it appears, are photographs of his subjects taken from life.

Chassériau's statement is published in Valbert Chevillard's monograph on the painter (Paris 1893) p. 48. Strong hostility for portrait painting was also expressed by

George Frederic Watts who would '. . . submit to the drudgery of portrait painting no longer'. See *George Frederic Watts, the Annals of an Artist's Life*, M.S. Watts, vol. 1 (London 1912) p. 208. Geraldine Pelles, *Art, Artists and Society* (1963) pp. 31–3, describes the reactions of artists to the indignities of portrait painting. She records the statement of Ingres's wife, that following the execution of each portrait the artist vowed he would do no more.

The new convention in Ingres's portraits, the hand to the head and especially that in the Moitessier painting, has been thought to originate in the Herculaneum wall painting *Herakles and Telephus* which the artist may have seen earlier in Italy (M. Davies, *Burl. Mag.* (June 1936) p. 266). There is no reason why both factors, the photograph and the antique, should not have influenced him. The particular position of the Moitessier hand in the National Gallery (London) portrait completed in 1856 is very close to that of the mural which incidentally was widely known through Blanquart-Évrard's popular *Album photographique de l'artiste et de l'amateur*, published in 1851. This included a photograph of the Herakles and Telephus painting (19). Could the pose in general have been derived from this, a photographic commonplace enhanced by reference to Classical Antiquity?

Count d'Haussonville was a founding member of the Société Héliographique, the first French photographic society in 1851. In 1856 its membership included a Monsieur A. Moitessier.

Ingres's late self-portrait in Antwerp (1865) is recorded as having been painted from a photograph of that in the Uffizi (1857–8) which as suggested may itself have depended on a photograph. See Henri Delaborde, *Ingres, sa vie, ses travaux, sa doctrine* (Paris 1870) p. 253.

The original source of Ingres's statement about using photographs is obscure. It occurs in George Besson, *La Photographie Française* (1936), then in Louis Chéronnet's superbly illustrated *Petit Musée de la Curiosité photographique* (1945) p. 22, repeated in 1957 by Heinrich Schwarz in 'Daumier, Gill and Nadar', *G.B.A.* (1957) – Besson given as source – and again in Gernsheim, 'Aesthetic Trends in Photography Past and Present', *Motif*, no. 1 (London November 1958) p. 5. Michel Braive (*The Era of the Photograph*

(London 1966) p. 128) has Ingres directing these comments on the photograph to his pupils, Flandrin and Amaury-Duval: 'Look at this, gentlemen! Which of you would be capable of such fidelity, such firmness of line, such delicacy of modelling?' As usual, no source is given. Amaury-Duval's (Pineaux Duval) *L'Atelier d'Ingres* (Paris 1878) contains several references to photography but a passage like that quoted above cannot be found.

12. (pp. 52–4) *David Octavius Hill*

See monograph by Heinrich Schwarz, *David Octavius Hill*, translated by Helene E. Fraenkel (London 1932). Schwarz notes that Hill often made preliminary drawings of his subjects, varying the viewpoints and lighting before the execution of the photographs. A good collection of Hill's photographs is in the Royal Photographic Society, London.

Etty's *Self-Portrait with palette* is in the National Portrait Gallery, London. The other (21), from the same Hill and Adamson photograph, is in the City of York Art Gallery. See H. Schwarz, in the *Art Quarterly* (Winter 1958) pp. 391–6. Lady Eastlake's appraisal of Hill's photographs is from the *London Quarterly* (1857). See also, *Quarterly Review* (December 1845 to March 1846) p. 338. I am grateful to Bruce Laughton for bringing the Wilson Steer letter to my attention.

13. (pp. 54–5) *Frith*

Frith on Dickens's portrait: *A Victorian Canvas, The Memoirs of W.P. Frith R.A.*, edited by Nevile Wallis (London 1957) p. 97. The *Derby Day* photograph is discussed by Gernsheim ('Frith is known to have employed a photographer, Robert Howlett, to make a series of photographs of the scene') in the catalogue of the Frith exhibition, Whitechapel Art Gallery, no. 31 (1951). A photograph of the grandstand, possibly once used by Frith, is reproduced in Wallis (op. cit.), facing p. 96. For Ruskin's comment see 'The R.A. in 1858', Everyman edition of Ruskin's *Pre-Raphaelitism, Lectures on Architecture and Painting*, edited by Laurence

Binyon (London 1907) p. 282. For the artist's defence of his *Paddington Station* see Wallis (op. cit.) pp. 104–5. But Gernsheim says photographs were employed here: *Motif*, no. 3 (London September 1959) p. 73. For Frith on *The Marriage of the Prince of Wales*: Wallis (op. cit.) pp. 110 ff. See Frith, *Further Reminiscences* (London 1888) pp. 410 ff. on the Tenniel and Du Maurier photographs. Frith's hostility towards photography was no doubt exacerbated by the inroads it made on the production of his engravings, the major source of his livelihood (see p. 120).

14. (pp. 55–6) *The use of photographs by portrait painters*

Freund's account of the Yvon painting is from her very useful publication *La photographie en France au dix-neuvième siècle* (Paris 1936) pp. 120 ff. Her source: *Journal de l'Industrie Photographique*, organ of the Chambre Syndicale de la Photographie (January 1880).

Brett's comment was made in a paper read before the London Camera Club in April 1889. See the *Brit. Journ. Photo.* (London 5 April 1889) p. 236.

References to Watts's response to Cameron's photographs are in M.S. Watts (op. cit.), vol. 1 p. 208 and Gernsheim, *Julia Margaret Cameron* (London 1948). See also Gernsheim, *Lewis Carroll, Photographer* (London 1949) and Mrs Russell Barrington's book on Leighton, vol. 1 p. 205 (some artists like Watts used photographs 'intelligently'). References to Watts's use of the Ellen Terry photographs are in David Loshak, 'G. F. Watts and Ellen Terry', *Burl. Mag.* (November 1963) pp. 476–85.

Meryon's description of his use of photographs is from Loys Delteil, *Charles Meryon*, translated by G. J. Renier (London 1928) p. 39.

Flandrin also used photographs of Louis Napoleon for the portrait painted in 1861 and 62. Shown in the place of honour at the Salon of 1863 it was praised for its astoundingly skilful characterization, '*à la fois intime et historique, c'est l'homme et le souverain...*'. See Louis Flandrin, *Hippolyte Flandrin, sa vie et son œuvre* (Paris 1902) pp. 259–60.

15. (pp. 56–8) *Photographs on canvas*

The reference to Lenbach's photo-projections on canvas is from Karl Raupp, *Die Kunst für Alle* (1889) p. 325, and Erich Stenger (op. cit.). Gernsheim, *Masterpieces of Victorian Photography* (London 1951) p. 13, mentions Claudet's 'photo-sciagraphy'. There is also a description of Lenbach's use of projected photographs. Other sources cited in text.

16. (pp. 58–61) *Photographic tone*

Van Deren Coke quotes a letter from Professor Wilenski in which John Singer Sargent's painting, *Entrance to Santa Maria della Salute*, is associated with a photograph of the same subject once in Wilenski's possession ('Camera and Canvas', *Art in America*, no. 3 (New York 1961) p. 73).

Frank Sutcliffe records his interview with Ruskin in the early 1870s discussing photographs in natural colours: 'I tremble to think [said Ruskin] what would happen if photographers were able to take photographs in colour, seeing what terrible mistakes they make now when they have only monochrome to deal with. They always seem to underexpose their plates, and by so doing upset the whole scheme of tone rendering' (quoted from the *Photo. Journ.* by Alex Strasser in *Immortal Portraits* (London and New York 1941) p. 74).

17. (pp. 61–2) *Artificial light*

Daumier was one of Nadar's many friends and the photographer's studio was frequently the meeting-place of the Paris *bohème* and of artists and writers: Delacroix, Rousseau, Courbet, Manet, Baudelaire, Champfleury, etc., most of whom sat before his prolific camera.

Adhémar's suggestion is made in *Honoré Daumier* (Paris 1954) pp. 47ff. See also my review of the Arts Council of Great Britain's Daumier exhibition (1961), *Burl. Mag.* (August 1961).

Fantin's studio was described by his friend, Adolphe Julien (*Fantin-Latour . . . sa vie et ses amitiés* (Paris 1909) p. 155). Amédée Pigeon who took the photographs by artificial light, and his brother, a professor in the Faculty of Sciences at Dijon, were among those congregated in the artist's studio.

For a précis of the use of artificial light in photography see Erich Stenger, *The March of Photography*, translated by Edward Epstean (London, New York; first published Germany 1950) (1958) pp. 80–86. Jacques-Émile Blanche noted that 'Fantin's *atelier* was lit like that of an early photographer'. And commenting on the portrait of the Dubourg family, Blanche said it was as if Nadar himself had taken them in their Sunday best (*De David à Degas* (Paris third edition 1919) p. 24).

18. (pp. 62–6) *Manet*

It seems appropriate in this context to mention that in 1860 Manet used a 'little black looking-glass' for his painting, the *Guitar Player*, to check on the tonality of the head which he painted in just two hours. After consulting the mirror he said 'It was all there; I didn't add another brush stroke.' (Antonin Proust, *Édouard Manet, Souvenirs* (Paris 1913).)

Manet's use of a Nadar photograph is described in Jean Adhémar's catalogue of the exhibition, *Un siècle de la vision nouvelle* (B.N. Paris 1955). This contains many other useful references to art and photography. Michel Braive (op. cit.) reproduces one of Nadar's photographs of Baudelaire which, undeniably, is that on which Manet's etching was based.

One of the Lemonnier water-colours is in the Clark Art Institute, Williamstown, Massachusetts, another is in the Louvre. Manet's request for her photograph is cited in Kurt Martin, *Édouard Manet*, catalogue no. 23 (London 1959), though no source is provided. See also E. Haverkamp-Begemann, S. D. Lawder, C. W. Talbot, *Drawings from the Clark Art Institute*, vol. II (New Haven, Connecticut 1964) p. 108. My thanks to Standish D. Lawder for these references.

See Jamot, catalogue of Manet exhibition, no. 432 (Paris (Orangerie) 1932), on the photographic source of the Laurent portrait.

According to Théodore Duret (*Histoire d'Édouard Manet* (Paris 1919 edition, appendix 2)), Manet's drawing of Courbet, to be used as the frontispiece to M. D'Ideville's book on Courbet (published in 1878), was

based both on the artist's memory and on a photograph.

19. (pp. 66–75) *The Execution of the Emperor Maximilian*

Liebermann's article, 'Ein Beitrag zur Arbeitsweise Manets', was published in *Kunst und Künstler* (1910) pp. 483 ff. An album of photographs from the Sirot Collection now in the B.N. Est. contains many photographs of Maximilian and others pertaining to the Mexican campaign and the execution. For more information on Diaz, and his role in the conflict, see Mrs Alec Tweedie, *Porfirio Diaz* (London 1906). Diaz, she writes, never met Maximilian. The final evacuation of French troops from Mexico took place on 5 February 1867. The most comprehensive reconstruction of Manet's paintings and lithograph on this subject was made by Nils G. Sandblad, *Manet: Three Studies in Artistic Conception* (Lund, Sweden 1954), though the sources of news from Mexico which he cites are too limited and thus tend to suggest later dates for Manet's modifications in the different versions of the painting. Sandblad refers to a photograph of Maximilian's firing squad reproduced in 1903 by Ernst Schmit Ritter von Tavera. Those photographs were later mentioned by Meier-Graefe who quotes Liebermann, and then in 1948 by Kurt Martin. Mistakenly, I believe, Sandblad finds the source of the sergeant in the Mannheim painting in the figure at the extreme left in the photograph of the firing squad. Sandblad, interestingly, imputes a special iconographic meaning to the painting of the rim of Maximilian's sombrero: a corona to symbolize the moral force.

Other good news sources on the Maximilian affair: *The Times* (London) *Figaro* and *Le Moniteur* (Paris). Sandblad's main source is the *Mémorial Diplomatique* (Paris). The *Esperanza* of Queretaro would be a worthwhile source though difficult to obtain.

Mulnier (25 boulevard des Italiens) also offered for sale photographs of Miramon and Mejia.

French uniforms with long blouses worn in 1867 can be seen in Manet's painting of the exhibition grounds and in a contemporary engraving (anonymous) of soldiers viewing Krupp's big cannon shown there.

Among artists who retouched photographs to supplement their incomes were Ford Madox Brown and Lowes Dickinson. Arthur Hughes and Frederick Shields, followers of the Pre-Raphaelites, did the same, Shields referring to it as 'hateful slavery' (see Ernestine Mills, *The Life and Letters of Frederick Shields* (London 1912) pp. 121 ff). Shields also worked for Rossetti, retouching photographic reproductions in preparation for publication (ibid. p. 205). In some cases, Rossetti found it expedient to change the dates of his works by this method. Holman Hunt referred to painters switching to the more lucrative field of photography: *Pre-Raphaelitism and the Pre-Raphaelite Brotherhood* (London 1905) volume 1, p. 45.

The statement on Smetham is from Sarah Smetham and William Davies, *Letters of James Smetham* (London 1891) p. 18. I am grateful to Raymond Watkinson for leading me to the sources given for Smetham and Shields.

For Madox Brown's palliative see the *Illustrated Photographer* (London 7 February 1868) p. 12. Leslie's comments were made in *Hand-Book for Young Painters* (second edition London 1870) pp. 309–10.

3. LANDSCAPE AND *GENRE*

21. (pp. 77–83) *Exoticism and reportage*

Burty's assessment of French and English styles is in 'La Photographie en 1861', *G.B.A.* (September 1861) p. 241.

Vernet seems to have been in the centre of the excitement over the daguerreotype discovery. A painting in the Musée Carnavalet, Paris, by Prosper Lafaye shows an evening gathering in 1839 at M. Irisson's, 10 rue d'Antin with Horace Vernet apparently leading the discussion about the discovery of the daguerreotype.

On Vernet and Goupil-Fesquet in the Near East see Amédée Durande, *Joseph, Carle et Horace Vernet, Correspondance* (Paris 1863) p. 128, and Goupil-Fesquet, *Voyage en Orient avec Horace Vernet en 1838 et 1840*. See also Beaumont Newhall's illustrated article in *Magazine of Art* (Washington, D.C. May 1951). Charles Blanc's comment on Vernet's

eye is from his *Les trois Vernet* (Paris 1898) p. 136.

Other noteworthy photographers of the Near East were Baron Gros and Maxime du Camp who took photographs of Egypt, Nubia, Palestine and Syria between 1849 and 1851 (published 1852).

Early photographs of remote places were bound to demonstrate the inaccuracies of artists like William Hodges and John Webber and to render an important service to anthropological investigation. Photographs were taken in Yucatán as early as 1841 by the artist Frederick Catherwood who, a few years earlier, had depended on a camera lucida for the authenticity of his views there (see *Image* (George Eastman House, Rochester, N.Y., May 1953)). Stenger in *The March of Photography*, p. 170, says that in 1844 Arago promoted a daguerreotype expedition to photograph some of the aborigines of Brazil. In his fascinating *European Vision and the South Pacific 1768–1850* (O.U.P. 1960) Bernard Smith describes the difficulties involved in obtaining objective pictorial representations of ethnological subjects due to the stylistic and other preconceptions of artists. With the use of photography from Dumont D'Urville's second voyage (*c.* 1840), the more passive recordings made with the camera were bound to obliterate the vestiges of the Noble Savage myth. In 1860, Professor Gustave Fritsch took such photographs of indigenous South African tribes (Stenger, op. cit.).

I thank Francis Haskell for the Gautier piece on Gérôme. Fanny Field Hering in her well-illustrated book on Gérôme (New York 1892) records further comments by Gautier on the artist's paintings of contemporary Rome: 'Place upon a perfect photographic proof a vivid, clear, charming colour, and add the *style* – which is the very soul of the artist and which no instrument can give – and you will have the *Pifferari* [street musicians] of M. Gérôme. . . .' See also Gérôme's friend and biographer, Charles Moreau-Vauthier, *Correspondances et Mémoires de Jean-Léon Gérôme* (Paris 1906).

22. (pp. 83–5) *Fenton and Brady*

Both Fenton and Brady were trained as painters, the former in the Delaroche *atelier*, the latter by Samuel Morse, both these masters being intimately involved in the early history of photography. Literature on Fenton includes his 'Narrative of a Photographic Trip to the Seat of War in the Crimea', *Photo. Journ.* (21 January 1856) pp. 284–91, and H. and A. Gernsheim, *Roger Fenton, Photographer of the Crimean War* (London 1958), which is well illustrated. On Brady the literature is quite extensive. See Boni's bibliographic guide (op. cit.) and especially the lavishly illustrated book on Brady by James D. Horan (New York 1955) which contains many additional bibliographical references and sources of the photographs. One of Brady's assistants, Alexander Gardner, published a two-volume *Photographic Sketch Book of the Civil War* in 1866 (reprinted by Dover Publications, New York 1959) which is worth consulting. The sickening effects of war photographs were described by Oliver Wendell Holmes in 'Doings of the Sunbeam', *Atlantic Monthly* (July 1863).

23. (pp. 85–9) *Early landscape photography*

Over 4,000 photographs by Talbot and his assistants are in the collection of the Science Museum, London. Many of them are of landscape and city views taken in the early 1840s. The report on Bayard's process is discussed by Raoul Rochette in *Le Moniteur* (13 November 1839).

24. (pp. 89–92) *Corot and the blurred image*

Blanquart-Évrard's albumen-on-glass process is discussed in the *Art Journal* (November and December 1849) pp. 345, 358.

The blurred effects in foliage and for that matter in pedestrian traffic are readily found among the earliest photographs for which long exposure times were necessary. Many of Talbot's landscape and city views, as examples, contain those features which in addition to the natural properties of the paper negative resulted in images intrinsically similar to those of Corot's new style.

On Corot's trips to Arras see André Coquis, *Corot et la critique contemporaine* (Paris (1959) pp. 60–62. Other references to Corot

and the painters and photographers in Arras are given in Constant Le Gentil, *L'Atelier de Constant Dutilleux* (Arras 1887) p. 12, and Moreau-Nélaton, *Histoire de Corot et ses œuvres* (Paris 1905) p. 136.

An excellent critical article written in 1964 on the author's earlier references to Corot and landscape photography is by J. E. L. Heideman, 'Corot en de fotografie', *Overdruk uit Opstellen* voor H. van de Waal (Amsterdam/Leiden 1970) pp. 54–67. Much new light is thrown on the subject by Dr Heideman.

25. (pp. 92–5) *Millet, Rousseau, Daubigny, Dutilleux*

Millet's letter to Rousseau about Eugène Cuvelier is from Julia Cartwright, *Jean-François Millet* (London second edition 1902) p. 217, as is his discussion with Wheelwright, p. 161 (source: E. Wheelwright, 'Recollections of Millet', *Atlantic Monthly* (September 1876)). Millet's views on portrait photography expressed to Wheelwright were shared by Ruskin and others. This art, Millet said, 'would never reach perfection till the process could be performed instantaneously, and without the knowledge of the sitter. Only in that way, if at all, could a natural and lifelike portrait be obtained.' It is worth noting that among the first physiologists to utilize photography extensively in the study of facial expression was Dr Guillaume Duchenne who took photographs by electric light to illustrate his *Mécanisme de la Physionomie Humaine* in 1862. Some of his photographs were later reproduced in Darwin's *Expression of the Emotions in Man and Animals* (1872) in addition to several taken by Rejlander, the famous pictorial photographer and by others. For his requirements Darwin found such photographs superior to 'any drawing, however carefully executed'. Millet's letters asking for photographs are given in Moreau-Nélaton, *Millet raconté par lui-même*, vol. III (Paris 1921) p. 45, and Cartwright (op. cit.) p. 283.

About's criticism of landscape painting is from his *Voyage à travers l'Exposition des Beaux-Arts* (1855). Baudelaire's attack on Rousseau was made in his Salon review of 1859 and Zola's in 1867 (see *Émile Zola Salons*, edited by Hemmings and Niess (Geneva, Paris 1959) p. 114). Daubigny's style changed in the same manner and about the same time as Corot's. He was praised by the Goncourts for his '*science d'observation*', by Gautier as 'the first objective landscapist', and by Castagnary for his 'truth of impression'. He was described as the chief of the Impressionist school by L. Lagrange (*c*. 1865) and was exonerated by Charles Blanc, for idealizing the image of the camera obscura. Nadar, who had purchased Daubigny's *Les bords de l'Oise*, satirized the extreme realism of the painting in his 'Jury au Salon de 1859'. A guileless visitor to the exhibition is shown stripped down, being stopped by a guard from diving into the river in the foreground of the picture (*Journal amusant* (1859)) (60). Daubigny himself claimed to have avoided the banality of the photograph (letter to Frédéric Henriet, 1872). In England too the attitude was already explicit in mid century that artists must transcend the minutiae and literalness of photography. Breadth of effect, indistinct large masses, the 'abstract' character of nature were held to be in the province of painting (see John Leighton on photography and art, *Journ. Photo. Soc.* (21 June 1853)). But sharp focus and detailed finish were also rejected by many photographers as too commonplace, their medium said to be as suited to Rembrandtism as it was to Pre-Raphaelitism (see p. 113).

Dutilleux's statement is recorded by Le Gentil in *Notice sur Dutilleux* (1866) p. 93.

26. (pp. 95–100) *John Ruskin*

The best source for Ruskin's writings is the monumental, punctiliously indexed, Cook and Wedderburn, *The Complete Works of John Ruskin* (London 1903–12). For his *Diaries* see Evans and Howard (London 1956); references here to his use of photographs include the following: *July 1 (1849)* Chamouni (drawing a glacier): 'I could not fathom it; returned to it in the evening to try to write a detailed description. Took a dag[uerreotype]. . . .' *July 4* Chamouni: took daguerreotypes of glacier and pines. *July 5* Chamouni: took daguerreotypes. *December 30* Venice: a 'precious door' between the Abbazia and Madonna dell'Orto 'must be daguerreotyped'. My thanks to Luke Hermann of the Ashmolean Museum, Oxford, for supplying

copies of some of Ruskin's photographs. Ruskin's contempt for Canaletto's inaccuracy may be contrasted with Antonio Conti's praise, 100 years earlier, for the Venetian artist's true-to-life representations (see note 1) in assessing the extremism of nineteenth-century naturalism, largely due to the pressures exerted by photography.

27. (pp. 101–2) *Turner*

Walter Sickert referred to Turner's studio as having been 'crammed with negatives', though the source of his information is not revealed (letter to *The Times* (15 August 1929)). Richmond's statement is in A. M. W. Stirling, *The Richmond Papers* (London 1926) p. 163. For Thornbury's account in full, quoted from a letter by Mayall, see *The Life of J. M. W. Turner, R.A.*, vol. II (London 1862) p. 259 and the second edition (1877) pp. 348 ff. Minor discrepancies exist in the two texts. Among the photographs taken of Niagara before 1847 are those by Langenheim of Philadelphia (1845), and a useful reference in the *Art-Union* (1 May 1848) p. 136 describes the 'cloud of vapour curling over the great falls of Niagara . . . every curve of the falling fluid mass is most curiously preserved . . .' in these daguerreotype views 'taken on the spot by Mr Mayall . . .'.

According to John Gage, Mayall's views on colouring and chiaroscuro (see Gage's source in the *Athenaeum* (17 April and 24 April 1847)) correspond with Turner's at the time they met in Mayall's studio. The photographer, known also as 'Professor Highschool', was then engaged in research on colour and light and the unusual tints of his daguerreotypes received much attention. This may account somewhat for the apparent compatibility of the painter and the photographer during these few years of their acquaintance. Gage refers to Cosmo Monkhouse's description of Turner's loan of £300 to Mayall who was financially distressed at the time of a patent litigation; a surprisingly generous gesture on Turner's part considering his pinchpenny reputation, and further indicating that Turner and Mayall 'hit it off' very well. Monkhouse's information, adding to that given by Thornbury, came from Mayall who recalled that Turner, un-asked, offered the funds 'on the understanding that he was to repay him if he could' (see Monkhouse, *Turner* (1929) p. 120 (first edition 1876)). Gage also describes Daniel John Pound, a protégé of Turner, who engraved some of Mayall's portraits of artists, which suggests that he may have been introduced to the photographer by Turner. I am most grateful to John Gage for his kindness in supplying me with these references.

28. (pp. 102–6) *Criticisms of Pre-Raphaelitism*

For criticism of the Pre-Raphaelites by photographers see *Photo. News* (13 December 1861) p. 595 (reprinted from the *London Review*).

Seddon's painting is now in the Tate Gallery, London. The small version on paper sometimes referred to ($11\frac{3}{4}$ by $14\frac{3}{8}$ inches) may in fact be the photograph in question. The sale catalogue of 'the valuable contents of the residence of Dante G. Rossetti (deceased)', i.e. 16 Cheyne Walk, Chelsea, was issued by T. G. Wharton, Marton & Co., London. See also *Dante G. Rossetti, his family letters* with a memoir by W. M. Rossetti (London 1895) vol. I, p. 191, and vol. II pp. 146–7, for details of Rossetti's connection with this painting. I am indebted to Alastair Grieve for directing me to these references to the Seddon photograph. But Grieve also points to an ambiguity here: was Seddon's photograph taken from nature, in the first place, or from his larger painting? In a letter to James Anderson Rose (26 June 1865) D. G. Rossetti describes a painted-over photograph which he made from *The Beloved*, comparing its composition with his 'similar thing by Seddon, now ten years old, which is as good as the first day' (see *Letters of Dante Gabriel Rossetti*, edited by Doughty and Wahl (O.U.P. 1965), letter no. 612). The technique of photographing a finished painting or drawing, or one in progress, and then working over it was not unusual. Similar examples are known in the work of Manet, Degas and Burne-Jones (see note 54). Alan Bowness has kindly drawn my attention to a photograph of Burne-Jones's painting, *The Sleep of Arthur in Avalon* (begun 1881), taken during its execution and worked on till the

artist's death in 1898. (See Christie's sale catalogue, *English Pictures, Drawings and Bronzes 1840–60* (26 April 1963), no. 96, purchased with three other small studies by Hahn & Son, London). Malcolm Cormack of the Fitzwilliam Museum, Cambridge, has shown me photographs of drawings by Burne-Jones presumably worked over by the artist in preparation for the Kelmscott Chaucer.

In Ruskin's comparison of the daguerreotype and drawings of the Fribourg towers, figure 1 (top) represents the 'Düreresque' and figure 3 (bottom) the 'Blottesque'. The former, more carefully rendered, was superior, Ruskin stated, for it records more facts. The other is 'for ever an empty dream' which may have merit only if it is 'founded first on the Düreresque knowledge, and suggestive of it through all its own mystery or incompletion'. Students, he insisted, must begin with the Düreresque (*Modern Painters* (vol. IV from 1897 edition, London p. 83) (67).

I am indebted to Anthony Green for alerting me to the Kingsley dialogue.

However vehement Ruskin's protestations that the Pre-Raphaelite style could not be equated with photography, and whatever the truth of this, many people could not but associate with photography an art which was so fundamentalist in its belief in naturalism. The *Art Journal*, describing landscape photographs in the 1856 exhibition of the Photographic Society, suggested that the Pre-Raphaelites might study some of them 'and learn how the sun paints, disclosing every minute line on trunk and leaf – yet blending all into one – light melting by undulations into shadow'. In the same year the *Athenaeum* regarded the clefts in the mountains of Holman Hunt's *Scapegoat* as 'photographically studied', though this was not an implied criticism. In 1860 William Dyce, whose paintings were as meticulously produced as were those of the most dedicated Pre-Raphaelite, was accused of basing his *Pegwell Bay* on a photograph. This was immediately denied in the *Art Journal*, the picture declared to have been painted entirely from nature. In later years, with persistent regularity, Pre-Raphaelite painting continued to be related to photography. Whether in direct condemnation or inadvertently, the stigma remained. When Millais's *Order of*

Release, as an example, was shown at a retrospective exhibition in 1881, in a kind of back-handed tribute it was said to have been 'saved by expression and colour from the realism of a photograph'.

29. (pp. 106–8) *The Pre-Raphaelites' use of photography*

H. Mark Anthony was a painter-photographer who from 1834 to 1840 worked in Paris and Fontainebleau, influenced by Corot and Dupré, and later by Madox Brown and the P.R.B.

Burne-Jones and Morris's model in armour is noted in Robin Ironside, *Pre-Raphaelite Painters*, catalogue by John Gere (London 1948) p. 47, though no source is given. University College, London, owns Burne-Jones's large photographic collection of Old Masters, chiefly Renaissance painters.

Alastair Grieve calls attention to an entry for 30 January 1872 in G. B. Boyce's diary, *Cold Water Soc. Journ.* (1941): 'I lent to Burne-Jones a sheet of Richardson's photographs . . .'.

Millais's photographs of Murthly Waters are described in J. G. Millais, *The Life and Letters of Sir John Everett Millais P.R.A.*, vol. II (London 1899) p. 199, and recently brought to light is Millais's use of photographs made by Beatrix Potter's father who, on the artist's instructions, would select and pose the subjects accordingly. (See *The Journal of Beatrix Potter, 1881–1897* transcribed from code by Leslie Linder (London 1966)):
(30 January 1884) Millais wanted Rupert Potter to provide him with a photograph of a running stream to use in the landscape background of the *Drummer Boy*. 'When he painted *Pomona* he wanted a photo of an apple tree . . .'.
(14 March 1884) Millais 'asked papa if he couldn't find a background for his big picture in Devonshire . . .'.
(8 July 1884) For Gladstone's portrait, already begun from one sitting, 'There is some talk of papa's photographing the old person.' Also, 'It was definitely settled that papa should take Earl Beaconsfield . . .' but he died before the picture could be made. (Millais executed two other portraits of Gladstone, in 1879 and 1889.)
(28 July 1884) 'Papa has been photograph-

ing old Gladstone this morning at Mr Millais'.' With minor variations, Millais followed the photograph closely.

(15 November 1885) An interesting variation on the use of a photograph : 'Mr Millais came here 15th. in the evening to get papa to photograph next morning. "I just want you to photograph that little boy of Effie's . . . [and Millais describes the painting, *Bubbles*, first called *A Child's World*] I want just to compare it, I get this little thing [the photo of the picture] and I hold [it] in my hand and compare it with the life, and I can see where the drawing's wrong."'

Several photographs of Millais and his friends by Rupert Potter are reproduced in J. G. Millais (op. cit.), vol. II, pp. 240 ff. Significantly, not a whisper of this working arrangement between the artist and the photographer appears either in the letters or in the extensive biography by Millais's son.

Holman Hunt wrote of his expedition in 1854 to the Dead Sea: 'Graham was to photograph, Sim was to shoot, and I to draw when our destination was reached' (*Pre-Raphaelitism and the Pre-Raphaelite Brotherhood*, vol. I (London 1905) p. 425). Again, in the Holy Land from 1864, Hunt wrote of having been deterred by the spare and awkward proportions of the model posing as Christ (probably for the *Shadow of the Cross*), and that certain large photographs of antique figures sent by his friend Luard reminded him of the fullness of form he should seek for this subject (ibid. vol. II p. 294).

Rossetti's photographs of Jane Morris were taken in July 1865. Eighteen of these plus a letter preparing her for the photographer's visit are deposited in the Victoria and Albert Museum. The sculptor Alexander Munro introduced the author and photographer Lewis Carroll to Rossetti, Hunt, Arthur Hughes and others in that circle of friends. Carroll's photographs may well have been employed by these artists. Among others he took photographs of Madame Beyer, a model employed by Munro and Rossetti, though the subsequent history of these photographs is not known (recorded in Carroll's diary: 9 October 1863. See Gernsheim, *Lewis Carroll, Photographer* (London 1949)).

Rossetti's note to 'Mamma' is given by his brother in the *Family Letters* (op. cit.). My gratitude is due to Malcolm Cormack for alerting me to this and other references to the P.R.B. and photography. The mention of photographs for the *Salutation of Beatrice* is in W. M. Rossetti, *Dante Gabriel Rossetti as Designer and Writer* (London 1889) p. 110. Alastair Grieve has led me to another letter from D. G. Rossetti to his mother in 1864 (Doughty and Wahl (op. cit.) vol. II p. 496): 'I find one of the two photographs of the boy ought to have been kept here and is wanted at once' (possibly for the Llandaff triptych, suggests Grieve). Rossetti's early interest in photography is apparent in his letter to Ford Madox Brown (29 January 1853): 'My intention was to come and dine and get you to accompany me afterwards to the Photographic Exhibition whither I had promised to take my pupil . . .' (*Pre-Raphaelite Diaries and Letters*, W. M. Rossetti (London 1900) p. 31).

Holman Hunt, Millais, Frank Dicksee and Ruskin were among the first subscribers to Eadweard Muybridge's vast collection of photographs called *Animal Locomotion* (1887) (see p. 168).

Despite his reservations about photography, Brett was the most forthcoming of the Pre-Raphaelites concerning the obvious usefulness of that medium. A fuller rendering of his statement to the London Camera Club is in the *Brit. Journ. Photo* (London 5 April 1889) pp. 235–7. There also. Brett acknowledges unsparingly the debt painters owe to Muybridge for his large collection of photographs (see p. 172). Beatrix Potter noted that Brett was 'an enthusiastic photographer' (*The Journal of Beatrix Potter, 1881–1897* (15 December 1883) p. 58).

30. (pp. 108–13) *Composite pictures*

Meryon encountered difficulties in piecing together five daguerreotypes of San Francisco to make a large panoramic etching, one metre wide (Loÿs Delteil (op. cit.) p. 52).

On Meryon and photography see particularly, *Charles Meryon, Sailor, Engraver and Etcher*, memoir and complete catalogue translated from Philippe Burty by Marcus B. Huish (London 1879) pp. 17–18.

Ruskin's insistence on detail, his preference for the particular over the general, disregarding the total unity of a painting, was criticized by William Page – an American artist working in Rome in the 1850s, Page had been a pupil of Samuel Morse and

he was a close friend of Mathew Brady. Like others not intimidated by attitudes which proscribed the use of photographs, Page employed them freely, principally to obtain an overall harmonious effect in his paintings. Small photographs, he believed, were especially useful in this way because they allowed the artist, at once, to take in the whole of even the most complex scenes. Page wrote of his Italian journey: 'Photographs were widely used by the international group of painters in Rome, and many studios turned out pictures of models in Roman costume for artists who could not afford the price of living models.' Page sometimes enlarged directly from a squared-off photograph (see Joshua C. Taylor, 'The fascinating Mrs Page', the *Art Quarterly* vol. xx (1957) pp. 347 ff.). This was also the practice of the American Impressionist Theodore Robinson and Walter Sickert. Newton described his manner of taking photographs preparatory to painting in *Journ. Photo. Soc.* (2 June 1853) p. 75. See also Newton's illuminating article, 'Upon Photography in an Artistic View, and its relations to the Arts', delivered to the first meeting of the new Photographic Society, London: photographs ought to be artistically, not chemically beautiful; a knowledge of 'the *principles* of art' will enhance the photograph and most important, 'the object is better obtained by the whole subject being a little *out of focus* . . . more *suggestive* of the true character of nature' (ibid. p. 67).

For further discussion of Nègre, André Jammes's superbly produced monograph, *Charles Nègre, Photographe* (Paris 1963), is recommended. See also A. Scharf and A. Jammes, 'Le réalisme de la photographie et la Réaction des Peintres', *Art de France*, vol. iv (Paris 1964) pp. 174–89. The Jammes Collection is the best source of Nègre photographs.

Lacan's book, *Esquisses photographiques* (Paris 1856), is worth consulting for its broad coverage of photography in that period. Lacan was himself trained as a painter, a pupil of Léon Cogniet.

31. (pp. 113–15) *Clouds*

For Leslie on clouds see (op. cit.) (London 1870) p. 258.

Despite Constable's often quoted meteorological accuracy, his clouds are predominantly of the cumulus type. A much greater range of cloud formations will be found in the illustrations to Ruskin's *Modern Painters*. Striated cirrus clouds, seldom found in earlier art, are here represented from Turner, in whose work they are so stylistically compatible, and from Ruskin's own drawings – the result of his relentless scrutiny of nature. Such clouds are rare indeed in photographs of the period.

See A. J. Wall's criticism in 1896 of the anomalies in composite landscape photographs, *Artistic Landscape Photography* (London) pp. 70 ff.

32. (p. 115) *John Linnell*

All the information on Linnell and photography is from Alfred T. Story's life of the artist, vol. ii (London 1892), see pp. 116, 146, 151, 224. A letter of 1863 to the painter William Henry Hunt indicates that Linnell had, in fact, set up photographic apparatus in an old shop in Bayswater (ibid. p. 138). Varley's letter to Linnell also states that the current exhibition of the new Photographic Society is excellent and 'works in the Royal Academy show that photography is doing much good to the arts'. Cornelius Varley was known for his earlier invention of the 'graphic telescope', a type of camera lucida used by many artists including the painter Cotman and the sculptor Chantrey (see Sidney D. Kitson, *The Life of John Sell Cotman* (London 1937), and George Jones R.A., *Sir Francis Chantrey, R.A., Recollections* (London 1849) p. 276).

33. (pp. 115–17) *Pictorial truth and alternatives*

Thornbury's remarks are from his book on Turner, op. cit. (second edition 1877) p. 411.

Eastlake's recommendation to use photographs is given in *Journ. Photo. Soc.* (June 1853) p. 76.

Hamerton took photographs of landscapes in 1859 but relinquished their use because of the difficulties of working from them. He supported, however, the idea of artists taking their own photographs rather than purchasing them ready-made since they could then

vary the conditions to suit their particular needs. In answer to a friend who declared that 'the discovery of photography had made painting no longer of any use, since all that painting did could be done much more truthfully [by] the photograph', Hamerton, like Ruskin, insisted that the artist could render nature more precisely than the camera. Thus he was contemptuous of 'one of our most popular painters of winter scenery [who] always works from the photograph alone, and never even draws from nature' (*Thoughts about Art* (London 1873) p. 60, etc.). Hamerton's disdain for photography as simply a reflection of nature was countered by P. H. Emerson, at the time an unremitting exponent of 'naturalistic' photography. If Hamerton was right, he argued, then 'a monkey with a camera could produce as good pictures as Mr Hamerton could take with the same instrument' (*Naturalistic Photography* (London 1889) p. 282).

Leighton never to my knowledge used photographs in his work, though he owned a Kodak, according to his biographer, Mrs Russell Barrington (London 1906): 'To the end of his life he could make no use whatever of photography in his work' (ibid. vol. 1 pp. 205–6). He did not, however, rule it out for others, believing that it all depended on the intelligence with which it was used (see Hans Roth, 'Die Photographie im Zeitgenössischen Werturteil', *Photo Magazin* (Munich April 1959) pp. 43 ff.).

Poynter succeeded Leighton as P.R.A. in 1896. For his views on photography and art see *Ten Lectures on Art* (London 1879) pp. 38, 190. He believed photographs were of a certain value in preliminary studies, but in finishing, the artist should 'go it alone'. The 1870s had produced, he complained, 'those poor substitutes for photography in the shape of elaborate studies from nature which some of our modern artists give us under the name of realism . . .' etc.

Orchardson, whose work certainly suggests it, occasionally used photographs – of some trees, for example, for his painting, *The Dove*. See his *Life* by Hilda Orchardson Gray (London n.d.) p. 246, and James Stanley Little's article in *The Art Annual* (London 1895) p. 8.

4. DELACROIX AND PHOTOGRAPHY

34. (pp. 119–25)

The first reference to photography in Delacroix's known writings is in the *Journal* entry for 7 May 1847, in a criticism of the sculptor Clésinger's *Femme piquée par un serpent* which he had seen that day in the Salon exhibition. The critic Planche, wrote Delacroix, was right: 'It is a daguerreotype in sculpture.' Planche's observations almost provoked the sculptor into a duel.

All citations from the *Journal* in this chapter are from André Joubin's revised edition of 1950. References to Delacroix's letters are from Joubin, *Correspondance Générale d'Eugène Delacroix* (Paris 1937–8). The essay on Mme Cavé's drawing method was published in the *Revue des deux mondes* (Paris 15 September 1850) p. 144 and is also in the artist's *Oeuvres Littéraires*, edited by G. Crès, vol. 1 (Paris 1923) pp. 9 ff., 137 ff. Part of it was incorporated in Delacroix's report to the Ministry of Public Instruction.

Joubin noted that Delacroix executed a number of drawings after Ziégler's 'daguerreotypes', though he may have mistaken them for drawings made from other photographs (see p. 123).

The first issue of *La Lumière* appeared on 9 February 1851 in which the original membership of the Société Héliographique was published as follows: President, Baron Gros (not the painter), MM. Bayard, Éd. Becquerel, Benjamin Delessert, E. Durieu, Mestral, de Montfort, Count Léon de Laborde, Niepce de Saint-Victor, J. Ziégler ('*membres du comité*). Also: Count Olympe Aguado, Arnoux, Aussandon, Baldus, Barre, Champfleury, C. Chevalier, Cousin, Delacroix, Desmaisons, Fortier, Le Gray, Count d'Haussonville, Horeau, Lemaître, Le Secq, Lerebours, Leisse, de Mercey, de Montesquieu, Prince de Montleart, Peccarère, du Ponçeau, Puech, Puille, Regnault, Schlumberger, Renard, Wey, Vigier. The list is not complete, notes Ziégler, recording for the Société, and is augmented daily. By 1855 the following names could be added, together with those from the reorganized Société Héliographique which now became the Société française de Photographie: Cuvelier, Claudet, Nadar, Bisson, Blanquart-Évrard, Vallou de Ville-

neuve, Roger Fenton, Théophile Gautier and the painters Charles Nègre, Philippe Rousseau, Svoboda, William Newton, Le Blanc, Horsin-Déon, Defonds, Bouquet and Béranger. Delacroix's membership continues in the new group. (See *Bull. de la Soc. française de Photo.*, from vol. I, I January 1855.)

Delacroix's letter of thanks for the 'splendid photographs . . .' is dated 2 February 1853 and is in the collection of George Eastman House, Rochester, N.Y. (see Beaumont Newhall, 'Delacroix and Photography', *Magazine of Art* (Philadelphia November 1952)). The George Eastman House contains an album of over 100 photographs by Durieu which Newhall linked with Delacroix. Van Deren Coke couples a Delacroix sketch of a nude female, executed in Dieppe in 1854 with one of Durieu's recumbent nudes in the Eastman House album and also a daguerreotype of the artist (*c.* 1842) with a similar (reversed) self-portrait drawing on a sheet of sketches reproduced by Escholier (Coke: 'Two Delacroix drawings made from photographs', *The Art Journal* (New York, College Art Association of America, Spring 1962) pp. 172–4; Raymond Escholier, *Delacroix*, vol. III (Paris 1929) p. 200, '*Dessins d'après des photographies. En bas: Delacroix et Mme Cavé*'). On this same theme, see A. Scharf and A. Jammes, 'Le réalisme de la photographie et la Réaction des Peintres', *Art de France*, vol. IV (Paris 1964) pp. 181 ff., in which the identification is made with photographs in the B.N. Est. album. This has been taken further by F.A. Trapp in 'The Art of Delacroix and the Camera's Eye', *Apollo* (London April 1966) pp. 278–88. I am grateful to Dr R. S. Schultze of the Kodak Museum, Harrow, for putting me on the trail of the Delacroix album several years ago and to Dr Lee Johnson for helping me track down the elusive odalisque.

Jean-Louis-Marie-Eugène Durieu (1800–1874) is first mentioned in the *Journal* on 26 February 1850. Durieu, a Paris lawyer, was appointed Directeur Général des Cultes in 1848 and had instituted a commission for the conservation of religious art and architectural monuments, in which Delacroix participated. Durieu retired to private life in 1849 when he probably began to practise photography; he was initially interested in its application to the recording of artistic monuments.

Delacroix's revulsion for Marcantonio and his preference for photographs is reiterated on 19 November 1853 when, at the house of the print publisher Gihaut, the artist was shown a new edition of the Italian's engravings, reproduced for the first time photographically by Benjamin Delessert, a fellow member of the Société Héliographique. These were issued in parts, in 1853–5, in 1858 and again in 1863 – the year incidentally that Manet used Marcantonio in composing his group of figures in the *Déjeuner sur l'herbe*.

Delacroix's photographic activities in 1854 include the execution of a few works in *cliché-verre*. Probably through his friend Dutilleux in Arras he met Cuvelier who joined the Société about 1854. The artist's letter to Cuvelier reveals his interest in the technique: 'I have seen with great pleasure the photographic prints of the engravings [Dutilleux's], the drawings are very bad, but the process is quite ingenious and I would very much like to find some time to try some in that medium' (Joubin, *Correspondance Générale d'E.D.*, vol. III p. 195). In another letter Delacroix thanks Dutilleux for describing the process to him and he mentions Cuvelier's satisfaction with his own '*très imparfait essai*'. A *cliché-verre* executed by Delacroix has been identified by Joubin as *Un tigre en arrêt*. In Robaut's Delacroix catalogue, it is listed as no. 1282, '*Dessin sur verre collodionne*', 1855. In a letter to Dutilleux (Joubin, loc. cit.), Delacroix spoke highly of some photographs which the former had sent to Paris, though their nature is not revealed: 'As far as my work is concerned, how much I regret that such an admirable invention came so late! The possibility of studying such images would have had an influence on me that I can only guess at from the usefulness which they do have now, despite the little time that I can devote to this kind of thoroughgoing study. These images are the palpable demonstration of the real form of nature, of which before we've never had anything but very imperfect notions.' (See note 5, *cliché-verre*.)

The number of photographs taken during one session in Durieu's studio may be estimated from Delacroix's *Journal* entry, 18 June 1854: 'Eight o'clock, chez Durieu. Until nearly 5.00, we have done nothing but pose [models]. Thévelin [possibly Thévenin an engraver, though Trapp, op. cit., says

Thévelin was more likely the name of the model] has already made as many drawings as Durieu has taken photographs: one or one and a half minutes or more for each.'

Another reference to Delacroix's use of a photograph for his large portrait of Alfred Bruyas in Montpellier is made by Pierre Borel in his *Lettres de Gustave Courbet à Alfred Bruyas* (Geneva 1951) p. 64. Borel reproduces a photograph which bears some resemblance to the painting, though they do not conform in the positions of the heads.

5. THE DILEMMA OF REALISM

35. (pp. 127–30) *Style be damned! Voilà l'ennemi!*

Courbet's pronouncements in the name of Realism are given in Bruyas, *Autographes sur l'exposé du tableau La Rencontre* (Paris 1856) p. 1, f.n. 2, and in Georges Riat, *Gustave Courbet, Peintre* (Paris 1906) p. 72: quoted in Gerstle Mack, *Gustave Courbet* (London 1951) p. 68.

Monet's extremist view on objective vision (told possibly to the American painter Theodore Robinson) is cited by Kenneth Clark, *Landscape into Art* (Edinburgh 1956) p. 104.

Millet's belief that '*Le beau c'est le vrai*' was shared, and often applied in its most exaggerated forms, by many of his contemporaries. The passion for pictorial veracity, whether or not photographs were consulted, appears sometimes to have bordered on the absurd. Seymour Haden who owned *The Angelus*, a painting by Alphonse Legros (pupil of Courbet), had become so irritated by the deficiencies of its perspective – though this occupied a very minor part of the picture and was not at all essential to the success or failure of the religious scene – that he corrected the 'faults' with his own brush. That impertinence moved Legros to retrieve the picture in order to restore it to its original' condition (see Pennell's *Life of Whistler*, vol. 1 (London, Philadelphia 1908) p. 77). Baudelaire, in his Salon review of 1859, wrote of the same painting being similarly depreciated by a friend of his, and he dismissed the criticism as pettifogging in view of the picture's essential merit.

The reaction of Ingres and Delacroix to Courbet's singular approach to painting was recorded in 1848 by Courbet's friend Francis Wey in his partially published manuscript *Notre Maître-Peintre G. Courbet* in the B.N. Est. Way, who first met Courbet during the execution of the *Après-dîner à Ornans*, became known for his articles on photography (notably 'Comment le soleil est devenu peintre' in the *Musée des Familles* (June and July 1853)), and for his active participation in the Société Héliographique. Wey's interest in photography and his eagerness to promote precision in painting led him to believe that an alliance between photography and painting would be beneficial though, like Delacroix, he warned artists that photographs must be employed 'intelligently'. This he expressed in the first issue of *La Lumière* (9 February 1851). Furthermore, he advocated here the use of photographs on paper, because they reproduced the tonal masses of nature rather than the details conveyed by the daguerreotype, thus presenting tone and form most advantageously. See also the following issue of *La Lumière* in which Wey urges portrait and history painters to consult photographs.

The incrimination of the *Return from the Fair* is mentioned by André Fontainas, *Courbet* (Paris 1921) p. 20. No source is given though it may have derived from Proudhon's defence of that painting against a similar accusation (see p. 138).

Louis de Geofroy may have been the first critic to employ the label 'Realist' to include Courbet and the Barbizon painters (see his Salon review of 1850–51 in *Revue des Deux Mondes* (1851) pp. 929–30). Delécluze's attack appeared in the *Journal des Débats* (21 March 1851); the Goncourts' was published in their Salon review (1852) in *Études d'Art* (Paris 1893) p. 7, and that by Henriet in his review 'Coup d'œil sur le Salon de 1853' published in *Journal des Théâtres*. Delaborde's criticism is from 'La photographie et la gravure' (1856), in *Mélanges sur l'Art contemporain* (Paris 1866) pp. 359 ff.

The well-known comparison between Courbet's *Bather* and a percheron allegedly made by the Empress Eugénie was reiterated by Nadar who called the *Baigneuse* '*une espèce Percheronne*' in his 'Jury au Salon de 1853', *Le Journal pour Rire*. Nadar was merciless in his caricatures of Courbet's

paintings as he was with most others. Referring to the bather's enormous buttocks, he quipped, 'Now that M. Courbet has let us see his moon, what the devil will he show us next year?' The caustic comments which accompanied Nadar's drawings, in the same 'Jury au Salon', were soon echoed, usually with more malice, by other critics. Of the *Wrestlers*, Nadar's visitor to the Salon is supposed to have remarked: 'wrestlers with varicose veins like that! Molière is right; the plague take varicose veins and others like Courbet'. Théodore de Banville's satirical poem, 'Bonjour, Monsieur Courbet!' a travesty on *La Rencontre* (October 1855) contains the lines, '*C'étaient dans les ruisseaux des murmures absurdes, Et l'on eût dit les rocs esquissés par Nadar!*' (from *Courbet, raconté par lui-même et par ses amis*, by Pierre Courthion, vol. 1 (Geneva 1948) p. 114).

By 1847 Champfleury had already linked the impersonal and bloodless fidelity of the daguerreotype with bourgeois manners in taste. In *Pauvre Trompette, Fantaisies de Printemps* (Paris 1847) pp. 8–9, he describes the conversation of a *petit-bourgeois* and his young children admiring the porcelain brilliancy of a painting at an exhibition as '*daguerréotype fidèle*'. The farcical and pretentious antics of '*M. Prudhomme au Salon*' is typified in the admiration of a painting by this archetypal bourgeois because '*Son mouchoir est parfait d'exactitude*' at which his companion responds '*Oui, c'est de la laine toute pure*' (ibid, p. 27).

The problem of distinguishing between literal realism and artistic Realism is approached in Duranty's introduction to Champfleury's facetious *Les Amis de la Nature* (Paris 1859) which contains this passage about Balzac's realistic characters: '*Qui pourra venir dire: Voici qui est d'invention et voilà qui est du daguerréotype.*' In his 'L'Aventurier Challes', written in 1854 (published in 1857 in *Le Réalisme*), Champfleury attacks the critics of Courbet's paintings in the 1853 Salon, deploring the alacrity with which they associated any truthful work with the daguerreotype. Had the daguerreotype been invented in the seventeenth century, he wrote (i.e. when Grégoire de Challes, writer and soldier of fortune, lived), Challes would surely have been accused of using it.

The Realist painter François Bonvin's contempt for photography ('*que j'abhorre*') stems more likely from a fear of that kind of criticism than from any criticism of its intrinsic imagery. He even resisted having his portrait taken by Nadar and had to be persuaded by friends to do so (see Moreau-Nélaton, *Bonvin* (Paris 1927) p. 103. See also (ibid.) pp. 95 and 123).

36. (pp. 130–4) *Nudes and obscenities*

Sources for the references to 'immoral' photographs are: daguerreotype of drinkers in a restaurant, Gernsheim, *L. J. M. Daguerre* p. 136, who cites C. W. Sipley, *Pennsylvania Arts and Sciences* (1937); court case in England, *Le Moniteur de la Photographie* (October 1863) p. 111. See also, *Photo. News* (London 3 August 1860) letter: 'a man who takes a walk with his wife and daughters dare not venture to look at the windows of many of our photographic publishers. . . .' The same journal carried a similar item (10 August 1960): 'infamous traffic', public 'pollution', a 'prostitution' of the beautiful art of photography perpetrated by publishers in Kentish Town, Clapham and in the Strand. See also (ibid.) 17 August and 24 August 1860. Obscenities in Japanese art in contrast to the West are discussed by Rodolphe Lindau, *Un voyage autour du Japon* (Paris 1864). For photographs denied privilege of the open post, *Photo. News* (17 April 1862) p. 192; Disderi's complaint, *L'Art de la Photographie* (Paris 1862) p. 302.

It is said that a photographic dealer's Pimlico establishment was raided in 1874 when over 130,000 photographs plus 5,000 slides were impounded (see John Gross, review of H. Montgomery Hyde's *History of Pornography*, the *Observer* (London 26 July 1964)). Stenger cites the following: 1873 (England), the Society for the Suppression of Vice protested against the sale and distribution of photographs of famous actors in theatrical costume; 1881 (Hamburg), photographic reproductions of Titian's *Venus* and other paintings confiscated as obscene; early 1880s (Boston) it was fashionable for well-to-do ladies to sit for their photographs in the nude. The photographers were female. In England, *c.* 1895, it was customary for young society women to possess an album containing such portraits of all their female friends. An extreme case of moral rectitude is the refusal, as recently as 1933, of New York

customs officials to admit a portfolio of photographs of Michelangelo's Sistine Chapel paintings because they were 'shocking pornography' (*The March of Photography*, p. 121). An avalanche of obscene photographs is described in A. Bigeon, *La Photographie et le Droit* (Paris 1893) Chapter XII, 'Les photographies obscènes'.

Lacan (op. cit.) noted that M. Goüin (a former pupil of Girodet), M. Moulin and M. Braquehais were already (in 1856) producing such 'académies' for the *ateliers* of Paris. To these names may be added those of L. D'Olivier and Anatole and Achille Quinet and of course Villeneuve.

Courbet's letter to Bruyas asking for the photograph of a nude is in Pierre Borel, *Le Roman de Gustave Courbet* (Paris 1922) p. 57. See also Borel, *Lettres de Courbet à Alfred Bruyas*, p. 26, for another reference to Bruyas's photographs. A good collection of Villeneuve's photographs is in the B.N. Est. They all bear the acquisition dates, the photograph in question marked 1854. The letter from Frankfurt describing Courbet's use of a photograph for his *Venus* is cited in Charles Léger, *Courbet et son temps* (Paris 1948) p. 69. In 1858 before leaving for Frankfurt Courbet stayed in Brussels with the photographer, Radoux (one of the first calotypists in Belgium), from whom possibly he got the photograph mentioned by Scholderer (ibid. p. 67). Riat (op. cit. p. 164) quotes Courbet writing from Frankfurt: '*On m'a fait cadeau aussi, d'une photographie, représentant ce cerf mort, avec mes coups de fusil.*'

37. (pp. 134–6) *Other photographs used by Courbet*

For the Proudhon portrait Courbet asked Castagnary to secure a death-mask and any photographs taken by Carjat. He asked also for a print of a photograph of Proudhon by Reutlinger (in the pose Courbet himself suggested). Mack (op. cit. p. 195) says that Carjat sent all the required photographs plus one of a portrait painting by the Belgian, Amédée Bourson, which itself may have depended on the Reutlinger photograph and which Courbet copied for a small bust of Proudhon (probably in 1867 for Mme Proudhon, using his own signature). In the

large finished painting, the portrait of Proudhon resembles the Reutlinger photograph taken probably in the 1850s. The initials P.J.P. and the date – 1853 – on the painting correspond not to the year it is sometimes assumed to have been started but more likely to that of the Reutlinger photograph with Proudhon as he was twelve years before his death.

The use of one of the Carjat photographs of Proudhon was intended for the *La rue* portrait (Léger, op. cit. p. 119). Some of Courbet's marines were painted in Palavas not far from Sète, both places easily accessible from Montpellier. The subject of sea and sky was popular among photographers before being used by Courbet. By 1854 Baron Gros was able to photograph with fair accuracy the action of waves. Charles Marville's photographs of sea and sky also precede the paintings of that kind by Courbet. A report of 15 June 1860 announced that photographers were then able to 'fix the image of the rolling waves of the sea': A. Claudet, *Photo. Journ.*, p. 259. Le Gray's photographs taken at Cette (Sète) were widely known in 1856.

38. (pp. 137–8) *Realism in painting defended*

Champfleury's vindication of Realism was made in *Le Réalisme* (op. cit. pp. 91–4); Duranty's periodical *Réalisme* was published in six issues: no. 1, 10 July 1856 to no. 6, April/May 1857.

The position of the German portrait painter Wilhelm Leibl was more extreme. 'If only I paint men and women as they are [he is quoted as saying], with all the detail, their souls must be in the picture, too'. (Lucia Moholy, *100 Years of Photography* (London 1939) p. 106. No source given.) This may be contrasted with Schopenhauer's advice to the painter Julius Hamel in 1856, 'that the portrait should not be a reflection in a mirror [for] a daguerreotype produces that far better', and that 'the portrait must be a lyric poem, through which a whole personality, with all its thoughts, feelings and desires, speaks'. (Quoted by Goldscheider in *Vermeer* (London 1958) p. 33. No source given.) Even the philosopher and critic, Hippolyte Taine, an advocate of

realism in art, held certain reservations
about it. In lectures given to the École des
Beaux-Arts in 1865, he questioned literal

**6. THE POWER OF
PHOTOGRAPHY**

347

imitation in any art. That belonged to the
realm of photography and could not be
compared with the essential superiority of
painting (*Philosophie de l'Art.* vol. 1 (Librairie
Hachette, Paris, twenty-third edition) pp.
23 ff.).

Proudhon's *Du Principe de l'Art et de sa
Destination Sociale* was begun about 1863 and
published in 1865 after his death. His rather
generous view of photography and the Ideal
may have been influenced by the defence
put forward in an important litigation of
1861–2 just before his book was written.
(See p. 151).

39. (pp. 139–42) *Idealism in photography defended*

The Goncourts' criticism of Realism is from
their Salon review of 1855, published in
Études d'Art, p. 170.

The photograph (by Bilordeau) of a man
cutting his corns was rejected as unsuitable
by the jury of the photographic Salon in
1859 (see *Photo. Journ.* (London 15 June
1859) p. 153. Actually Bilordeaux, a manu-
facturer of photographic prints).

Often 'low life' subjects were likewise
excluded from photographic exhibitions in
England.

Delaborde challenged Ziégler in 'La
photographie et la gravure' (1856). See
Mélanges sur l'art contemporain (Paris 1866)
pp. 359 ff. See also an article by A. Bonnardot
on the same theme in the *Revue universelle des
arts*, vol II (Paris October 1855) p. 46.
Durieu's report on the 1855 photographic
Salon was published as *Rapport . . . dans les
Salons de la Société française de Photographie*
(Paris 1 August to 15 November 1855).

Count de Laborde's trenchant advice was
given in *De l'union des arts et de l'industrie*,
vol. II (Paris 1856) p. 542.

Nadar's drawing in 1855 *Pluie de photo-
graphes* (*Le Journal pour Rire*) was an appro-
priate comment on the large number of
practising photographers in France at that
time.

40. (pp. 143–6) *The exhibition of 1859*

The Palais de l'Industrie was then called the
Palais de Champs-Élysées. On this impor-
tant photographic exhibition see: Louis
Figuier, *La Photographie au Salon de 1859*
(Paris 1860); Philippe Burty's review in the
G.B.A. (15 May 1859) pp. 209–21. Figuier
notes that many specimens of natural colour
photography by Testud de Beauregard and
Niepce de Saint-Victor were shown. The
process was not yet perfected.

Interestingly, no daguerreotypes were
mentioned in reviews of this exhibition, and
of several other kinds of photographs about
200 were made from waxed paper negatives
(calotypes) and about 700 by the wet collo-
dion method. That year Nadar was called
the 'Titian of photography' in *La Lumière*,
an allusion probably to his great *Panthéon* of
portrait photographs which by that time
included many of Europe's and practically
all of France's outstanding artists, writers,
musicians and actors.

Nadar's 1859 drawing symbolizing the
amicability of painting and photography
was preceded by others in the same style
published in 1855 (*Petit Journal pour Rire*)
with photography ringing the bell for admis-
sion to the Salon, and in 1857 (*Le Journal
amusant*) showing 'painting' booting 'photo-
graphy' out of the exhibition of Fine Arts
(93, 94). The year 1857 was the year in
which Nadar's complaints to the Société
française de Photographie caused the for-
mation of the committee comprising
Delacroix, Gautier and others whose mission
it was to press for admittance to the
Salon.

Chesneau's denunciation was published
in the *Revue des Races Latines* (Paris 1859)
pp. 19 ff. See also the *Revue des Deux Mondes*
(1 June 1859) for Delaborde's criticism
of '*la simple imitation matérielle*' in art.

Baudelaire's ferocious attack on photo-
graphy is translated from the *Curiosités
aesthétiques* (third edition Paris 1880). His
view of photography seems more positive in
1846 when he compared the 'marvellously
brutal' truth of the sun-drenched landscapes

by Lottier with coloured daguerreotypes (ibid. p. 180). His diatribe in 1859 was meaningfully followed by a section called 'The Queen of the Faculties', the critic's antidote to the doctrinaire copying of nature. Here the man of imagination is extolled.

Aiming his criticisms particularly at the Impressionists, the 'Orientalist' painter, Eugène Fromentin, lamented the artist's love for absolute truth at the expense of the 'fantasies of the imagination'. Photography, he said, had altered the traditional ways of seeing, and of feeling too. Impersonality, the particular effects of light as seen in photographs, are becoming predominant in painting, and with them the proscription of subjectivity, of choice and of artifice (see *The Masters of Past Time, Les Maîtres d'autrefois* (1876), translation by Andrew Boyle, first published 1913, Chapter XVIII).

For Delacroix's essay, 'Réalisme et idéalisme' see *Oeuvres Littéraires*, pp. 57 ff., and *Journal* (1 September 1859). Joubin's f.n. in *Journal* says, '*Ce passage ne ce trouve pas non plus dans* L'Agenda. *Il a été publié par* Piron (p. 406) *qui l'avait copié sur un album de Delacroix, aujourd'hui perdu.*'

41. (pp. 147–9) *Salons and criticisms of photographic style in art*

Nadar's satirical drawing is from the 'Nadar Jury, 1861', *Journal pour Rire*.

For Zola's Salon reviews see *Émile Zola Salons* (op. cit.).

Blanc's *Grammaire* . . . was published in Paris, see pp. 564 ff. For his declaration about photography's blindness see '*L'oeuvre de Marc-Antoine*', *G.B.A.* (September 1863) pp. 268 ff., an opinion already given by others.

The distinction between the artist-photographer and the '*opérateur vulgaire*' could not always be clearly drawn and artists like Constantin Guys, for example, had to contend with the more or less 'straight' though very effective photographs of the dandy, the *demi-mondaine*, and the carriage-crowd taken by Nadar, Disderi, Carjat, Reutlinger and Pierre Petit, among many others whose prints compare very favourably with his own drawings. These are elaborately juxtaposed by François Boucher in *Au temps de Baudelaire, Guys et Nadar* (Paris 1945). My thanks are due to Michel Strauss who first showed me this captivating little book and also introduced me to Gautier's *Abécédaire*.

42. (pp. 149–54) *The Mayer and Pierson case*

Details of the Mayer and Pierson trial will be found in their book *La Photographie* (Paris 1862) pp. 217 ff., and in *Le Moniteur de la Photographie* (15 December 1862) p. 149. The court's final statement is in *Recueil général des lois et des arrêts*, J.-B. Sirey, vol. 9 (1861–5) pp. 261–2.

Count Cavour, the popular Italian statesman, died in 1861 which may in some degree account for the great demand for his portrait photograph. Palmerston, equally popular, was Prime Minister of England at the time of the litigation.

An earlier lawsuit was brought by the painter Müller against Disderi for publishing his *Vive l'empereur!* as a photograph without permission (*Art Journal* (November 1855) p. 319).

The complexity of the copyright dilemma is illustrated in 1859 when H. P. Robinson staged a model for a photograph based on Wallis's painting, *The Death of Chatterton* (1856), and used the same title in advertising the photograph. Augustus Egg, who owned the painting, had already sold the rights to an engraver who had Robinson served with an injunction which the court upheld (*Photo. Journ.* (15 September 1860) p. 45 from *Athenaeum* (25 June 1859)).

Flandrin's comments on drawing and photography are from his *Lettres et Pensées* (Henri Delaborde, Paris 1865) p. 438.

Ingres's response to the report on the École was first published on 15 November in the official *Moniteur*. Chesneau's pamphlet, *Le Décret du 13 novembre et L'Académie des beaux-arts*, was written on 21 January and published that year (1864).

43. (pp. 154–7) *Artistic photography*

Disderi had been an artist, once a pupil of the *genre* painter Chasselat Saint-Ange, probably in the late 1830s.

As symptomatic as it is amusing, the inclusion in the R.A. of the worked-over photograph reported in the *Photo. News*

(24 May 1861) was only a forerunner of similar difficulties to be encountered later. Sickert's insistence that the true character of such paintings be acknowledged in the catalogues (see p. 192) suggests that many other paintings of that nature passed through the net.

The statement that the creation of combination photographs was as demanding of the photographer as paintings were of the artist appeared in a review of the Photographic Society exhibition, the *Art Journal* (1 February 1863) p. 38. Robinson set great store on the aesthetic merit of combination printing, comparing himself no less with Zeuxis who had also once combined the best features of five young ladies from Crotona to produce his famous picture of Helena. An exaggeration, perhaps, of this concept, Robinson's *Fading Away* made from five separate negatives required three years' practice before the principal subject was sufficiently able to convey the appearance of slipping into oblivion (see *Brit. Journ. Photo.* (1860) p. 95 and Robinson's *Pictorial Effect in Photography* (1869)). In the 1840s and 1850s other distinguished 'High Art' photographers include William Lake Price (once also a painter and draughtsman), Turner's friend Mayall who illustrated the Lord's Prayer about 1845 and later other subjects from poetry and literature, and, of course, O. G. Rejlander (once a portrait painter) some of whose studies are called '*ersatz* Raphael' by Gernsheim (*Creative Photography* (London 1962)). Probably the best known of such photographs is Rejlander's *Two Ways of Life*, a large combination print made in 1857 from more than thirty separate negatives which echoes, as did Couture's painting, *The Decadence of the Romans*, Lord Lytton's (Edward Bulwer) notorious book, *The Last Days of Pompeii* (published in several editions from 1834). *Genre* and historical subjects in photographs were popular also in France where Bayard, Adolphe Braun and Charles Nègre are among the earliest practitioners.

44. (pp. 157–60) *Engraving versus photography*

Almost immediately after Niepce and the appearance of the daguerreotype, the idea of etching these plates for printing occurred. Among the earliest successful methods proposed were those of Alfred Donné in Paris (1839), Joseph Berres in Vienna (1840) and Hippolyte Fizeau in Paris (1841). Though similar photo-mechanical processes had been known since the invention of photography and were later refined (e.g. Niepce de Saint-Victor's heliogravure (1853) and Pretsch's photo-galvanography (1854) among others) such reproductions were not it seems considered commercially feasible on a large scale until much later in the century (see Raymond Lécuyer's well-illustrated chapter on this subject in his *Histoire de la Photographie*. For a full contemporary description of Donné's process see the *Comptes rendus des séances de l'Académie des Sciences*, vol. II (1839) pp. 411, 423, 714, 801.

Delessert's prices are given in Lacan (op. cit.) p. 119. Those for Harvey and Duncan's engravings, in the *Art-Union* (October 1845) p. 313.

Alinari's photographs were featured in the 1859 Paris exhibition.

Criticisms of Lasinio are in the *Athenaeum* (London 27 October 1855) and in Ruskin's *Modern Painters*, vol. III and vol. IV.

The meeting of outraged engravers and the text of Frith's letter was reported in the *Photo. News* (6 February 1863) p. 63. For Frith's and Landseer's prices see F. G. Stevens, *Memoirs of Sir Edwin Landseer* (London 1874) p. 144, and the 'foe-to-graphic art' pun is from Roget (op. cit.), vol. II, p. 136 f.n.

Zola took a rather jaundiced view of painters who worked with the reproduction in mind. He berates Gérôme, in his 1867 Salon review, for making a picture so that Goupil can reproduce it in photography and engraving and sell it in the thousands (*Émile Zola Salons*, op. cit.).

For the full record of the investigation of the R.A. see the *Report of the Commissioners – an Inquiry into the Royal Academy – Minutes of Evidence* (London 1863). Paragraphs 2355 ff. give Doo's testimony.

45. (pp. 160–3) *Photographic reproductions of works of art*

The collection of Talbot photographs in the Science Museum, London, contains a number of prints intended as illustrations for the

350 Stirling Maxwell edition which was limited

Stirling Maxwell edition which was limited to only twenty-five copies.

In Courbet's letters to Bruyas in 1854 and 1855 several requests are made for photographs and negatives including *The Rencontre*, *The Bathers* and his portraits including *The Man with a pipe*. Photographs, collodion on glass, were to be made for him by a M. Laisne and two or three others but Courbet was not happy with the results (see Pierre Borel, *Le Roman de Gustave Courbet* from the artist's letters (Paris 1922)). Other documents (Courbet, Box 1, B.N. Est.) indicate that later Courbet was still interested in having his works reproduced by photography. Much later in 1917, Robert Delaunay called photography '*un art criminel*' because it so badly distorted pictures of his like the *Hommage à Blériot*. In the interests of reproduction something, he said, is sacrificed by photography which is different from a musical score played to an audience (letter to the publisher of Vell I Nou, Barcelona in R. Delaunay, *Du Cubisme à L'Art Abstrait*, edited by Pierre Francastel (Paris 1957) pp. 129 ff.).

Delaborde's views on photographic reproduction will be found in his 'La Photographie et La Gravure' (1856), published in *Mélanges sur l'Art Contemporain* (Paris 1866) pp. 359–88.

Artists who made their living selling views of Pompeii and Herculaneum were protected by an act of government which forbade foreigners to use their cameras in those areas (*Athenaeum* (15 March 1856)).

For discussions on the illustration of books with photographs see Anatole Jakovsky, 'Les premiers livres illustrés par la photographie d'après nature' (Paris 1948), 14 pp., copy in B.N. Est. and R. S. Schultze, *Books Illustrated with Original Photographs (1855–1885)* (Vienna and Darmstadt 1961). Stenger, *The March of Photography*, pp. 188–91, supplies many examples. See also Gernsheim, *L. J. M. Daguerre*, Appendices pp. 190–91.

Redon's views on photographic reproductions are in his *À soi-même* (Paris 1922).

Saint-Victor's despondent denunciation of photography is given in Stenger's *History of Photography*, translated by Epstean (Easton, Pennsylvania 1939) p. 184, no source cited. And the sharp response by M. de Sainte-Santin to the ravages of photography will be found in the *G.B.A.* as 'De quelques arts qui s'en vont' (1 October 1865) pp. 304–17. Burty's shrewd observations on the future of engraving were published in the *G.B.A.* (July 1867) p. 95. The implications of photography as a means of reproducing works of art were discussed with extraordinary comprehension by William M. Ivins, Jun., in *Prints and Visual Communication*, Chapter VII, 'New reports and new vision' (London 1953).

7. IMPRESSIONISM

46. (pp. 165–6) *The clandestine use of photography*

Pennell's statement was sent to *The Studio* and published in one of its first numbers in 1893, vol. I, p. 102. See also Hector Maclean, *Photography for Artists* (London 1896). Sickert's frivolous quip is from his letter to *The Times* (15 August 1929). It is worth noting that neither Courbet, Manet, Degas, Gauguin or Derain, all of whom frequently had recourse to photography, ever saw fit to mention the fact (as far as I can discover) in as candid a way as Delacroix did, if indeed they referred to it at all.

The word 'impressionism' itself had earlier become inextricably associated with both the photographic process and its images. It would be redundant to cite the many examples in the literature on the subject which refer to the 'impression of the entire view', 'these impressionable plates', etc. In 1861 Burty described the 'impressions' one receives in looking at certain landscape photographs, because of the peculiar way in which they record light ('La photographie en 1861', *G.B.A.* (September) p. 244). When Monet's painting, *Impression: Sunrise*, was singled out for abuse in the exhibition of 1874, one may justifiably conclude that, in some part, it embodied a derogatory association with the images of the camera.

47. (p. 166) *The Impressionists' use of photography*

According to François Daulte, Bazille's *Jeune Homme nu couché sur l'herbe* (c. 1869) was begun out-of-doors and completed in

the studio after a photograph. Though his sources are not made clear, he writes that 'occasionally Bazille used the photograph simply as reference material. Thus it took the place of the absent model' (*Frédéric Bazille et son temps* (Geneva 1952) pp. 151, 184). Gaston Poulain noted that Monet's *Femmes au jardin* (1867) had its origin in two photographs taken at Méric (near Montpellier) which were owned by the Bazille family (*L'Amour de l'Art* (Paris March 1937) pp. 89–92, illustrated). The painting, he says, was executed at Bazille's request and since, like his own picture of his family that year, it was intended as a group portrait, Monet was probably supplied with the photographs to enhance its accuracy, the commission carried out in the artist's garden at Ville-d'Avray in the north of France. The similarities which exist between the painting and the photographs are confined to the individual figures and their costumes. George Heard Hamilton suggests that Monet employed as an *aide-mémoire* a photograph taken of Rouen Cathedral when reworking a painting at Giverny (see *Claude Monet's paintings of Rouen Cathedral*, Charlton Lecture, University of Durham (O.U.P. 1960): *Monet, Rouen Cathedral*).

If Cézanne may be used in this context the evidence is more rewarding, though in some cases these examples occur after his early Impressionist period. His self-portrait of 1861, as Rewald shows (*The Ordeal of Paul Cézanne*, figures 1 and 2), was painted directly from a photograph. Rewald (ibid. p. 62) quotes from a letter, probably of 1868, sent by the artist's friend and amateur painter, Fortune Marion, to the musician, Heinrich Morstatt: 'Cézanne is planning a picture for which he will use some portraits. . . . I have your photograph and you will be in it.' Dr Robert Ratcliffe has kindly drawn my attention to a portrait drawing of Victor Choquet (*c.* 1877) based on a small photograph according to Perruchot (*Cézanne* (London 1961), figures 31 and 32). The artist's *Melting Snow in Fontainebleau* of about 1880 was done from a photograph (reproduced by Rewald, *The Ordeal of Paul Cézanne*) as was the male *Bather* of about 1885–90, the photograph reproduced in *Masters of Modern Art*, edited by Alfred H. Barr, Jun. (M.M.A. 1954) p. 22. Maurice Denis stated, in the 1890s, that Cézanne painted landscapes from photographs as he painted flower-pieces from magazine illustrations (*Journal*, vol. 1 (Paris 1942) p. 157).

Like Delacroix, Cézanne seems to have accepted photography at its face value, as another kind of image from which the artist interprets nature. Émile Bernard was astonished at Cézanne's deviation from the usual prejudices against photography. In his *Souvenirs sur Paul Cézanne* (Paris 1920), which Francis Haskell so kindly pointed out to me, he recalled that his friend was not an enemy of photography and that he even executed some paintings from photographs (p. 55). It is not to denigrate the artist's inventive powers, but rather to applaud them for exploring photographic form that I draw a parallel between the peculiar tipped axes often found in buildings represented by Cézanne and the same, not uncommon feature found in the uncompromising perspective of photographs.

Despite the similarities between snapshots and the paintings of Caillebotte and Raffaelli, very little is available about any direct use they may have made of the photograph. The same applies to Renoir, Sisley and Pissarro. Renoir's views on photography are recorded in retrospect by his son (*Renoir My Father*) (London 1962), but they throw little light on the problem. Degas's use of photographs is discussed in Chapter 8.

This is perhaps the appropriate place to mention the caricaturist and photographer Bertall's remark in 1874–5, that 'the custom of seeing at any time and anywhere, objects correctly fixed and immobilized on paper, gives to the eye of the painter, as it does to that of the public, an exigence that it never had before' (*La Comédie de notre temps*, vol. 1 (Paris 1874–5) p. 441).

48. (pp. 166–9) *Theodore Robinson*

Literary sources for Robinson include John Baur, *Theodore Robinson* (Brooklyn 1946) and Baur, 'Photographic Studies by an Impressionist', *G.B.A.* (October 1946) pp. 319ff., well illustrated. See also, *Modern French Masters by American Artists*, edited by John C. van Dyke (New York 1896) p. 172: Robinson insisted that as a 'Realist' Monet was 'not necessarily an undiscriminating note-taker, a photographer of more or less interesting facts'.

49. (pp. 169–77) *The blurred image*

The notice in the *Spectator* was published on 4 June 1842.

As early as 1842 a beautifully graphic description of this peculiarity was given in Louis Viardot's 'Topaz the Portrait Painter' (op. cit.) where the multiple images and blurring-out in photographs caused by the movements of the subjects are clearly noticed. Some of Topaz's clients 'could not sit steady for a second, the result was, they were recorded on the plate with two heads, and a group of hands like Vishnu, the heathen god. They jerked their tails at some fatal moment, rendering them invisible to the photograph.'

Examples of such multiple and trace images are found with great frequency in the earliest photographs and occur to this day as a constant characteristic of photography depending not only on the movements of the subject but also on the length of an exposure determined by the light factor, the sensitivity and size of the plate and the quality of the lens. Some of Eugène Atget's large photographs, for example, taken at the beginning of this century, contain delightfully surprising distortions of this kind. Once frowned upon by the more punctilious photographer such elements of photographic form, now considered natural attributes of the camera, have come into a new prominence.

Monet, of course, was not the only Impressionist to use the blurred notation; it features consistently in that style of painting.

Chesneau's appreciation of the *Boulevard des Capucines* appeared in the *Paris-Journal* (7 May 1874).

Leroy's dialogue was published in *Le Charivari* (25 April 1874). A comparison of Monet's incomprehensible 'black tongue-lickings' with photographs such as Adolphe Braun's 1867 panoramic view of Paris taken from the quai du Louvre, with its vestigial recording of figures moving across the Pont des Arts is a clear demonstration that Monet's schematic notations could have had am empirical visual basis (109, 110).

The criticism of Corot's trees is cited by Signac in *D'Eugène Delacroix au Néo-Impressionisme* (Paris 1899), the original source not identified (see Éditions Miroirs de l'Art, Hermann, Paris 1964 with introduction and notes by Françoise Cachin, p. 128).

Le Gray's landscape views of the Forest of Fontainebleau shown in the 1859 photographic Salon were described by Burty: 'The air plays through the leaves, and the sun streaks the dark grass like the hide of a panther. Unfortunately, the foregrounds and backgrounds are blurred [*trèsmous*].' Hamerton criticized one of Le Gray's marine photographs because of the massing of tones into a 'vacuity of light or a vacuity of shade' comparing it unfavourably with Holman Hunt's *Fairlight Downs: Sunlight on the Sea*, exhibited in 1858 (*Thoughts about Art* (London 1873) pp. 52 ff.). With these criticisms in mind it is instructive to compare Le Gray's photographs of Fontainebleau with the very early paintings of the Impressionists in which the same characteristics of tone and description of foliation predominate. A striking parallel exists between Monet's painting of 1865, *Route du Bas-Bréau* and Le Gray's photograph probably of the same subject taken in the 1850s. The *sousbois* subjects popular with landscape photographers in Fontainebleau in the 1850s, in many cases with hardly a patch of sky to be seen, were not common in traditional landscape painting but appear at the same time in the works of Diaz, Rousseau and Courbet and in those of Renoir, Monet, Pissarro, Bazille and Cézanne.

Monet's desire to record the nuances of changing light was communicated in a letter of 7 October 1890 when he was working on his series of haystacks (see Gustave Geffroy, *Claude Monet, sa vie, son temps, son œuvre* (Paris 1922) p. 189).

50. (p. 176) *Nadar*

Nadar's photographs from balloons were taken from altitudes considerably higher than are found in Impressionist paintings, and though much more pertinent comparisons could be made with popular stereoscopic photographs there may be some substance in the idea that Nadar's photographs served at least to stimulate an awareness of this new viewpoint encompassing large areas of the metropolis. The exact relation between Nadar and the Impressionists is ambiguous. Nadar was not closely associated with them despite statements made to the contrary, which were based largely on Monet's words in 1880 to

T. Taboureux: 'The dealers didn't want us, yet we had to exhibit, but where?... Nadar, the great Nadar, who is as good as bread, lent us his place' ('Claude Monet', *La vie Moderne* (12 June 1880) quoted in Venturi, *Les Archives de l'Impressionisme*, vol. II (Paris New York 1939) pp. 339–40). Durand-Ruel also mentioned this in his memoirs and Alexander Pothey noted, in 1876, that the Impressionists used the 'anciens ateliers de Nadar' in the boulevard des Capucines (Venturi (op. cit.) p. 301). Burty, in 1875, wrote similarly (see Geffroy (op. cit.) p. 55).

Nadar opened his studios at 35 boulevard des Capucines in 1860. A gigantic signature was placed on the façade with everything, outside and inside, walls and accessories, the frames and even the signatures on the photographs and Nadar's own clothes, everything painted or coloured red. Nadar had actually vacated no. 35 two years before the famous 1874 exhibition of the Impressionists, the premises in turn probably rented from him by Gustave Le Gray (who already occupied space at that address) and Menut-Alophe. His new studios were located at 51 rue d'Anjou (off Saint-Honoré). Though Monet and Bazille met Nadar at the home of a relative of Bazille in the winter of 1864–5, the acquaintance seems only to have been a casual one. Nadar's more intimate friends were of the older generation: Delacroix, Daumier, Doré, Baudelaire, Champfleury. However, he too was antipathetic to the régime of Louis Napoleon and its official art and, probably in sympathy with the aims of those young painters, may, as the holder of the master lease, have used his influence in obtaining for them space for their first group exhibition. See useful notes and further bibliographical references in the catalogue of the Nadar exhibition (B.N. 1965).

An interesting modification of the stereoscopic photograph in the 1860s was that of puncturing the images in appropriate places and colouring the backs of the photographs so that, by applying the principle of the diorama, sometimes with the use of movable mirrors, a scene might be changed from day to night and other temporal effects of light produced. In 1863 the photographic Salon in Paris exhibited a stereo-viewer which permitted the introduction of moving tinted glasses giving the illusions of sunrise, sunset and moonlight (see *Photo. News* (10 July 1863) p. 325).

51. (pp. 177–9) *Natural colour*

In the 1863 Paris exhibition a method was demonstrated for producing pieces of sculpture by photography. That elicited a little pamphlet by Gautier (who visited the inventor's studio) designed to assuage the fears of sculptors that it was their turn to be victimized by photography (*Photo-sculpture* (Paris 1865) 12 pp.).

The article in the *Quarterly Review* (London) appeared in October 1864, pp. 518–19. Lecoq's advice to painters is from his *Éducation de la mémoire ...* (1879 edition). See translation by L. D. Luard, *The Training of the Memory in Art* (London 1911) p. 97. The Gauguin reference is given by Bengt Danielsson, *Gauguin in the South Seas*, English edition (London 1965) p. 171 (original source in *Écho de Paris* (13 May 1895), interview by Eugène Tardieu).

Edward Burne-Jones commented on realism and direct transcripts from nature: 'I suppose by the time the "photographic artist" can give all the colours as correctly as the shapes, people will begin to find out that the realism they talk about isn't art at all but science....' (1895), from Georgiana Burne-Jones, *Memorials of Edward Burne-Jones* (London 1904), cited in Richard Friedenthal, *Letters of the Great Artists* (London 1963).

The landscape painter and photographer T. F. Goodall was quoted by P. H. Emerson (op. cit.): 'When photographs can be taken in natural colour, then will be the time to discuss the probably dying groans of painting.' Alfred Stevens had no fear that colour photography would replace painting: 'The wonderful invention of photography is far below the level of art, even if it were possible to reproduce colour, photography would still be inferior to painting' (*A Painter's Philosophy* (London 1904) p. 22; first published 1886).

A significant prognostication along the same lines was made in 1903 by Sidney Allan writing in the important new magazine *Camera Work*, pp. 21 ff.: 'Should colour-photography ever be rendered successful only dream-pictures and colour orgies will hold their place in painting.' And in the same journal in 1908, the warning appeared again, but with a new twist. The landscape painter Auguste Pointelin said: 'I believe that colour photography, having finally become practical, will rid painting of all the

detestable and finicky daubers who know nothing of nor understand nature.'

Reminiscing on Bonnard's great gifts, Maurice Denis recalled the past: 'Where are the days, Bonnard, when by perversity [for the sake of argument] to upset Serusier's pontificating you said to him that if they could do photography in colour "*les peintres seraient foutus*"?' (Denis 'L'Époche du Symbolisme', *G.B.A.* (1934) pp. 165 ff., from *Théories*, Hermann, Paris 1964 p. 66).

8. DEGAS AND THE INSTANTANEOUS IMAGE

52. (pp. 181–2) *Instantaneity*

Daguerre's claim to instantaneity in 1844 was never substantiated, though his method for recording horses in gallop and birds in flight was mentioned by Arago that year (see Gernsheim, *L. J. M. Daguerre*, p. 119).

Talbot's experiment with electric flash was carried out at the Royal Institution in London, and was well covered by the Press, including the *Art Journal* (1 August 1851) p. 218. In 1858 Lake Price wrote of photographs taken with 1/150th of a second exposures (*A Manual of Photographic Manipulation*).

In assessing the essentially relative character of the term 'instantaneous' it might be as well to keep in mind that the first railway trains were thought to go dangerously fast – at ten to fifteen miles an hour!

The London Stereoscopic Company advertised 100,000 views for sale around 1860, and Gernsheim notes that in 1856, two years after its establishment, it already offered 10,000 different stereoscopic slides and had sold half a million viewers (*History of Photography*, p. 191).

The description of Robinson's 'streets of Leamington' is from the *Photo. Journ.* (16 April 1860) p. 192; of the London Stereoscopic Company's views, *Photo. News* (2 August and 18 October 1861). Holmes's sensitive article, 'The Human Wheel . . .', was published in the *Atlantic Monthly* (1863) p. 567.

53. (pp. 183–5) *Degas's 'photographic eye'*

'Nothing in art should suggest that it is accidental . . . not even movement', wrote Degas to Paul-Albert Bartholomé (sculptor and painter) in 1886 (Guérin, *Lettres de Degas* (Paris 1931)).

Degas's letter requesting the Mérante photographs is in Guérin. A series of *cartes* probably by Disderi, executed in 1876, show Mérante, Coralli, Terraris and Louise Fiocre in different poses simulating action, in the costumes of the ballet, *Pierre de Médicis* (122–4). Also known are Disderi's photographs of Adèle Mérante and Louise Fiocre, many of the latter in tutu and in poses paralleling those of Degas's dancers.

Other photographs of Mérante and Terraris relevant here were taken in 1876 by Anatole Pougnet, the subjects posed in costume for the opera *Sylvia* presented for the first time in June that year. Mérante arranged the choreography for this and played the role of Aminta. A large collection of the type of photographs described above is in the library of the Paris Opéra.

Valéry knew Degas in the artist's later years. His comments are from *Degas Danse Dessin* (Paris 1938). See translation by David Paul, *Degas Manet Morisot* (London 1960) pp. 24, 70, 166. Degas gave Valéry a photograph which is identified as an interior showing Degas, Renoir, Mallarmé and his daughter, taken probably in the 1890s during Degas's great preoccupation with the photographic camera. In *La Nouvelle Peinture* (1876) Edmond Duranty favourably compared Degas's acute urban realism with those whose 'purposeless pose[s] before the photographer's lens' were devoid of action and life.

Blanche's encomium is from his *De David à Degas* (Paris 1919) pp. 297–8. For Lemoisne's association of Degas's paintings with photography see *L'art de notre temps, Degas* (Paris 1921) pp. 65, 77. Quite rightly he suggests that the violation of traditional rules of composition in Degas's Bellelli family portrait (Paris 1861–2 from studies made in Naples and Florence 1856–60) points to the influence of photography (256). In fact, the more imaginative portrait photographer at the time deliberately organized his subjects to get '*la pose la plus naturelle*' and '*les gestes de bonne compagnie*'

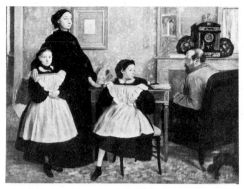 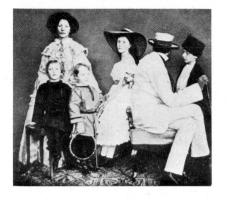

256 (*left*). Degas: *The Bellelli Family.* 1861–62

257 (*right*). Lincke(?): Photograph of the Russian Ambassador and his family. Berlin 1859

as Burty said in his 1861 review of the photographic Salon (op. cit.). Disderi himself instructed photographers to compensate for the stiff and awkward appearances, which dutiful clients had to maintain through the relatively long exposures, by arranging them to effect a greater aura of spontaneity (op. cit. p. 107). Many examples of this kind of synthetic naturalism readily occur in early photography including of course Disderi's own portraits. But what may be quite acceptable in a painted portrait will often seem ludicrous in a photograph as is the case when a zealous Berlin photographer in 1859 'shot' the Russian Ambassador and his family, His Excellency turned completely away from the camera, *profil perdu*, not unlike the male figure in the *Bellelli* painting (257).

A number of other uncomplimentary things were said about Degas in relation to photography by Coquiot: *Degas* (Paris 1924) pp. 161–9 and pp. 211–12.

Meier-Graefe's commentary is from his *Degas* (translation London 1923) pp. 59, 62.

54. (pp. 185–9) *Degas's use of photographs*

In 1854 Degas executed a portrait of himself at the age of six or seven from a daguerreotype taken about 1840–41, an almost unavoidable practice with this category of painting (reproduced in Marcel Guérin, *Dix-neuf portraits de Degas par lui-même* (Paris 1931)). Gerhard Fries of Frankfurt has most

kindly provided the description of the drawing by Degas, made from a photograph of his brother, and both Fries and Theodore Reff indicate that on occasion Degas used photographic reproductions to copy earlier works of art (see G. Fries in *Art de France* (1964) and T. Reff in *Burl. Mag.* (June 1964) et seq.).

According to Cabanne the photograph used for *Bouderie* is in the possession of Guérin's family. My thanks are due to Ronald Davey who originally supplied me with this and other references to Degas's use of photographs and to M. Cabanne who kindly added to the information given in his fine book on Degas. Another version of the *Bouderie*, called *Conversation*, was executed by Degas about 1895 in his later, more perfunctory style (now in the Paul Mellon Collection. See Robert Goldwater in *Art News* (March 1966)).

Rewald's article on the Metternich portrait was published in *L'Amour de l'Art* (Paris March 1937) p. 89. Another photograph associated by Guérin with *Degas saluant* is reproduced in his *Dix-neuf portraits . . .* and dated by him, 1862. The photograph in question was presented to the B.N. by Halévy (B.N. Est. no. D.8252). Degas's double portrait of Valernes and himself (*c.* 1864) suggests the use of a photograph (for the self-portrait at least) not only because of its general appearance but also because of the absence of the usual reversed image in self-portraits.

For comments on Degas as a photographer see Jeanne Fèvre, *Mon oncle Degas*

(Geneva 1949). She describes his passionate interest in photography in the 1890s and how, despite its mechanical nature, he used it 'intelligently' (creatively). His control of the lighting, his compositions, she compares with the old Dutch Masters. She praises his '*l'œil* Kodak' with which he was able to catch each instantaneous aspect of daily life.

René Gimpel was told by the painter Lerolle (7 April 1931) of Degas's interest in photography. 'He composed his photos exactly like his pictures; he didn't place you in some extravagant manner but in fore-shortened studies not always comprehensible at first glance; often half the person would be outside the plate, as in some of his canvases.' (René Gimpel, *Diary of an Art Dealer* (London 1966) p. 413, translated by John Rosenberg from the French edition 1963.)

P. D. Trevor-Roper's association of Degas's 'highly myopic' eyesight with his later use of photography is not in this case without substance (see his controversial article, 'The influence of eye disease on pictorial art', *Proceedings of the Royal Society of Medicine* (September 1959)).

For details of Degas's association with the photographer Barnes in Dieppe see his letters to Ludovic Halévy in 1885 (Guérin, *Lettres de Degas*). Halévy, incidentally, was co-author of a one-act comedy, *La Photographie*, produced in Paris, 1864.

As already described in the cases of Rossetti and Burne-Jones (note 28), Degas too may have worked over a faint photograph made from one of his own drawings. The signed drawing of a woman reading a letter, in the possession of the Redfern Gallery, London, was examined by X-ray, and the photographic base revealed; the original, purchased at the Degas *atelier* sale in 1919, is in the collection of the B.N., the same sheet containing another drawing, *Chanteuse de café-concert*. Such a method of reworking a drawing yet retaining the original was clearly desirable, photography obviating the technique of transfer by grid. My thanks are due to the Director of the Redfern Gallery, Mr Rex de C. Nan Kivell, who very kindly supplied me with the details. Manet too, it should be mentioned here, is reported to have made a drawing (in the Fogg Institute) over a faint photographic print of the painting *Spring* (John Richardson, *Édouard Manet* (London 1958) pp. 20, 130). This is not surprising considering his use of photographs for other portraits at that time (see pp. 64–5).

55. (pp. 189–95) *Problems of perspective*

Geofroy's comment on this distortion of perspective scale was made in *Revue des Deux Mondes* (Paris 1851) pp. 946ff. He referred to Meissonier's *Jouer de luth* and other works exhibited in the Salon of 1850–51. Nadar's comic lithograph is from his 'Jury au Salon de 1859', *Journal amusant* (4 June 1859) p. 6. Newton's warning in 'Upon photography in an artistic view, and its Relation to the Arts' was given in *Journ. Photo. Soc.*, vol. 1 (London 1853), no. 1.

The etcher and engraver Félix Bracquemond called attention to this same fault in *Du dessin et de la couleur* (Paris 1855) pp. 141–2, as did John Brett who believed that photographic dwarfing in perspective scale 'degrades the really fine scenes' in landscape painting (*Brit. Journ. Photo.* (London 5 April 1889) pp. 235–7). Because of this distortion portraits in the 1859 photographic Salon in Paris were described as having hands as large as those of a navvy (*Photo. Journ.* (15 June 1859) p. 153).

In his review of the same Salon (op. cit.) Burty took care to explain the cause of this phenomenon, suggesting a corrective. Like Delacroix, Ruskin advised artists who used photographs to make allowances for the distortions in the perspective of interiors and figures (see W. G. Collingwood, *The Art Teaching of John Ruskin* (London 1891) p. 47). For the whole of Francis Frith's description see 'The Art of Photography', *Art Journal* (1859) pp. 71–2. Jane Carlyle's disgust with Tait's painting is recorded by Amy Woolner in *Thomas Woolner, R.A.* (London 1917) p. 150. G. F. Watts is quoted by M. S. Watts (op. cit.), vol. III, p. 34. For the candid views of Pennell see his 'Photography as a Hindrance and a Help to Art', in *Brit. Journ. Photo.* (London 8 May 1891) p. 295. 'With a short focus lens it is impossible to obtain any true foreshortening', wrote Alfred Wall (op. cit.) p. 170.

Parsey's main point was that what the eye sees is reinforced or even determined by the

mind. 'We see by knowledge,' he wrote, and criticizing the theories of perspective then being taught in the R.A. Schools, he accused the Academy of an unwillingness to accept the truth of three point (perpendicular) and other types of perspective which photography had confirmed.

The experiment with the three different lenses was performed by Dr H. Streintz in Germany (see *Photographische Correspondenz* (October 1892)). Many others have been made since then.

For a revised chronology of Degas's notebooks see Theodore Reff in *Burl. Mag.* (December 1965).

Professor Gombrich discusses this 'aberration' in 'Visual Discovery through Art', *Arts Magazine* (November 1965) in which a most unusual photograph by Ralph M. Evans is reproduced to demonstrate his point, and also in 'The Analysis of Vision in Art', *Art and Illusion* (London 1960) pp. 299 ff. This psychological conditioning of the eye is, among others, dealt with by Rudolf Arnheim, *Art and Visual Perception* (London 1956).

56. (pp. 196–8) *Japanese prints*

Huysmans's early comparison of the figures '*coupés par le cadre*' in Degas's compositions and in Japanese prints was made in *L'art moderne* (see second edition (Paris 1902) pp. 129, 250).

Ukiyo-e, sometimes *ukiyo-ye*, literally: *ouki*, that which floats; *yo*, world, life; *yé*, painting. This school existed from about 1615 to 1867. I am grateful to Frederick Gore for showing me pertinent examples from Hiroshige's *One Hundred Views of Yedo* in his collection and for his helpful observations on the subject. In his *catalogue raisonné*, Lemoisne describes Degas's collection of Japanese prints which he said included about forty landscapes by Hiroshige. It is not impossible that some of the Japanese prints known to Degas and his contemporaries were themselves influenced by the fortuitous compositions of instantaneous photographs. The very marked change, for example, in Hiroshige's views of Yedo, one of his last series of prints, could have been inspired by photographs, despite the fact that most of the elements in these new compositions

existed, though on a less assertive level, in his earlier work, as it did in the work of some of his contemporaries. It is sometimes thought, though for unimpressive reasons, that Hiroshige II (1858–67) was responsible for these compositional extremes in the late Yedo series. Kin-no-suke Sakurada (known as Renjio Shinoke), the 'father' of Japanese photography, may first have seen a daguerreotype in 1844 when he was a student of painting. This photograph, thought to have been a portrait brought to Nagasaki by a Dutch trader (the Dutch had access to Japan for two centuries), was probably the initial stimulation for Renjio later to take up photography (see *The Practical Photographer* (London 1896) pp. 239 ff.). Other foreign ships were allowed to refuel and take on provisions in Japan from 1843, when also official interest in the technologies and publications of foreign countries was sanctioned. Perry's first agreement was concluded in 1853, the year the Shogun died. He returned the following year to sign the first treaty opening up three ports and soon after, similar treaties were signed with other Powers. In 1856 a convention was concluded which allowed Americans residence rights in two Japanese cities, Nagasaki being one of them. The year 1858 saw the official opening of Japan. But earlier in the 1850s Western travellers are known to have visited parts of the Empire during which time trade with the West had begun. There was, in short, plenty of time for Japanese artists to have become acquainted with photography. The great interest of the Japanese in photography is already recorded in the *Journ. Photo. Soc.* (5 March 1859) and by other subsequent periodicals. *Photo. News* in 1859–60 published a series of articles called 'Through Japan with a Camera'.

The story of Bracquemond's discovery of the *Mangwa* volume about 1856–7 is told by Léonce Bénédite, 'Whistler', *G.B.A.* (1 August 1905) p. 142, and by James Laver, *Whistler* (London 1951) pp. 95–6.

For Goncourt's comparison of Japanese prints with photographs see his *Outamaro* (Paris 1891) p. 55. Strange's reference to the Hiroshiges in Rossetti's possession is in *The Colour-Prints of Hiroshige* (London, New York 1925) pp. 124 ff.

57. (pp. 198–205) *Cutting-off and cinematic progression*

The use of a photograph for the Boston Museum, *Carriage at the Races*, has been traced verbally from Degas to his friend Rouart, through Rouart's son and Charles Sterling to Heinrich Schwarz (see Van Deren Coke, *The Painter and the Photograph* (University of New Mexico Press 1964) p. 69, n. 34).

Disderi's 'Châssis multiplicateurs' is described in his book, *L'Art de la Photographie* p. 100 and figure 7. Among the Disderi photographs kept in the B.N. Est. are uncut multiple *cartes* including one of Mercier de l'Opéra in six different poses, some of Mérante, his wife and Eugénie Clot, plus other photographs of relevance to Degas including a composite one of the legs only of dancers called *Les jambes de l'Opéra*. (258) Nadar also took photographs of Adèle Mérante in ballet costume.

Claudet had taken daguerreotypes of ballet-dancers from the Italian opera 'all but in motion', reported the *Spectator* in 1842 (30 July). 'A momentary suspension of movement . . . in postures . . . such as posing on one toe with the other leg extended, and resting on the points of both feet' was all that was necessary. This is surprisingly early, given even those conditions, but with the plates only two or three inches high (as they were described) the focal length of the lens and thus the exposure time could be considerably reduced.

Chevreul made some interesting observations on the perception of sequential images. He drew an analogy between repetitive patterns of light on the broken surface of a river and the motion of dancers, grouped to impart an overall rhythm of movement: 'We see in an assemblage of dancers, in the manœuvres of a battalion, and in the evolution of the line, co-ordinate movements in which the individuals disappear, so to speak, to show themselves as part of a whole' (see *The Principles of Harmony and Contrast of Colours and their Application to the Arts*, third edition (translated London 1860), 'Motion' pp. 397–8).

A description of the 'progressive series' photographs of the lecturer in London is given in *Photo. News* (12 September 1862)

258. Disderi: *The Legs of the Opera.*
Uncut *cartes-de-visite* photographs.
1860s

p. 444. Though the phenomenon of the persistence of vision was known and even explained much earlier the theory was firmly established in 1829 in Joseph-Antoine Plateau's doctoral dissertation. In 1833 he designed the first means of synthetizing successive images with a phenakistiscope, a revolving disc on which the separate pictures held up to a mirror coalesced in a moving one by viewing them from the back through slots. This popular nineteenth-century amusement was discussed by Baudelaire in his 'Philosophy of Toys', one of the essays in *L'Art Romantique*, first published in 1853.

58. (pp. 205–9) *Degas's horses*

For the first publications of Muybridge's photographs in Europe, see note 59. Valéry's association of Degas with Muybridge was made in *Degas Danse Dessin*, pp. 70–71. It should be noted that Géricault's use of the traditional 'flying gallop' did not betray a deficiency in his observation of equestrian locomotion, as the drawings in his Chicago sketch-book confirm. In all likelihood his Derby pictures represent a deliberate acknowledgement of the much-favoured stereotyped attitudes given currency by the popular English sporting prints.

Many of the members of the Jockey Club at Longchamp were amateur photographers in the early 1860s (see *Photo. Review* (1 June 1863) p. 41), and it was said in 1862 that Nadar had taken successful photographs of horses '*par les procédés rapides*', though unfortunately their precise appearance is not described (*Le Moniteur de la Photographie* (15 November 1862) p. 129). See 15 April 1861 issue, p. 17, on equestrian portraits taken at the Bois de Boulogne by Nadar, Disderi and others. Gautier suggested the existence of photographs of horses in rapid motion as early as 1861 when he compared the attitudes of those animals in Eugène Fromentin's paintings with 'le mouvement de la photographie spontanée' (*Abécédaire du Salon de 1861*, p. 170).

Other correspondences between Muybridge and Degas will be found in figures 3 and 6 in the Muybridge plate 580 ('Annie G. walking') and drawings 99–3 and 201c (third and fourth Degas *atelier* sale cata-

logue); figures 5 and 11 in Muybridge plate 621 ('Annie G. in canter') and drawings 130–1 and 45–2 (third *atelier* sale catalogue). Numbers 338 and 204b (fourth *atelier* sale catalogue) plus several other pastel drawings, paintings and sculptures almost coincide with other photographs of Annie G. (See also A. Scharf, 'Painting, Photography, and the Image of Movement', *Burl. Mag.* (May 1962).) Van Deren Coke (*The Painter and the Photograph*) makes a very plausible comparison between Muybridge's draught-horse, Johnson, and one of Degas's sculptures in the Cone Collection, Baltimore Museum of Art. Degas's letter to Bartholomé is in Guérin, *Lettres de Degas*, p. 116.

9. THE REPRESENTATION OF MOVEMENT IN PHOTOGRAPHY AND ART

59. (pp. 211–17) *Muybridge*

Alken's book *The Beauties and the Defects in the Figure of the Horse*, first published in 1816, appeared again, ironically, in 1881 amidst the clamour over Muybridge. Here, Alken's views on equestrian physiognomy, recalling the *naïveté* of Lebrun and Lavater, are consistent with his physiological observations.

Newhall (*Image* (April 1952)) writes that in *Aperçus Equestres* by Lieutenant L. Wachter (1862) the positions of the gallop correspond exactly to later photographs.

Duhousset used a photograph for one of the drawings illustrating his book but it was of a standing horse, suggesting that photographs showing clearly horses in motion were not available. Marey's chronograph involved a system of pneumatic chambers attached to the shoes of the animal which on contact with the ground sent impulses through flexible tubes to a recording device held by what must have been a highly occupied rider.

Some of the first publications to introduce Muybridge were: *Scientific American* (New York 19 October 1878); *La Nature* (Paris 14 December 1878); *The Times* (London 28 April 1879); *Illustrated London News* (29 March 1879); *Berliner Fremdenblatt* (26 April 1879); *Wiener Landwirthschaftliche Zeitung* (26 April 1879); *Field* (London

28 June 1879). In 1881 and 1882 articles on Muybridge were carried by, among others: *Le Globe, Figaro, Standard, Le Temps, Gentleman's Magazine, Athenaeum*, and of course by the many art and photographic periodicals. See also: *G.B.A.* (1884), four articles by Duhousset; *Magazine of Art* (London 1882), H. Baden Pritchard on pp. 70–73; *Illustrated Sporting and Dramatic News* (2 July 1882), a review of *The Horse in Motion* by Edward L. Anderson; *The Gallop* (Edinburgh 1883), again E. L. Anderson (illustrated with photographs by Muybridge and others).

On early cinematic projection, William I. Homer says that Muybridge had already given a similar demonstration in San Francisco, 4 May 1880, and that in 1870 'sequentially posed photographs' were projected in Philadelphia by Henry R. Heyl by means of a 'phasmatrope' (letter to *Burl. Mag.* (September 1962)).

Muybridge's views on perception were given in *Animals in Motion* (London 1899) p. 164.

Demenÿ is quoted in Georges Potonniée, *Cent ans de Photographie* (Paris 1940) p. 158, no source indicated. A story submitted by F. Hopkinson Smith in 1893 describes Meissonier's sleepless night, 'after Muybridge showed him a negative of some hunters taking a five-barred gate. He had been doing the Sheridan-ride-gallop himself all his life, and the shock to his sense of truth – for if Meissonier was not true he was nothing – must have been tremendous. He is reported to have said, "*Mais, maintenant, je suis trop âgé*"' (*American Illustrators* (New York 1893) pp. 23–4). The description of Meissonier's miniature railway and the artist's words on the meeting with Stanford are in Vallery C. O. Gréard, *Meissonier,* (translated edition 1897) p. 210. Meissonier was consistently attacked for his worship of literal truth, for his '*industries*', for producing mere '*petites photographies coloriées*'. Conversely, he was praised for achieving such an exalted standard of verisimilitude that photography itself was vanquished. The story that on studying Muybridge's photographs he changed the attitude of a horse in one of his pictures was given in the *Athenaeum* (18 March 1882) p. 356.

An attempt to deflate Muybridge's reputation was made by Terry Ramsaye in *A Million and One Nights* (first published 1926, 'the first complete source book on the motion picture'): the idea of photographing running horses in sequential positions came from Stanford. The electro-magnetic and timing mechanisms which activated the camera shutters at Palo Alto were the work of the young scientist and railway engineer, John Isaacs. The animation of Muybridge's photographs in the zoöpraxiscope was done at the initiative of Meissonier and credit for the contrivance was due to precursors like Franz von Uchatius, Henry Heyl and Émile Reynaud. Muybridge did not suggest to Edison that the zoöpraxiscope and the phonograph be combined to produce talking pictures. Factually, Ramsaye is not always immaculate. His propensity for a scenario-type literary style does not inspire confidence. And though his major contentions are without doubt true, he is bent on debunking and refuses to give to Muybridge credit for carrying out this vast work so successfully. Ramsaye does throw considerable light on the mysterious five years between 1872 and 1877 which almost always form a lacuna in the Muybridge biography. It reads like the script of an early Griffith film. I am grateful to Colin Osman for pointing out this book to me.

60. (pp. 217–22) *Animal locomotion*

On Muybridge and Eakins see Lloyd Goodrich, *Thomas Eakins* (New York 1933), and Charles Bregler, 'Photographs by Eakins', *Mag. of Art* (Philadelphia January 1943). See the 1925 edition of *Animals in Motion*, where Muybridge pointedly omitted Eakins's name in rendering his thanks to the University of Pennsylvania. A. Hyatt Mayor says that Eakins's photographs were sold as artists' studies, 'Photographs of Eakins and Degas', *Metro. Mus. Bull.* (Summer 1944) pp. 1–7.

The 1901 edition of *The Human Figure in Motion* (a selection from *Animal Locomotion*), which contains the list of subscribers from the large publication of 1887, includes an extensive bibliography of magazine and newspaper articles on Muybridge.

The American painter of the Wild West, Frederick Remington, is sometimes credited with prefiguring Muybridge in his remarkable representations of galloping horses. But

Remington was born in 1861, began practising art about 1880, and his first sketches among the Indians were made about 1884 *after* Muybridge had become a *cause célèbre*. He may have been influenced in his early work by the Plains Indian manner of showing horses in movement, but the kinds of horses for which he is best known do not appear in his work until about 1888, just following the publication of *Animal Locomotion*. His early illustrations for *Harper's Weekly*, like the *Indian Scouts on Geronimo's Trail* (1886), are awkward in the representation of motion. In 1888 at the Metropolitan Museum he was transfixed by Meissonier's *Friedland 1807* and by 1891 a great change is apparent in his work which then bears the undeniable stamp of Muybridge and the anatomy of equestrian locomotion.

61. (pp. 222–7) *Muybridge: pros and cons*

Muybridge's lecture to the Royal Institution, 'The science of animal locomotion in its relation to design in art', was delivered on 22 March 1889. That to the Royal Society was described with comments on perception by Professor E. Ray Lankester in *Nature* (23 May 1889) pp. 78 ff. Muybridge's photographs could then be seen or purchased in a shop off the Strand (38 Craven Street). A comprehensive account of Muybridge's demonstration before the London Institution at the end of that year is given in the *Brit. Journ. Photo.* (20 December 1889) pp. 826–7.

Muybridge showed the works of earlier artists whose representations of animals and birds in movement were more or less correct. He cited Japanese artists who showed the wings of birds in the down-stroke (see e.g. Hokusai's series *History of the Isle Hachi-Jo* (1816)). This rarely occurs in European art, but it will be found in Carpaccio's *Portrait of a Knight in a Landscape* (*c.* 1510–26) and in Franceso Cossa's frescoes in the Palazzo Schifanoia (Ferrara) in the lower register of the April section. The bird here recalls those in Egyptian reliefs, though it is likely that Cossa used this unconventional form, as the composition of the fresco suggests, more for the purposes of design than for that of visual accuracy.

John Brett, who very likely attended one of Muybridge's demonstrations, gave his complimentary opinion in the *Brit. Journ. Photo.* (5 April 1889) pp. 235–7. On the other hand, Emerson's resentment (op. cit. p. 161) may have been fostered by Muybridge's purported statement doubting whether photography could be considered as a Fine Art (see Lankester, op. cit.). For the comments of others alienated by Muybridge see: H. P. Robinson, 'Fog or Focus', *Internat. Annual of Anthony's Photo. Bull.* (1889) pp. 196–8, quoted in Newhall, *History of Photography*, p. 110; Abney, 'Are Instantaneous Photographs True?', *Internat. Annual of Anthony's Photo. Bull.* (1889) pp. 285–7, cited by Newhall; 'Photography and the Development of Kinetic Visualization', *Journ. Warburg and Courtauld Institutes*, vol. VII (London 1944).

Rodin on Muybridge is from his conversations with Paul Gsell, *On Art and Artists* (London 1958) Chapter IV, 'Movement in Art'.

Rood: *Modern Chromatics* (New York 1879) pp. 207–8. Rood refers to a complete bibliography on the subject of persistence of vision by J. Plateau published by the Belgian Academy of Sciences in 1877.

Véron's discussion: *Aesthetics* (translation London 1879; first published 1878).

Pennell's comments do not lack animosity for Eakins, his old master. See his address before the London Camera Club Conference, 'Photography as a hindrance and a help to art', *Brit. Journ. Photo.* (8 May 1891) p. 295, also given in Newhall, *History of Photography* (op. cit.) p. 108. In Pennell's representations of cyclists in the mid 1880s, he uses the blurred image to impart to the wheels the appearance of motion.

62. (pp. 227–9) *Marey*

Marey's 'photographic gun' was modelled after Pierre Janssen's 'astronomical revolver' designed originally to record (at ten-second intervals) the transit of the planet Venus across the Sun in 1874. In 1876, concurrent with Muybridge's renewed efforts in consecutive-series photography, Janssen noted the possibility of extending the use of this instrument beyond the recording of celestial phenomena, into the physiology of animal

movement if only photographic plates could be made more sensitive to light and the exposure times shortened. Marey's 'gun' was faster than Janssen's and he could 'shoot' with very short exposures (c. 1/720th of a second) a bird in flight each twelfth of a second – corresponding closely to the length of time the human retina retains any image impressed on it. Marey's application of chronophotography far transcended studies in locomotion, and was applied very effectively to ballistics, hydraulics and the biological sciences.

Marey's reports and demonstrations are in the *comptes rendus* of the Académie des Sciences, most of which are summed up with other material added in *Le Mouvement* (Paris 1894; translation *Movement*, London 1895). See also Marey's *La Machine Animale* (Paris 1878) and *Le Vol Des Oiseaux* (Paris 1890). Boni (op. cit. note 2) supplies a more extensive bibliography.

In *Movement* (p. 59), Marey indicated that as early as 1865 Messrs Onimus and Martin utilized photography in their study of the action of an animal's heart. The result of their time exposure was a double image showing that organ in the extreme positions of contraction and dilatation.

Professor Otto Stelzer of Hamburg has most kindly supplied me with examples of the precocious work of Wilhelm Busch (1832–1908). In his drawings of the 1860s and 70s this artist was already making use of the vestigial image as also that of extreme foreshortening, both kinds reproduced in Stelzer's book, *Kunst und Photographie* (Munich 1966).

63. (pp. 229–31) *Seurat*

Any special concern with optical phenomena inevitably involved photography. Scientists associated with Seurat – Helmholtz, Brücke, Rood, Chevreul – had all to some extent been engaged and certainly interested in the properties of light-sensitive substances and photographic optics. Visual effects called 'irradiation' (aureoles of light around objects), for example, discussed by Brücke (see *L'optique et la peinture*, Helmholtz, and *Principes scientifiques des Beaux-Arts*, Brücke, published in one volume (Paris third edition 1885) pp. 137, 140) and later employed in

the paintings of Seurat, had been noticed as occurring in photographs. Methods for avoiding them were proposed in 1859 (*Photo. Journ.*, vol. VI, p. 90). That peculiarities of this kind had been a problem from the first is indicated by Samuel Morse's partner, Draper, who in 1840 described the difficulties encountered in portrait photography because of what was then called 'solarization', and the particular halo effect around dark objects on lighter backgrounds is discussed in *The Lond., Edin., and Dublin Philosophical Mag. and Journ. of Science* (September 1840).

Seurat's friendship with the remarkable Charles Cros, whom Félix Fénéon called 'an encyclopedic soul', would have put him in close touch with the latest developments in natural-colour photography. In 1876 Cros had taken photographs using yellow, red and blue filters in a colour-separation process paralleled by Helmholtz's description of the tri-colour sensation of the eye, with mixtures of these dependent on a physiological-psychological function of the human optical system. In 1883 he was producing positive natural-colour proofs on paper. Fénéon's tribute to this unusual man who was also occupied with ballooning, acoustical vibrations and interplanetary communication, who wrote poetry and discovered the principle of the gramophone before Edison, is in *La Cravache* (18 August 1888) as 'Feu Cros' (see Fénéon's *Oeuvres* (Paris 1948) pp. 246–53). In 1869, the year he published his *Solution Générale du problème de la photographie des couleurs*, Cros thanked Manet for the loan of a painting which he photographed in colour. 'I am so happy that my first successful effort has been made from one of your works. I'll send you some prints in a few day's time.' (See *Portrait of Manet by himself and his contemporaries*, by Pierre Courthion and Pierre Cailler; translated by Michael Ross (London 1960) p. 65.)

It is worth mentioning that photomechanical colour-screen printing processes were employed by the mid 1880s, developments probably from Max Jaffé's first practical cross-line, half-tone technique in 1877. In 1885 F. E. Ives of Philadelphia used such a photo-mechanical means for reproducing colour prints (see William Ivins, Jun., 'Photography and the "modern" point of view', *Metro. Mus. Studies I* (New York 1928–9) p. 16).

For a discussion on Seurat, Charles Henry and Marey see letters by William I. Homer and A. Scharf in *Burl. Mag.* (September 1962). Jean Renoir's comment is in his book, *Renoir my Father* (London 1962) which Andrew Forge very kindly pointed out to me.

Seurat, it seems, was aware that the attitude of the horse in his *Le Cirque* (exhibited 1890–91) did not conform to the positions as rendered by Muybridge. He may have known Rood's views approving of the flying gallop. When Puvis de Chavannes (who owned a set of *Animal Locomotion*) visited the group exhibition of the Indépendants in March 1891, Seurat is said to have remarked to Signac, 'He will notice the mistake I have made in the horse' (Coquiot, *Seurat* (Paris 1924) pp. 166–7, quoted by Rewald, *Post-Impressionism*, p. 422).

10. PHOTOGRAPHY AS ART: ART AS PHOTOGRAPHY

64. (pp. 232–6) *Experiments and 'tricks' with photography*

L'Illustration (Paris 14 July 1900) noted the number of photographers operating in the Paris Exposition Universelle that year.

For a historical résumé of the conflict between the purists and the outragers in pictorial photography see A. Scharf, *Creative Photography* (London 1965).

Du Hauron's 'Transformism', first proposed in 1889, was reported by Nadar's son, Paul, in *Paris-Photographe* (1892) pp. 227 ff. It was subsequently mentioned in several books on photographic 'amusements', in *Les récréations photographiques* by A. Bergeret and F. Drouin for example (Paris 1893), the authors upholding the dignity and usefulness of such experiment and play. *La Nature* in 1888 described photographs like du Hauron's by a M. Darlot indicating also that fifteen years previously an Italian photographer, using cylindrical mirrors, developed a technique for producing 'caricatures'.

The literature on this kind of photography is extensive and it is beyond the scope of the present study to provide more than a few examples. The attitude which formed the basis for 'free-range' photography was well expressed by Claudet in 1866: 'Call it a *heresy* or a *dodge* if you like but look at the result, and if it be good what matters the name given to it? ... Are there no dodges in painting, sculpture, and the other arts? ... Let us, then, without prejudice ... examine calmly any new theories or processes which may be offered ...', etc. (see *Brit. Journ. Photo.* (16 November 1866) pp. 546 ff.). Walter Woodbury's popular *Photographic Amusements*, published in several editions from 1896, is worth consulting in this context.

Van Doesburg's discussion of the creative process was published in *Die Form* (15 May 1929) in connection with an important Stuttgart exhibition, 'Film und Foto'. It is translated by Standish Lawder in the magazine *Form*, no. 1 (Girton, Cambridge, Summer 1966).

'The Naissance of Art in Photography' appeared in *The Studio* (June 1893) p. 87; 'Methods of Suppression . . .' also in the *Studio* (1894) pp. 13 ff.

65. (pp. 236–42) *Artistic photography*

For Wall's rejection of rough-patterned photographic surfaces see (op. cit.) p. 97. Appropriately, Wall repeats (p. 19) a statement made by G. A. Storey A.R.A. that the two rivals, photography and art, 'stand opposite to each other like two armies in battle array'.

More on gum-bichromate prints is in J. Cruwys Richards, *The Gum-Bichromate Process* (London 1905), in A. Horsley Hinton, the *Artist* (London January to April 1898) pp. 13 ff., in Sizeranne (op. cit.), Bourgeois (op. cit.), in Demachy and Puyo, *Les Procédés d'Art en Photographie* (Paris 1906). In Alfred Maskell and Robert Demachy, *Photo-Aquatint or the Gum-Bichromate Process* (London 1897), the authors write: 'the advocates of pure photography "cannot stop the flowing tide" by which individual expression will supersede mechanism. . . .' The bromoil transfer method was developed soon after, a process allowing for the arbitrary use of coloured oil pigments and grounds. (170)

Robinson's broad claims for pictorial photography were made in his *Art Photography* (London 1890). There, he complained of the 'complete absence of imagination' in a painting by Degas. See also Robinson's

Elements of Pictorial Photography (1896) p. 71 where he quotes the passage on realism and photography from *Nineteenth Century*. Pennell's indignant words are from *Contemporary Review* (1897) pp. 824–36, 'Is photography Among the Fine Arts?', cited by Newhall in *Art in America* (Autumn 1957) pp. 43–6.

CAMERA WORK:

Shaw's statement in *Camera Work* appeared in the fourth issue (October 1903, pp. 13 ff.), and Maeterlinck's in the third (1903).

The series of 'interviews' on pictorial photography was edited with comments by George Besson (no. 24, October 1908). Other comments published were by the writers and critics Gustave Geffroy, Camille Mauclair and Frantz Jourdain; by the artists Steinlen, Chéret, Willette, Raffaélli, Bartholomé, etc. The April issue contained natural-colour photographic reproductions by Steichen. A similar inquiry by Stieglitz in *Manuscripts*, no. 4 (New York December 1922), is noted by Richard Hamilton in the catalogue of the Duchamp exhibition, London, Arts Council 1966. Stieglitz's gallery '291' inspired Picabia's publication, *391*, which first appeared in Barcelona in 1917, later in New York. Picabia had collaborated with Stieglitz on the 1913 edition of *Camera Work* in the year of the famous Armory Show to which the '291' exhibitions were a significant prelude. That year, *Camera Work* included photographs by Julia Margaret Cameron, an article on modern art and, illustrated in colour, three paintings by Steichen. In the following year '291' held an exhibition of children's art and one of African woodcarvings. In a later issue of *391*, produced in Zürich, Picabia pays tribute to *Camera Work*, '291' and 'Alfred Stieglitz' by including these names in a drawing on a grid shared with other *avant-garde* notables such as Apollinaire, Duchamp and Tzara.

66. (pp. 242–8) *Photographic painting*

The rap on the knuckles of the French painting Salon was dealt by a Mr Harrison in the American magazine the *Forum* (quoted by Wall (op. cit.) p. 105).

The selection made by François Jourdain in his 'Vingt Ans de Grand Art ou la Leçon de la Niaiserie' (*L'art Officiel de Jules Grevy à Albert Lebrun* (Le Point, Souillac, Mulhouse April 1949)) necessarily distorts the character of those exhibitions as a whole but sufficient *niaiseries* adorned those galleries to properly horrify the more demanding critic.

The 'triumphs' of machine-made art were to blame for art's 'failure in style', wrote Francis Palgrave, author of the famous *Golden Treasury*: 'When, as we daily see in the deluge of illustrated books and magazines, the photograph, with its inevitable falsifications of light and shade, is reproduced with the blotch and scratch and smuttiness inherent in the "processes", the result is one not merely devoid of charm, but actively destructive to the popular taste and fineness of perception for the really true and beautiful in art.' ('The Decline in Art', *Nineteenth Century* (London January 1888) p. 89, f.n. 11.)

The *Studio* article was written by Charles Holme, its first editor. Here, he acutely observed that 'The unselected naturalism of the camera was strangely reflected in the supremely selected naturalism of Japanese art', but he was reluctant to push the parallel beyond that (see note 56). Holme stressed the point that the photographic style predominated whether or not the artist used the lens. The artist 'saw Nature with the unloving eye of the camera, and deliberately noted fact after fact, detail after detail, much in the same mechanical way'. He described the distortions in tone and perspective which with the other peculiarities of photographic truth were popularly accepted, and he attributed the lack of colour in popular prints to the predominance of monochrome reproductions put before the public. A total of eighteen artists answered the *Studio* questionnaire.

The van Beers painting referred to was actually *La Sirène*, exhibited in the Brussels Salon. Highly criticized for its 'excessive fineness of execution', it was thus said to have been painted on a photographic base. The indignant artist offered to scratch out the head in the painting down to the ground to show that the initial drawing had, in fact, been executed in red ink. Van Beers challenged his detractors to pay him £1,000 if this were not found to be so and, surprisingly, offered the painting to those who found it so distasteful if their charges were discovered to be true (see *The Magazine of Art* (London 1892) pp. 400–1).

As his statement in *The Studio* suggests, Sickert was quite candid about his own use of photography, despite his expressed admonitions about that medium (see, for example, 'Modern Realism in Painting' in André Theuriet's *Bastien-Lepage and his Art* (London 1892)). Several examples of his paintings done from photographs, often from those taken under his own supervision, are described by Robert Emmons in his *Life and Opinions of Walter Sickert* (London 1941); see especially pp. 179, 200, 202, 213, 254. Osbert Sitwell also mentions the artist's attitude towards photography in his introduction to *A Free House* (London 1947). Twenty-three photographs from the magnificent illustrations to J. Thomson and Adolphe Smith's *Street Life in London* (issued monthly, 1877–8) were in Sickert's possession, though he does not seem to have made any direct use of them. They are deposited in the Greenwich Central Library and were kindly brought to my attention by David Leggatt, Chief Librarian there.

The works of the artists scolded by George Moore justify his criticisms. Herkomer used the camera obscura in the 1870s and 1880s, a practice rarely followed after the invention of photography; his painting *Found*, in the Tate Gallery, was executed with the help of that instrument (see J. Saxon Mills, *The Life and Letters of Sir Hubert Herkomer* (London 1923) pp. 97, 143). A visitor to his studio in Bushey, 1883, described 'photographic sketches' among its contents (ibid. p. 140). Among the letters to the artist from Herbert Spencer in 1898 are two which relate to photographs used for a portrait of the philosopher (ibid. p. 255). Herkomer's interest in photographic and other reproductive techniques included cinematography. From about 1913 he made 'a good many' films which were supplied to the early 'picture houses' (ibid. p. 308). In 1908 Herkomer wrote: 'Photography has never helped the landscape painter . . . it can only be a useful adjunct . . . if the painter can do without it, or if it comes to his aid in later life' (*My school and my Gospel*, p. 120).

Menpes's debt to photography was revealed indirectly in 1890 in Sickert's letter from Dieppe to the *Whirlwind*, calculated probably to impugn the ability of Marion Harry Spielmann, art critic for the *Pall Mall Gazette*. An imaginary interview was described, with an incompetent critic 'who criticized Mr Menpes's sketches of Japan, without taking into account the vital share that instantaneous photography had in their production' (23 August p. 143). I am indebted to Dr Wendy Baron for supplying this information. It took no act of imagination to see how dependent on photography Menpes was, not only for his many watercolour drawings of Japan but for those of India and other exotic places.

'I have myself no doubt whatsoever [wrote Alfred Hartley in 1893] that the very existence of a certain school of modern painters is due to the influence of photography; there may *possibly* not be a camera amongst them, but the view which they take is nevertheless a photographic view and is directly traceable to the influence I speak of, and but for photography the eye would never naturally have been brought to see Nature as these painters see it.' (*The Studio* (August 1893) p. 174.)

II. BEYOND PHOTOGRAPHY

67. (pp. 249–54) *Post-Impressionist reactions*

SOURCES. Whistler: *The Gentle Art of Making Enemies* (London, third edition 1904) p. 128, first published in the *World* (22 May 1878). Fénéon: *La Cravache* (Paris 29 June 1889). Dujardin: 'Le cloisonisme', *Revue indépendante* (19 May 1888) (see John Rewald, *Post-Impressionism*, p. 157). Aurier: 'Les peintres symbolistes', *Oeuvres Posthumes* (Paris 1893) pp. 294–309, first published in the *Revue encyclopédique* (1892). Aurier's 'Le symbolisme en peinture', written in February 1891, is also included in the *Oeuvres*. There also he attacks the banality of photographic realism and warns of the perils of 'la vérité concrète'.

Redon: *A soi-même* (Journal 1867–1915) (Paris 1922) p. 62. His views on photography cited in the text were written in 1878, in a passage of reminiscences about his friendship in Paris with the painter Paul Chenavard (*c.* 1870). Redon recalled their conversations about Delacroix whom they both admired. Chenavard, it will be remembered, shared Delacroix's photographs in Dieppe (in 1854). He communicated Delacroix's

great interest in photography to Redon, who refused to believe it without absolute proof.

Gauguin: *Lettres de Gauguin à sa femme et à ses amis* (Paris 1946) (Gauguin to Bernard, Arles, November 1888) p. 150. See Rewald (op. cit.) p. 198. See also Charles Morice, *Paul Gauguin* (Paris 1920) p. 246 and H. R. Rookmaaker, *Synthetist Art Theories* (Amsterdam 1959) p. 238. Despite his statements, Gauguin not infrequently used photographs, in many cases reproductions of earlier works of art, including some from Classical Antiquity which seems inconsistent with his expressed views on the art of the past. The source of some of these photographs has been shown to be those published by Gustave Arosa, Gauguin's guardian and friend (see William M. Kane, 'Gauguin's *Le Cheval Blanc*: Sources and Syncretic Meanings', *Burl. Mag.* (July 1966)). Earlier Arosa photographs were on view, for example, in 1869, at the eighth exhibition of the Société française de Photographie. Arosa's photographs, of a very high quality, also include landscapes, peculiar rock formations, close-up plant studies and still-lifes of everyday objects used by peasant families. Wildenstein reproduces two of the Fóntainebleau Forest in *Gauguin, sa vie, son œuvre* (Paris 1958), several others being deposited in the B.N. Est. Gauguin's photographs were also supplied from additional sources. His painting of the Marquesan *Girl with a Fan* (1902) was based on a photograph noted by Schwarz ('Art and Photography: Fore-runners and Influences', *Mag. of Art* (U.S. November 1949)) and identified by Bengt Danielsson as taken by the artist's friend Louis Grelet in 1902 in 'the house of pleasure' in Atuona (*Gauguin in the South Seas*). Danielsson's splendid book contains other references to photographs used by the artist for his paintings. There, too, is a description of a large camera on a tripod in Gauguin's Paris studio in 1894, possibly that listed by Wildenstein (op. cit.) in an inventory of the artist's belongings after his death in 1903. The inventory also included a small album of photographs. Excluding Gauguin's derivations from photographs of works of art, at least six paintings have been identified with photographs '*d'après nature*'.

Van Gogh: from *The Complete Letters*, vol. ii (London: Thames and Hudson 1959) pp. 588–90, and *Further Letters* (*1886–89*) (London, Boston, New York 1929) p. 393.

Munch: see 'Edvard Munch I Speilet' ('In Reflection'), by Paal Hougen, *Aftenposten* (Oslo 25 May 1963), and 'Geniet Munch' ('The Genius Munch'), ibid. The source of the quotation is from *Naerbilde av et geni* (*Close-up of a genius*), a biography of Munch published in Oslo (1963) by Rolf Stenersen. I am indebted to Tom Scharf who kindly supplied me with the information on Munch.

Signac: *D'Eugène Delacroix au néo-impressionnisme*, ed. Hermann (Paris 1964) p. 92.

Denis: *Théories* (From Symbolism to Classicism), ed. Hermann (Paris 1964) pp. 53, 112–13, 118. See also p. 115 citing Aurier's comments on the pure naturalism of paintings like Dagnan-Bouveret's *Une Noce chez le photographe* (Salon 1879) which could go no further (176). Denis applauds this artist's later return to the 'great European tradition' which is *not* pure naturalism. Denis interchanged the names 'neo-traditionalism' and 'Nabis'.

Bell: 'The Aesthetic Hypothesis', *Art* (1931 edition) pp. 18ff.

Derain: see James Thrall Soby, *Salvador Dali* (M.M.A. 1946) p. 10. Such pronouncements notwithstanding, Derain is known to have employed at least one photograph in that period, as Van Deren Coke shows, deriving much advantage. both from its literal composition and details and from its peculiarities in the strange flat tones which describe the solid forms. See Coke's excellent comparison between the photograph and the painting, *At the Suresnes Ball* of 1903 (*The Painter and the Photograph* (University of New Mexico Press 1964) pp. 16–17). Man Ray writes of his visit to Derain in the 1920s when the latter told him of his great interest in photography, believing that it could be very useful to painters. 'He then produced some photographs of nudes, saying he studied them before starting a painting.' Derain then commissioned Ray to take others, of a documentary nature, not to copy from, but to 'guide' him (see Man Ray, *Self-Portrait* (London 1963) p. 221).

Apollinaire: *The Cubist Painters* (1913) translated by Lionel Abel (New York 1949) p. 11 and *Les Peintres Cubistes* (Paris: Hermann, 1965) p. 48. On photography and the Impressionists see ibid. p. 53.

Gleizes: *Vers une conscience plastique* (Paris 1932) pp. 245–6.

Other artists and writers made it explicitly clear that Cubism was a conscious departure from photographic imagery. Cubism is the search for essential structures 'instead of reproducing in their photographic or tactile appearances the movement of the masses in a landscape or the play of the muscles in a body . . .' (Léon Werth, 'Exposition Picasso', *La Phalange* (Paris June 1910)). Cubism's 'new plastic signs' derived from the Masters, controlled by the intelligence, are antithetical to the idea of catching on the canvas 'no more than a retinal photograph more or less modified by "personal feeling"' (Jean Metzinger, 'Cubisme et tradition', *Paris-Journal* (16 August 1911)). 'The aim of art is not the servile imitation of nature. . . . It must be a translation, an interpretation. . . . Imitation . . . may . . . be an art, but one that photography may easily bring to perfection' (Maurice Raynal, *Salon de juin: Troisième exposition de la Société normande de Peintre Moderne*, Catalogue (Rouen 15 June to 15 July 1912)). The Cubists regard as superficial the principle of painting an object as one sees it. 'They consider that photography does portraits quite as well as M. G. Ferrier or E. Carrière . . .' (Raynal, 'Qu'est-ce que . . . le "Cubisme"?', *Comœdia illustré* (Paris 20 December 1913)). '. . . modern mechanical achievements such as colour photography, the cinematograph . . . have made completely superfluous the development of the visual, sentimental, representational and popular subject in painting.' How can those Salon paintings 'hope to compete with what is shown on the screen of any cinema in the world' (Fernand Léger, 'Les origines de la peinture et sa valeur représentative', *Montjoie!*, no. 9–10 (Paris June 1913)). These comments are extracted from Edward F. Fry's extremely useful collection of documents on Cubism (London 1966), translations by Jonathan Griffin.

Futurists: from the catalogue of the Sackville Gallery exhibition (March 1912). Quotation from the descriptive text of Boccioni's *The Street Enters the House*, probably written by Boccioni himself. Balla: *Manifesto on Colour* (October 1918).

Die Brücke: from Heinrich Schwarz, 'Art and Photography: Forerunners and Influences' (op. cit.) p. 252. Source: the *Brücke Manifesto* (1907).

Kandinsky: the discussion of the polarities between pure abstraction and representation is translated by Ralph Manheim in *Concerning the Spiritual in Art*, Documents of Modern Art (New York 1963 edition) p. 48.

Breton: the catalogue introduction to Ernst's Paris exhibition (1920) goes on to describe, as had Marinetti, the consequences on human thought and emotion of the slow and fast motion cinema. (Reprinted in Ernst, *Beyond Painting*, Documents of Modern Art (New York 1948) p. 177.)

Matisse: Alfred J. Barr, Jun., *Matisse* (New York 1951) Appendix I, p. 562.

Crane: *Line and Form* (London 1900) p. 53.

Photographs served other Post-Impressionists, not so much now to authenticate a view of nature or a portrait but as Delacroix and Cézanne proposed, as another image of the physical world from which the artist was as free to select as he was from actual nature. The *aide-mémoire* umbrella covered a variety of uses, almost everything short of literal transcription. Toulouse-Lautrec used photographs on occasion. These were taken of his models by his painter friends René Grenier and François Gauzi (see François Daulte, 'Plus vrai que nature', *L'Oeil* (October 1960)). See also P. Huisman and M. G. Dortu, *Lautrec by Lautrec*, translated by Corinne Bellow (London 1964), for sumptuously illustrated examples. Rewald quotes Thadée Natanson on Bonnard's quick trips to foreign parts 'to absorb the impact and to return with highly significant photographs and characteristic souvenirs . . .' (*Bonnard* (M.M.A. 1948) p. 47, from 'P. Bonnard', *La Vie* (15 June 1912)). James Ensor's use of photographs for the painting *Old Woman with Masks* (1889), for his sketch of Tolstoy and for a posthumous portrait is noted by Libby Tannenbaum in *James Ensor* (M.M.A. 1951, exhibition catalogue) pp. 78, 81. In Brian Reade's *Art Nouveau and Alphonse Mucha* (Victoria and Albert Museum 1963) the artist's use of photographs, in the execution of his complicated draperies especially, is described by his son (p. 13). Mucha in Paris about 1898 took a photograph of Gauguin's friend, Anna 'the Javanese', according to Danielsson (op. cit. repro. figure 25).

G. B. Shaw often commented on photography and in 1901 he made this summary dismissal of art: 'If you cannot see at a glance that the old game is up, that the camera has hopelessly beaten the pencil and

paint-brush as an instrument of artistic representation, then you will never make a true critic: you are only like most critics, a picture fancier. . . . Some day the camera will do all the work of Velasquez and Peter de Hooghe, colour and all.' (From *The Amateur Photographer*, quoted by Alex Strasser in *Immortal Portraits* (London and New York 1941) p. 92.) True to the letter of Shaw's prophecy photographers like J.C.Strauss (1904), Guido Rey (1908) and Richard Polak (1914) took pictures in direct imitation of the subjects and compositions of the Old Masters – Polak's *Photographs from life in old Dutch costume* were more or less unrelieved pastiches of de Hooch and Vermeer (175).

12. BEYOND ART

68. (pp. 255–68) *Futurism and chronophotography*

Duchamp's statements referring to photographs like those of Muybridge and Marey were made on different occasions: to Beaumont Newhall in an unrecorded interview (see his *History of Photography* (M.M.A. 1949, first edition) p. 218) and in October 1959 to Reyner Banham at the Institute of Contemporary Arts, London. My thanks are due to Dr Banham for this information. Richard Hamilton says that the artist remembered seeing Marey's work in a popular illustrated magazine of 1911 (Catalogue of the Arts Council of Great Britain Duchamp exhibition (1966) p. 37). Hamilton writes: 'it is reasonable to assume that Duchamp set about a serious exploration of Marey's scientific research when he thought that it could help solve this particular problem', referring to the artist's preoccupation at the time with simultaneity. Several publications at the beginning of this century carried reproductions of Marey's chronophotographs and would have been easily available to Duchamp. One of them, by Marey's assistant, Demenÿ, *Les Origines du Cinématographe*, appeared in 1909 and, of course, Marey's own *Le Mouvement* was readily obtainable from its publication in 1894. *Le Monde Moderne*, an illustrated monthly, reproduced a relevant chronophotograph by Marey in 1895. *La Nature*, in 1910 and 1911, carried notices on chronophotography and cinematic exploration, though the illustrations do not precisely relate to the visual character of Duchamp's paintings, as do those of other articles in earlier issues of this journal. A follower of Marey, Dr Paul Richer, issued his *Physiologie artistique de l'homme en mouvement* in 1895. This actually contained schematic drawings, probably based on chronophotographs, of a figure descending a staircase (184). Marey's photographs of the trajectories of moving bodies were the prototypes for the early time-and-motion studies of Frank Gilbreth who translated photographs into wire structures (see his book, *Motion Study* published London 1911).

Boccioni was a voracious reader of scientific treatises and it is unlikely that he avoided the works of Marey. The criticisms of the Futurists cited in the text are recorded by Raffaelle Carrieri, *Futurism* (Milan; translation 1963). One of the accusations, by Roger Allard, was recorded by Boccioni in *Lacerba* (Florence 1 August 1913) where he also answered other criticisms of that kind. Boccioni's 'mistaken critic' was Henri des Pruraux, writing probably in *La Voce* (31 October 1912). Delaunay's comments will be found in his notebook (1912). Severini's *Dance of the Pan Pan* was ridiculed by Germain Bazin (Carrieri, op. cit.) p.57). Possibly with some bearing on the association of Futurist painting with the instantaneous photograph of a sneeze (Louis Vauxcelles on the Salon d'Automne (1912): 'Les Futuristes', *Gil Blas* (6 February 1912)) was the fact that among the first, and well-publicized, films shown in the Kinetoscope in New York in 1894 was W.Laurie Dickson's *Record of a Sneeze* (Dickson worked with Edison). Carrieri says (op. cit. p. 114) that Balla's works were often equated with the cinema. For additional references to Futurism and photography see Otto Stelzer (op. cit.) pp. 116–25.

Balla's well-known *Goodbyes on the Staircase* of 1908, with its rationalized oscillation pattern in the spiralling steps suggests some acquaintance with chronophotographic form well before its obvious expression in the *Girl X Balcony* and *Violinist*, both of 1912. The latter picture, incidentally, bears a strong resemblance to one of Bragaglia's photographs of a cellist (1911) (198, 199). Balla's linear study for his painting, *Iridescent Penetration* (1914), is analogous in form to

Marey's diagrammatic interpretations of his photographs.

The work of the Bragaglias is discussed in some detail in the well-illustrated article by Piero Racanicchi, 'Fotodinamismo Futurista', *Critica e Storia della Fotografia*, *Popular Photography*, no. 2 (Milan 1962–3; Edizioni Tecniche).

69. (pp. 268–73) *Picasso*

Picasso used a photograph for his drawing of the *Three Ballerinas* (1917?). See Alfred H. Barr, Jun., *Picasso* (M.M.A. 1946) p. 97. Barr (ibid. p. 130) also offers: 'The grotesque foreshortening of the running figure in the background of *By the Sea* suggests the snapshots of reclining picnickers whose feet are comically magnified by the camera.' Both Barr and Coke note the expressive use Picasso made of this photographic peculiarity: '. . . the abrupt foreshortening seems the result of action in time more than the static optical distortion of the camera lens' (Barr); 'It took an artist of Picasso's keen perception to capitalize upon what was thought by most everyone else to be an undesirable effect' (Coke, *The Painter and the Photograph*, p. 23). Coke refers to Pavel Tchelitchew's paintings of the 1930s, the well-known one of a matador, especially, as incorporating the same distortion. Coke also reproduces a photograph of Rimbaud, one of Renoir and another of Picasso's son Paul astride a donkey, all three of which Picasso used for drawings made between 1917 and 1921.

In Gertrude Stein's book, *Picasso* (London 1938) pp. 8–9, she recalled that in 1909 the artist showed her some photographs of a Spanish village to demonstrate how Cubist in reality they appeared. These photographs, according to Stein, were used to confirm the extraordinary character of Picasso's paintings of that village, to show that the Cubism of paintings like the so-called *Horta de Ebro* and *Maison sur la colline* was no more fantastic than nature herself. They were, writes Stein, 'almost exactly like the photographs', and she cites Oscar Wilde's paradox that Nature copies Art: 'certainly the Spanish villages were as Cubistic as these paintings'. See also Coke, *The Painter and the Photograph*, p. 22, where the publication of

this photograph in the magazine *Transition* (1928) is cited, the information supplied by Dr Frederick Deknatel. More recently, the photograph is used by Edward F. Fry in *Cubism* (London 1966) figure 14.

Man Ray worked with Picasso in the production of photograms ('rayographs') in 1936 and a *cliché-verre* by Picasso was coupled with a rayograph to produce a portrait, probably of Dora Maar (who was herself a photographer working also in photomontage). In 1960 Picasso utilized photographs, cut to shape, as the basic elements in his so-called *découpages* (see Coke, *The Painter and the Photograph*, pp. 24, 64).

70. (pp. 272–5) *Alvin Langdon Coburn and vortography*

Coburn's critic in *Photograms of the Year* (1917–18) was W. R. Bland who elaborated pointedly on the 'which way up' theme in describing the vortograph: 'Give it a half-turn from right to left, bringing it "landscape way"'; try it through a mirror; 'There is no position in which this Vortograph may be placed which will not have its supporters'; 'It haunts me. I begin to see things in it.' Tongue-in-cheek though this was, Mr Bland (ridiculing Coburn's explicit disregard for top or bottom, *Photograms* (1916)), had unwittingly discovered one of the principles of Vorticism. Ezra Pound wrote in 1918 that Vorticism was based on Pater's idea that 'all arts approach the condition of music'. Coburn expressed the desire to do for photography what Cézanne and Matisse had done for painting and Stravinsky and Scriabin for music. He was also inspired by H. G. Wells and, no doubt, influenced by his friend, the Cubist painter Max Weber. See Nancy Newhall's excellent *Alvin Langdon Coburn Portfolio*, published by George Eastman House (Rochester, N.Y. 1962). Coburn's vortograph, *The Centre of the Vortex*, was a representation of Pound made by multiple mirror reflections.

71. (pp. 275–89) *Collage: Photomontage*

Many early photographs and projection slides illustrating scenes from history, the

Bible, from literature or dealing with contemporary moral tales or fantasies, were made with a great variety of stage-props. These convey the same sense of heterogeneity as do the more deliberate photomontages. See, for example, Olive Cook, *Movement in Two Dimensions* (London 1963), and Gernsheim, *Creative Photography* (London 1962).

For early examples of collage with photographs in books on photographic amusements, see especially A. Bergeret and F. Drouin, *Les récréations photographiques* (Paris 1893); Walter Woodbury, *Photographic Amusements* (1893; first edition); C. Chaplot, *La photographie récréative et fantaisiste* (Paris 1902 (?)). Often, such divertissements were featured in periodicals of the 1880s and 1890s such as *La Nature*, *L'Illustration*, *The Picture Magazine*, the *Scientific American* and, of course, in photographic journals.

Excellent examples of the use of photomontage on postcards published in the first years of this century will be found in A. Jakovsky, *A Picture Postcard Album* (London 1961). See also Paul Éluard's 'Les plus belles cartes postales' in *Minotaure*, no. 3–4 (December 1933).

In *Les quatre cents coups du diable* (1906), Méliès made use of painted sets combined with photographs as he also did in other films. Paul Leni's *Waxworks* (*Das Wachsfigurenkabinett*), made about 1922 when photomontage was especially popular in Dada groups, incorporated montage sequences, prismatic and other effects, recalling the paintings of Franz Marc and Lyonel Feininger. Montage techniques were often used in films of the 1920s (see Siegfried Kracauer, *From Caligari to Hitler* (London 1947), and George A. Huaco, *The Sociology of Film Art* (New York, London 1965)).

Papini's letter on collage to Boccioni was published in *Lacerba* (15 March 1914) (see Carrieri (op. cit.) p. 128). Picasso's criticism of the Futurists' use of collage may have been directed principally at Severini whose use of a moustache in a collage was too *simpliste*. Severini soon recanted in favour of the primacy of the metaphorical function.

Carrà's *French Officers* was one of his series of paintings and collages on the war. Apollinaire's *Après la Marne, Joffre visite la front en auto* described the same subject and Marinetti reproduced a typographical collage (*Les mots en liberté* (1919)), representing Joffre's famous speech to troops in the front lines.

For additional information on Berlin Dada see Hans Richter, *Dada Art and Anti-Art* (London 1965) pp. 101–33, and his useful bibliography on Dada. Also worth consulting is Hannah Höch's letter to Coke on the origins of Dada photomontage in *The Painter and the Photograph*, p. 23. Two oleolithographs of a similar type to those cited are reproduced in Peter Pollack, *Picture History of Photography* (London 1963) p. 164, a military 'cartouche' and a cavalryman, both designed for pasting in photographs. (212) Stenger describes the sale, about 1880, of regimental cards with all but the heads illustrated, the appropriate photographs to be inserted by the troops themselves. In 1910, he says, illustrations of helmets were available with real feathered plumes which could be added to the portraits (*The March of Photography*, p. 116).

The most complete work on Heartfield to date has been written by his brother, Wieland Herzfelde, *John Heartfield: Leben und Werk* (Dresden 1962), well documented and with over 300 illustrations. There is almost nothing in English, with the exception of Peter Selz's choice article in the *Massachusetts Review* (Winter 1963). Aragon's essay, 'John Heartfield et la beauté révolutionnaire' (1935) is reprinted in his *Les collages* (Paris 1965) (Hermann: Miroirs de l'art). Apparently John Heartfield anglicized his name during the First World War as a deliberate gesture of repugnance for the jingoism of the militaristic Reich. Heartfield was highly occupied with photography and photomontage in the 1920s and 1930s, his work including typographical designs for book publishers. His brother's firm, Malik-Verlag, issued most of Upton Sinclair's books in translation, the dust-covers executed by Heartfield. On one occasion, in 1930, Heartfield was prosecuted for infringing the copyright on a photograph of the writer Emil Ludwig, his family and dog, which the artist used pointedly to illustrate the back cover of Sinclair's critical study of American literature from the economic point of view, *Das Geld schreibt* (*Money Writes*). Ordered to obscure the identities of the subjects or not use the photograph at all, Heartfield added insult to injury by cutting

out the heads in the photograph – including that of the dog – and republishing it in that state, much to the delight of his public.

A recent example of the power of photomontage to provoke the most bitter responses occurred in January 1965 when the Shah of Iran reacted smartly to a rather uncomplimentary photomontage published in the *Kölner Stadt-Anzeiger* by the Austrian artist Harald Sattler. Even the President of Germany became involved in the imbroglio (see Neal Ascherson in the *Observer* (London 10 January 1965)). The situation could perhaps be compared with Daumier's effronteries to Louis-Philippe, though it is debatable (Gerald Scarfe notwithstanding) whether satirical drawings today can incite the same responses as equally satirical photomontages. Surprisingly, however, the libel actions taken against the satirical magazine, *Private Eye*, result more from the written word than from the frequent use of some very objurgatory photomontages.

Richter's association of photomontage with film form is no doubt an expression of his own concern with the cinema medium. See his 'Easel – Scroll – Film', *Magazine of Art* (New York February 1952) pp. 78–86. See also, 'Hans Richter – Constructivist and Dadaist' by Mike Weaver, *Image* (London October 1965), and Richter's 'The Badly Trained Sensibility' (ibid.), a reprint from an article of 1924. The unusual format and compositions of his 'scroll paintings' (from *c.* 1919) are obviously and directly related to his films (see catalogue of the Hans Richter exhibition, Galleria Civica d'Arte Moderna, Turin (1962), which also includes an extensive bibliography of works by and on Richter).

Ernst's best-known photomontages of 1920 include the *Chinese Nightingale*, the *Massacre of the Innocents* and the famous *Fatagagas*. In addition to sources cited in the text see special issue of *Artforum* (Los Angeles September 1966), 'Surrealism', which includes discussions on collage and photomontage. Lucy Lippard (ibid. p. 11) questions the usual assumption that Baargeld and Arp contributed to the *Fatagagas*. Ernst's two haunting series of montages, *La femme 100 têtes* (1929) and *Une semaine de bonté* (1934), were made, strictly speaking, from engravings but the peculiarities in tone and in the contour of forms suggest that in many cases these engravings were made originally from photographic plates.

Several of the elements in *La femme 100 têtes* come from engravings by artists like H. Thiriat and E. A. Tilly who worked mainly from photographs. These will be found, for example, in popular illustrated scientific journals of the 1880s and 1890s like Tissandier's *La Nature* (Paris), and reproduced in the pictorial magazines of other countries. Such sources are worth uncovering. Not only do they reveal the subtle imagination that would, for example, convert 'a curiosity constructed from an orange', a lattice structure cut from the peel, into a weird, tentacled, mushroom-like growth in a landscape or into a gigantic bird's nest hovering over a nocturnal city, but they demonstrate also Ernst's scrupulous care with the formal integration of such objects to heighten the pictorial reality of the composition. Minute attention is paid to apparently insignificant details. Fragments are carefully cut and their edges touched with paint to eliminate any piecemeal appearance. Highlights and shadows are employed to give the alien forms the logic of light and space. Intrusive elements are usually removed. Overall, by the deftest application of the fine brush, the characteristic linear shading is maintained.

Aragon's essays on collage were produced from 1923 to 1965. He writes of the years 1917–*c.* 1922 (op. cit. p. 60): 'During this period between the revolution and the inflation, several people believed they could solve the problem of the uselessness of art by adapting artistic means to propaganda ends. It was then that collage gave birth to these photomontages. . . .' Among the reproductions here are photomontages by Ernst, Rodchenko, and an unusual collage with photographic elements by Léger (1933).

72. (pp. 290–3) *Surrealism: the mechanization of inspiration*

Ernst's collection of frottages, *Histoire naturelle*, appeared first in 1926 and is reproduced in his *Beyond Painting*. See ibid. p. 21 for his views on collage and 'superreality'. Other early photo and engraving collages are described in the catalogue of the Arts Council of Great Britain Max Ernst

exhibition (1961). Breton's conception of decalcomania (1927) is reprinted in Patrick Waldberg, *Surrealism* (London 1965) p. 87. See also *Minotaure*, no. 8 (1936) pp. 18–24, for a well-illustrated article on decalcomania by Benjamin Péret.

For Dali's statement on 'phenomenal reality' (made in 1941) see *The Secret Life of Salvador Dali* (London 1948). On his use of photographs see Marcel Jean, *The History of Surrealist Painting* (London 1960; Paris 1959) p. 199. Both Ernst and Jean speak of Magritte's work as painted collages. See also Coke (*The Painter and the Photograph*) on Dali's metamorphosis of a photograph of Franklin D. Roosevelt in 1942 and his use of a photograph which provoked a lawsuit. It is worth mentioning that in Man Ray's solarized photographs, such as the *Primacy of Matter over Mind* (1931), the distortion of form is similar to, though not as exaggerated as, Dali's liquefactious figures.

Even Marey's chronophotographs were incorporated into the Surrealist iconography. Jean writes of the revival of Surrealist activity during the last war, referring to an article by Raoul Ubac,

'Note on Movement and the Eye', in which Marey's work was discussed (op. cit. p. 335). Marey's so-called 'chronograms' of athletes are illustrated in Jean (ibid. p. 18). See also Jean's article in *Minotaure*, no. 1 (June 1933).

Similarly, Eugène Atget was 'discovered' by the Surrealists, by Berenice Abbott in 1926, particularly. She was then an assistant to Man Ray in Paris. In that year, four Atget photographs were published in *La Révolution Surréaliste* (the official organ of that movement). Atget hawked his photographs around the studios of Paris and was thought of as a 'primitive', as the Douanier Rousseau of the street. His incomparably haunting views of Paris, several of which were used in the production of postcards, were taken between 1898 and 1915, totalling more than 800. They were purchased by Picasso, Braque, Derain, Utrillo, Duchamp, Man Ray and Dali among others. Some of them are reputed to have been used for paintings according to Arthur D. Trottenberg (see his introduction to *A Vision of Paris* (New York 1963)).

Surrealist writers, Breton, Éluard, Georges Hugnet, Jacques Prévert, E. L. T. Mesens as

259. Ubac: *Fossil*. Relief photograph of the Paris Opera. *Minotaure*. 1937–39

260. Ubac. *Fossil*. Relief photograph from *Minotaure*. 1937–39

examples, found photomontage an expedient tool for visual statement. See especially: Hugnet's *La Septième Face du Dé (Poèmes – découpages)* (Paris 1936). Several good examples of Surrealist photomontage are in the catalogue, L'*EXPOSITION INTER-NATIONALE DU SURREALISME* (1959 –60), Galerie Daniel Cordier, Paris.

Photographers who have consciously used a Surrealist means of expression include: Man Ray, Angus McBean, Cecil Beaton, Dora Maar and Ubac, not to mention innumerable others whose works in some ways reflect some sensitivity to the so-called 'superreal' (259, 260).

Paul Nash's photographs (taken 1931–46), several of which he used for his paintings, are reproduced in *Fertile Image* (edited by Margaret Nash, introduced by James Laver) (London 1951). Strictly speaking, Nash was not a Surrealist, though a few of his photographs in which he employed the effects of photomontage and double exposure clearly lean in that direction and others show a marked propensity for that kind of poetic statement.

Roland Penrose and Miró made use of photographic collage elements in their paintings. Patrick Waldberg (op. cit.) reproduces photographs and photomontages by Dora Maar, Raoul Michelet (Ubac) and Jacques Prévert. On Dora Maar as a photographer see Marcel Jean, *The History of Surrealist Painting*, p. 280, and on Ubac's 'relief' photographs, ibid. pp. 270–71.

73. (pp. 293–303) *From Constructivism to the Bauhaus*

For Lissitzky's references to photography and the cinema see *El Lissitzky 1929. Russland: Architektur für eine Weltrevolution* (Berlin 1965; first published Vienna 1930) pp. 124–8 especially. Sixty of his photographs and 'typofotos' were published in Berlin (*c.* 1929) as part of a series of books on 'the new photography', edited by Franz Roh, a vigorous advocate of 'subjective' photography. Lissitzky and Rodchenko are discussed in this context by Camilla Gray, *The Great Experiment: Russian Art 1863–1922* (London 1962) and by the same writer, see 'Alexander Rodchenko: a Constructivist Designer', *Typographica 11* (London June 1965). Rodchenko's photographic work was first published in the Russian journals *Kino-Fot* (1922), *Pro Eto* (1923) and *Lef* (1923–5).

Malevich's *The Non-Objective World*, written in 1924, was first published in Munich, 1927, as vol. 11 of the Bauhaus books. The first English translation from the German was published in Chicago, 1959. An article in *Photograms of the Year* (1917–18 p. 20)

referring to wartime aerial reconnaissance describes 'Hundreds and thousands of photographs, flawless in their definition . . . secured from our machines flying at a height of ten thousand feet or more.'

Some of Moholy-Nagy's photomontages of about 1924 were intended to be pictoriali-

tional canvas ground. In some cases, *CHF 1942* for example, his paintings were colour variations of stills from his films. The question of subjectivity and objectivity in art was pursued at length by Mondrian in his famous essay: 'Plastic Art and Pure Plastic Art'. In his relentless search for abstract

261. Moholy-Nagy: *Our Big Men.* 'Contrasts of proportion and perspective by a few lines.' 1920s

zations for a film so that, as he later wrote, 'all of its scenes can be visualized at once' (see his *Vision in Motion* (Chicago 1947) pp. 285 ff.). This, perhaps, explains the diagrammatic linear elements which unite the photographic fragments illustrating the many montage sequences of the script (261).

The titles to Moholy-Nagy's paintings convey the impersonal identification and serial markings of machine-made products: *E IV 1922, Q XXV 1923, C XII 1924, LK IIII 1936,* etc. But it should be noted that while many of his paintings were later executed on materials such as formica, plexiglass and metal plates, for most of them, before the early 1940s especially, he used the tradi-

universal truths Mondrian was led to reject all figurative expression in art, including the cinema which ironically not only helped to make his kind of art possible, but relevant too.

THE PHOTOGRAM: Man Ray describes his discovery of the 'rayograph' in *Self-Portrait* (London 1963) pp. 128 ff. His painting of 1919, *Admiration of the Orchestrelle for the Cinematograph* (M.M.A.) (262), executed with the aid of an air-brush, directly prefigures his photograms. This painting was possibly a reference to Richter's scroll paintings (see note 71) and also to the scroll drawings by Eggeling made in conjunction with their films.

262. Man Ray:
*Admiration of
the Orchestrelle*
for the Cinematograph.
1919
(air-brush painting)

The subtle spatial effects and impersonality obtainable in the photogram gave impetus to the use of the air-brush in the rendering of superimposed, transparent layers of paint especially suitable to the non-absorbent surfaces of metallic and synthetic materials (see Moholy-Nagy, *The New Vision* (fourth edition, New York 1947) p. 39). In 'Abstract of an Artist' (ibid.) Moholy-Nagy clearly indicates his intention to re-create, in these spray-paintings, the 'characteristics of photograms'. Here also is his manifesto of anonymity: 'My photographic experiments, especially photograms, helped to convince me that even the complete mechanization of technics may not constitute a menace to its essential creativeness.' 'The illiterate of the future [he wrote in *The New Vision*] will be . . . the person who cannot photograph.'

Ludwig Hirschfeld-Mack's coloured light projections ('reflected light play') are discussed by Basil Gilbert in *Form*, no. 2 (September 1966), and see letter from Hirschfeld-Mack to Standish Lawder (ibid.).

Paul Klee's 'chromatic superimpositions', as in his *Graduated Shades of Red-Green* and *Fugue in Red* of 1921 to the whimsical *Seafarer* of 1923, unquestionably echo the current interest in the Bauhaus for 'light-painting'. These so-called *Fugues* are no doubt analo-

gous to the reflected light experiments at the Bauhaus in the early 1920s which were sometimes accompanied by piano music. For Klee's description of his *Little Jester in a Trance* (1929) see *The Thinking Eye* (London, New York 1961) p. 130.

74. (pp. 304–12) *Photomicrographs and telephotographs*

Klee's reference to microscopic images is from his essay. *On Modern Art*, presented first in a lecture of 1924, published in 1945 and now reissued in Robert L. Herbert's judicious selection of essays, *Modern Artists on Art* (Englewood Cliffs, N.J. 1964).

In his pedagogic writings of the early 1920s, Klee spoke of the microscopic and macroscopic 'dynamic'. In trying to evolve a theory of 'form-production' he sought, in natural forms, what he called 'cosmogenesis': structural and kinetic characteristics like heavy and light, mobility and immobility, radiation, rotation, explosion and even masculinity and femininity. See *The Thinking Eye*, pp. 5, 22–3, etc.

It should perhaps be said that the distribution of books like Robert Hooke's famous and elegantly illustrated *Micrographia* in 1664, however well known to the *cognoscenti* of the period, cannot be compared with the large-scale dissemination of such publications in this century. Hooke's engravings of a flea fascinated William Blake and undoubtedly influenced his painting, *Ghost of a Flea* (*c.* 1820), in its segmented surface, protruding tongue and in other ways as also in a small drawing of the same date (see Geoffrey Keynes, 'Blake's Visionary Heads and the Ghost of a Flea', *Bull. of the N.Y. Public Library* (November 1960) which refers also to Dr Charles Singer's earlier comparison in 1955). This isolated example anticipates the more universal sensitivity of later artists to microcosmic nature. My thanks are due to Catriona Robertson for her helpful information on Blake.

Léger's views on 'The New Realism' were published in *Art Front*, II (December 1935). I quote from an extract in R. Goldwater and M. Treves, *Artists on Art* (New York 1945).

A sizeable collection of nineteenth-century photomicrographs is in the Conservatoire National des Arts et Métiers, Paris. Talbot's photographs, taken through a solar microscope are in the Science Museum, London. Some of Talbot's photomicrographs were taken as early as 1835. See 'Some account of the art of photogenic drawing . . .' (read before the Royal Society, 31 January 1839, published in London by R. & J. E. Taylor, 1839) where Talbot wrote on its application to the microscope: 'Contemplating the beautiful picture which the solar microscope produces . . .'. The British Museum Subject Index for 1881–1900 includes seventeen books especially concerned with photomicrography. A book by D. Catt (1905) employs the terminology, *Scenes from the Microscope* and, by 1929, the idea that nature can herself produce art is implicit in K. Blossfeldt's book of close-up photographs from plants called *Art Forms in Nature*.

Lippold is quoted by Alfred J. Barr, Jun., in *Masters of Modern Art* (M.M.A. 1954) p. 181, from Dorothy Canning Miller, *Fifteen Americans* (M.M.A. 1952). Calder's observations are in 'What Abstract Art Means to Me', *M.M.A. Bull.*, 18, no. 3 (1951).

The article by Peter Blanc was published in *Magazine of Art* (Philadelphia April 1951) pp. 145–52; Max Bill's in *Graphis* (Zürich January 1948) pp. 80 ff. Gabo's statement is from his Trowbridge Lecture given in Yale University, 1948, and published in *Three Lectures on Modern Art*, Philosophical Library (New York 1949). Articles like 'Photomicrographs Offer Inspiration for the Design of New Ornament; Six Designs', in *American Architect and Building News* (May 1932) and 'Textile Designs and Motives: an unexplored Field of Nature; Demonstration by Polarized Light of New Microcrystallization', in *Roy. Soc. Arts Journ.* (27 February 1931) pp. 355–66, reflect the value for other arts of microscopic form. Sir William Rothenstein, then Principal of the Royal College of Art, chaired the R.S.A. meeting (11 February). The report of the discussion following F. G. Wood's demonstration is interesting in its references to the suggestive character of such apparently abstract imagery. Here, too, a German book on plant forms was mentioned, probably K. Blossfeldt's *Art Forms in Nature*.

75. (pp. 312–21) *Art and photography today*

For a more detailed description of the Guggenheim Museum exhibition of 'works based on the photographic image' see New York Commentary (illustrated) by Dore Ashton, *Studio International* (March 1966). In the same journal (April 1966), Ashton's review, 'The Artist as Dissenter' describes the revival, among many young artists, of polemical photomontage in the tradition of Heartfield and Grosz.

Léger's observations on the fragment were originally made in 'A New Realism – the Object (its Plastic and Cinematographic Value)', *Little Review* (New York June 1923). See Standish Lawder, 'Fernand Léger and Ballet Mécanique', *Image* (London October 1965). For Léger's very illuminating views on the meaning and importance of the cinema in the machine age see 'À propos du cinéma' in the collection of his essays, *Fonctions de la peinture* (ed. Gonthier, Paris 1965) pp. 168–71. 'À propos du cinéma' first appeared in *Cahiers d'Art* (Paris 1933). See also Léger's 'Essai critique sur la valeur plastique du film d'Abel Gance, La roue', *Comédia* (Paris 1922), reprinted in *Fonctions de la peinture*, pp. 160–63, and 'Autour du Ballet mécanique' (ibid.) pp. 164–7.

For Kozloff's appreciation of Rauschenberg see Catalogue of Whitechapel Gallery, London exhibition (February–March 1964).

See 'Photographic Realism: on the Paintings of Juan Genovés' by José L. Castillejo, *Art International*, 33rd Venice Biennale no. (Summer 1966) and, for reproductions of his work, Marlborough Gallery (London) exhibition catalogue (February–March 1967).

The atavistic tendencies of some artists and critics, appalled at the propagation of mixed media in contemporary art, are exemplified in the article by the sculptor Phillip Pavia, 'Stone Notes: Direct Carving', *Art News* (New York May 1966). Pop and Op artists, he complains, 'have resurrected the mixed mediums – photography on painting, photography on wood cutting, photography on graphic screen plates'. He calls it a semi-criminal act, done with the conscience of the counterfeiter, a 'sick technique'.

An interesting example of the use of an early photograph, its appeal heightened by specific literary connotations, is the painting by Leland Bell of the inhabitants of Maupassant's notorious Maison Tellier, based on an incredibly compelling photograph taken in Rouen at the end of the last century (see Coke, *The Painter and the Photograph*).

A look through the intriguing collection of early photographs in a book like the *Petit Musée de la Curiosité photographique* by Louis Chéronnet (Éditions 'Tel'; Paris 1945), in which the Maison Tellier photograph is reproduced, makes it easy to understand the appreciation many artists have for such images.

A refreshingly unsophisticated attitude towards the use of photographic reproductions for painting is that of the present English 'primitive', James Lloyd. His paintings of farm and country scenes are derived mainly from photographs though, as he says, these are used only to give him a start. But what is most interesting is his dependence on the mechanical half-tone screen texture in order that his subjects may be given the appearance of volume which otherwise, untrained in painting techniques, he would have difficulty in obtaining. Like Henri Rousseau who also found photographs expedient, Lloyd's intense concentration on detail, considering his lack of formal instruction and the subjects he prefers to represent, makes the photograph a most feasible vehicle. When questioned about his reliance on photographs, his simple answer was, 'You can't ask ferrets or foxes to stop still while you paint, can you?' He wonders why people need to look at paintings when they have colour photography, though he does not question his own compulsion to paint (see Barrie Sturt-Penrose, 'Primitives in Private', the *Observer* colour supplement (London 12 February 1966)).

76. (pp. 323–5) *Conclusion: Photographic reproduction and 'Mass Culture'*

Le musée imaginaire is the first volume of André Malraux's *Essais de Psychologie de l'Art* (first published in Geneva 1947). The *Essays* appeared in three volumes by 1950 and were later revised with the title, *Les Voix du silence* and a fourth volume added.

Earlier, in 1936, a more sanguine view had been taken by Walter Benjamin in an analysis of photographic reproduction and the deterioration of uniqueness in original works of art. With photography, and especially with the cinema, the value of exhibiting works of art is, he said, inevitably diminished as is also the 'aura' surrounding the 'authenticity' of an object. 'For the first time in world history mechanical reproduction emancipates the work of art from its parasitical dependence on ritual.' The idea of reproduction is consistent with the nature of mass society ('L'oeuvre d'art à l'époque de sa reproduction méchanisée', in *Zeitschrift für Sozialforschung*, pp. 40–68, translated by Pierre Klossowski, Paris 1937). Parts of this work are translated and discussed by Donald K. McNamee in 'The Pioneer Ideas of Walter Benjamin', *The Structurist*, no. 6 (1966) pp. 47–54, special issue on art and technology, annual art publication of the University of Saskatchewan, Saskatoon, Canada. My thanks are due to Peter DeFrancia for pointing out the Benjamin reference. Benjamin's assumptions are very provocative indeed, and spur the imagination, but they do not stand up to close scrutiny. The 'ritual' around art and the 'aura' surrounding uniqueness, which he says mechanical reproduction has made obsolescent, may in fact have been rendered by photography and the cinema even more vigorous than ever before.

Edgar Wind also discusses the transformation in the creation and in the perception of art brought about by photo-mechanical reproduction. The artist's awareness, he says, of the photogenic potential of his work has conditioned his production, and Wind speaks of the congruency of the modern palette with colour-printing. But he does not agree so readily with Malraux that through mere photographic manipulation and strategic juxta-position small coins, for example, will have 'the same plastic eloquence' as huge monuments ('The Mechanization of Art' in *Art and Anarchy* (London 1963), 1960 Reith Lectures revised).

Daniel J. Boorstin makes a number of censorious comments on mass communication and the narcissism of the camera-toting public in *The Image*, first published in 1962. All shades of opinion on the subject will be found in the revealing anthology, *Mass Culture* (The Popular Arts in America), edited by Bernard Rosenberg and David Manning White, N.Y., London, first published in 1957. An excellent discussion on the effects of photographic reproduction on the visual arts is contained in William M. Ivins Jr., *Prints and Visual Communication*, Chapter VII, 'New Reports and New Vision. The Nineteenth Century', London 1953.

List of illustrations

22 Photograph taken on ordinary plate, insensitive to most colours. From A. E. Garrett, *The Advance of Photography*. 1911.

23 The same subject taken on panchromatic plate. From A. E. Garrett, *The Advance of Photography*. 1911.

24 Charles Nègre: *Le joueur d'orgue de barbarie*. Paris *c*. 1850 (calotype). Collection André Jammes.

25 Nadar: *The Catacombs of Paris*. *c*. 1860.

26 Daumier: *Don Quixote and Sancho Panza*. *c*. 1860. (Oil on panel, grisaille.) Van Beuren Collection, Newport, R.I. By permission of Mr A. Van Beuren.

27 Fantin-Latour: *Autour du piano*. 1884.

28 Fantin-Latour: *Portrait of Édouard Manet*. 1867. Courtesy of the Art Institute of Chicago.

29 Nadar: *Portrait of Charles Baudelaire*. 1859.

30 Manet: *Portrait of Charles Baudelaire*. 1865 (etching).

31 Manet: *Portrait of Méry Laurent*. 1882 (pastel). Collection Musée de Dijon.

32 Manet: *The Execution of the Emperor Maximilian*. 1867(?). Mannheim Museum.

33 Photograph of the Emperor Maximilian.

34 Manet: *The Execution of the Emperor Maximilian*. 1867(?) (detail). Mannheim Museum.

35 Photograph of General Miramon.

36 Manet: *The Execution of the Emperor Maximilian*. 1867(?) (detail). Mannheim Museum.

37 Photograph of General Mejia.

38 Manet: *The Execution of the Emperor Maximilian*. 1867(?) (detail). Mannheim Museum.

39 Photograph of General Diaz.

40 Manet: *The Execution of the Emperor Maximilian*.. 1867(?) (detail). Mannheim Museum.

41 Photograph of the firing squad in the execution of Maximilian. 19 June 1867.

42 Disderi(?): Composite *carte* photograph relating to the execution of Maximilian. Probably 1867. Courtesy Bibliothèque Nationale, Paris.

43 *Carte* photograph (composite?) showing the execution of Maximilian, Miramon and Mejia, 19 June 1867, n.d. Sirot Collection, Bibliothèque Nationale, Paris.

44 Photo-painting from *Album photographique des uniformes de l'armée française*. 1866.

45 Benjamin B. Turner: Landscape photograph. *c*. 1855. Collection André Jammes.

46 Henri Le Secq: *Sunset in Dieppe*. *c*. 1853 (calotype).

47 Beyrouth, Lebanon, 1839 (from engraving on daguerreotype plate). From Lerebours, *Excursions daguerriennes*. Paris 1840–42. George Eastman House Collection, Rochester, New York.

48 Gérôme: *The Muezzin. Evening*. 1882.

49 Gérôme: *Oedipus. Bonaparte before the Sphinx*. 1886.

50 Roger Fenton: *Valley of the Shadow of Death*. The Crimea 1855. Photo: Science Museum, London.

51 Mathew Brady or assistant: *Missionary Ridge, Gettysburg*. 1863.

52 Fox Talbot: Calotype of trees. Early 1840s. Photo: Science Museum, London.

53 William J. Newton: Calotype view of Burnham Beeches. *c.* 1850–53. Collection André Jammes.

54 Hippolyte Bayard: *The Roofs of Paris from Montmartre*. 1842 (direct positive on paper).

55 Photographic study used by Theodore Robinson for *The Layette*. *c.* 1889–90. Photo: Brooklyn Museum. By permission of Mr Ira Spanierman, New York.

56 Theodore Robinson: *The Layette*. *c.* 1891. In the Collection of the Corcoran Gallery of Art, Washington D.C.

57 Corot: *The Bent Tree*. *c.* 1855–60. Reproduced by courtesy of the Trustees of The National Gallery, London.

58 Adalbert Cuvelier(?): Photograph taken in the environs of Arras(?). 1852.

59 Daubigny: *Les bords de la Seine*. Salon of 1852.

60 Nadar: Satire on Daubigny's *Les bords de l'Oise* exhibited in the Salon of 1859.

61 The Grand Canal, Venice. Engraving on daguerreotype taken 1839–42. Published in *Excursions daguerriennes*. 1842.

62 Ruskin: *The Chapel of St Mary of the Thorn, Pisa*. 1872. Ashmolean Museum, Oxford. Ruskin wrote of this drawing: 'an old study of my own from photograph'.

63 Photograph of the Ducal Palace, Venice, in Ruskin's collection. Courtesy Ashmolean Museum, Oxford.

64 Daguerreotype of the Niagara Falls *c.* 1854. A later photograph conveying probably what Turner saw in those of Mayall.

65 J. M. W. Turner: *The Wreck Buoy*. Begun probably 1808–9, extensively reworked 1849. Walker Art Gallery, Liverpool.

66 Thomas Seddon: *Jerusalem and the Valley of Jehoshaphat from the Hill of Evil Counsel*. 1854. Reproduced by courtesy of the Trustees of The Tate Gallery, London.

67 Ruskin: Drawings and a daguerreotype of the Towers of the Swiss Fribourg. 1856. 1. Drawing in the 'Düreresque' style which he supported. 3. Drawing in the 'Blottesque' style which he rejected. Collection J. G. Links, London.

68 Millais: *Murthly Moss*. 1887.

69 Emerson and Goodall: *Gunner Working up to Fowl*. Photograph from *Life and Landscape on the Norfolk Broads*. 1886.

70 H. P. Robinson: *Women and Children in the Country*. 1860 (composite photograph). George Eastman House Collection, Rochester New York.

71 Millais: *Apple Blossoms*. 1856–9. Exhibited as *Spring* in 1859. Collection Lord Leverhulme. By permission of Lord Leverhulme and the Royal Academy of Arts.

72 Charles Nègre: *Market Scene on the Quais*. Paris (oil on canvas). Courtesy André Jammes.

73 Charles Nègre: *Market Scene on the Quais*. Paris 1852 (calotype). Courtesy André Jammes.

74–6 Eugène Durieu: Photographs of male nude from album belonging to Delacroix. Probably 1853. Bibliothèque Nationale, Paris.

77 Delacroix: Sheet of sketches made from photographs taken by Durieu. *c.* 1854. Musée Bonnat, Bayone.

78 Marcantonio Raimondi: *Adam Enticing Eve.* After Raphael. Early sixteenth century.

79 Photograph of female nude from the Delacroix album. Bibliothèque Nationale, Paris.

80 Delacroix: Sheet of drawings. Musée Bonnat, Bayonne.

81 Photograph of female nude from the Delacroix album. Bibliothèque Nationale, Paris.

82 Delacroix: *Odalisque.* 1857. (12 × 14 inches.) Stavros S. Niarchos Collection.

83 Courbet: *L'atelier.* 1855 (detail). Louvre.

84 Villeneuve: Nude study. Photograph. Bibliothèque Nationale, Paris. Acquisition date, 1854.

85 Courbet: *La femme au perroquet.* 1866. The Metropolitan Museum of Art, New York. Bequest of Mrs H.O. Havemeyer 1929. The H.O. Havemeyer Collection.

86 Nude study. Photograph, anon. n.d. Bibliothèque Nationale, Paris.

87 Courbet: *Les baigneuses.* 1853 (detail). Musée Fabre, Montpellier.

88 Villeneuve: Nude study. Photograph. Bibliothèque Nationale, Paris. Acquisition date, 1853.

89 Adolphe Braun: *Le château de Chillon.* Photograph. 1867. Collection Société française de Photographie.

90 Courbet: *Le château de Chillon.* Signed and dated 1874. Musée Courbet, Ornans. By permission of Les Amis de Gustave Courbet, Paris.

91 Gustave Le Gray: *Sky and Sea.* 1860 (photograph).

92 Courbet: Seascape. n.d.

93 Nadar: *Photography Asking for Just a Little Place in the Exhibition of Fine Arts.* From *Petit Journal pour Rire.* 1855.

94 Nadar: *The Ingratitude of Painting, Refusing the Smallest Place in its Exhibition, to Photography to whom it Owes so Much.* From *Le Journal amusant.* 1857.

95 Nadar: *Painting Offering Photography a Place in the Exhibition of Fine Arts.* Paris 1859.

96 Nadar: Satire on the battle paintings shown in the Salon of 1861 (lithograph).

97 Yvon: *Solferino.* Salon of 1861 (detail).

98 Mayer and Pierson: *Carte* photograph of Lord Palmerston. 1861.

99 Mayer and Pierson: *Carte* photograph of Count Cavour. 1861.

100 Daumier: *Nadar élevant la photographie à la hauteur de l'art.* 1862 (lithograph).

101 A. Beer: *The Fisherman's Daughter.* Before 1860 (photograph). Collection Royal Photographic Society, London.

102 Dr Diamond: *Still-life.* 1850s(?) (photograph). Collection Royal Photographic Society, London.

103 Theodore Robinson: *Two in a Boat.* 1891. The Phillips Collection, Washington, D.C.

104 Photographic study used for Robinson's *Two in a Boat. c.* 1890. Photo: Brooklyn Museum. By permission of Mr Ira Spanierman, New York.

105 Achille Quinet: *View of Paris. c.* 1860 (photograph).

106 Achille Quinet: *View of Paris. c.* 1860 (photograph (detail)).

107 Achille Quinet: *The Pantheon, Paris.* 1860s(?) (photograph (detail)).

108 Monet: *Boulevard des Capucines.* 1873. By permission of Mrs Marshall Field Sen., New York.

109 Adolphe Braun: *The Pont des Arts.* 1867 (detail from panoramic photograph of Paris). Collection Société française de Photographie, Paris.

110 Monet: *Boulevard des Capucines.* 1873 (detail). By permission of Mrs Marshall Field Sen., New York.

111 Monet: *Poplars at Giverny. Sunrise.* 1888. Collection The Museum of Modern Art, New York. Gift of Mr and Mrs William Jaffe.

112 *Le Pont-Neuf.* Engraving on daguerreotype plate published in *Excursions Daguerriennes,* 1842.

113 and 114 (detail). Hippolyte Jouvin: *Le Pont-Neuf.* 1860–5 (stereoscopic photograph). Collection André Jammes.

115 Hippolyte Jouvin: *Place des Victoires.* 1860–65 (stereoscopic photograph). Collection André Jammes.

116 Gustave Caillebotte: *Un refuge, boulevard Haussmann.* 1880. By courtesy of Wildenstein Ltd, London.

117 Gustave Caillebotte: *Boulevard, vue d'en haut.* 1880. By courtesy of Wildenstein Ltd, London.

118 Nadar: Aerial photograph taken from a balloon. 1858. Bibliothèque Nationale, Paris.

119 and 120 (detail). Hippolyte Jouvin: *Boulevard de Strasbourg.* 1860–5 (stereoscopic photograph). Collection André Jammes.

121 Anon: Detail from instantaneous photograph. 1860s(?).

122–4 Disderi: Series of *cartes-de-visite* showing Mérante, Coralli, Terraris and Louise Fiocre in the costumes of the ballet, *Pierre de Médicis.* Probably 1876.

125 Degas: *Le foyer de la danse.* 1872. Louvre. Camondo Bequest.

126 Degas: *The Woman with the Chrysanthemums* (Mme Hertel). 1865. The Metropolitan Museum of Art, New York. Bequest of Mrs H.O. Havemeyer 1929. The H.O. Havemeyer Collection.

127 Degas: *Bouderie.* 1873–5. The Metropolitan Museum of Art, New York. Bequest of Mrs H.O. Havemeyer 1929. The H.O. Havemeyer Collection.

128 Photograph of Paul Poujaud, Mme Arthur Fontaine and Degas, posed by the artist in 1894.

129 Disderi: *Carte* photograph of the Prince and Princess de Metternich. *c.* 1860.

130 Degas: *Portrait of the Princess de Metternich.* Reproduced by courtesy of the Trustees of the National Gallery, London. Copyright S.P.A.D.E.M., Paris.

131 *Carte* photograph of Degas taken probably 1862.

132 Degas: Self-portrait, *Degas saluant*. *c.* 1862. Calouste Gulbenkian Foundation, Lisbon.

133 Nadar: Satire on *Le frileux*, Charles Marschal's painting exhibited in the Salon of 1859.

134 Degas: *Portraits dans un bureau, Nouvelle Orléans*. 1873. Musée des Beaux-Arts, Pau.

135 Robert Tait: *A Chelsea Interior*. Exhibited R.A. 1858. Collection Marquess of Northampton.

136 Vermeer: *Soldier and Laughing Girl*. *c.* 1657. Copyright, The Frick Collection, New York.

137 Streintz: Photographs demonstrating differences in perspective scale according to lens and viewpoint. 1892.

138 Hiroshige: *The Haneda Ferry and Benten Shrine*. 1858. From *One Hundred Views of Yedo*.

139 Instantaneous photograph of the Borough High Street, London, taken in 1887 under the direction of Charles Spurgeon Jun.

140 Degas: *Place de la Concorde* (*Vicomte Ludovic Lepic and his Daughters*). *c.* 1875. Formerly Gerstenberg Collection, Berlin.

141 Hippolyte Jouvin: *Boulevard des Capucines*. 1860–65 (stereoscopic photograph). Collection André Jammes.

142 Detail of above.

143 Degas: *Carriage at the Races*. 1873. Courtesy Museum of Fine Arts, Boston. Arthur Gordon Tompkins Residuary Fund.

144 Cham: Detail from page of caricatures and satire on Disderi. *Le Charivari*. December 1861.

145 Degas: Dancer in sequential poses. n.d. Collection Oscar Schmitz, Dresden.

146 Degas: *Dancer Tying her Slipper*. 1883(?). The Cleveland Museum of Art, Gift of Hanna Fund.

147 Muybridge: *Female, lifting a towel, wiping herself* . . . Consecutive series photographs from *Animal Locomotion*, published 1887.

148 Disderi: Martha Muravieva in dancing costume. 1864. Uncut sheet of *cartes-de-visite*. George Eastman House Collection, Rochester, New York.

149 Degas: *Le pas battu*. *c.* 1879 (pastel on monotype). Collection Buhrle, Zürich.

150 Muybridge: Consecutive series photographs showing phases of movement in a horse's trot and gallop. 1877–8. Published in *La Nature*. 14 December 1878.

151 Géricault: *Course de chevaux à Epsom, le Derby en 1821*. Louvre.

152 Muybridge: *Annie G. in Canter*. From *Animal Locomotion*. 1887.

153 Degas: *Jockey vu de profil* (actually, Annie G. in Canter). 1887 or after (charcoal).

154 Degas: *Annie G. in Canter*. 1887 or after.

155 Replica of Muybridge's zoöpraxiscope, 1880. Crown copyright. Science Museum, London.

156 Muybridge: *American Eagle Flying*. From *Animal Locomotion*. 1887.

157 Muybridge: *Cockatoo Flying*. From *Animal Locomotion*. 1887.

158 Detaille: *En batterie*. Exhibited in Salon of 1890.

159 Stanley Berkeley: *For God and the King*. 1889.

160 Muybridge: *Pandora jumping hurdle*. From *Animal Locomotion*. 1887.

161 Marey: Chronophotograph of walking figure. *c.* 1887.

162 Rodin: *St John the Baptist*. First conceived 1878 (bronze). Collection The Museum of Modern Art, New York. Mrs Simon Guggenheim Fund.

163 Marey: Chronophotograph of the flight of a bird. 1887. Archives de Cinémathèque Française, Paris.

164 Wilhelm Busch: *Der Photograph*. 1871. Courtesy Otto Stelzer.

165 Seurat: *Le Chahut*. 1889–90. Kröller-Müller Museum.

166 Marey: Graph of a figure jumping. 1880s (from chronophotograph).

167 Du Hauron (and others): 'Transformism' in photography. *c.* 1889.

168 *The Pneumatic Pencil*. From *The Picture Magazine*. 1894.

169 Drawing made with the pneumatic pencil. From *The Picture Magazine*. 1894.

170 Rudolph Dührkoop: Photograph of Alfred Kerr. 1904 (Bromoil print). Collection Royal Photographic Society, London.

171 Herkomer: *Self-portrait*. *c.* 1910 (lithograph).

172 R.Y.Young: *Mrs Jones is out*. 1900 (stereoscopic photograph).

173 *The Oath of the Horatii*. Late nineteenth century (photograph). Collection Louis Chéronnet.

174 *Le triomphe de la République*. Late nineteenth century (photograph). Collection Louis Chéronnet.

175 Richard Polak: *The Painter and his Model*. 1915 (photograph).

176 Dagnan-Bouveret: *Une noce chez le photographe*. Salon of 1879 (painting).

177 Gérôme: *Grand Bath at Broussa*. 1885 (painting).

178 William Logsdail: *St Martin-in-the-Fields*. Exhibited R.A. 1888 (painting). Reproduced by courtesy of the Trustees of the Tate Gallery, London.

179 Mortimer Menpes: *Umbrellas and Commerce*. Japan. 1890s (water-colour).

180 Duchamp: *Portrait*, or *Five Silhouettes of a Woman on Different Planes*. 1911. Philadelphia Museum of Art. The Louise and Walter Arensberg Collection.

181 Marey: Chronophotograph of English boxer. 1880s. Archives de Cinémathèque Française, Paris.

182 Duchamp: *Nude Descending a Staircase No. 1*. 1911. Philadelphia Museum of Art. The Louise and Walter Arensberg Collection.

183 Duchamp: *Nude Descending a Staircase No. 2*. 1912. Philadelphia Museum of Art. The Louise and Walter Arensberg Collection.

184 Paul Richer: Figure descending a staircase. Drawing based on chronophotographs. From *Physiologie Artistique de l'homme en mouvement*. 1895.

185 Marey: Graph of movements in a horse's walk. 1886 (from chrono-photograph).

186 John Tenniel: Danvers the Dancer as Dame Hatley in *Black-Eyed Susan* at the Royalty Theatre. 1875.

187 Gibson: *The Gentleman's Dilemma.* c. 1900.

188 *The Canter.* From *The Picture Magazine.* 1893.

189 Marey or follower: Chronophotograph of figure during standing jump.

190 Boccioni: *Unique Forms of Continuity in Space.* 1913.

191 Balla: *Girl X Balcony.* 1912. Civica Galleria d'Arte Moderna, Milan.

192 Marey: Chronophotographs of walking and running man and of bird in flight. 1880s.

193 Balla: *Swifts: Paths of Movement + Dynamic Sequences.* 1913. Collection The Museum of Modern Art, New York.

194 Marey: Diagram from chronophotograph of gull in flight. 1880s.

195 Marey: Chronophotograph of the flight of a bird, 1887. Archives de Cinémathèque Française, Paris.

196 Severini: *Dancer at the Bal Tabarin.* 1912 (detail). Collection Riccardo Jucker, Milan.

197 A.G. Bragaglia: Photograph of Balla in dynamic sequences before his painting, *Dynamism of a Dog on a Leash.* 1911.

198 A.G. Bragaglia: Photograph of a cellist. 1911.

199 Balla: *Rhythm of a Violinist.* 1912. Reproduced by courtesy of the Trustees of The Tate Gallery, London and Mr Eric Estorick.

200 Naum Gabo: *Linear Construction.* 1942–3 (plastic with plastic thread).

Reproduced by courtesy of the Trustees of The Tate Gallery, London.

201 Marey: Stereoscopic chronophotographs showing geometric forms engendered by the rotation of a threaded metal armature. Probably 1890s.

202 Marey: Chronophotograph of a fencer. 1880s. Archives de Cinémathèque Française, Paris.

203 Gris: *The Table.* 1914 (coloured papers, printed matter, gouache on canvas). Philadelphia Museum of Art. A.E. Gallatin Collection.

204 Avelot: *Les groupes sympathiques.* (*Photographies instantanées.*) Caricature of double exposure from *Le Rire.* 1901.

205 Picasso: Untitled. 1937. In artist's possession.

206 W.J. Demorest: *A Photographic Feat.* 1894. From Woodbury, *Photographic Amusements.* 1896.

207 Picasso: *On the Beach.* Dinard 1928. By permission of Mr George L.K. Morris.

208 Photomontage and painting by Sir Edward Blount. 1873. The Gernsheim Collection, University of Texas.

209 Photomontage. *Giant Roosters and Hens to Provide Large Easter Eggs.* From *L'Illustration Européenne.* Brussels 2 April 1911.

210 Ferdinand Zecca: *A la conquête de l'air. c.* 1901 (film still).

211 Carlo Carrà: *French Official Observing Enemy Movements.* 1915. By courtesy of Il Milione, Milan.

212 R. de Moraine: Military 'cartouche' for pasting in photograph. Late

nineteenth century(?) (lithograph). George Eastman House Collection, Rochester, New York.

213 George Grosz: *The Montage-Paster (The Engineer) Heartfield.* 1920 (water-colour and collage). Collection The Museum of Modern Art, New York. Gift of A. Conger Goodyear.

214 Hanna Höch: *Dada Dance.* 1922 (photomontage). Courtesy Marlborough Gallery, London.

215 John Heartfield: *Millions Stand behind Me. The Meaning of the Hitler Salute.* 16 October 1932 (photomontage). Courtesy Professor Heartfield.

216 John Heartfield: *I, Vandervelde Recommend Best the Freedom of the West.* 3 June 1930 (typophotomontage). Courtesy Professor Heartfield.

217 John Heartfield: *As in the Middle Ages, so in the Third Reich.* 31 May 1934 (photomontage). Courtesy Professor Heartfield.

218 Police photograph of a murder victim. Stuttgart *c.* 1929.

219 John Heartfield: *A Pan-German. The Bosom from which it Crept is still Fruitful.* 2 November 1933 (photomontage). Courtesy Professor Heartfield.

220 Page of advertisements from *Der Fliegenden Blätter.* Munich 1899.

221 Max Ernst: *Paysage à mon goût.* 1920 (photomontage).

222 Max Ernst: *The Landscape Changes Three Times (II).* From *La femme 100 têtes.* 1929 (montage from engravings).

223 *A Curiosity Constructed from an Orange.* By H. Thiriat 1889 (engraving from photograph).

224 Max Ernst: *The Sunday Spectre Makes Shrill Sounds.* From *La femme 100 têtes.* 1929 (montage from engravings).

225 H. Thiriat: Engraving from photograph. 1891.

226 Photograph from which illustration 225 was made.

227 Man Ray: Drawing and photo-collage elements illustrating Lautréamont's famous words. Published in *Minotaure.* 1933.

228 *A Startling Trick.* Engraving from *The Picture Magazine.* 1894. Also published in *La Nature*, 1880: 'Experiment Concerning Inertia'.

229 André Breton: *The Comte de Foix about to Assassinate his Son.* 1929. By permission of Mr Patrick Waldberg.

230 Max Ernst: *In the Stable of the Sphinx.* Frottage from the *Histoire Naturelle.* 1927.

231 Oscar Dominguez: *Decalcomania without object.* 1937.

232 René Magritte: *Time Transfixed.* 1932. Reproduced by courtesy of the Trustees of The Tate Gallery, London and the Edward James Collection.

233 El. Lissitzky: *Tatlin working on the monument to the Third International*(?) (drawing and photocollage) 1917(?) Courtesy Grosvenor Gallery, London.

234 Photographs of aircraft in flight used by Malevich in *The Non-Objective World.* First published 1927. (Bauhausbuch 11, Munich.) By permission of Herr Hans Wingler, Darmstadt.

235 Malevich: *Suprematist composition conveying a feeling of universal space.* 1916. First published in *The Non-Objective World* 1927. (Bauhausbuch 11, Munich.) By permission of Herr Hans Wingler, Darmstadt.

236 Aerial photograph used by Malevich in *The Non-Objective World*. First published 1927. (Bauhausbuch 11, Munich.) By permission of Herr Hans Wingler, Darmstadt.

237 Moholy-Nagy: Photogram. 1923.

238 Alvin Langdon Coburn: A Vortograph *c.* 1917.

239 Man Ray: Rayograph for the *Champs Délicieux*. 1921. By permission of Man Ray.

240 Kurt Schwerdtfeger: *Reflected Light Composition. c.* 1923.

241 R.E.Liesegang: Reticulated, solarized photograph. 1920. Courtesy Standish D.Lawder.

242 Marey: Stereoscopic trajectory photograph of a slow walk. 1885.

243 Klee: *The Mocker Mocked*. 1930. Collection The Museum of Modern Art, New York. Gift of J.B. Newmann.

244 Klee: *Little Jester in a Trance*. 1929.

245 Fox Talbot: Photomicrograph of butterfly wings. 1840s. Photo: Science Museum, London.

246 Fox Talbot: Photomicrograph of botanical sections taken with solar microscope. 1841. Photo: Science Museum, London.

247 Warren de la Rue: Photograph of the moon. 1857. Photo: Science Museum, London.

248 The nebula in Andromeda (beyond the solar system). Photo by the Yerkes Observatory. Published in *Marvels of the Universe*. 1910.

249 A.Leal: Photomicrograph of growth on water-weeds. Published in *Marvels of the Universe*. 1910.

250 Richard Lippold: *Variation Number 7: Full Moon*. 1949–50 (brass, chromium and stainless steel wire). Collection The Museum of Modern Art, New York. Mrs Simon Guggenheim Fund.

251 Photographs of snow crystals by W.A.Bentley. From *Marvels of the Universe*. 1910.

252 Robert Rauschenberg: *Barge*. 1962 (detail) (whole 80×389 inches). Leo Castelli Gallery. Collection: the artist. Photo: Rudolph Burckhardt.

253 Andy Warhol: *Marilyn Monroe*. 1962 (silkscreen on canvas). Permission Leo Castelli Gallery.

254 Juan Genovés: *Exceeding the Limit*. 1966 (oil on canvas). Courtesy Marlborough Gallery, London.

255 a–d. Richard Hamilton: Stages in the painting, *People*. 1965–6 (oil and cellulose on photo, $31\frac{3}{4} \times 47\frac{3}{4}$ inches). Courtesy the artist and Robert Fraser Gallery.

256 Degas: *The Bellelli Family*. 1861–2. Louvre.

257 Lincke(?): Photograph of the Russian Ambassador and his family. Berlin 1859.

258 Disderi: *The Legs of the Opera*. Uncut *cartes-de-visite* photographs. 1860s. Bibliothèque Nationale, Paris.

259 Ubac. *Fossil*. Relief photograph of the Paris Opera. *Minotaure*. 1937–9.

260 Ubac. *Fossil*. Relief photograph from *Minotaure*. 1937–9.

261 Moholy-Nagy: *Our Big Men*. 'Contrasts of proportion and perspective by a few lines.' 1920s. Courtesy Klinkhardt & Biermann, Brunswick.

262 Man Ray: *Admiration of the Orchestrelle for the Cinematograph*. 1919 (air-brush painting). Collection The Museum of Modern Art, New York. Gift of A.Conger Goodyear.

Index

References to sources of information, and acknowledgements to those who suggested some of them, are made mostly in appropriate parts of the NOTES and not in the INDEX. Page numbers in *italics* refer to illustrations.

Of Further Interest from Penguin Books

WAYS OF SEEING

John Berger

'Seeing comes before words. The child looks and recognizes before it can speak. But there is also another sense in which seeing comes before words. It is seeing which establishes our place in the surrounding world; we explain that world with words, but words can never undo the fact that we are surrounded by it. The relation between what we see and what we know is never settled.' So begins this book, based on the acclaimed television series. *Ways of Seeing* widens the horizons, quickens the perceptions, and enlivens new vistas as we look at art, the world, and ourselves.

Books on Art from Penguin Books

STYLE AND CIVILIZATION SERIES

This series aims to interpret the important styles in European art in the broadest context of the civilization and thought of their times.

EARLY MEDIEVAL

George Henderson

This book traces developments in European art from the age of the barbarian migrations to the age of the pilgrimage roads and the great monasteries. The beliefs and loyalties of early medieval men and women, their popular lore and their hard-won learning, are sifted in an attempt to explain the meaning of the term 'Early Medieval' in art.

BYZANTINE STYLE AND CIVILIZATION

Steven Runciman

For more than eleven centuries Christian civilization was dominated in the East by the imperial city of Constantinople, and a deeply religious conception of the universe is reflected in Byzantine art.

HIGH RENAISSANCE

Michael Levey

Michael Levey views High Renaissance as an age triumphantly sure that art can rise above nature. Here, writing absorbingly and aided by a great understanding of the period and a selection of over 150 illustrations, Levey demonstrates how Michelangelo's 'David', Titian's 'Assunta', a piece of Spanish jewellery, or a Palissy dish – to name only a few – illustrate the defiant virtuosity of the High Renaissance.

NEO-CLASSICISM

Hugh Honour

Jacques-Louis David's martyr icons of the French Revolution, Claude-Nicolas Ledoux's symbolic architecture of pure geometry, Antonio Canova's idealized erotic marbles – in such Neo-classical masterpieces the culminating phase of the Enlightenment found artistic expression.

REALISM

Linda Nochlin

This book discusses the acute social awareness and preoccupation with actuality in art and literature that followed the social and political up-heavals of the mid–nineteenth century.